JAMES TURRELL the other horizon

Diese umfassende Gesamtpublikation erschien anläßlich der Ausstellung
„James Turrell: the other horizon" im MAK, Wien 1998/99.
This comprehensive catalogue was published on the occasion of the retrospective
exhibition "James Turrell: the other horizon" at MAK, Vienna 1998/99.

MAK
Applied Arts | Contemporary Art

JAMES TURRELL the other horizon

Mit Beiträgen von / With essays by

Daniel Birnbaum

Georges Didi-Huberman

Michael Rotondi

Paul Virilio

Herausgegeben von / Edited by
Peter Noever, MAK

Hatje Cantz

JAMES TURRELL: the other horizon

Ausstellung / Exhibition: James Turrell, Peter Noever

Kurator / Curator: Daniela Zyman
Assistenz / Assistance: Ruth Lackner, Claudia Seidel
Technische Gesamtkoordination / Technical Coordination: Philipp Krummel, Harald Trapp
Assistent des Künstlers / Assistance to the artist: Michael Bond

Wir danken den Leihgebern / We thank all the lenders:
Michael Hue-Williams Fine Art, London; James Turrell, Flagstaff, Arizona

Besonderer Dank an / Special thanks to: Janet Olmsted Cross, New York; Janet Schultz,
Flagstaff, Arizona; Barbara Gladstone, New York; Carine Asscher, Paris; Jessica Beer, Vienna;
EMIS Modegalerie, Vienna; Setagaya Art Museum, Tokyo; Magasin 3, Stockholm

Für die Unterstützung danken wir / We thank for their support:
Bundesministerium für Unterricht und kulturelle Angelegenheiten,
Bundeskanzleramt – Kunstsektion, MAK ART SOCIETY

MAK
Stubenring 5, A-1010 Vienna, Austria
Tel. (+43-1) 711 36-0, Fax (+43-1) 713 10 26
E-Mail: office@MAK.at, www.MAK.at

Herausgeber / Editor: Peter Noever
Redaktion / Catalogue editing: Daniela Zyman, Ruth Lackner, Claudia Seidel
Graphik-Design / Graphic design: Maria-Anna Friedl
Übersetzung / Translation: Brian Holmes, Margret Millischer, Werner Rappl, Claudia Spinner

ISBN 3-7757-9062-4

Erschienen im / Published by: Hatje Cantz Verlag
Senefelderstraße 12, 73760 Ostfildern-Ruit, Germany
Tel. (+49) 711 4405-0
Fax (+49) 711 4405-220
Internet: www.hatjecantz.de

Auslieferung in den USA / Distribution in the US: D.A.P.
155 Avenue of the Americas, 2nd floot, New York, NY 10013
Tel. (+1) 212 627 1999
Fax (+1) 212 627 9484

Printed in Germany

Cover: Hover, 1983

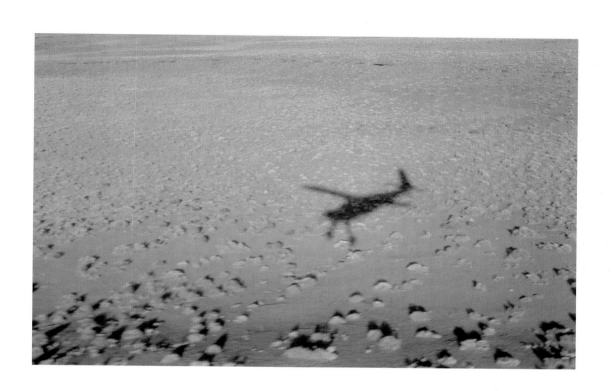

Inhaltsverzeichnis

Contents

Peter Noever

NUVATUKYA'OVI![1]

Zum Thema

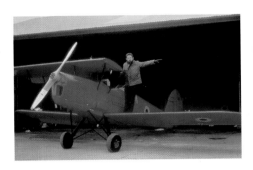

Einer unter vielen, kein Solitär, sondern ein Vulkan inmitten der San Francisco Peaks, unweit der im Norden von Arizona gelegenen Stadt Flagstaff, ein Teil der riesigen, über 6.000 km² großen San Francisco Volcanic Fields: der *Roden Crater*.

Spätestens aber, wenn wir in die magischen Lichträume von James Turrells *Roden Crater* eintauchen, wenn wir diese neuartigen und doch vertrauten räumlichen Gebilde psychisch und physisch erfahren und wahrnehmen, spätestens dann eröffnet sich uns eine überraschende Dimension, die einer neuen „Einsicht" in unsere Existenz zwischen Gegenwart und Geschichte, zwischen Himmel und Erde gleichkommt. Erst in der Erfahrung des Eintretens begreifen wir diese stolz über die offene, farbenprächtige, malerische Landschaft herausragende weibliche Kurve als außergewöhnliches Experiment und Abenteuer zeitgenössischer Kunst.

Es gibt auch andere „Orte", die die unmittelbare sinnliche Wahrnehmung Turrell'scher Kunst ermöglichen – etwa seine skulpturalen Licht-Rauminstallationen (in Privatsammlungen und Museen)[2], aber erst der Eintritt in die unterirdische, geheimnisvoll anmutende Anlage des *Roden Crater* vermittelt dem Besucher das Gefühl, selbst zum Mittelpunkt des Universums geworden zu sein. Und doch kannte ich den Roden Crater, er war mir vertraut, lange bevor ich noch die San Francisco Peaks, von den Hopi bezeichnenderweise „Nuvatukya'ovi" genannt, bereiste. Ein erster Blick zeigt den Vulkan weit entfernt am Horizont, kurz vor Sonnenuntergang – ein ergreifendes Naturschauspiel, begleitet jedoch von dem drückenden und ungewissen Gefühl, das Ziel möglicherweise erst nach Einbruch der Dunkelheit zu erreichen –, als wir mit Jim's 1946er Dodge Power Wagon von seiner Ranch „Walking Cane" losfahren und über das 2.500 m hoch gelegene Plateau der High Desert zwischen Lavaströmen, dichten Büschen und Pflanzen dem mächtigen, 300 m hohen Vulkan entgegensteuern. Die Fahrt ist selbst schon ein eindrucksvoller Vorgeschmack auf Turrells lebenslange Auseinandersetzung mit dem Medium Licht: durch das Licht an sich, den Sonnenuntergang, durch Wolken und Vollmond nähern wir uns aus dem Krater geschnittenen Räumen, die in einer besonderen Intensität das Sternenlicht und den Mond unter dem Polarstern zusammenfassen.

James Turrell mit seinem einmotorigen Helio Courier, Baujahr 1967 / James Turrell with his single-engined Helio Courier, constructed in 1967

Meine erste Begegnung mit James Turrell liegt jedoch noch weiter zurück und fand im Sommer 1991 auf der kleinen Insel Inishkame, unmittelbar bei Castletown an der südirischen Küste in West Cork statt.

Er plante und arbeitete damals am *Irish Sky Garden*, einem weiteren ausgedehnten und vielschichtigen Projekt, einer in die faszinierende südirische Landschaft eingebetteten Anlage mit verschiedenen Stationen oder Wahrnehmungsräumen: einem mit einer halb-elliptoiden Eintiefung versehenen Krater, einem Hügel, einer Pyramide, umfriedeten Weiden und Wiesen, die sich in den Teichen spiegeln. Ein halb natürlicher, halb von Menschenhand geschaffener Himmels-

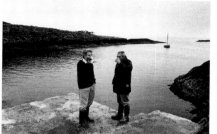

Erstes Treffen auf der Insel Inishkame, Irland, Sommer 1991 / first meeting on Inishkame Island, Ireland, summer 1991

garten mit spezifischen Ausblicken oder Orten, die die vielschichtigen Phänomene von Licht und Natur sichtbar werden lassen.

Hier traf ich James Turrell, der die zwei einzigen aus Stein gebauten Fischerhäuser auf dieser Insel bewohnte. Bereits damals sprachen wir von einer Ausstellung in Wien, in der versucht werden sollte, seiner vielschichtigen und komplexen Arbeitsweise gerecht zu werden – eben den Betrachter das erfahren zu lassen, was weder beschreibend noch bezeichnend oder partiell beleuchtend zu erklären ist.

Ich erinnere mich aber auch an einen Ausspruch des Schweizer Kunsthändlers, damals noch übereifriger Betreiber des Projekts, der meinte, daß der Besucher den *Irish Sky Garden,* wenn dieser einmal fertiggestellt sein würde, mit dem wehmütigen Gefühl, ein Paradies betreten zu haben, verlassen werde. Das Projekt wurde nicht realisiert, lediglich der Künstler wurde vom Kunsthändler mit schmerzhaften immateriellen und materiellen Blessuren zurückgelassen.

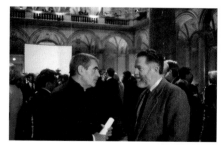

James Turrell bei der Neueröffnung des MAK, 1. Mai 1993 / James Turrell at the reopening of the MAK, May 1st 1993

Noch im Herbst des gleichen Jahres trafen wir uns in Wien, damit Turrell das MAK, das 1991 noch eine einzige Baustelle war, in allen sichtbaren und unsichtbaren Details kennenlernen konnte. Die Realisierung seines ersten Vorschlags für eine Intervention – die Verwandlung der MAK-Säulenhalle in ein *Skyspace*[3] – scheiterte an den in diesem Bereich bereits zu weit fortgeschrittenen Renovierungs- und Reparaturarbeiten und an den finanziellen Anforderungen.

San Francisco Peaks, Arizona, August 1994

Seitdem hat sich der Kontakt laufend intensiviert. Ich besuchte James Turrell mehrmals in Flagstaff und fand in liegender Stellung im bereits exakt kreisförmig ausgekofferten Trichter an der Spitze des *Roden Crater* die Vorstellungen und Intentionen des Künstlers wieder. Dabei wurde mir allmählich auch bewußt, warum seine Wahl gerade auf diesen Ort gefallen war. Der leidenschaftliche Pilot Turrell verbrachte 1974 zwischen der Bergkette der Rockies im Westen und dem Pazifik im Osten, von Kanada bis zur mexikanischen Grenze in einem Zeitraum von sieben Monaten über 500 Flugstunden in seiner einmotorigen Helio Courier aus dem Jahre 1967. Nachts schlief er in einen Schlafsack gewickelt unter seinem Flugzeug. Von Beginn an wußte er genau, was er suchte. Tief verwurzelt in der endlos erscheinenden Landschaft Arizonas und dem darüberliegenden Himmel, dessen Farben sich wie ein immer wiederkehrendes Naturschauspiel oft bis zu einem intensiven Tintenschwarz verändern, war Turrell auf der Suche nach einem Ort zur Realisierung, quasi zur Krönung seiner Vorstellungen. Sein (Lebens-)Werk sollte größer als die mächtigste Kathedrale und dennoch als solches nicht wahrnehmbar sein, ein verborgenes und dennoch im tiefsten Inneren des erloschenen Vulkans

zugängliches Instrument des Sehens, eine Art Observatorium, das möglicherweise über die Bewegung von Planeten und Sternen, von Erde, Sonne und Mond hinaus die Zeit erahnen läßt.

Mein bislang letzter Besuch fand im Mai 1997 statt – gemeinsam mit Daniela Zyman, der Kuratorin der nun verwirklichten MAK-Ausstellung – auf seiner Ranch in Arizona. Daß unsere Gespräche rund um die und auf der Spitze des *Roden Crater* stattfanden, war auch gleichsam der Startschuß für den Countdown des Ausstellungsprojektes *the other horizon*[4], wie das im *Roden Crater* erfahrbar gemachte Erlebnis eines entgrenzten Himmels, einer die Erde überwölbenden Kuppel bezeichnet werden kann. Die Eröffnung, die Wahrnehmung eines anderen, weiteren Horizonts aber steht auch sinnbildlich über Turrells ganzem Werk von den frühen Lichtprojektionen bis zu den aktuellen Himmelsobservatorien.

James Turrell auf seiner Ranch Walking Cane, Arizona mit Peter Noever / James Turrell on his ranch Walking Cane, Arizona with Peter Noever, August 1994

Ziel der MAK-Ausstellung ist es, mit einer repräsentativen Auswahl aus dem Gesamtwerk dem zentralen Anliegen, das der Künstler mit der ihm eigenen gelassenen Besessenheit seit je verfolgt, zu entsprechen: der Verbindung von Konkretion und Vision, von individuellem, greifbarem Erfahren und der Unwirklichkeit des Traums. Dieses doppelte Erleben soll dem Betrachter in Turrells komplexesten Lichtinstallationen zugänglich gemacht werden – auf seine eigene Gefahr allerdings, denn mir scheint neuerdings, ich habe in der intensiven Auseinandersetzung mit der vorliegenden Publikation und der Realisierung von Jim's tatsächlich überzeugend gelungener Wiener Ausstellung den letzten Funken an Realitätssinn verloren. Und so frage ich mich, ob ich den *Roden Crater* im Turrell'schen Sinn bereits erfahren habe, ob er tatsächlich vorhanden ist oder ob ich das Opfer einer Projektion des Künstlers, einer von ihm geschaffenen Lichtspiegelung, einer Vision geworden bin.

James Turrell, Daniela Zyman, Peter Noever. Ausstellungsvorbereitungen / preparing the exhibition, MAK, Vienna, September 1998

James Turrell, Kyung-Lim Lee in Peter Noevers *Grube / Pit*, Breitenbrunn, Burgenland, July 1997

1 Schau! Welch herausragendes Zeichen an unserem westlichen Horizont! (Hopi)
2 wie etwa: Israel Museum, Jerusalem; P.S.1, New York; Denver Art Museum, Denver; Kunstverein Westfalen, Düsseldorf; und seit November 1998, MAK, Wien
3 siehe S. 202–204
4 *The other Horizon* ist auch der Titel des im MAK errichteten *Skyspace*.

Peter Noever

NUVATUKYA'OVI![1]

On the Subject

Not a solitary peak, but a volcano among many, situated in the middle of the San Francisco Peaks, not far from Flagstaff, Arizona, and part of the gigantic San Francisco Volcanic Fieldswith, width over 3,500 square miles: the *Roden Crater.*

As soon as we enter the magic light spaces of James Turrell's *Roden Crater,* as soon as we perceive and experience these unprecedented yet familiar spatial constellations with our body and mind, at the very latest then, if not before, a surprisingly new dimension opens up, a new "insight" into our existence between the present and the past, between sky and earth. And only upon entering are we able to comprehend the sweeping, female curve towering proudly over the open, picturesquely colorful landscape as an unusual experiment and adventure in contemporary art.

There are, of course, other "places" which allow for an immediate sensual experience of Turrell's art – his sculptural light-space installations, for instance (in private collections and museums)[2], but only entering these underground, mystery-laden chambers of the *Roden Crater* evokes the feeling of having become the hub of the universe. And yet, I knew the *Roden Crater,* was familiar with it long before I travelled to the San Francisco Peaks, which are quite appropriately called "Nuvatukya'ovi" by the Hopi. A first glance onto the volcano looming far off on the horizon, shortly before sundown – an amazing natural sight accompanied by the uneasy and slightly worrisome feeling of probably being able to reach it only after nightfall. This was at the time when we had started out from Jim's ranch "Walking Cane" in his 1946 Dodge Power Wagon, approaching the massive 900-foot crater across the High Desert plateau, at 7,500 feet above sea level, across hardened beds of lava and through dense shrubbery and undergrowth. The drive itself already provided an impressive perspective onto Turrell's life-long preoccupation with the medium light: It is through light itself, the sunset, clouds and the full moon, that we approached the spaces cut into the crater, spaces that condense both starlight and moonlight under the pole-star with an unfamiliar intensity.

My first encounter with James Turrell took place even earlier, however: It was in the summer of 1991, on the small island of Inishkame near Castletown in West Cork, on the southern coast of Ireland, that we first met. At that point, he was planning the *Irish Sky Garden,* an extensive, multifaceted project to be imbedded into the splendid landscape of Southern Ireland, including various stations and perceptual spaces, among them a crater with a semi-elliptoid opening, a hill, a pyramid and fenced-in

James Turrells Dodge Wagon, Baujahr 1946 / constructed in 1946

pastures and meadows reflecting in various pools. A sky garden, half natural, half man-made, with observation points and places revealing the many-sided phenomena of light and nature.

This is where I met James Turrell, who inhabited the only two fishermen's houses made of stone on the whole island. Already then we talked about an exhibition in Vienna, which was to do justice to his intricate, complex approach, to his attempts of providing the viewer with an experience of something which may not be explained away as descriptive or indicative, or even as partially illuminating.

I do, too, remember the words of the Swiss art dealer, at that time highly enthusiastic about the project, that viewers who would have the chance to see the future, finished *Irish Sky Garden* would leave it with the sad feeling of having been in paradise.

Der Horizont am Rand des *Roden Crater* Trichters / the horizon at the rim of the *Roden Crater* bowl, Arizona, September 1997

The project was not realized, however, and it was the artist who was left by the art dealer, with painful material and immaterial damages.

In the fall of the same year, Turrell and I met in Vienna. He was to familiarize himself with the MAK, which, in 1991, was nothing but a construction-site, in all its obvious and hidden aspects. His first suggestion for an intervention – turning the MAK Main Hall into a *Skyspace* [3] – could not be realized because the renovation had already progressed too far for this idea, not to mention financial constraints.

After that, our contact intensified. I repeatedly visited Turrell in Flagstaff and, lying down in the just carved, precisely circular shape at the top of the *Roden Crater,* I discovered the artist's ideas and intentions for myself. I also began to understand why he had chosen this very site. In 1974, Turrell, passionate about flying, spent more than 500 hours in seven months flying in his 1967 single-engine Helio Courier in an area between the Rockies in the West and the Pacific Ocean in the

„Skywatch", *Roden Crater*, Arizona, September 1997

East, from Canada to the Mexican border. At night, he slept under his plane, wrapped in a sleeping bag. He knew from the very beginning what he was looking for. Deeply rooted in the sheer boundless landscape of Arizona and the sky above, whose color often turned a dense inky black as in an endlessly recurring natural phenomenon, Turrell was looking for a place to realize, to epitomize perhaps, his ideas. His (life's) work was to be bigger than the greatest cathedral and yet not to be perceived as such, a hidden instrument of seeing, accessible from the very core of the extinct volcano, a kind of observatory which might evoke time beyond the movement of planets and stars, the earth, the sun and the moon.

My last visit to date was in May 1997 – together with Daniela Zyman, the curator of the finally realized MAK exhibition – at his ranch in Arizona. The fact that our talks took place around and on top of the *Roden Crater* was quite appropriate to the beginning countdown for the exhibition project the other horizon[4], a phrase that may well apply to the sense of a sky without limits, a vault across the earth, which may be experienced on top of the *Roden Crater*. And yet, the opening, the perception of an another horizon could also be taken as a metaphor for Turrell's entire work, from his early light projections to his most recent sky observatories.

James Turrell in Peter Noevers *Grube / Pit*, Breitenbrunn, Burgenland, July 1997

The exhibition at the MAK intends to do justice to the artist's central idea, which, typical for him, has haunted him with a quiet passion: combining vision and concretion, individual, tangible sensations with the intangibility of dreams. It is this double experience that Turrell aims at in his most complex light installations – to be accessed by the viewer at his own risk, however. I, too,

seem to have left behind the last trace of my sense for reality while being immersed in this publication and Jim's utterly convincing exhibition in Vienna. And thus, I wonder if I have already experienced the *Roden Crater* in Turrell's sense, if it really does exist or if I'm just a victim of the artist's projection, a reflection of light, a vision.

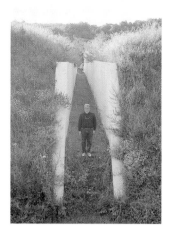

James Turrell in Peter Noevers *Grube /
Pit*, Breitenbrunn, Burgenland, July
1997

1 Look! What a prominent feature on our western horizon! (Hopi)
2 As in: Israel Museum, Jerusalem; P.S.1, New York; Denver Art Museum, Denver; Art Space Kunstverein Westfalen, Dusseldorf; and since November 1998 MAK, Vienna
3 See p. 202–204
4 *The other Horizon* is also the title of the *Skyspace* erected in the MAK

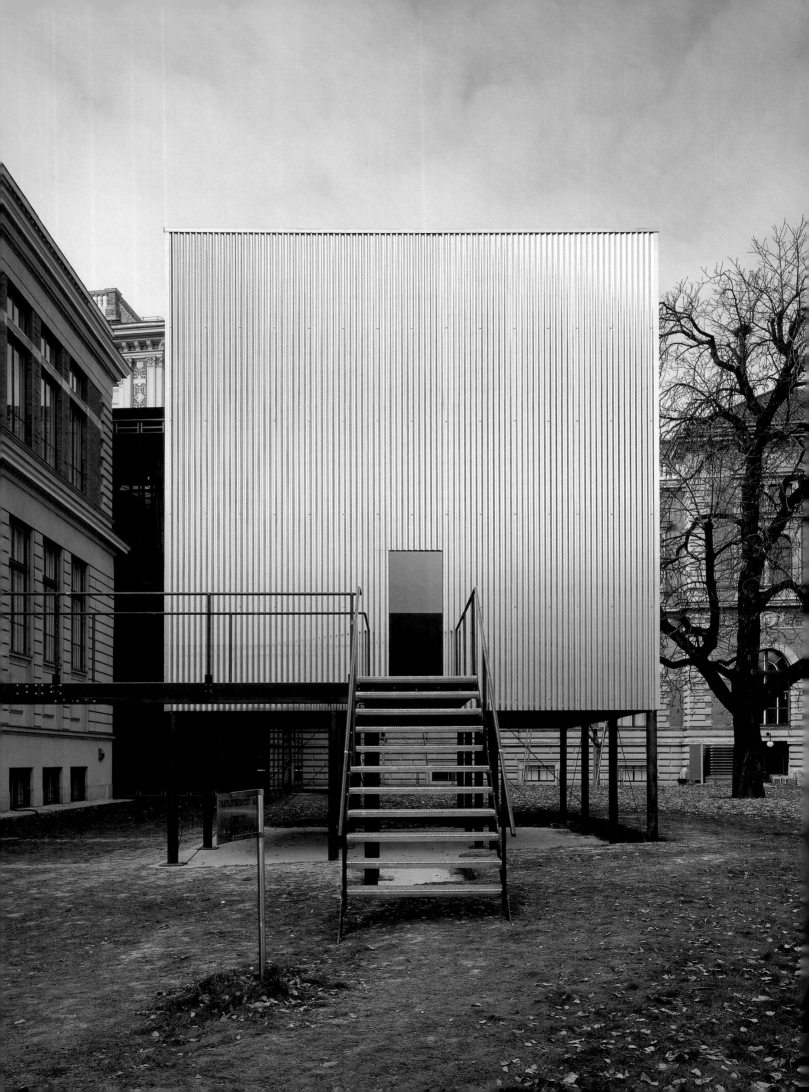

Daniela Zyman

the other horizon: ZUR AUSSTELLUNG IM MAK

Farbe ist der Ort, wo das Bewußtsein und das Universum zusammentreffen.
Paul Cézanne

Beim Betreten der MAK-Ausstellungshalle, erscheint am Ende einer steilen Treppenflucht ein Ausschnitt von zwei ineinander gelagerten Rechtecken, das eine materiell weiß, solide, das andere makellos strahlend, blau, dazwischen diffus schimmernd, körperloses Licht. Über die Treppe nähert man sich den beiden Flächen; das weiße Rechteck erweist sich als weiße Wand, durchbrochen von einer scharfkantigen Eintrittsöffnung (*aperture*), die, ist man am Ende der Treppe angelangt, den Blick in einen azurblauen Raum freigibt. Was aus der Ferne als homogene Farbfläche anmutete, erscheint nun zu einem lichten Blau verdichtet, das aus einer unergründlichen Tiefe strahlt und in eine „endlose" räumliche Ausdehnung weist. Im Gehen durch den Raum, entgegen dem blauen Farbfeld, löst sich das Gefühl, in einem euklidischen Raum zu sein suksessive auf, man läßt ihn hinter sich, um an der Grenze des Raumes in Farbe einzutauchen.
Diese genau kalkulierte Wirkungsweise der stetigen Veränderung des Wahrgenommenen – Treppe und Farbflächen aus der Fernsicht, das Kippen der Fläche in die Tiefe des dreidimensionalen Raumes, das Durchqueren des strahlenden Zwischenraumes und das „Fallen" in die blaue Farbmasse an der äußersten Raumgrenze, ist das Erscheinungsbild der bislang neuesten Arbeit von James Turrell, *Wide Out*, einem für das MAK konzipierten *Ganzfeld*-Raum, der die zentrale Ausstellungshalle in Besitz nimmt. *Wide Out* ist ein sich steigerndes Wechselspiel von Distanz, Illusion und Wahrnehmung, das in eine *Ganzfeld*erfahrung führt, bei der nach und nach die atmosphärische Dichte und kraftvolle Masse des Lichts physisch spürbar wird, scheinbar haptisch ertastbar in seiner Feinstofflichkeit. Es ist die intensive Erfahrung eines farbig gegenstandslosen Lichtfelds, das völlig homogen ist und die Gesamtheit des Gesichtsfelds ausfüllt.
Dieser begehbare Sehraum konstituiert sich um/durch die Begriffe der Dimensionalität und Farbe. Durch die nuancierte Lichtwirkung, die präzise abgestimmten Proportionen, den Verlauf der Sichtachsen und deren Abstimmung auf den Blickpunkt des Betrachters und die Auflösung der Volumina und Raumgrenzen entsteht das ästhetische Feld. Tiefe, Raumtiefe ist in ständigem Wechselspiel zur Fläche, als perspektivisches Enigma, als Beziehung zwischen dem Naheliegenden (Da) und dem In-der-Ferne-liegenden (Dort) und der Verbindung zueinander: „Was rätselhaft ist, ist die Verbindung zwischen den Dingen – daß ich die Dinge jeweils an ihrem Platz sehe, eben weil sie sich gegenseitig verdecken –, daß sie vor meinem Blick Rivalen sind, eben weil sie jeweils an ihrem Ort sind".[1] Diese enigmatische Natur des Raumes und seiner Dimensionalität,

The other Horizon 1998
Skyspace im MAK-Garten / *Skyspace* in the MAK garden

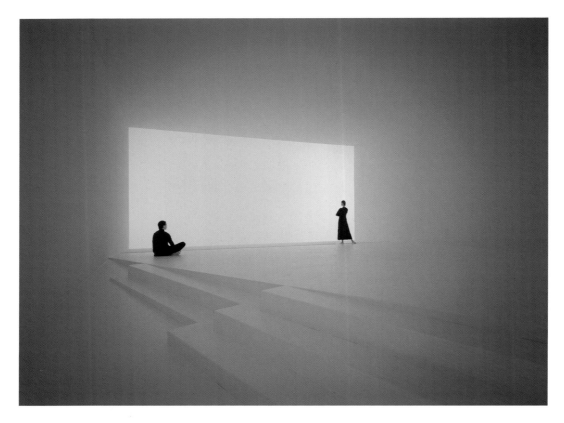

Wide Out 1998
MAK-Ausstellungshalle / MAK Exhibition Hall

verstärkt Turrell durch die Materialisierung des Zwischenraumes – des Transitorischen – des atmosphärischen Raumes *(ambient space)* durch Licht.

Prana und *St. Elmo's Breath*, zwei Arbeiten aus der Serie der *Space Division Constructions*, beruhen auf der Teilung unseres Wahrnehmungsbildes. Was wir sehen, ist die flache Frontalität des soliden Rahmens und die unbeständige Tiefe eines schimmernden Farbfeldes. Was wir vor uns haben sind zwei Raumteile, die Turrell als Betrachtungsraum *(viewing space)* und als Wahrnehmungsraum *(sensing space)* bezeichnet. Beide Raumteile sind mit eigenen Lichtquellen ausgestaltet, die sich einander an der Grenze der beiden Räume abtasten, sich gegenseitig bedingend, ohne ineinander zu fließen. Wiederum entwickelt sich das Bild entlang der Interferenzlinie des Öffnungsausschnitts, der sich in einer atmosphärischen Schwingung befindet. Das aus der Distanz, beim Eintritt in den Betrachtungsraum, wahrgenommene Farbfeld entsteht aus der äußersten Ausdehnung der Licht-Raum-Struktur des Wahrnehmungsraumes, wo sich Licht materialisiert und zur Oberfläche wird. Die farbige Fläche vor Augen verflüchtigt sich im Näherkommen und kehrt als Öffnung in einen Raum wieder, einem Lichtraum, der nicht leer ist, sondern atmosphärisch dicht und distanzlos gedehnt. Auf diese transitorische Qualität verweisen auch die Titel der Arbeiten, so bedeutet *Prana* in der indischen Philosophie das vitale, energetisch-geistige Prinzip, das als „letzter Atem" eines Menschen im Übergang in die Ewigkeit auf der Welt verbleibt und in der Meditation des Yogi, dem *pranayama*, in den Körper, zwischen dem Ein- und Ausatmen, einfließt und ihn mit Energie anfüllt. *St. Elmo's Breath* symbolisiert den Energieaustausch von Luft und Materie im Phänomen der Elmsfeuer, bei der sich Luft als glimmendes Licht an Kanten und hervorragenden Spitzen in die Atmosphäre entlädt.

Das Enigma des Raumes, das aus der „Rivalität der Dinge" entsteht, ist in den Arbeiten Turrells von abstrakter Natur, in einer Art auch das Spiel der Malerei zwischen Rahmen und Raum beschreibend. Farbe erscheint in *Milk Run II* und *Key Lime* π, zwei komplexen Lichtinstallatio-

nen der *Spectral Wedgeworks*, als graphische Lineatur und diagonal verlaufende Farbfläche. Linie und Fläche nehmen an einer Seite nahezu denselben Ausgangspunkt ein und markieren den Raum in seiner Vertikalen. Wohingegen die gelbe Linie den Raum auch horizontal begrenzt, öffnet die farbige Fläche die Zeichnung in die Tiefe. Durch einen kräftigen blauen Schimmer an ihrem äußersten Rand verrinnt die strahlende Farbmonochromie der Fläche in eine unergründliche Dunkelheit, in ein „Dort", das sich nicht preisgibt. Haltlos wendet sich der Blick und fokussiert den gelben Rahmen, um erneut in die Tiefe des Raumes zu tauchen und ihn zu ergründen. Durch das Pichler-Tor führt ein Steg aus der Ausstellungshalle in den MAK-Garten zu einem mit Wellblech verkleidetem Kubus auf Stelzen. Durch eine Türöffnung gelangt man in den Raum, in dem Sitzbänke aus Holz entlang der Wände verlaufen. In der Decke des Raumes ist eine scharfkantige Öffnung zu sehen, *The other Horizon*, ein *Skyspace*, das in die architektonische Struktur des Kubus eingeschnitten ist und den Blick erneut auf eine Farbfläche lenkt, die den Raum nach oben hin abschließt. Diffus, schimmernd und körperlos erscheint ein Ausschnitt des Himmels flach und greifbar nahe. Der Zwischenraum von Himmel und Erde materialisiert sich als Farbfeld, die sonst nicht faßbare Distanz scheint überwunden, der innere Horizont des Raumes ist mit dem äußeren in eine Deckungsgleichheit gebracht – ein anderer Horizont. Und wie zu Anfang bedeutet diese Fläche Distanz, Illusion und Wahrnehmung, die an dieser Stelle offenläßt, wie es wohl sein könnte, in das unendliche Blau des Himmels zu fallen.

Die Räume Turrells sind mannigfache Erhellung, das Wirken zwischen Raum und Farbe mittels Licht. Es ist eine Farbe, die wir von nirgendwoher kennen, eine gegenstandslose, räumliche, physische Farbigkeit, die alles zu beinhalten scheint, Textur, Materialität, Dichte, Kontur. Trotz der Fremdheit gegenüber ihrer Konsistenz ist sie gleichermaßen vertraut in ihrer Urqualität und Radianz. Die Farb-Licht-Raum-Verbindungen Turrells erschließen bislang unbemerkt gebliebene Gegenden, „erwecken im gewöhnlichen Sehen tief ruhende Kräfte".[2] In diesen Lichträumen vermag der Betrachter die Erfahrung nachzuvollziehen, die Kleist beschrieb als er die Seelandschaft Friedrichs, den „Mönch am Meer", vor Augen hatte: „Das Bild liegt mit seinen zwei oder drei geheimnisvollen Gegenständen wie die Apokalypse da, (…) und da es in seiner Einförmigkeit und Uferlosigkeit nichts als den Rahmen zum Vordergrund hat, so ist es, wenn man es betrachtet, als wenn einem die Augenlider weggeschnitten wären".[3]

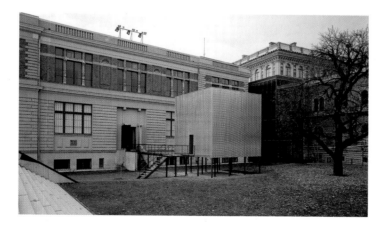

The other Horizon 1998

Skyspace im MAK-Garten / *Skyspace* in the MAK garden

1 Maurice Merleau-Ponty, „Das Auge und der Geist", 1964.
2 Ebd.
3 Heinrich von Kleist, Clemens Brentano, Achim von Arnim, „Verschiedene Empfindungen vor einer Seelandschaft von Friedrich, worauf ein Kapuziner", 1810.

Daniela Zyman

the other horizon: ON THE EXHIBITION AT THE MAK

Color is the place where the mind and the universe meet.
Paul Cézanne

Upon entering the MAK exhibition hall, one faces a field of two interlocking rectangles at the end of a steep stairway – one rectangle of a material solid white, the other of an immaculate blue radiance, and between the two shimmering, ethereal light. The staircase leads right up to the two surfaces, and the white plane proves to be a white wall with a sharply outlined entrance aperture, which, at the end of the staircase, yields the view into an azure space. What seemed, at distance, a homogenous color surface deepens into a dense pale blue, radiating from an unfathomable depth and suggesting an endless expanse. While crossing the space and walking towards the blue light, the sense of being in an Euclidean space is gradually lost, it is left behind for a total immersion into color at its very confines.

The precisely calculated, ever changing effectualities of that what is seen – staircase and color fields from afar, the surface turning into three-dimensional space, the crossing of a glowing substance in between and the "falling" into a blue light of color – is the apparent manifestation of James Turrell's most recent work, *Wide Out,* a *Ganzfeld* space conceived for the MAK and occupying the central exhibition hall. *Wide Out* convokes the perpetual interplay of distance, illusion and perception evoking a *Ganzfeld* experience where atmospheric density and the powerful mass of light gradually become physically felt, haptically verifiable it seems, in their fine materiality. It's the intense experience of an objectless colored field, absolutely homogenous and occupying the peripheral totality of the visual sphere.

This walk-in sensing space is constituted by/through the concepts of dimensionality and color. The aesthetic field evolves from a differentiated light modulation, the precision of proportions, the alignments of the visual axes onto the viewer's focal point and the dissolution of volumes and spatial limits. Depth, spatial depth in reciprocity to surface poses a perspectivist enigma, challenging the relationship between what is near *(here)* and what is far *(there),* and their interdependence: "The enigma consists in the fact that I see things, each one in its place precisely because they eclipse one another, and that they are rivals before my sight precisely because each one is in its own place."[1] Turrell reinforces this enigmatic nature of space and its dimensionality by materializing the space in between – the transitory – the ambient space through light.

Prana and *St. Elmo's Breath,* two works from Turrell's *Space Division Construction* series, are based on a division of the perceptional field. What we see is the flat frontality of the solid frame and the inconstant depth of a shimmering color field. We enter a space divided in two; Turrell calls one viewing space and the other sensing space. Both parts have their own light sources which sense

each other at the dividing lines, defining each other without ever merging. The image, once more, appears along the line of interference of the aperture, placed in an atmospheric oscillation. The color field perceived from afar, upon entering the viewing space, results from an utmost extension of the light-space-structure in the sensing space, where light materializes into surface. The color surface seen by the viewer dissolves as he approaches, and it becomes an opening into a space, a light space, which is not empty but atmospherically dense and extended without distance.

The transitory quality of these works is also indicated by their titles: *Prana,* for instance, represents the vital energy/mind in Hindu philosophy, the "last breath" of a person, which remains on earth in its transition to eternity, and which, in yogi meditation, the *pranayama,* flows into the body between inhaling and exhaling, filling it with energy. *St. Elmo's Breath* symbolizes the energetic exchange of air and matter in the phenomenon called *St. Elmo's fire,* when air is discharged into the atmosphere as a glimmering light around protruding edges and points.

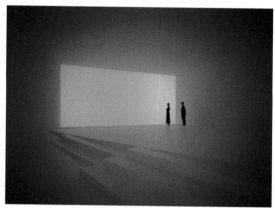

Wide Out 1998
MAK-Ausstellungshalle / MAK Exhibition Hall

In Turrell's works, the "rivalry of things" which constitutes the enigma of space is of abstract nature, in a certain sense it even describes the struggle in painting between frame and space. In *Milk Run II* and *Key Lime π,* two complex light installations of the *Spectral Wedgework* series, color appears both as a graphic lining and diagonally arranged color field. On one side, line and surface depart from an almost identical point, marking off the space vertically. While the yellow line also delimits the space horizontally, the color field provides an opening into depth. Through the powerful blue glint at its very outer edge, the brilliant monochrome color field appears to lose itself in an unfathomable darkness, into a "there" which does not reveal itself. The viewer's vision can take no hold and turns back to the yellow frame in order to re-immerse himself into the depth of the space to define it.

From the *Gate to the Garden,* a path leads from the exhibition hall to an outdoor cube on stilts lined with corrugated sheet iron. A door opens into a room with wooden benches along the walls. In the ceiling of the room, there is a sharply edged opening aperture, *The other Horizon,* a *Skyspace* which is imbedded into the architectural structure of the cube. Once again, the view is guided onto a color surface which defines the space from above. A section of the sky appears, diffuse, shimmering, ethereal, flat, and almost tangible. The space between sky and earth is materialized as a color field, the otherwise incomprehensible distance seems to have evaporated, inner and outer horizons have become one. And, as at the beginning, this surface entails distance, illusion, perception – without revealing how it could be to fall into the endless blue of the sky.

Turrell's spaces are multivalent enlightenment, the working of space and color through light. It is an unfamiliar color, an ethereal, spatial, physical color which seems to contain everything – texture, materiality, density, contour. While its consistency may be disconcerting, we do recognize its original quality and radiance. Turrell's color-light-space combinations remind us of areas that have been long forgotten and that "awaken powers dormant in ordinary vision".[2] In these light spaces, viewers may rediscover the experience Heinrich von Kleist attempted to describe in front of the seascape by Caspar David Friedrich, "The Monk by the Sea": "The image with its two or three mysterious objects lies before one like the apocalypse, (...) and since in its uniformity and boundlessness, it has no foreground but the frame, the viewer looking at it feels as if ones eyelids had been cut off."[3]

1 Maurice Merleau-Ponty, "Eye and Mind", 1964.
2 Ibid.
3 Heinrich von Kleist, Clemens Brentano, Achim von Arnim, „Verschiedene Empfindungen vor einer Seelandschaft von Friedrich, worauf ein Kapuziner", 1810.

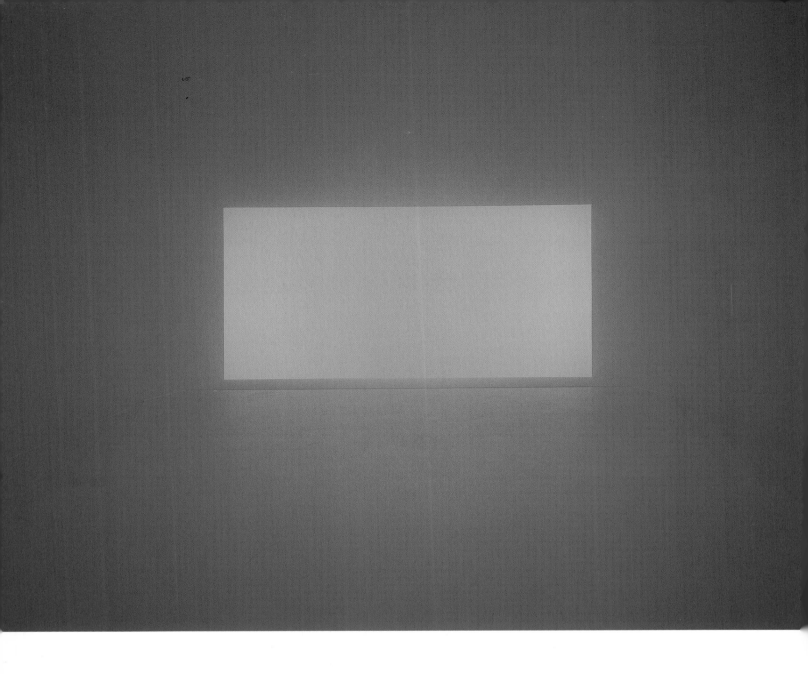

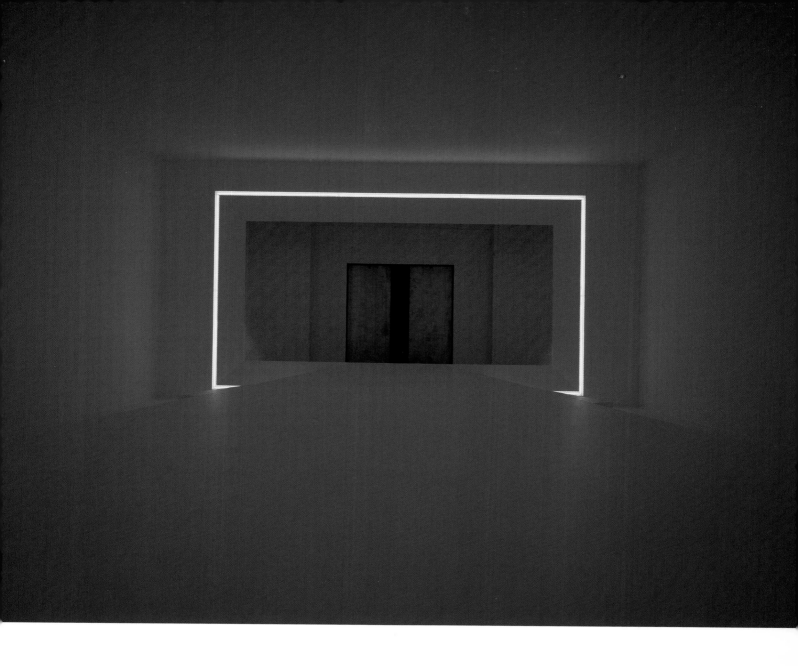

Abb.: Seite / page 20–23 **Wide Out** 1998

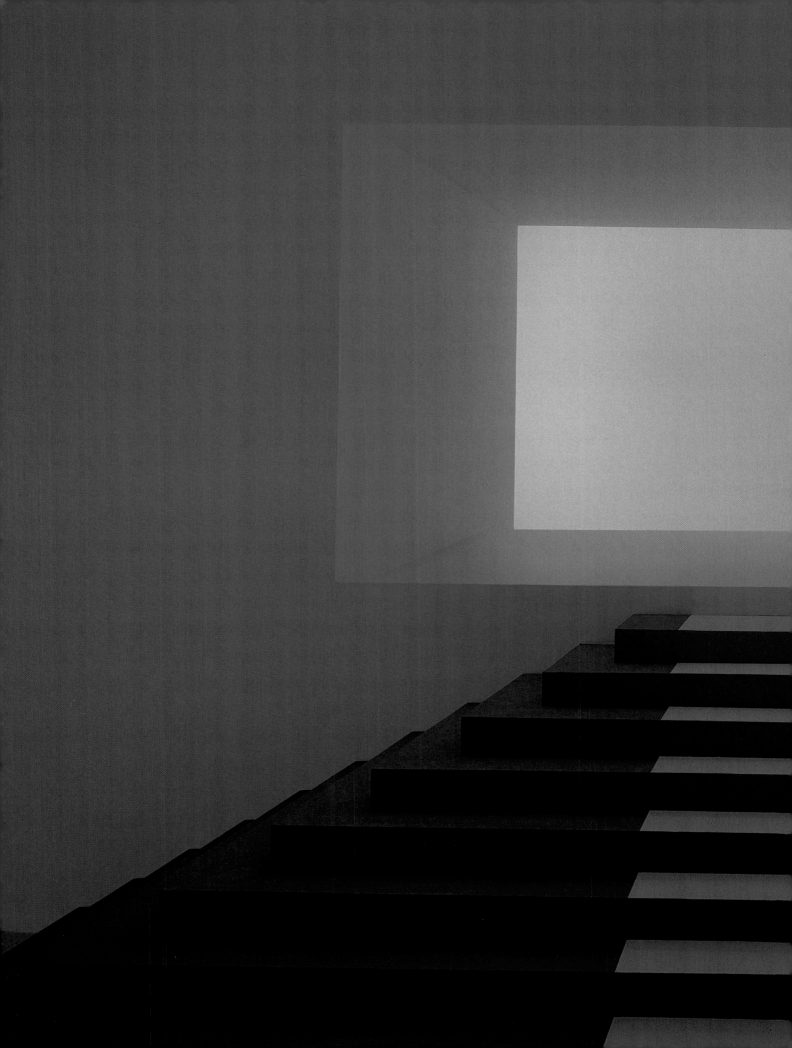

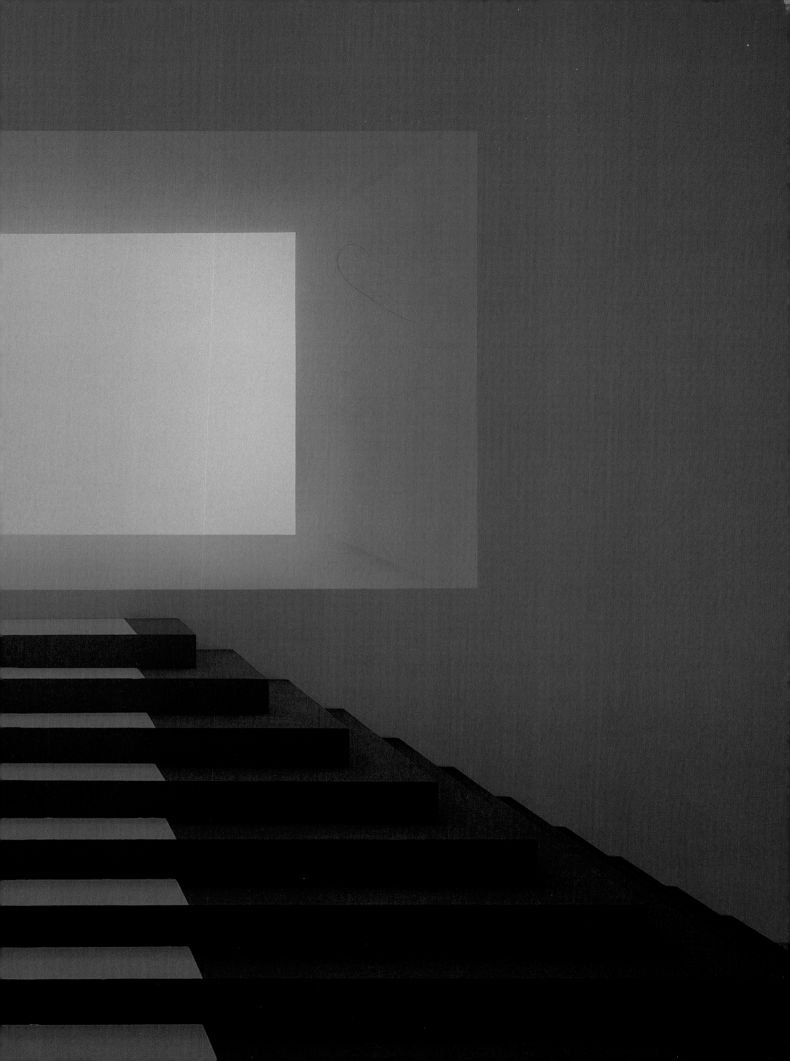

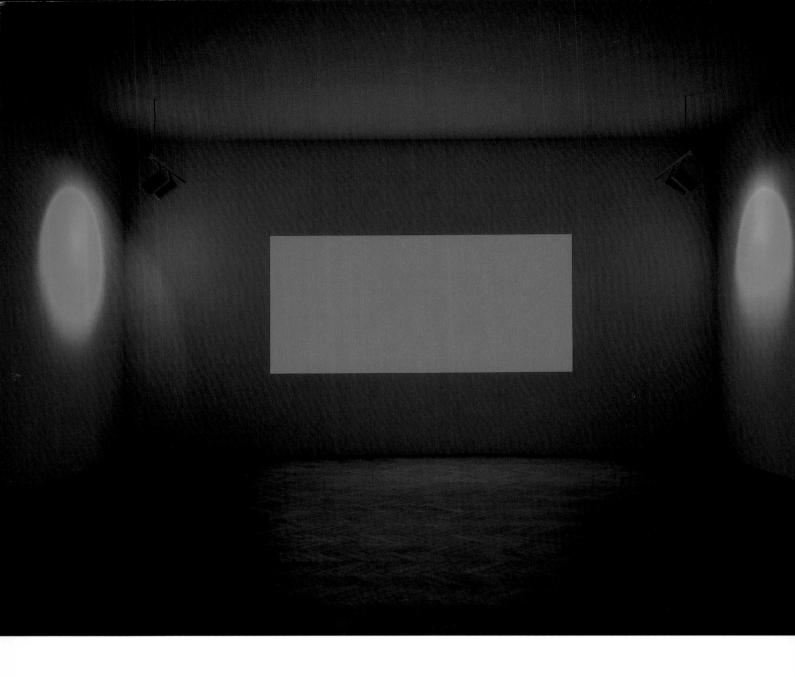

Prana 1991

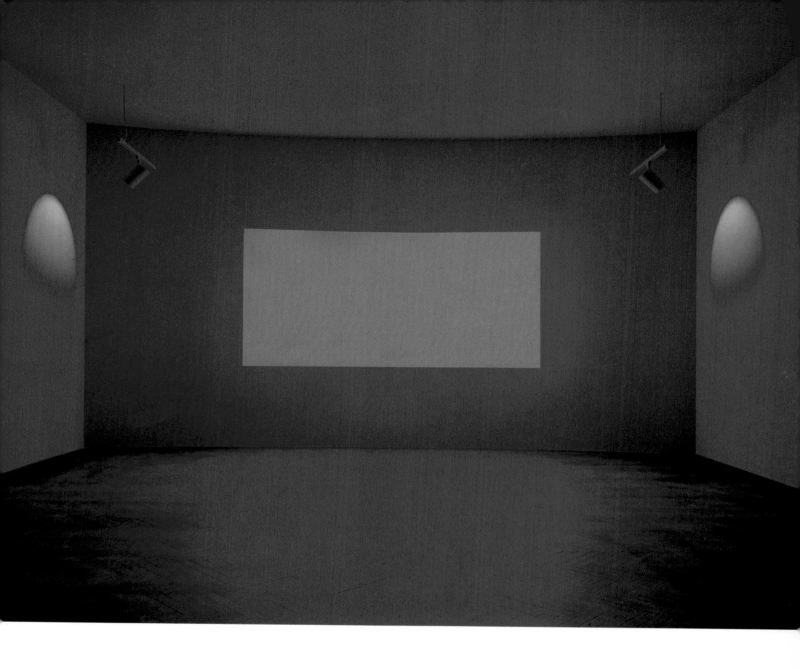

St. Elmo's Breath 1992

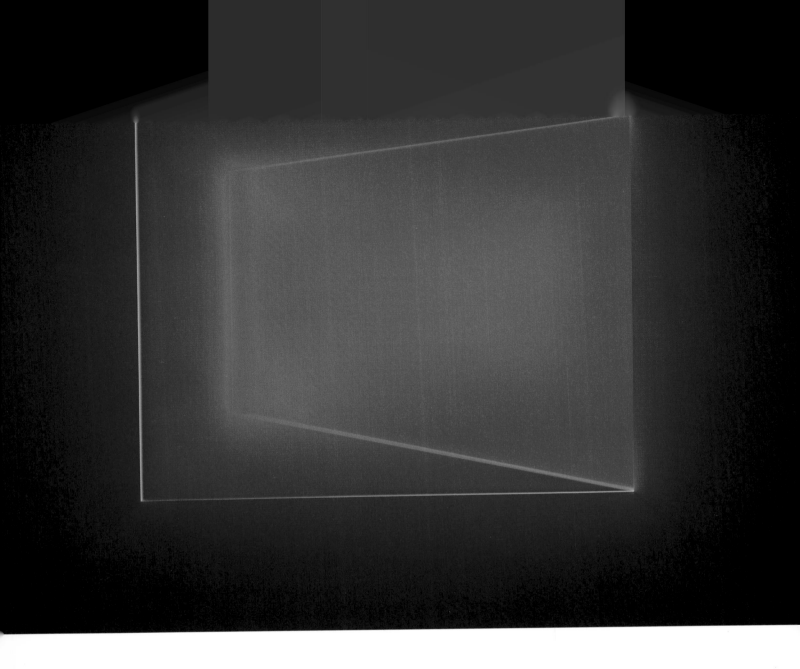

Key Lime π 1998

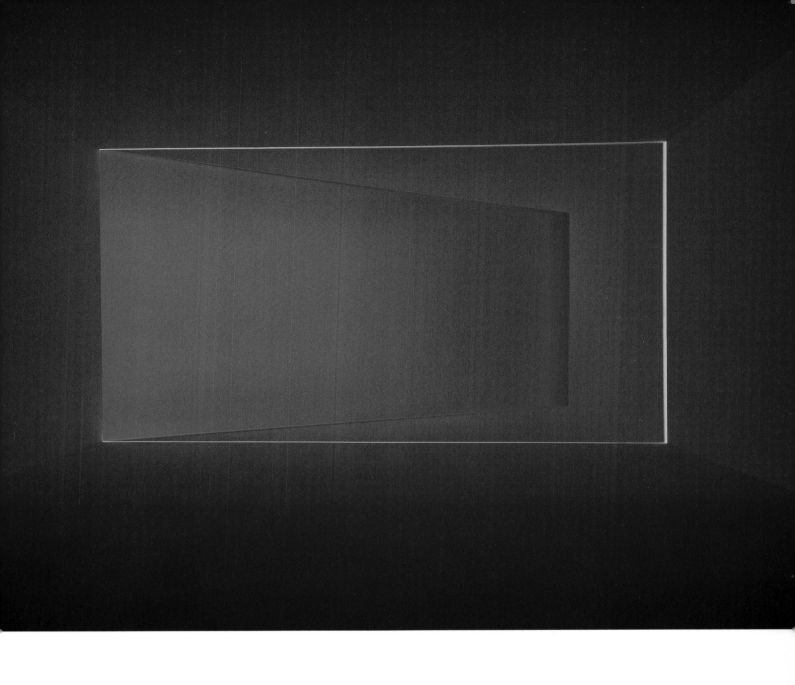

Milk Run II 1997

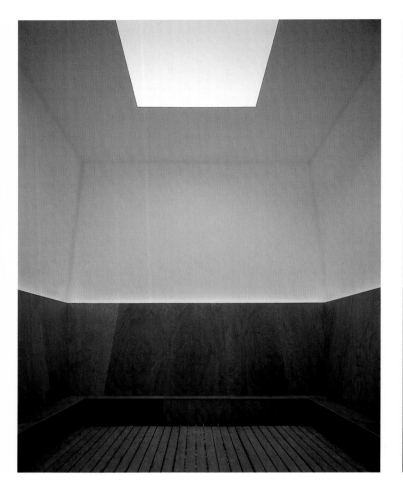 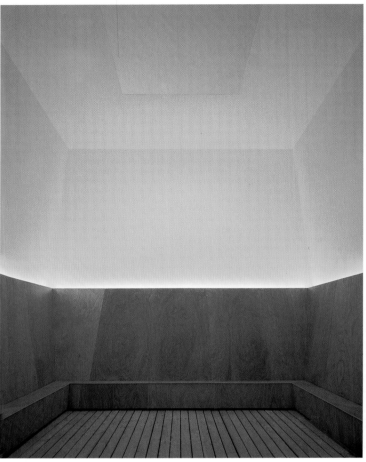

The other Horizon 1998
Innenansicht / interior view

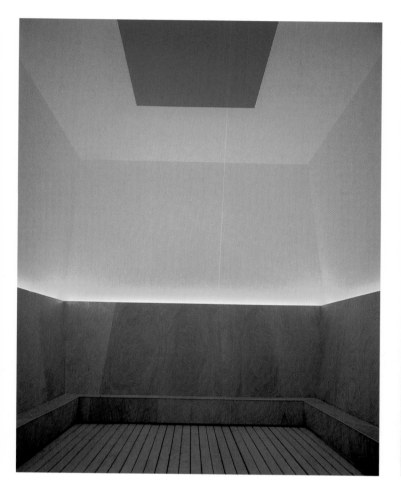
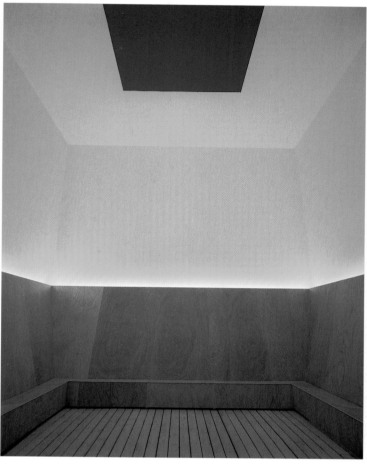

Georges Didi-Huberman

DIE FABEL DES ORTES

GEHEN IM ZWISCHENRAUM

A Looking into: über die Konstruktion der visuellen Kraft des Zwischenraums.
Weiße Träume und das Zurückziehen der Grenzen. Wenn der Ort uns wegführt.

GEHEN IN DER GRENZE

Outside in: das Werk ist immer an den Rändern. Vom Raum (*room*) zum Stück (*work*).
„Betrachtungsräume" (*Viewing chambers*): die Stätte schaffen, an der das Sehen stattfindet.
Die Erfahrung der Nacht.

GEHEN UNTER DEM BLICK DES HIMMELS

Skyspaces: der Überhang. Wenn auf der Erde sein bedeutet, unter dem Blick des Himmels zu sein.
Das Öffnen mit dem Rückzug verbinden, den Himmel (*sky*) mit der Haut (*skin*).

IN DIE FABEL DES ORTES FALLEN

Roden Crater: der Vulkan als „Betrachtungsraum". Bestandsaufnahme des Orts und Arbeit
am Rahmen. Die „Voluminosität". Geometrie und Anachronismus: die Fabel des Ortes.

Der Künstler ist Erfinder von *Orten*. Er gestaltet und erschafft bis dahin unmögliche oder undenkbare Räume: Aporien,
Fabeln des Ortes.
Die von James Turrell erarbeitete Gattung von Orten entsteht zunächst durch eine Auseinandersetzung mit dem Licht:
glühendes und nachtschwarzes Material, ephemer und massiv. Turrell ist in der Tat ein Bildhauer, der Dingen Masse und
Konsistenz verleiht, die fälschlicherweise als „immateriell" bezeichnet werden wie der Farbe, dem Zwischenraum, der
Grenze, dem Himmel, dem Strahl, der Nacht. Seine *Betrachtungsräume* erzeugen Orte, in denen *Sehen* eine *Stätte* findet,
das heißt, in denen *Sehen* zur Erfahrung der *chôra* wird, dieses „absoluten" Ortes der platonischen Fabel. Etwas, das auch
an das erinnert, was die Psychoanalytiker „weiße Träume" nennen.
Diese Skulptur der Überhänge, Himmel und Vulkane wird hier als eine Fabel der Wanderungen dargestellt – sodaß ein
Kunstwerk zu betrachten dem Gehen in der Wüste gleicht.

Es geht tatsächlich um eine Fabel. Diese ist es, die wir konstruieren und immer wieder rekonstruieren müssen, um zu versuchen, im wachen Zustand etwas von dem wieder einzufangen, was uns der Traum einst zum Geschenk gemacht hat. Die Ausübung des Denkens selbst, sogar des „kartesianischen", hängt mit diesem Verhältnis zwischen einer Konstruktion und dem Einst des Traumes zusammen.[1] Denn der Traum ist immer *einst*: der Traum gab uns *einst* die bestürzende Evidenz des Ortes. Doch das Erwachen raubt sie uns sogleich wieder, da ja die Einsicht in den Ort zuerst aus der Materie – der somatischen Materie – unseres Schlafes bestand. Alles, was einmal gegeben war (in einer *Einmaligkeit*, die sich von Zeit zu Zeit wiederholt und die der unausrottbare Hang zur Metaphysik Ursprung nennen möchte), all das wird in dieser anderen Materie unseres Selbst, dem Vergessen, aufgenommen und umgestaltet. Platons Fabel von der *chôra* hat nichts anderes geleistet, als auf ihre Weise eine paradoxe Erinnerung an diesen Zwang zum Vergessen des Ortes zu konstruieren.

Was James Turrell konstruiert, hängt auch mit diesem Spiel zusammen, mit dieser Erinnerung, mit dieser Fabel. Turrell begann sein Werk an dem Tag, als er im Alter von dreiundzwanzig Jahren einen konkreten Ort in Besitz nahm, um ihn zu entleeren, wieder zu verschließen, und in ihm schließlich neue Raum- und Lichtbedingungen zu schaffen, die den gegebenen Raum nach und nach in einen bearbeiteten Ort, in einen „offenen" Ort verwandelten. Es handelte sich dabei um ein beliebiges, an einer Straßenecke in Kalifornien gelegenes Hotel, um einen Durchzugsort, an dem Turrell beschloß, sich niederzulassen, zu schlafen und zu träumen, beinahe sechs Jahre lang, um dort das ganze Feld der Möglichkeiten des Raumes, des Lichts und der Farbe zu erforschen. Doch zuerst mußten die Zimmer geleert und der Raum zu einem seiner normalen Funktion *beraubten Ort*, zu einem *verlassenen Ort* gemacht werden (der, wie gesagt, die Hauptfigur dieser gesamten Fabel ist). Dieser Vorliebe ist Turrell seither bei der Wahl der Räume, die er so gerne neu gestaltet oder neu erfindet, treu geblieben. „Was mich interessiert," sagt er, „sind öffentliche, ihrer Funktion beraubte (*devoid*: entblößte, entleerte) Orte."[2] Er hatte also damit begonnen, alle Gegenstände aus den Räumen und alle Farben von den Wänden zu entfernen und vor allem alle Öffnungen zur Straße hin zu schließen. Das aufgelassene Hotel wurde zu einem reinen, wieder verschlossenen Schrein, als wäre es ein nur noch für den Schlaf und den Traumzustand geeigneter Raum. Vielleicht war das eine Art und Weise, diesen „hybriden Raum" neu zu erfinden, „der mit dem gewohnten Realitätsempfinden nichts zu tun hat", insbesondere das Gefühl, daß der Ort nur durch die Objekte und Funktionen existiert, die ihn bevölkern und ihn zu benennen vermögen.[3] (siehe *The Mendota*, S. 86–91)

Der Raum leerte sich also, um ein Ort des Rückzugs und der Unmittelbarkeit in bezug auf den Blick selbst zu werden: *a looking into*, wie Turrell es nennt, im Unterschied zu jedem auf der Suche nach einem Objekt befindlichen Blick (*a looking at*).[4] Der geleerte Raum wurde, wenn man das so sagen kann, zu einem weißen Raum, zu einem farblich weißen Raum, aber vor allem zu einem „weißen" Raum im Sinne von Freiraum, von *blank*, was sich weder nur auf die Farbe, noch nur auf das Weglassen von Farbe bezieht, sondern ganz allgemein auf den Zwischenraum, auf die Stummheit, auf die Entvölkerung, auf die endgültigen Leerstellen. Auf die reinen Virtualitäten. In diesem Sinne kann man bei Turrell von einem Wunsch zur Dekonstruktion von Trivialräumen sprechen – das heißt von Räumen, in denen es etwas Sichtbares zu unterscheiden, zu erkennen und zu benennen gibt –, um aus ihnen die reine und einfache *visuelle Kraft des lichterfüllten Zwischenraums* zu gewinnen. Es handelt sich in gewisser Weise darum, den Betrachter von allem wegzuführen, was er spontan als „Objekt" benennen und als „sichtbar" situieren könnte: ihm alles wegzunehmen, was ihm die gewohnten Bedingungen liefern würde, unter denen er einen der Kunst gewidmeten, „mit Werken angefüllten" Raum besichtigen, spüren und wahrnehmen

könnte. Die Arbeiten Turrells unterwerfen einen oft zunächst einem Akt des *Abschließens* und des Entzugs. Läßt man sich jedoch auf sie ein, so schenken sie einem eine Erfahrung, die so viel Licht spendet, daß sie schließlich einen Akt des *Öffnens* vollbringt.

In einer ungeheuren Vergrößerung oder Verschiebung entspricht das etwa dem vertrauten Akt des *Schließens* der Lider, um seinen Blick auf den Ort – und nicht auf die Bilder und Gegenstände – des Traumes hin zu *öffnen*. Das Schließen der Lider heißt hier: der Akt des Dämpfens oder Abtötens jeglicher aspekthaften Sichtbarkeit (das englische Wort *deaden* mit seinem blanken, tödlichen Klang ist wesentlich schöner).[5] Und so den besorgten Blick auf ein gegenstands- und flächenloses Wahrnehmungsfeld zu lenken, in dem das Licht so schwer, homogen, intensiv und ohne Quelle ist, daß es gleichsam zur – kompakten und greifbaren – Substanz des gesamten Ortes wird. Deshalb drängt sich der Traum hier als Matrix und Paradigma (des Vergessens) auf, nicht als (erinnerte) Anspielung oder Metapher. Es geht hier niemals um Traumbilder. Es geht nur darum, das sei noch einmal gesagt, diesem Ort die elementare, absolut *virtuelle* Kraft einer Abbildbarkeit ohne „Abbildungen" zu geben.

Der Traum – den wir um seiner eigentlichen Bedeutung willen immer vergessen haben – hallt wahrhaftig in uns nach als die Allmacht des Ortes; so würde ich jedenfalls Platons Fabel des *Timaios* verstehen.[6] Weil wir nicht mehr wußten, was uns im Traum widerfuhr, drängt sich uns die Macht des Ortes auf. Weil wir in derselben Bewegung aus den Wolken fallen und dorthin entschwinden hätten können, haben wir dabei *den Ort* mittels dieser ontologischen Grundwertung *gesetzt*, die aus jedem Traum einen nahen Verwandten der Angst macht.[7] Gerade aus diesem *Rückzug der Grenzen* und aus der Unmöglichkeit, seine Ausdehnung zu ermessen, entsteht für uns jener Ort – jener „Ort der Aufnahme", jener „Nährgrund", wie Platon auch sagte.[8]

Wo, von wo aus träumen wir eigentlich? Es gibt Leute, die glauben, vor oder hinter den Augen zu träumen. Es gibt Leute, die glauben, in der Mundhöhle zu träumen, oder im Spalt zwischen einem Schleier und ihrer Haut. Viele träumen in einem mehr oder weniger konkaven Raum, der sich abflacht.[9] Alle gestalten ihre Organe *außerhalb ihrer Grenzen* neu, und alle benützen die Signifikanten ihrer Muttersprache als Werkzeuge, um ihren Körper zu verändern oder ihr Fleisch zu neuem Leben zu erwecken, um immer wieder die Funktionalität ihres eigenen Körpers zu überschreiten. Dann wird der Organismus selbst zu einem Spiel von Räumen, die Maßstäbe verschieben sich und kehren sich um, die kleinen Dinge verschlingen die fetten, und die Größen verlieren in der atmosphärischen Trübung einer allgemeinen Hypochondrie jegliche gemeinsame Bedeutung.[10] Aber es gibt auch Träume – oder irgendwo irgend etwas in jedem Traum, man erinnert sich ja so wenig –, die nichts als ein *Stück* reiner Zufriedenheit bieten : „weiße" *(blank)* Träume, ohne Inhalt. Reine Träger, reine Virtualitäten, die nochmals die Allmacht der *chôra* heraufbeschwören.[11]

Existiert das – dieses *Wo* – wirklich? Es ist uns nicht gegeben, es zu wissen, da uns nur gegeben ist, es zu vergessen (dieses *Wo* läßt sich nicht psychologisch beobachten, sondern nur metapsychologisch konstruieren). Wie sollen wir mit offenen Augen etwas von dieser Macht des Ortes erfahren? Wie sollen wir die Abwesenheit in ihm erfassen, und aus diesem Erfassen zum Werk, zur Öffnung gelangen? Maler, Bildhauer oder Architekten setzen diese Frage wahrscheinlich in ihrem Werk um, wenn die Hingabe, mit der sie den visuellen Raum bearbeiten, bis zum Wunsch geht, ihn zum Verschwinden zu bringen. Leonardo da Vinci liebte es bekanntlich, im Nebel gesehene Körper zu erforschen oder den Nebel selbst als Träger der Körper; in jeder Parzelle der sichtbaren Welt sah er entschwindende Unendlichkeiten; er bat die Luft, ihm ihre Farbe mitzuteilen; und er ging sogar so weit, die Perspektive selbst dem Gesetz des *Entschwindens* zu unterwerfen.[12] Als ob das Hervorbringen eines visuellen Werks eigentlich bedeutete, *sich den Mächten eines Ortes zu unterwerfen, der uns* von den sichtbaren Dingen wegführt. James Turell verfolgt wahrscheinlich genau diesen Weg, er, der das Wort *yield* in seiner Vieldeutigkeit von „geben",

„produzieren" und „ausatmen" liebt, aber auch als Akt, in dem man nachgibt oder in dem man sich der entleerenden Macht des Ortes unterwirft.[13]

Gehen in der Grenze

Unsere alten Fabeln haben uns beigebracht, daß die entleerende Macht des Ortes in einer Einfachheit aus gefährlichen Wagnissen und subtilen Gleichgewichten beruht: in einer Einfachheit, die sich konstruiert, rhythmisiert und verfeinert. Der verlassene Ort ist nicht einfach ein Ort, an dem sich überhaupt nichts befindet. Um Abwesenheit deutlich sichtbar zu machen, bedarf es eines Minimums an symbolischer Bindung oder an deren Fiktion (was in gewisser Weise dasselbe ist). Um das Grenzenlose zu präsentieren, bedarf es eines Minimums an Architektur, das heißt einer Kunst der Kanten, Trennwände und Ränder. All das bedingt eine bestimmte Dialektik, ein Spiel, eine Begegnung gegensätzlicher Dinge, die an ihren Grenzen aneinandergefügt sind oder ineinander übergehen oder sich verschieben oder all dies rhythmisch aufeinanderfolgen lassen. Bereits in seinen Anfängen im *Mendota Hotel* näherte James Turrell den Begriff des Raumes (*room, studio*) und den Begriff des Werks (*work*) einander an. Doch bald zeigte sich die Notwendigkeit einer rhythmischen Abfolge, in der der Tag an den Rand der Nacht und das Erwachen an den Rand des Schlafes rückte: so entwarf Turrell eine Reihe von Öffnungen, und der Rückzug des Raumes traf auf das von draußen einfallende Licht. So entstand das Spiel zwischen dem Innen und dem Außen; Kunstlicht – zum Beispiel in den *Cross Corner Projections* – traf auf Außenlicht – in den *Mendota Stoppages* –; und die starre Architektur der Kanten traf auf die zufälligen Bewegungen der Lichtbahnen unter Einbeziehung der Straßenszenerie.

So ist die große Einfachheit, mit der sich eine Arbeit von Turrell erfassen läßt, niemals unmittelbar. Zunächst weil es *Zeit braucht*: Zeit, in der sich die Reste unseres vertrauten, sichtbaren Raumes auflösen und die schweigende Dichte und die visuelle Kraft des Ortes einsinken. Und dann weil diese Einfachheit ständig auf einer Beziehung zwischen mindestens zwei Dingen beruht, die sich widersprechen und vermengen. *Das Werk liegt immer an den Rändern:* eines Schattens und eines Lichts; eines direkten und eines indirekten Lichts; eines Innen- und eines Außenraumes; einer visuellen und einer taktilen Qualität; einer extrem wandelbaren, beweglichen Arbeit – denn Turrell macht mit dem Licht oft das, was Sol LeWitt mit Bleistiftstrichen macht: eine Kasuistik in Form musikalischer Fugen[14] – und eines extrem einheitlichen, unteilbaren, in gewissem Sinn massiven Ergebnisses.

Turrell errichtet Tempel, wie ich es nannte, man könnte es auch einfacher mit seinem Wort „Betrachtungsräume" (*viewing chambers*) bezeichnen, sehende oder zum Seher machende: Zimmer, in denen die Erfahrung des Sehens zum sich selbst erhellenden Vorgang wird (was nicht heißt, daß wir wissen, was wir sehen oder daß wir uns dort „sehen sehen", wie sich der Betrachter bei Paul Valéry das für seine schöne Seele vorstellte). Es sind Architekturen, in denen das *Wirken der Ränder* – außerordentlich komplexe und subtile Artikulationen der Ebenen, Volumina und farbigen Elemente – *selbst die Stätte schafft, an der das Sehen stattfindet.* Damit das Sehen zu einer ungewöhnlichen Erfahrung wird, die selbst eine Grenze ist. Turrell liebt die ägyptischen Pyramiden, nicht wegen ihrer perfekten Formen oder ihrer Grabkammern; er liebt sie vor allem, weil die perfekt geformte Geschlossenheit ihrer Grabkammern einen ungewöhnlichen Augenblick zuläßt (einen einzigen Augenblick im Jahr), an dem das Licht von außen, ein Sonnenstrahl, bis zum Boden des Schachtes dringt, um das Gesicht des Pharaos zu erleuchten.[15] Und die gleiche Faszination besitzen für ihn die Bunker der Maginot-Linie, weil sie Orte darstellen, die zugleich geschaffen wurden, um sich in sie zurückzuziehen und um hinauszusehen. Damit entsprechen sie genau der Dialektik einer Sorge und einer stets wachsamen, stets „am Rand befindlichen"[16] Voraussicht.

Wie wir sehen können; je weiter wir vordringen, desto weniger kann der Raum als einfache räumliche Ausdehnung definiert werden. Allmählich zeigt sich, daß der gesuchte Ort nicht zu einer Vorstellung, sondern zur sinnlichen, zeitlichen Erfahrung eines Erblickens der Ränder wird. Die „Betrachtungsräume" James Turrells – zum Beispiel das vielsagend *Outside In* benannte Architekturprojekt – konstruieren ihre Kantensysteme für visuelle Erfahrungen, die man als *borderline* bezeichnen möchte: Grenzerfahrungen, in denen sich die Grenze in einer Phänomenologie der Zeit-des-Sehens konstituiert, einer Zeit, die allmählich selbst *den Ort als solchen* konstituiert. So wie das Pantheon in Rom die Menschen unter das Auge eines Stück Himmels stellt, das aus der durch den rituellen Gang festgelegten Zeit ausgeschnitten ist, so gleichen auch die Konstruktionen Turrells Tempeln. Diese rituelle Zeit, die die Menschen in der Vergangenheit ihren Schäfchen auferlegten, diese Zeit wird hier zum schlichten und freiwilligen Angebot des Wartens: Warten und *schauen in der Zeit*, wie der Gegenstand des Blicks in seinen leuchtenden Möglichkeitszustand zurückkehrt. Dann wird das Licht zum Ort, und der Ort zu einer Substanz, durch die unser Körper hindurchgeht, um ihren zärtlichen Schutz oder ihre Brise zu spüren. Der Gegenstand des Sehens, der für gewöhnlich *vor* uns liegt, wird zu einem Ort des Sehens, *in* dem wir uns befinden. Und doch zeigt sich dieser nur als die reine und geheimnisvolle taktile Qualität des Lichts.[17]

Blick, Zeit, Berührung: Es gibt also ein Subjekt, das dieses Werk voraussetzt und einlädt. Nicht nur ein Objekt, und sei es auch „Kunst". Der wahre *Borderline*-Charakter dieses Werks liegt darin, daß sein Ort schwankt oder wandert zwischen unserem Erwachen am konstruierten Ort, an dem Ort, den wir tatsächlich betreten, und unserem Vergessen der *chôra*, jenem Ort, an dem sich in unseren Träumen ein Großteil unserer Existenz ereignet: das, von dem wir gegen unseren Willen *durchdrungen* sind. Die „Betrachtungsräume" von James Turrell sind de facto große *Camerae obscurae*, und in diesem Sinne funktionieren sie vielleicht als Metaphern des Auges. Aber ungeachtet dessen, was der Großteil der Kommentatoren über Turrell sagt und ungeachtet gelegentlicher Äußerungen von Turrell selbst, ist der eigentliche Einsatz, um den es bei dieser Arbeit in der Zeit geht, nicht das wahrnehmende Auge selbst. Das wahrnehmende Auge, das all die Experimente der Gestalttheorie, also der Psychologie der Formen, nach Belieben in Kategorien stecken, dieses Auge ist nur die Schnittstelle zwischen dem sichtbaren Raum und dem durch das Werk für jeden einzelnen erschaffenen Ort des Sehens (an dem jeder seinen eigenen Wünschen, seinen eigenen Erinnerungen und seinem eigenen Vergessen sowie seinem eigenen Körper und seinem eigenen Schicksal folgend denkt, träumt und erwacht).

Daher ist zum Verständnis einer solchen Bearbeitung des Ortes eine Phänomenologie – und nicht eine Psychologie – der Wahrnehmung erforderlich. Ein Denken, das nicht versucht, die Magie der Wahrnehmungseffekte zu erklären, sondern in sie das einzubeziehen, was eben kein Effekt mehr ist: ein Wesen, ein Subjekt, das sich dem Ort öffnet. Der Ort des Sehens ist jenseits der seine Räumlichkeit bestimmenden sichtbaren Formen zu denken; der Blick ist über die Augen hinausgehend zu denken, denn auch im Traum blicken wir mit geschlossenen Augen. Daher kann eine Phänomenologie des *Blicks im Wachzustand* nur bei der *Seherfahrung der Nacht* beginnen:

„Wenn [...] die Welt der klaren und wohlartikulierten Gegenstände sich auflöst, so zeichnet unser seiner Welt beraubtes wahrnehmendes Sein sich eine Räumlichkeit ohne Dinge vor. Nichts anderes geschieht in der Nacht. Sie ist nicht ein Gegenstand mir gegenüber, sie umhüllt mich, sie durchdringt all meine Sinne, sie erstickt meine Erinnerungen, sie löscht beinahe meine persönliche Identität aus. Ich finde mich nicht mehr auf meinen Wahrnehmungsposten zurückgezogen, von dem aus ich auf Abstand die Profile der Gegenstände vorüberziehen sehe. Die Nacht ist ohne Profile, sie selber ist es, die mich anrührt, und ihre Einheit ist die mystische Einheit des Mana. Selbst ein Schrei oder ein fernes Licht bevölkern sie nur vage, als ganze nur belebt sie sich, und sie ist reine Tiefe, ohne Vorder- und

Hintergründe, ohne Oberflächen, ohne Abstand von ihr zu mir. Jeder Raum für die Reflexion ist getragen von einem Denken, das seine Teile verknüpft, doch dieses Denken vollzieht sich von nirgendwoher. Dahingegen vereine ich mich dem nächtlichen Raum von seiner eigenen Mitte her. Die Angst der Neuropathen in der Nacht rührt daher, daß sie uns unsere Kontingenz spüren läßt, die schwebende und unermüdliche Bewegung, durch die wir uns in den Dingen zu übersteigen und zu verankern suchen, ohne daß wir jemals gewiß wären, sie zu finden."[18]

Und diese Gewißheit nimmt Turrell dem Betrachter von Kunstwerken, der es wagt, in eines seiner *Dark Pieces* vorzudringen, die in den achtziger Jahren entstanden sind: Orte ohne sichtbare Grenzen, an denen der Schatten buchstäblich vor uns aufsteigt[19] und uns schließlich ganz umhüllt. Man muß *in* diesen Werken ebenso lange verweilen wie vor einem schwarzen Gemälde von Ad Reinhardt: zwanzig volle Minuten im Schweigen und in der Dunkelheit, dann tauchen *im* Betrachter selbst – wie Blitzlichter – einige seltsame *borderline light experiences* auf, einige intensive Sehereignisse, die sich dem unvorhersehbaren Wirken einiger vorüberziehender Photonen verdanken, oder einem minimalen Druck auf den Sehnerv oder einfach dem gestiegenen Verlangen, nicht blind zu sein.[20] Die Sehverhältnisse des Ortes machen dadurch seinen nicht reflexiven und unkontrollierbaren Charakter ganz deutlich. Seinen Symptomcharakter könnte man sagen. Merleau-Ponty stellte bereits fest, daß es nicht möglich sei, die Wahrheit einer Raumerfahrung „im gewöhnlichen Leben zu fassen, da sie sich da verbirgt hinter dem, was sie uns selbst zum Erwerb macht. Ziehen wir einen Ausnahmefall heran, in dem sie vor unseren Augen sich zersetzt und wiederherstellt, [...]"[21] Das entspricht genau der Erfahrung der Nacht, die in ihrer Unabänderlichkeit als Beispiel beinahe zu deutlich ist. Doch auch bei Tag bietet das Sonnenlicht, genau betrachtet, eine Vielzahl unvergleichlicher Erfahrungen, in denen *die Ränder sich verschieben* und uns wie das Seltsame schlechthin erreichen:

„Glaube ich in einem Hohlweg von fern einen großen platten Stein auf dem Boden zu sehen, der in Wirklichkeit nur ein Sonnenfleck ist, so kann ich nicht sagen, je den platten Stein in dem Sinne gesehen zu haben, in dem ich näherkommend den Lichtfleck sehe. Der platte Stein erscheint, wie alles Ferne, in einem nur verworren strukturierten Feld, in dem die Zusammenhänge noch nicht deutlich sich artikulieren. Insofern ist eine Illusion, wie ein Bild, nicht beobachtbar, d. h. mein Leib findet an ihr keinen Anhalt und ich kann sie nicht in sie erkundenden Bewegungen vor mir entfalten. [...] Jede Empfindung geht schon schwanger mit einem Sinne, fügt sich schon einer verworrenen oder klaren Konfiguration ein; und kein einziges Sinnesdatum, das dasselbe bliebe, wenn ich von dem vermeintlichen Stein meiner Täuschung zu dem wirklichen Sonnenfleck komme. [...] Ich sehe den illusionären Stein insofern, als mein ganzes Wahrnehmungs- und Bewegungsfeld dem hellen Flecken den Sinn 'Stein auf dem Weg' gibt. Und schon bin ich gewärtig, seine glatte, feste Oberfläche unter meinem Fuß zu fühlen. Denn nicht unterscheiden sich richtiges Sehen und illusionäres Sehen voneinander wie adäquates und inadäquates Denken [...]."[22]

Genau dort, zwischen einem Lichtfleck und einer Steinfläche, liegt zweifellos die Arbeit von James Turrell, der sich weigert, zwischen richtigem und illusionärem Sehen zu unterscheiden, so wie man zwischen adäquatem und inadäquatem Denken unterscheiden würde. Denn ungeachtet seiner objektiven Überprüfbarkeit bleibt das Sehen immer *unverbesserlich*: es ist das, was es selbst uns ohne unser willentliches Zutun gibt, es ist unverbesserlich in seiner Hingabe an die Träume, Phantasiegebilde oder Wünsche, mit denen es, ganz seinsvergessen manchmal, schon schwanger geht.

Im Grunde will Turrell vielleicht Orte schaffen, deren Erfahrung die des geheimen, nie völlig stabilen Gleichgewichts zwischen zwei symmetrischen Abgründen wäre: zwischen jenem des Selbstverlustes im Schlaf und jenem des Selbstverlustes im Erwachen, in der geschäftigen Auseinandersetzung mit den Dingen der Welt; zwischen der Leere einer absoluten Nacht und dem überbevölkerten Raum, der uns rastlos unter der Sonne umtreibt. Das Gleichgewicht zwischen diesen beiden Arten von Erleuchtungen oder Verblendungen würde dadurch den Wert einer außergewöhnlichen Erfahrung gewinnen: einer paradoxen Zeit, in der das Nichts in eine aus beinahe nichts gebildete Dichte überginge, in der sich das Licht von den Dingen zurückzöge, die es üblicherweise beleuchtet, um alleine, ganz anders und ertastbar zu erscheinen. Ein paradoxer Ort gleichsam, an dem die Andersartigkeit, die Distanz und die absolute Äußerlichkeit eines Lichtfeldes mit dem unweigerlich singulären Rückzug unserer körperlichen Existenz in das Erstaunen angesichts unseres eigenen Sehvermögens verbunden wäre. Der *Borderline*-Charakter, den dieses Werk erzeugt, verbindet immer wieder das Offene mit dem, was sich entzieht.

Es ist verblüffend, die Beschreibung genau dieses Doppelcharakters – doppelt wie etwas Gefaltetes – auf den wenigen Seiten wiederzufinden, die Heidegger den Künsten des Raumes im allgemeinen und der Skulptur im besonderen widmet. Dort schreibt er von der Verweigerung, die uns der Ort entgegenhält, bis ein Werk seine eigentliche Einfachheit in der Erfahrung einer Verunsicherung hervortreten läßt – *zwischen* der Lichtung und der Verbergung, *zwischen* dem Hervorkommen am Ort und der Entschiedenheit seines Sich-Zurückstellens.[23] Er beschrieb auch das besondere Vermögen, das die Skulptur entfaltet, wenn sie Orte *verkörpert*, wenn es ihr gelingt, dem Menschen unbemerkt gebliebene Gegenden zu *erschließen*. Durch den Vorgang des Eingrenzens des Raumes kann es also gelingen, die Unbegrenztheit des Ortes zu *gestalten* und den Menschen dort in eine „freie Versammlung" zu stellen, wie Heidegger es nannte. Die Leere ist damit nicht länger die Kehrseite des Ortes, sondern „mit dem Eigentümlichen des Ortes verschwistert". Nicht ein Fehlen, sondern ein Vorgang, der des „Hervorbringens".[24] Damit treffen Sein, Bauen und Wohnen zusammen. Damit treffen „freie Weite" und „Versammlung" des Menschen zusammen. Damit erinnert man sich, daß auf der Erde zu sein bedeutet, unter dem Himmel zu sein, und daß der neu erfundene Ort sich immer selbst erinnert, daß Tempel seinerzeit errichtet wurden, um diese Erinnerung selbst zu verkörpern.[25]

Das, worin Heideggers Überlegungen zum Raum münden, ist zweifellos nichts anderes als das, wovon Turrell ausgeht und wohin er immer wieder zurückkehrt, wenn er seine Werke baut. Denn Turrell, der Wüstenbewohner, der kalifornische Künstler, der es liebt, alleine zu fliegen[26] – Turrell weiß, daß auf der Erde zu sein bedeutet, *unter dem Blick des Himmels zu sein*. Auch hier ist es nicht erforderlich, die Sterne als Gottesbilder zu sehen, um in uns diese unabdingbare Nötigung zum *Aufenthalt* auf der Erde, zu unseren Schritten, zu unseren Verhängnissen, zu unserem Raumgefühl im allgemeinen zu verspüren, die das Himmelsgewölbe darstellt.[27] Der Himmel umfaßt ganz einfach alles. „Zugleich erkennt man, daß auch Raum und Leere und Zeit außerhalb des Himmels nicht sein kann", schrieb Aristoteles in seiner kleinen monographischen Abhandlung „Über den Himmel".[28] Der Himmel sah unser aller Geburt, er, der nie geboren wurde, und er wird uns alle sterben sehen, er, der die gesamte Zeit umspannt, er, der „unentstanden und unvergänglich ist und nicht zunimmt und sich nicht verändert".[29]

Und wenn wir die Bläue dieses „Ortes der Orte" betrachten, wissen wir, daß seine Farbe, von der Aristoteles betont, daß sie vom Pigment der Maler nicht nachgemacht werden könne, sich nie änderte oder alterte und seit dem Ursprung der Zeiten immer diese selbe Farbe war.[30] Diese Farbe ist aber darum noch nicht einfach: Sie lebt ihr Leben, sie atmet, sie folgt eigenen Gesetzen und weist seltsame Symptome auf, bei Tag wie bei Nacht:

„Manchmal in klaren Nächten hat man den Anblick von mannigfachen Erscheinungen am Himmel, etwa von 'Klüften', 'Gruben', blutroten Stellen.[…] Es wurde ja klargestellt, daß die obere Luftschicht sich verdichten und Feuer fangen kann und daß die Entzündung manchmal den Eindruck einer Feuersbrunst, manchmal fliegender Fackeln und Sterne macht; da ist es gar nicht erstaunlich, wenn eben diese Luft, sich verdichtend, mannigfache Farben annimmt. Denn einerseits Licht, das durch ein dichteres Medium geschwächt hindurchscheint, andrerseits eine Luftschicht, die reflektiert, sie werden mannigfache Färbungen verursachen, vor allem Rot und Purpur. [...] so sehen z. B. auf- und untergehende Sterne bei Hitze, und durch Rauch hindurch, rot aus. Auch infolge von Lichtbrechung tritt das Phänomen auf, wenn die reflektierende Luftschicht nicht die Form, sondern die Farbe wiedergibt […]" [31]

Es gibt Werke von James Turrell, die genau dazu geschaffen sind, um diese unkontrollierbare Farbe des Himmels wie Behältnisse aufzunehmen. Unter der Bezeichnung *Skyspaces* entstanden sie seit Beginn der siebziger Jahre im *Mendota Hotel*, dann für die Sammlung Panza di Biumo. Sie zwingen uns, bestimmte unserer Sehgewohnheiten beim Blick auf ein Kunstwerk umzustoßen. Üblicherweise kommen – in der modernistischen Optik des Ausstellungswerts – alle Bedingungen zusammen, um unserem Körper zu ermöglichen, das Werk zu beherrschen, wenn es klein ist, und es nach Belieben zu durchqueren, wenn es groß ist. Ohne auch nur einen Gedanken daran zu verschwenden, regeln wir nach Gutdünken den Abstand zwischen unserem Auge und dem gemalten Gegenstand oder der Skulptur. Das Werk ermöglicht es uns, die Bedingungen zu beherrschen, unter denen es sich darbietet. Hier in den *Skyspaces* können wir nur unseren Kopf zurückbiegen – bis das gesamte Gleichgewicht unseres Zielens auf das Werk sich umdreht. Was wir betrachten, ist ein nicht beherrschbarer Abstand; der Himmel ist in jedem Fall zu weit entfernt, er wird uns seine Details oder seine innerste Textur nie enthüllen; und von einem anderen Gesichtspunkt aus betrachtet, besetzt er bereits den ganzen Raum, er „berührt" uns bereits, da wir in ihm ersticken, wenn es heiß ist, und schlottern, wenn es friert. Was wir betrachten, *überragt* uns also buchstäblich, und daher *betrachtet uns das, was wir betrachten*, sind diese Werke doch alles in allem nichts anderes als architektonische *oculi*. (siehe *Skyspaces*, S. 96 – 101)

Und dann dehnt sich die Zeit bis zum Äußersten, damit diese Werke für uns sichtbar werden können. Eine solche Dehnung ist nicht unser Werk: der Himmel selbst entscheidet über seine Art, an jenem Tag eine Dämmerung „aufsteigen" zu lassen.[32] Der Himmel ist also nicht mehr der neutrale Hintergrund der zu sehenden Dinge, sondern das aktive Feld einer unvorhersehbaren visuellen Erfahrung. Der Himmel ist nicht länger irgendwie „rund um" oder „über" uns, sondern *genau dort*, über uns und uns gegenüber, er ist gegenwärtig, weil er veränderlich ist, er zwingt uns, ihn zu bewohnen oder sogar entgegenzusteigen. Er ist nicht mehr der „Rahmen" oder der „Hintergrund" der zu sehenden Dinge – wie ein Ring, der den Gegenstand begleitet, oder eine bläuliche Einfriedung, die ihn umgibt –, er ist *genau dort*, er ist selbst im Zentrum, umrahmt von den scharfen Kanten, die Turrell für ihn entworfen hat.

Was sehen wir also? Keine Skulptur und auch keine Malerei, sondern die architektonische Bedingung eines Experimentierens mit dem Ziel, Malerei *oder* Bildhauerei als Gattungen der Bildenden Kunst hinter sich zu lassen. Giotto hatte schon vor Entstehen des Begriffs der Bildenden Kunst in der Scrovegnikapelle von Padua symbolisch jene paradoxe Duplizität des Himmels angedeutet, die Turrell hier physisch ins Werk setzt: einerseits, indem er durch die übergenaue Vermessung des Raumes der hierarchischen Ebenen, in die sein Jüngstes Gericht einschließlich der Fenster unterteilt ist, einen *Himmel reiner Tiefe* evoziert; andrerseits, indem er an den Rändern seines Freskos andeutet, daß der Himmel, wie ihn die heiligen Texte erwähnen, ein Mantel sein kann, ein Gewebe, kurz ein riesiges *Feld*, das zwei goldgeschmückte Erzengel entrollen. James Turrell wieder weiß genau sowohl um die schwindelerregende Tiefe des Himmels – er, der an den Schalt-

hebeln seines kleinen Flugzeugs unglaubliche Sturzflüge oder Steigflüge durchführt – als auch um die linguistische und phantasmatische Nähe der Worte *sky* und *skin*.[33]

Zweifellos träumte Turrell davon, eine Ausstellung im Himmel zu machen. Schon 1968 schuf er in Zusammenarbeit mit Sam Francis ein *Skywriting Piece*, bei dem beide die Rauchstreifen ihrer Flugzeuge verwendeten. In gewisser Weise bietet sich ihm der Himmel selbst als genaue – und symmetrische – Entsprechung der abgeschiedenen Räume des *Mendota Hotel* dar: gleichzeitig ein gigantischer Raum *(studio)* und ein gigantischer Teil seiner Arbeit *(work)*. In jedem Fall Orte für Experimente – paradoxe Spielarten des Ateliers, in denen er die optische Umkehrung der Krümmungen der Erde, die Textur der Wolken oder die visuelle Kraft des Windes beobachten kann.[34] Zweifellos träumt Turrell davon, für immer in den Himmel zu fallen, zweifellos träumt er, dort zu schlafen, dort zu träumen – dort zu sterben vielleicht.

In die Fabel des Ortes fallen

Erinnern wir uns – und schließen wir damit den Kreis der Fabel – an Moses' Tod nach seinem unendlich langen Marsch durch die Wüste und seinem entscheidenden Aufenthalt auf der Spitze des Berges Sinai: zunächst erhebt er seine Stimme zu einem langen, an den Himmel und die Erde gerichteten Gedicht. Er ruft die Wüste an. Er ruft die Anwesenheit Gottes am Sinai an, und er spricht von Gott wie von einem einfachen Stein: „Der Fels, der dich erzeugte", der Fels, der ein ganzes Volk nährt.[35] Dann erhebt er die Hand gen Himmel. Er spricht vom geoffenbarten, in Stein gemeißelten Gesetz wie von einer Lebensquelle. Da befiehlt ihm die Stimme Gottes: „Sterben sollst du auf dem Berge, auf den du steigst, und dich zu deinen Stammesgenossen scharen" in deinem Rückzug, in deiner neuerlichen Einsamkeit.[36] Moses wird den Bewohnern der Erde die Hand nochmals entgegenstrecken, um sie zu segnen, und er wird alleine auf den Berg Nebo steigen, wo Gott ihn mit ein und derselben Bewegung das Land seiner Begierde *schauen läßt* und ihn *sterben läßt*, indem er ihn für immer dem Blick und dem Kontakt der Menschen entzieht.[37] Moses hatte an jener Stelle diese *Randständigkeit* der visuellen Erfahrung gefunden – oder nach dem Sinai wiedergefunden –, die hier einmal mehr als visionäre Erfahrung wiedergegeben ist: ein Ort der äußersten Enden und Ränder, ein Ort äußerster Steinigkeit, der zu den äußersten Enden des Himmels hin offensteht.

Weit, ganz weit von den antiken Propheten entfernt suchte auch James Turrell einen *Ort des Äußersten* für seine visuellen Experimente. Er zog nicht vierzig Jahre durch die *Painted Desert* in Arizona und er schritt nicht die Wege oder Pfade ab, wie das zum Beispiel Richard Long bis heute tut. Er investierte einfach das Geld eines Guggenheim-Stipendiums in eine Menge Kerosin und begann mit seinem kleinen Helio Courier eine unermüdliche Suche nach dem *auserwählten verlassenen Ort*, wenn man das so nennen kann. Nach ungefähr sieben Monaten ständiger Flüge sollte ihm der auserwählte Ort – geodätisch, phantasmatisch, astronomisch und ästhetisch auserwählt – in Form eines im Hopi-Gebiet gelegenen Kraters erscheinen, der eine riesige Wüstenregion beherrscht. Das war im Jahr 1974, dem Zeitpunkt, seit dem der Künstler ohne Unterlaß – und ohne Ende – einen Großteil seiner Energie darauf verwendet, die Vulkanstätte in ein Netz von *viewing chambers* zu verwandeln; dort soll ein Experimentierfeld der Sinne entstehen, das den Himmel mit der Erde vereint.[38]

Was ist ein Krater anderes als der Inbegriff des Randes zwischen diesen beiden symmetrischen Abgründen des Himmelsgrundes und des Grundes der Erde? Als einzige Erhebung in der ebenen Landschaft, aus der er emporragt, schleudert uns der *Roden Crater* der Wolken entgegen; gleichzeitig kommt seine beunruhigende Kraft von unten, da er, obwohl er erloschen ist, Teil eines noch aktiven vulkanischen Systems ist. Es ist unmöglich, an diesem Ort die furchterregende Gewalt des Ortes zu ignorieren. Auf der anderen Seite ergibt seine topologische Struktur selbst –

ein emporragendes Loch, eine sich aushöhlende Höhe – ein wahres heuristisches Feld, um alle Formen der *Bestandsaufnahme des Ortes* auszuprobieren. Die architektonischen Korrekturen am *Roden Crater* wurden ausschließlich unter Verwendung von vorhandenen Materialien (Sand, Kieselerden, Schlacken, Lava) durchgeführt; insgesamt wurde der *Roden Crater* geschaffen, um dem Betrachter eine sehr lange Flugbahn von möglichen Richtungen zu geben, die sich vervielfältigen, von atmosphärischen Farben, die sich verändern, von Horizonten, die ihre Krümmung umkehren oder sich absenken oder sich abnorm heben… Leonardo da Vinci machte seinerzeit das Auge zum Sammelbecken der Welt und stellte fest, daß sich in der geringsten seiner Bewegungen alles verändert: der Himmel ebenso wie der Horizont und die Wahrnehmung der Ferne.[39] Der von Turrell bearbeitete Vulkan wäre die architektonische Monumentalversion eines solchen Auges, das sich auf die Welt öffnet, um sie in ihrer ständigen Veränderung zu sehen und um sich mit ihr zu ändern.

Erstaunlich bleibt, daß hier die Macht des Ortes – noch Erde und schon Himmel, noch Himmel und schon Abgrund – nur über die Öffnung und die Bearbeitung des Rahmens, des Randes stattfindet. Vor dem menschlichen Eingriff ist der *Roden Crater* bloße Natur, mächtig und beeindruckend, aber noch kein Ort. Es bedarf des Erinnerungsschatzes der Hopi, durch den das geringste Geschehnis am Horizont Bedeutung erhält, durch den die Weite der Wüste *gestaltet* und die Farbfelder der Erde und des Himmels *ausgerichtet* werden. Es bedarf der Einschnitte, die James Turrell vorgenommen hat und die an das uralte – und strukturelle – Gesetz erinnern, demzufolge die Grenzenlosigkeit nur im Rahmen einer strengen architektonischen Anordnung *präsentiert* werden kann. Dieses Paradoxon ist letztlich nur Ausdruck einer Situation, die vielen starken Werken gemeinsam ist, deren essentielle Einfachheit das Ergebnis einer komplexen und stets prekär ausbalancierten Arbeit ist. (siehe *Crater Spaces / Roden Crater*, S. 156–179)

So sind die *Skyspaces* von Turrell nie *einfach* offene Fenster zum Himmel, auch wenn der einfache Akt, lange den Himmel zu betrachten, das Ergebnis eines Großteils ihrer architektonischen Arbeit vermittelt. Sie verlangen nämlich, daß man der physischen Struktur der Kanten und der Dicke der sich verjüngenden Ränder höchste Aufmerksamkeit widmet. Sie verlangen als absolut grundlegendes Element das subtile Spiel der Beziehung zwischen Außenlicht und Innenlicht (sei es Kunstlicht oder nicht, obwohl es für Turrell nur einfach „Licht" gibt, gleich ob Sonnenlicht oder geschaffenes Licht, gleich ob mittels Metall oder Gas erzeugt[40]). Weiters verlangen sie auch, daß eine geeignete Malerei für Wände und Boden, ja sogar die leichte Krümmung der Innenflächen ausgewählt wird. Man könnte sagen, daß Turrell eigentlich nie aufgehört hat, nach den Grenzen zu fragen und Ränder herzustellen. Seit seinen ersten Arbeiten in den Jahren 1965– 1966, in denen er versuchte Flammenflächen, *Flat Flames*, zu schaffen – Flammen, die flächig wie Gemälde sein sollten,[41] – bis zu den *Structural Cuts* im Anschluß an die *Veils*, die *Wedgeworks* und die *Shallow Space Constructions* – schuf Turrell eigentlich immer paradoxe Räume in einem Spiel nicht graphischer Linien: *Wesenszüge* in dem Sinn, in dem Heidegger den Wesenszug als das Wirken einer Dialektik, ja sogar eines Kampfes und als das Ergebnis eines *Öffnens*, einer wesentlichen „Aufstellung" und eines wesentlichen Leuchtens erfaßte.[42]

Einen Rand, einen Rahmen zu zeichnen, bedeutet nicht immer, ein zu sehendes Ding zu umschließen oder den Fokus auf es zu richten. Bei Turrell ist der Rahmen der Ort eines Initiationsrituals zwischen den heterogenen Bedingungen der Sichtbarkeit – und genau am Ort dieses Initiationsritus entsteht jener Ort, jene *chôra*, für die wir versuchen, einige Worte zu finden. Wie wir bei *Blood Lust* gesehen haben, dient die Schärfe der Schnitte und der Ecken hier dazu, den Raum unschärfer erscheinen zu lassen und einen beschränkten Raum zu entgrenzen. Es ist offensichtlich, daß in „Through the looking-glass" – „Alice hinter den Spiegeln" von Lewis Carroll – der Vorgang des *through*, die Auswirkungen des Öffnens und des Durchquerens für Alice die wesentlichen Aspekte des Experiments sind: stürzen, in den Ort fallen. Bekanntlich geht Alice

in dem Augenblick durch den Spiegel, in dem die glatte und metallische Fläche des Spiegels ihre beruhigende Präzision, mit der sie die sichtbaren Dinge verdoppelt, aufgibt, um plötzlich zu verschwimmen und dahinzuschmelzen „ganz wie ein heller silbriger Nebel".[43] Die Werke Turrells laden uns nicht dazu ein, den surrealistischen Bazar der Traumbilder zu betreten, sondern dazu, genau im Übergang vom sichtbaren Raum in den Ort des Sehens zu verweilen – *through the looking-space*.

Und wenn Turrell mit solcher Strenge und Hartnäckigkeit mit der „natürlichsten" Bedingung unseres Sehens, dem Licht, arbeitet, so tut er dies deshalb, weil bereits die Wahrnehmung – phänomenologisch betrachtet – sich ständig an den Grenzen und Übergängen abspielt und uns dort immer in seltsamer Verwirrung zurückläßt. „Zu Unrecht hat man gemeint, die Grenzen des Gesichtsfeldes lieferten stets einen objektiven Bezugspunkt", betont Merleau-Ponty: „Der Rand des Gesichtsfeldes ist keine reale Linie", er ist eher ein Augenblick, eine unruhige Erfahrung der Zeit, die wir benötigen, um zu sehen.[44] Die spezifische Gabe des Werks des Bildhauers wäre die Verwendung von Linien, Trennwänden und Ausschnitten, um uns auf die Ebene der wesentlichen Tiefe des Ortes zu versetzen, dieser visuellen Tiefe, die Merleau-Ponty mit dem wunderbaren Wort *Voluminosität* erreichen wollte:

> „[…] bedarf es der Wiederentdeckung der primordialen Tiefe, die der Tiefe im Sinne einer Beziehung zwischen den Dingen oder auch zwischen den Ebenen, dieser objektivierten, von der Erfahrung losgelösten und in Breite verwandelten Tiefe, noch zugrunde liegt und ihr ihren Sinn verleiht, selbst aber die Dichtigkeit eines Mediums ohne Dinge ist. Lassen wir uns zur Welt sein, ohne sie aktiv uns zuzueignen, in einer Einstellung, wie auch gewisse Krankheiten sie begünstigen, so heben die Ebenen sich nicht mehr voneinander ab, die Farben verdichten sich nicht mehr zu Oberflächenfarben, sondern zerstreuen sich um die Gegenstände herum und werden zu atmosphärischen Farben; erwähnen wir z. B. einen Kranken, der, um auf einem Blatt Papier zu schreiben, erst mit der Feder eine Schicht von Weiß durchstoßen muß, ehe er an das Papier gelangt. Diese Voluminosität variiert je nach der betreffenden Farbe und ist gleichsam der Ausdruck ihres qualitativen Wesens. So gibt es denn eine Tiefe, die noch nicht zwischen Gegenständen statthat und um soviel weniger Abstände von einem zum anderen ermißt, sondern die einfache Offenheit der Wahrnehmung für ein kaum qualifiziertes Dingphantom ist."[45]

In der Wüste wäre es der Horizont selbst, der diese Offenheit bewirkt, in der Rahmen und Unbegrenztheit in eins fallen und zusammen dieses „kaum qualifizierte Dingphantom" bewirken, das wir als Ferne bezeichnen. Der Horizont ist eine Kante, eine Kante im Sichtbaren der Wüste. Aber gleichzeitig ist er eine Art lebender und trugbildhafter Rand, der unsere Sicht trüben und sich plötzlich „heben" kann, um „uns zu berühren". Am Horizont steigen auch die Luftspiegelungen auf, doch auch ohne sie bleibt der Horizont der Inbegriff des Ortes, an dem Wüste und Wünsche visuell verbunden sind. In der Painted Desert suchten die Hopi Indianer jahrhundertelang von festgelegten Punkten aus denselben Horizont ab, um seine von den Bergen ausgeschnittene Zackenlinie zur Skala eines richtiggehenden Himmelskalenders zu machen.[46] So wurde der Horizont zu einem Bereich, der die Himmelszeit anzeigt, eine *Zeitzone*, etwas, das Husserl mit demselben Wort bezeichnete, um ein ursprüngliches Wissen zu benennen – ein *Horizont-Wissen* –, in dem ihm zufolge jede geometrische Hervorbringung und jedes geometrische Werk begründet ist.[47] Dieser Hinweis allein müßte es uns ermöglichen, angesichts des Werks von James Turrell jenem kritischen Bewertungssystem einen Augenblick lang zu entkommen, das dem Werk, sobald es hervorgebracht wurde, seinen Platz in der unweigerlich vorformulierten Kunstgeschichte zuweisen möchte. Turrell wird natürlich der eines Tages zu schreibenden Geschichte des Minimalismus – oder der Auseinandersetzung mit dem Minimalismus – zugeordnet, der Tradition von Künstlern, die ihm tatsächlich oder scheinbar nahestehen wie Robert Irwin oder Douglas Wheeler.

Was es aber vor allem festzuhalten gilt, ist Turrells im wesentlichen *anachronistische* Verwendung von Skulptur oder Architektur als modernistische und jedenfalls *geometrische* Kunstformen. Turrell ist zweifellos ein „geometrischer" Künstler. Aber er ist kein Geometer der „polierten" Flächen, der „glatten" Kanten und der „vollendeten" Formen, noch ein Geometer der reinen Axiome:[48] ein *Skyspace* kann nicht als Ideal konzipiert werden, er wird mit Feingefühl adjustiert, so wie man eine Geige stimmt. Turrell ist ein Geometer auf der Suche nach dem Ort als Phänomen – man müßte mit Heidegger sagen: auf der Suche nach dem Ort als *Urphänomen*, dieses uns überschwemmende, vielleicht beängstigende ontologische Paradigma, das sich unserem Blick in demselben Augenblick erschließt, in dem uns die Bezugspunkte dessen, was wir für unsere sichtbare Welt halten, entgleiten.[49] „Axiomatisch" konzipiert ist dieser Ort nur auf der Basis von Grenzerfahrungen, die mit dem Himmel und der Wüste, mit dem Schlafen und Erwachen, mit der Kindheit und dem Wissen zu tun haben. Dieser Ort ist vielleicht nur ein großes *Spiel* – aber ein Spiel im Sinne von Eugen Fink: ein Spiel mit der Welt, ein Spiel als Bild der Welt.

Die Vielzahl der zu diesem Werk bereits vorgebrachten, einander heftig widersprechenden Interpretationen zwingt uns zur Annahme, daß im Werk selbst eine noch nicht faßbare Komplexität liegt (die schon allein deswegen nicht faßbar ist, weil sich das Werk in Entwicklung, das heißt in einem prekären Gleichgewicht, befindet, ungeachtet dessen, was erreicht wurde). Die Interpretationen suchten eiligst nach Bedeutungen, bevor sie die Frage nach der spezifischen Logik stellten, die dieses Werk in bezug auf jede Bedeutung entfaltete. Handelt es sich um ein „technisches" Werk? Ja, weil Turrell einige Präzisionstechniken einsetzt; nein, weil Turrell keine Technologie illustriert oder heroisiert.[50] Handelt es sich um ein Werk der „Perzeption"? Ja, denn es erforscht ein ganzes Feld von Perzeptionsphänomenen; nein, weil es frei von aller behavioristischen Ideologie ist und sich grundlegend als ein *nicht reflexives* Werk darbietet (wie könnte *ich mich denn dabei beobachten, wie ich den Sinn* für räumliche Grenzen verliere?[51]). Handelt es sich um ein „mystisches" Werk? Absolut nicht, wenn das Werk sich damit begnügt, Räume zu leeren, um Orte ohne Namen zu schaffen, ohne Symbole, ohne Parolen, ohne Gesetz und ohne eine andere Funktion als eine visuelle. Orte, die nichts anderes als die Abwesenheit evozieren sollten, in die wir immer versetzt werden, wenn wir sehen wollen. Die *Skyspaces* einer Mythologie des Himmels zuzuordnen, einem ikonographischen Symbolismus oder einem religiösen Synkretismus (der sich bis zur Absurdität versteigt, zwischen den amerikanischen Quäkern und den Zen-Buddhisten eine Brücke schlagen zu wollen), hieße nichts anderes, als genau das prekäre Gleichgewicht dieser *Fabel des Ortes* zu leugnen, das sich hier zu entwickeln versucht. All diese Fragen bleiben, wie man sieht, ziemlich unzureichend formuliert.[52]

Denn wenn es einen Ort gibt, um der verträumten antiken Aufforderung des *Timaios* zu antworten, so muß die Fabel ihn einerseits *außerhalb des Mythos*, andererseits *anachronistisch* einnehmen. Platon scheute bekanntlich nicht davor zurück, vom Ort zu verlangen, daß er seine eigene Denkweise aufbrechen sollte (was uns heute als Beispiel dienen könnte: vor jedem Werk die Denkweise aufzubrechen, die bis zu dem Moment, als unser Blick auf das Werk fiel, die unsrige war):

> „Damals nämlich unterschieden wir zwei Gattungen, jetzt aber [wo wir die Natur des Ortes denken wollen] haben wir noch eine neue dritte aufzuweisen. Jene zwei nämlich reichten für unsere damalige Betrachtungsweise hin, die eine gleichsam als das Urbild zu Grunde gelegt, nur dem Denken erfaßbar und stets auf gleiche Weise seiend, die andere die Nachahmung des Urbildes, dem Entstehen unterworfen und sichtbar; eine dritte aber unterschieden wir damals noch nicht, sondern meinten, daß jene beiden hinreichen würden. Nun aber scheint der Verlauf unserer Erörterung uns zu nötigen, daß wir eine schwierige und dunkle Gattung durch unsere Darstellung klar zu machen suchen."[53]

Weil das Werk Turrells den Ort betrifft, weil es Orte erfindet, erfordert es vielleicht auch, daß wir von ihm in „einer dritten Diskursgattung"[54] sprechen. Einer Gattung jenseits der klassischen

Dualismen, in die uns die moderne Kunstgeschichte seit langem stellt. Die klassischen Dualismen Platons bestehen nach wie vor und bestimmen weiterhin unsere Diskurse: das Vorbild im Gegensatz zur Kopie, das Intelligible im Gegensatz zum sinnlich Wahrnehmbaren (oder auch das „Intellektuelle" im Gegensatz zum „Sinnlichen"), das Unveränderliche im Gegensatz zum Vergänglichen. Das Wort *Fabel* kann hier als Zeichen für ein anachronistisches Sprechen stehen, für ein unangebrachtes Sprechen, das das Dilemma zwischen diesen beiden großen Gattungen des Diskurses verweigert, die immer noch in der klassischen platonischen Terminologie *Logos* und *Mythos* heißen[55] und sich im heutigen Kunstdiskurs in einer positivistischen Logik der zu Fortschrittslinien objektivierten Zeit und im metaphysischen Mythos einer in vermeintlichen Ursprüngen erstarrten Zeit verkörpern.

Kann eine Fabel, die ihre eigene Geschichte entleert, uns dabei helfen, über jenen Ort zu sprechen, der weder im eigentlichen noch im übertragenen Sinne zu verstehen ist? Aber auch eine hellseherische Fabel wird zwangsläufig wenig erhellend sein, da sie an ihren Ort, an diesen Bereich und diese Zeit gebunden bleibt, in der wir dem Schlaf verfallen und damit nach und nach unsere Fähigkeit verlieren, im Wachzustand zu denken.[56] An der Schwelle des Schlafes drängt sich mir oft das sehr vage Bild einer Wüste auf: ineinandergeschobene Dünen, die immer flacher werden und gleichzeitig beweglich und schwer sind. Und es ist nichts anderes als mein Körper, der beim Einschlafen schwerer wird. Das Bild bleibt nie stehen, die Dünen bewegen sich langsam unter dem Wind, der sie verschiebt. Und es ist nichts anderes als der verlangsamte Gang meines Atems.

Die hier nicht publizierten ersten drei Abschnitte dieses Artikels wurden 1990 in *Artstudio* (16, S. 6–17) veröffentlicht. Die vorliegenden vier Kapitel, die im gleichen Jahr verfaßt wurden, waren ursprünglich für den Katalog zur Ausstellung *James Turrell* in Poitiers (Le Confort moderne, 1991) bestimmt, der jedoch nie publiziert wurde.

Anmerkungen

1 Vgl. J.-L. Nancy, „Mundus est fabula", in: *Ego sum*, Paris 1979, S. 95–127. Nancy legt das „Fabuliergesetz" dar, dem Descartes sogar die Konstruktion des Cogito unterwirft.
2 Zit. nach C. Adcock, *James Turrell. The Art of Light and Space*, Berkeley–Los Angeles 1990, S. 196.
3 Wie man auch *Speisezimmer* oder *Kunstgalerie* sagt. Deshalb verzichtete Turrell wahrscheinlich gerade in diesen Jahren darauf, in Galerien auszustellen, sogar in so angesehenen wie Castelli in New York (vgl. ebd., S. 87–88). Als ob schon der Ausdruck „Kunstgalerie" und die damit verbundenen Erwartungen und Funktionen ein Hindernis für jegliche – ich meine: unerhörte – Erfahrung des zu entdeckenden Ortes darstellten.
4 Zit. in ebd., S. 36.
5 James Turrell hat sich schon früh für den in der Experimentalpsychologie des Sehens verwendeten Begriff des *Ganzfelds* interessiert: es handelt sich dabei um ein farbiges gegenstandsloses Feld, das völlig homogen ist und die Gesamtheit des Gesichtsfeldes ausfüllt. Die *Ganzfeld*-Erfahrung ist für das Subjekt die eines Lichtes, das nach und nach in seiner Atmosphäre, dann in seiner Masse und Dichte und schließlich in seiner Ertastbarkeit spürbar wird.
6 Nach P. Fédida, „Théorie des lieux", in: *Psychanalyse à l'Université*, XIV, Nr. 53 (1989), S. 3–14, und Nr. 56, S. 3–18.
7 Vgl. L. Binswanger, *Traum und Existenz*, Bern 1992, S. 124 ff.
8 Platon, *Timaios*, übers. v. F. Susemihl, 49 a: „ ... die vor allen, daß sie (die *chôra*) die Aufnehmerin und gleichsam Amme alles Werdens ist."
9 Vgl. B. D. Lewin, „Le sommeil, la bouche et l'écran du rêve" (1949), übers. v. J. B. Pontalis, in: *Nouvelle Revue de psychanalyse*, Nr. 5, 1972, S. 216–219.
10 Vgl. S. Freud, *Metapsychologische Ergänzung zur Traumlehre*, 1915; sowie P. Fédida „L'hypochondrie du rêve", in: *Nouvelle Revue de psychanalyse*, Nr. 5, 1972, S. 225–238
11 Vgl. B. D. Lewin, der a.a.O., S. 212–215, eine klinische Untersuchung der „weißen Träume" (blank) entwickelt.
12 Vgl. Leonardo da Vinci, *Sämtliche Gemälde und die Schriften zur Malerei*, hrsg. v. André Chastel, übers. v. Marianne Schneider, München 1990, S. 348 („Von den Körpern, die man im Nebel sieht"), S. 339 („Mir aber scheinen die Unterschiede unendlich viele zu sein, auf einer nie abreißenden Oberfläche, die in sich unendlich teilbar ist"), S. 262–264 („Von der Farbe der Luft"), S. 245–262 (über die „Perspektive der Deutlichkeit" oder *prospettiva di spedizione*, im Unterschied zur „linearen Perspektive" und der „Perspektive der Farben").
13 *Yield* ist auch der Titel einer Zeichnung von James Turrell für *First Light* (1989).
14 Vgl. insbesondere die Reihen „heuristischer" Zeichnungen mit dem Titel *Out of Corners* (1969) oder *Music for the Mendota* (1970). Die graphischen Arbeiten Turrells entsprechen meistens dem Bestreben, Transformationsstrukturen zu erforschen.
15 Vgl. K. Halbreich, L. Craig und W. Porter, „Powerful Places: an Interview with James Turrell", in: *Places*, 1983, Nr. I, S. 35
16 Ebd.
17 Das ist ein weiterer Wesenszug, der die Werke Turrells von einer einfachen Strategie der optischen Täuschung unterscheidet. Der *Trompe-l'œil*-Effekt funktioniert im allgemeinen nur aus der Distanz und jede Berührung ist untersagt, während die Lichtarbeiten Turrells im Grunde darauf abzielen, *uns zu berühren*. Auf die Frage „Versuchen Sie, einen Illusionsraum zu schaffen?" lautete seine Antwort: „Ich schaffe ger-

ne Räume, die sich auf das beziehen, was sie wirklich sind, das heißt ein Licht, das einen Raum bewohnt." Zit nach S. Pagé, „Entretien avec James Turrell", in: *James Turrell*, Ausstellungskat. ARC-Musée d'Art moderne de la Ville de Paris, Paris 1983; vgl. auch die Ausführungen Turrells über die taktilen Qualitäten des Lichts, zit. in C. Adcock, a.a.O., S. 2.

18 M. Merleau-Ponty, *Phänomenologie der Wahrnehmung*, übers. v. Rudolf Boehm, Berlin 1966, S. 329 f. Merleau-Ponty folgt hier E. Minkowski, Die gelebte Zeit, Kap.1 u. 2 übers. v. Lucien Kayser u. Meinrad Perrez, Salzburg 1971,1972.

19 „Night doesn't fall. It rises", sagt James Turrell. Vgl. K. Halbreicht, L. Craig und W. Porter, a.a.O., S. 37.

20 Vgl. C. Adcock, a.a.O., S. 106–111.

21 M. Merleau-Ponty, a.a.O., S. 285.

22 Ebd., S. 344 f.

23 Vgl. M. Heidegger, „Der Ursprung des Kunstwerkes" (1935/36), in: *Holzwege*, Frankfurt am Main 1980, S. 28–31.

24 Ders., *Die Kunst und der Raum* (1962), St. Gallen 1996, S.12; zur Wirkungskraft der Leere in der Kunst vgl. auch H. Maldiney, *Art et existence*, Paris 1985, S. 184–207.

25 M. Heidegger, *Die Kunst und der Raum*, S. 102–103; ders., „Bauen Wohnen Denken" (1952), in: *Vorträge und Aufsätze*, Pfullingen 1990, S. 139–143.

26 Vgl. die schöne Geschichte in: C. Adcock, a.a.O., S. XX–XXIII, auf französisch z. T. in: *James Turrell. À la levée du soir*, Ausstellungskat. Musée d'Art contemporain, Nîmes 1989, S. 9–14.

27 Es kommt vor, daß der Himmel selbst – sein besonders strahlendes Aussehen an diesem bestimmten Tag – in den Augen des Melancholikers *entscheidet*, daß der Moment des Selbstmords gekommen ist (nach einer mündlichen Mitteilung von Pierre Fédida).

28 Aristoteles, *Über den Himmel. Vom Werden und Vergehen*, übers. v. Dr. Paul Gohlke, Paderborn 1958, I, 9, 279a, S. 51.

29 Aristoteles, *Vom Himmel*, übers. v. Olof Gigon, München 1983, I, 3, 269b–270a.

30 Ebd., I, 3, 270b, und ders., *Meteorologie*, übers. v. Dr. Paul Gohlke, Paderborn 1955, III, 2, 372a.

31 Aristoteles, „Meteorologie. Über die Welt", in: *Werke*, übers. von Hans Strohm, 3., gegenüber der 2. berichtigte, unveränderte Auflage, Berlin 1984, Bd. 12, I, 5, 342a–b.

32 Vgl. die Beschreibung von G. Panza di Biumo, „Artist of the Sky", in: *Occluded Front. James Turrell*, Ausstellungskat. MOCA, Los Angeles 1985, S. 64 (über ein anderes Stück im Mendota Hotel mit Einbeziehung des Himmels): „Wir hatten in seinem Haus ein sehr interessantes Werk gesehen. Es bestand aus einem leeren Zimmer, mit von unten zwischen dem Boden und den Wänden hervorströmendem Licht, das den Innenraum erhellte, und einer Öffnung im oberen Teil der dem Meer zugewandten Westwand, durch die man nur den Himmel sah. Es war spät am Nachmittag. Wir setzten uns auf den Boden und betrachteten durch diese Öffnung den Sonnenuntergang. Zunächst war sie dunkelblau und wechselte dann zu hellblau. Im dunkelblauen Licht erschien der Raum, den man durch diese Öffnung sah, leer, an der Oberfläche der Wand; die Ränder des Fensters waren klar abgegrenzt. Man sah nicht die Dicke der Wand, auf der sich der leere Raum somit fortzusetzen schien. Das innere Licht war mit dem vom Himmel im Gleichgewicht. Die Öffnung war gleichsam eine ebene Fläche, sie erschien nicht mehr als Leere. Mit der tiefer am Horizont stehenden Sonne und dem sich ändernden Licht änderten sich auch unsere Sinneseindrücke. Man hatte den Eindruck zu sehen, wie die Öffnung den leeren Raum in eine Fläche verwandelte, bis sie aus fester farbiger Materie zu sein schien. Welch eigenartiger Eindruck, etwas zu sehen, das nicht existierte und zugleich doch real war! Die Farben änderten sich ohne Unterlaß, aber in einer Art, die wir nicht erfassen, wenn wir einen Sonnenuntergang im Freien betrachten: dunkelblau, hellblau, rot, hellrot, gold, gelb, dunkelrot, grün und schließlich violett, in ununterbrochener Abfolge."

33 Vgl. Adcock, a.a.O., S. 158.

34 Vgl. Halbreich, Craig und Porter, a.a.O., S. 35. Man denke an die Leidenschaft, mit der sich Leonardo da Vinci dem Himmel widmete und an seine zahlreichen Schriften sul volo. Vgl. Leonardo da Vinci, *Tagebücher und Aufzeichnungen*, München 1952, S. 291–378

35 Deuteronomium, 32, 1–31

36 Ebd., 32, 48–50

37 Ebd., 34, 1–6

38 Vgl. C. Adcock, a.a.O., S. 154–207. Vgl. auch C. Adcock und J. Russell, *James Turrell. The Roden Crater Project*, The University of Arizona Museum of Art, Tucson.

39 Vgl. Leonardo da Vinci, Sämtliche Gemälde und die Schriften zur Malerei, S. 220–226, 250–252, usw.

40 Vgl. S. Pagé, a.a.O.: „Es gibt nur natürliches Licht. Ob man Wasserstoff in der Sonne oder Wolfram in einer Glühlampe verbrennt oder Gas oder Phosphor erhitzt, sie alle enthüllen ihre Wesensart in den abgegebenen Farben. Ich liebe sie alle."

41 Vgl. C. Adcock, a.a.O., S. 5–6, der richtigerweise den Unterschied zwischen dieser Arbeit und den eher symbolischen oder „rituellen" Versuchen von Yves Klein betont.

42 Vgl. M. Heidegger, „Der Ursprung des Kunstwerkes", S. 29–31, 38–39.

43 Vgl. L. Carroll, *Alice hinter den Spiegeln*, übers. v. Christian Enzensberger, 1977, S. 22.

44 M. Merleau-Ponty, Phänomenologie der Wahrnehmung, S. 322.

45 Ebd., S. 310.

46 Vgl. E. C. Krupp, „Footprints to the Sky", in: *Mapping Spaces. A Topological Survey of the Work by James Turrell*, New York 1987, S. 30–39; J. M. Malville, C. Putnam, *Prehistoric Astronomy in the Southwest*, Boulder 1989, S. 16–17.

47 E. Husserl, „Der Ursprung der Geometrie" (1936), in: Jacques Derrida, *Husserls Weg in die Geschichte am Leitfaden der Geometrie*, München 1987, S. 227–228. Husserls Begriff des „Horizonts" wird von Derrida auf S. 143ff. kommentiert.

48 Um mit Husserl zu sprechen, vgl. a.a.O., S. 210–211, 229. Turrell bemerkt zu diesem wichtigen Punkt: „I don't care about 'perfect' walls, surfaces, and edges. I just don't want them to be noticed", zit. nach C. Adcock, a.a.O., S. 45.

49 Vgl. M. Heidegger, Die Kunst und der Raum, S. 7; ders., *Sein und Zeit* (1927), Tübingen 1986, S. 110–113.

50 Vgl. die nuancierte Haltung von James Turrell in Halbreich, Craig, Porter, a.a.O., S. 32, wo er die technologischen Aktivitäten der Menschheit des Abendlands mit denen eines Ozean vergleicht, der Korallenriffe erzeugt.

51 Ungeachtet der Äußerungen von James Turrell selbst (zit. nach C. Adcock, a.a.O., S. 205), der zuzeiten die minimalistische Position nachahmt und die Vorstellung eines *see yourself see* verteidigt. Sein Werk läßt es meiner Meinung nach beim bescheideneren und richtigeren *let you see* bewenden, das kein Verhalten vorschreibt.

52 Seltsamerweise fügte Rosalind Krauss, die für gewöhnlich gute Fragen stellt, diesem Katalog schlecht gestellter Fragen eine weitere hinzu: Ist Turrell „postmodern"? Es genügt, seine Werke ein wenig länger als einen Augenblick zu betrachten, um Züge zu entdecken, die jeder Ideologie der Postmoderne diametral entgegengesetzt sind: zum Beispiel seine Weigerung, die Vergangenheit als Zitat zu verwenden; der nicht-serielle und nicht-industrielle Charakter seiner Werke; die relative Einsamkeit, die sie von uns logischerweise fordern; der Charakter des Wartens und der prekären Wahrnehmung, den sie uns anbieten; und vor allem das notorische Fehlen dieser *exhilaration* (Hochstimmung), von der Krauss spricht, indem sie für Turrell auf eine Terminologie zurückgreift, die F. Jameson für ... Andy Warhol verwendete. Die adjektivische Beschreibung – „minimalistisch" oder nicht, „postmodern" oder nicht – ist meist nur Zeichen eines zu flüchtigen Blicks oder eines professionellen Kritikerreflexes. Der polemische Aspekt des Textes von Krauss ist vielleicht in so manchen Punkten gerechtfertigt, ja sogar mutig (die museographische Situation, die theoretische Situation). Aber seine künstlerische Stoßrichtung ist sicherlich nicht richtig. Vgl. R. E. Krauss, „The Cultural Logic of the Late Capitalist Museum", in: *October*, 1990, Nr. 54, S. 3–17.

53 Platon, *Timaios*, 48e–49a.

54 Vgl. J. Derrida, *Chôra*, übers. v. Hans-Dieter Gondek, Wien 1990, S. 13.

55 Ebd.

56 Vgl. P. Fédida, „Le conte et la zone d'endormissement", in: *Corps du vide et espace de séance*, Paris 1977, S. 155–191.

Georges Didi-Huberman

THE FABLE OF THE PLACE

TO WALK IN THE SPACING
Looking into: how to construct the visual power of spacing.
Blank dreams and the retirement of limits. When the place makes us absent.

TO WALK IN THE LIMITS
Outside in: the work is always on the edge. The room as work.
Viewing chambers: constructing the space where seeing takes place. The experience of night.

TO WALK BENEATH THE GAZE OF THE SKY
Skyspaces: the overhang. When being on the earth is being under the gaze of the sky.
Conjoining withdrawal and opening, sky and skin.

TO FALL INTO THE FABLE OF THE PLACE
Roden Crater: the volcano as *viewing chamber*. State of the site and work of the frame.
"Voluminosity". Geometry and anachronism: the fable of the place.

The artist is an inventor of *places*. He shapes and incarnates spaces which had been hitherto impossible, unthinkable: aporias, topical fables.
The particular genre of the places invented by James Turrell requires him to work first of all with *light:* an incandescent or nocturnal material, evanescent or massive. Turrell is a sculptor who lends mass and consistency to things known (wrongly) as "immaterial": color, spacing, the limit, the sky, the ray, the night. His *viewing chambers* construct places where *seeing* takes *place,* where seeing becomes the experience of the *chora,* the "absolute" place of the Platonic fable. Something that might also evoke what psychoanalysts call "blank dreams".
This sculpture of overhanging visions, of skies and volcanoes, is here presented as a pathfinding fable. Such that seeing a work of art becomes akin to walking in a desert.

To Walk in the Spacing

A fable, indeed. That is what we must now construct, in the attempt to grasp again, in a waking state, what the dream gave us in another, remote, time. The very exercise of thought, be it "Cartesian", stems from this relation between a construction and the other-timeness of the dream.[1] For the dream is always *remote:* in remote time the dream gave us the overwhelming evidence of the place. But waking dispossesses us of it immediately, since its obviousness was composed of the material – the somatic material – of our sleep. All that was given in one time (a *time* that repeats itself into the past, a *time* that incorrigible metaphysics would like to call an origin), all of that is taken up again, melded with that other material within ourselves which is oblivion. The Platonic fable of the *chora* constructed, in its own way, a paradoxical memory of this obligation to forget.

What James Turrell constructs also stems from this play, from this memory, from this fable. Turrell began to create his art on the day when, at the age of twenty-three, he occupied a concrete place, emptying it out, closing it up again, finally reconstructing in it conditions of spatiality and luminosity which little by little transformed the objective space into an "open" space. It was a banal Californian hotel located on a streetcorner, a place of temporary dwelling where Turrell had decided to settle, to sleep and to dream for almost six years, exploring an entire field of virtualities, spatial, luminous, colored. But first it was necessary to empty out the rooms, to make the space into a *place deprived* of its customary function, a *deserted place* (which is the main character of this whole fable). Since then this interest has not ceased to capture Turrell's attention in his choice of the spaces he likes to structure, or to "refiction". "I'm interested in public places that are devoid of their function", he explains.[2] Thus he began by taking all the objects out of the rooms, all the colors off the walls, and above all, by closing all the openings to the street. The disaffected hotel became a pure shrine, closed in on itself, as though to become nothing more than a place for sleep and for the trappings of dreams. A way, perhaps, of reinventing that "hybrid space which is in no way accompanied by the sensation of ordinary reality" – in particular the sensation that a place can only exist through the objects or functions which people it and succeed in naming it.[3] (see *The Mendota*, p. 86 – 91)

The space, then, is emptied out to become a place of withdrawal and imminence concerning the gaze itself: *a looking into,* as Turrell puts it, opposed to any vision in quest of an object (*a looking at*).[4] The unfilled space became an *espace blanc,* a chromatically white space but above all a *blank space,* to use a word that refers not to the simple suppression of colors but to *spacing* in general, to muteness, to depopulation, to definitive gaps. To pure virtualities. It is in this sense that one can speak of a desire, in Turrell's work, to deconstruct trivial spaces – where there is something visible to be discerned, recognized and named – in order to extract their pure and simple *power of luminous spacing.* It means: eliminate all that the spectator could spontaneously call an "object" and spontaneously situate as "visible", orphaning the spectator of all that provides him with the usual conditions for visiting an art space "filled with works", and for sensing and perceiving such a space. Turrell's works often begin by imposing an act of *closure* or privation. But the intent is always the gift of experience dispensed in light; and therefore the works allow, in the end, an act of *opening.*

In an extraordinary enlargement or displacement, it is like the intimate act of *closing* one's eyelids which allows to *open* one's vision to the place – and to the images or objects – of the dream. Closing the eyelids, here: the act of "deadening", of deactivating any visibility of aspects.[5] And thus, of submitting the disquieted vision to a field of perception void of objects and planes, a field where the light is so heavy, homogeneous, intense and sourceless, that it becomes like the very substance – compact and tactile – of the place in its entirety. That is why the dream imposes itself here as the matrix and paradigm (of oblivion), and not as allusion or metaphor (to be remembered). It is not a question of dream images. It will only be a question of giving this place the elementary, absolutely *virtual* power of a figurability without "figures".

Indeed, the dream – we have always forgotten for what it truly was – resonates in us like the omnipotence of the place: that, anyway, is how I understand the Platonic fable of the *Timaeus*.[6] It is because we no longer knew what was happening to us in the dream that the power of the place imposed itself upon us. It is because in the same movement we could both have fallen from the skies and flown up to meet them: this is why we have *produced the place* through the fundamental ontological value which makes every dream into a close cousin of anxiety.[7] Now, it is certainly in the *retirement of limits* and in the impossibility to measure any extension that the place – the "receptacle-place" or "nurse-place", as Plato says[8] – comes forth to us.

Where, from where, do we dream? There are people who believe they dream in front of or behind their eyes. There are people who believe they dream in the hollow of their mouth, or in the interstice between a veil and the skin. Many dream in a vaguely concave space that gradually flattens.[9] All reconfigure their organs *outside their boundaries,* and all use the signifiers of their mother tongue as devices to modify their bodies or to give birth to their flesh anew, constantly transgressing the functionality of the body. Then the organism itself becomes an interplay of spaces, the scales move and inverse, the little things eat the big ones, and sizes lose all common meaning in the atmospheric turmoil of generalized hypochondria.[10] But there are also dreams – or there is something, somewhere, in every dream, we fairly remember it – that offers nothing but an *expanse* of pure satisfaction: "blank dreams", without content. Pure screens, pure virtualities evoking once again the power of the *chora*.[11]

This – this *where* – does it really exist? It is not given to us to know, since it is only given to forget it; this *where* is not observed psychologically, it is only constructed metapsychologically. How, with our open eyes, can we experience something of the power of this place? How can we understand its absence, and make the work out of it, the opening? Painters, sculptors, and architects no doubt put this question into operation when they work with the visual space, all the way to its erasure. As we know, Leonardo da Vinci liked to wonder about bodies in fog and about fog itself as a bearer of bodies; in every parcel of the visible world he saw infinities drawing away into the distance; he asked the air to tell him its color; and he came to submit perspective to a *law of effacement*.[12] As though producing the work meant *submitting oneself to the powers of a place that distances us* from visible things. James Turrell no doubt follows the same path, he who loves the word *yield* in its polysemia: to give, to produce, to exhale, but also the act whereby one cedes, gives in, and submits to the voiding power of place.[13]

To Walk in the Limits

Our ancient fables taught us that the power of the void is a simplicity made of violent risks and subtle balances: a simplicity which is constructed, given rhythm and elaborated. The deserted place is not simply a place with nothing at all. To yield the visual clarity of absence, it requires the minimum of a symbolic alliance, or of its fiction (which, in a sense, is the same). To visualize the unlimited requires a minimum of architecture, that is, the art of joints, of partitions and edges. All that implies a kind of dialectic, a play of contradictions which meet at their limits, condensed or displaced or all that at once, rhythmically. In the inaugural experience of the *Mendota Hotel,* James Turrell already used the notions of *work* and of *space* (studio, room) simultaneously. But soon the demand for a rhythm emerged, joining day and night and waking and sleep; then Turrell retraced a whole set of openings, and the withdrawal of the space met the light of the outside. Henceforth, the interior played with the exterior; the artificial light – for example, in the pieces entitled *Cross Corner Projections* – played with the light from outside – that of the *Mendota Stoppages;* and the architectural immobility of the joint-lines played with the random mobility of the light-traces drawing on the busy ambiance of the street. Thus, the extreme simplicity that generally appears in a work by Turrell is never immediate. First of

all because *it takes time:* the time for the residues of our familiar visible space to evaporate, the time to let settle the silent compactness and power of the visual place. Then, because this simplicity constantly plays on the relations of at least two things, two things which contradict and contaminate each other. Always, *the work places itself on the edges:* the boundaries of shadow and light; of direct and indirect light; of internal and external space; of visual and tactile quality; of an art which is extremely mobile, articulated (for Turrell often does with light what Sol LeWitt does with pencil lines: a casuistry in the form of musical fugues[14]) and an extremely unitary result, indivisible, massive in a sense.

Turrell constructs what I have called temples, and what could in his own words be more simply called *viewing chambers:* rooms where the experience of seeing is given to itself as its own revelation (which does not mean that we know what we are seeing, nor that we "see ourselves seeing", as Valéry's spectator imagined for the satisfaction of his beautiful soul). These are architectural forms where *the edges* – extraordinarily complex and subtle articulations of planar, volumetric, and chromatic elements – *constitutes the very place where seeing takes place.* Such that seeing becomes a rare experience: itself a limit. Turrell loves the Egyptian pyramids, not for their perfect forms and deathly enclosures; he loves them above all because at rare moments (a single moment in the course of a year) the deathly closure of their perfect forms allows the outside light, a ray of sunshine, to penetrate all the way to the bottom of the shaft and illuminate the face of a pharaon.[15] And the bunkers of the Maginot line fascinate him as well, because they are places made at once for retreating inside and seeing outside, in a dialectic of anxiety and fore-sight, always keenly sharpened, always "on the edge".[16]

As one can see, the further we advance the less the place is defined as pure spatial extension. Little by little, the sought-after place becomes, not an idea, but the sensible, temporalized experience of a view from the edges. James Turrell's *viewing chambers* – for example, the architectural project eloquently entitled *Outside In* – construct their systems of joint-lines for visual experiences that one would like to call *borderline:* limit-experiences, where the limit is constituted in a phenomenology of *time to see,* a time which, itself, little by little, will come to constitute *the place as such.* The Roman Pantheon places humans beneath the eye of the sky, determined by the necessary time of a ritual walk. This is why Turrell's constructions are related to temples. The ritual time that men of the past imposed on the faithful, becomes the simple and free proposition to wait: waiting and *watching in time* for the object of the vision to return to its luminous conditionality. Then light becomes space, and the place is a substance that our body crosses, to experience its enveloping caress or breeze. The object of vision, *habitually in front of us,* becomes the place of our seeing. We are *inside it.* And yet this place presents itself only as a pure and mysterious tactility of light.[17]

Vision, time, touch: thus there is a subject supposed or convoked by this work. Not only an object, be it an "art object". The truly *borderline* character of the work is that its place floats or transits between our awareness of the constructed place, which we penetrate, and our oblivion of the *chora*-place, where a significant part of our existence is founded and agitated in our dreams. The *chora*-place that with which we are *penetrated,* despite everything. James Turrell's *viewing chambers* are, practically speaking, great *camerae obscurae,* perhaps they function in this respect as metaphors of the eye. But the perceptual eye – regardless of what most of Turrell's commentators say, regardless of what Turrell himself sometimes says – is not fundamentally at stake in all this temporal work. The experiments of *Gestalt,* of the psychology of form, can put the perceptual eye into a box; this eye is merely the interface between the visible space and the visual place that the work will constitute for each person (for each one thinking, each one dreaming, each one awakening to the place according to his own desire, his own memory and his own oblivion, according to his own lived body and his own destiny). This is why, in order to understand such a work of the place, one must begin by turning toward a phenomenology – and not a psychology – of perception. Toward a thinking which would not attempt

to explain the magic of perceptual effects, but would seek rather to *implicate* something which is not at all an effect: namely a being, a subject opening himself to the place. One must conceive of the visual place beyond the visual forms that circumscribe its spatiality: one must see beyond the eyes, since in dreams we also see, but with closed eyes. This is also why a phenomenology of the *waking vision* begins with the *visual experience of the night:*

> "When [...] the world of clear and articulate objects is abolished, our perceptual being, cut off from its world, evolves a spatiality without things. This is what happens in the night. Night is not an object before me; it enwraps me and infiltrates through all my senses, stifling my recollections and almost destroying my personal identity. I am no longer withdrawn into my perceptual look-out from which I watch the outlines of objects moving by at a distance. Night has no outlines; it is itself in contact with me and its unity is the mystical unity of the *mana.* Even shouts or a distant light people it only vaguely, and then it comes to life in its entirety; it is pure depth without foreground or background, without surfaces and without any distance separating it from me. All space for the reflecting mind is sustained by thinking which relates its parts to each other, but in this case the thinking starts from nowhere. On the contrary, it is from the heart of nocturnal space that I become united with it. The distress felt by neuropaths in the night is caused by the fact that it brings home to us our contingency, the uncaused and tireless impulse which drives us to seek an anchorage and to surmount ourselves in things, without any guarantee that we shall always find them."[18]

Turrell withdraws that same guarantee from the viewers who dare to enter one of his *Dark Spaces,* created in the 1980s: spaces without visible limits, where the shadow literally rises before us[19] to envelop us completely. One must stay *inside* these works as long as one remains in front of a black painting by Ad Reinhardt: twenty long minutes in silence and darkness, until strange *borderline light experiences* emerge *within* the viewer himself certain, certain intense visual events – like flashes – due to the unpredictability of a few passing photons, or to the least pressure exerted on the optic nerve, or simply to the intensified desire not to be blind.[20] The visuality of the space then fully displays its non-reflexive, unmasterable character. Its character as symptom. Indeed, Merleau-Ponty had already stated that the truth of an visual experience could not be grasped "in the ordinary run of living, because it is then hidden under its own acquisitions. We must examine some exceptional case in which it disintegrates and reforms before our eyes".[21] Such is the nocturnal experience, which provides an almost excessive modality of it, with no way out. But even under the sun, for one who looks closely, light reserves a number of incomparable experiences where *edges move* and come to touch us like strangeness itself:

> "If, on a sunken path, I think I can see, some distance away, a broad, flat stone on the ground, which is in reality a patch of sunlight, I cannot say that I ever see the flat stone in the sense in which I am to see, as I draw nearer, the patch of sunlight. The flat stone, like all things at a distance, appears only in a field of confused structure in which connections are not yet clearly articulated. In this sense, the illusion, like the image, is not observable, which means that my body has no grip on it, and that I cannot unfold it before me by any explanatory action. [...] Every sensation is already pregnant with a meaning, inserted into a configuration which is either clear or obscure, and there is no sense-datum which remains unchanged when I pass from the illusory stone to the real patch of sunlight. [...] I see the illusory stone in the sense that my whole perceptual and motor field endows the bright spot with the significance 'stone on the path'. And already I prepare to feel under my foot this smooth, firm surface. The fact is that correct and illusory vision are not distinguishable in the way that adequate and inadequate thought are [...].[22]

No doubt it is exactly there, between a patch of light and a field of stones, that the work of James Turrell lingers, refusing to distinguish between correct vision and illusory vision in the way one would

distinguish between adequate and inadequate thought. For vision, whatever its objective verifiability, always remains *incorrigible:* it is what it gives us despite ourselves, incorrigibly dedicated to dreams, fantasies, or desires with which, obliviously or not, it is pregnant.

To Walk beneath the Gaze of the Sky

Perhaps what James Turrell desires, in essence, is to produce spaces which would offer the always unmasterable experience of a secret balance between symmetrical abysses. Between the loss of self implied by sleep and that other loss of self provoked by awakening. Between the void of absolute night and the all-too populated space that agitates us vainly beneath the sun. Balancing these two bedazzlements or blindnesses would be a rare experience: a paradoxical time where nothingness yields to a thickness made of almost nothing, where light withdraws from the things which it illuminates to appear by itself, differently, as tactile. Like a paradoxical place which would combine otherness, distance, the absolute exteriority of a luminous expanse, with the mortally singular infolding of our corporeal existence, and the astonishment at our own power of seeing. The borderline character fomented by this work unceasingly conjoins *openess and withdrawal.*

It is striking to rediscover the very statement of this duplicitous character – double like the effect of a fold – in the few pages that Heidegger has devoted to the art of space in general, and to sculpture in particular. There he evokes the kind of refusal that the space sets against us, until a work makes its very simplicity come forth in a disconcerting moment – *between* clearing and reserve, *between* the awakening to the place and the sovereignty of its withdrawal.[23] He also evokes the specific power that sculpture deploys when, by *incorporating* places, it succeeds in *opening* unperceived realms. The delimitation of space can then *form* the limitlessness of the place, and so position man within what Heidegger calls a "free gathering". Then the void will no longer be the opposite but rather "the twin of place". Not a lack, but an operation, the very operation of "bringing to disclosure".[24] Being, building, and dwelling then come together. "Free vastness" and human "gathering" then come to-gether. And then one recalls that being on earth means being under the sky, and that the reinvented place always remembers that temples were constructed in the past to embody this very memory.[25]

What Heidegger arrived at in his reflection on space is no doubt exactly that from which Turrell constantly departs and that to which he constantly returns when he builds his works. Turrell, the desert dweller, the Californian artist, the lover of solitary flight[26] – Turrell knows well that being on earth means *being under the gaze of the sky.* Here again, one need not read the constellations in order to experience within oneself this constraint essential to our *station* on earth, to the steps we attempt and to our disasters, to our feeling of space in general: the constraint of the celestial vault.[27] The sky embraces all, quite simply. There is "no place or void or time outside the heaven", as Aristotle wrote in his little monographic treatise "On the Heavens".[28] The sky has always seen us born, and it was never born; it will always see us die, while it encompasses all time, is unen-gendered, incorruptible, unalterable.[29]

And when we look upon the blue of this "place of places", we know that its color – which as Aristotle stresses is irreproducible by painters' pigments – has never turned or aged, was always just that color since the very beginnings of time.[30] And yet this color is not simple: it lives its life, it breathes, it has its laws and its strange symptoms, both in daytime and at night:

> "Sometimes on a fine night we see a variety of appearances that form the sky: 'chasms' for instance and 'trenches' and blood-red colors.[...] For we have seen that the upper air condenses into an inflammable condition and that the combustion sometimes takes on the appearance of a burning flame, sometimes that of moving torches and stars. So it is not surprising that this same air when condensing should assume a variety of colors.[...] Thus on a hot day, or through a smoky medium, the stars when they rise and set look crimson. The light

will also create colors by reflection when the mirror is such as to reflect only color and not shape."[31]

Now, there are spaces made specifically by James Turrell to constitute receptacles for this unmasterable color of the sky. They are named *Skyspaces*, and have been built since the early seventies at the *Mendota Hotel*, then for the Panza di Biumo collection; they oblige us to reverse certain habitual conditions of vision brought to an artwork. For habitually – I mean in modernist exhibitions – all the necessary conditions are marshaled so that our body can either dominate the work if it is small, or explore it at will with if large. Without even thinking, we adjust at our convenience the distance between our eyes and the painted or sculpted object. In short, the work allows us to master the conditions under which it is exhibited. Here, in the *Skyspaces*, we cannot help but lean back our head – to the point of reversing the entire balance of our intentions toward the work. What we look upon is an unmasterable distance; the sky is always too far away, it will never yield us its detail or the intimacy of its texture; and from another point of view it invades the entirety of the piece, it "touches" us, since we stifle if the atmosphere is warm and shiver if it is cold. What we are looking at literally *hangs over* us, and in this respect *what we look at looks at us,* since these works are, all things considered, nothing other than architectural *oculi.* (see *Skypaces,* p. 96–101)

And, time must dilate extraordinarily before these works become visible to us. Such a dilation is not our doing: it is the sky itself which decides, in its way, to agree to let a twilight "rise".[32] Thus the sky is no longer the neutral background of things to be seen, but the active field of an unforeseeable visual experience. The sky is no longer vaguely "around" or "above" us, but *exactly there,* on top of us and against us, present because it is changing, obliging us to inhabit it, if not to rise up to meet it. It is no longer the "frame" or the "background" of things to be seen – like an ambient outline, a bluish holder around the object – it is *exactly there,* itself central, itself framed by the vibrant joint-lines that Turrell has conceived for it.

What do we then see? Neither a sculpture nor a painting. But the architectural condition of an experimentation aiming to go beyond painting *and* sculpture as genres of the fine arts. In the Scrovegni Chapel in Padua, even before the idea of the fine arts existed, Giotto had already symbolically indicated the double, paradoxical condition of the sky that Turrell puts physically to work here: on one hand, by suggesting a sky of *pure depth,* through the hyper-volumetrics of the hierarchical planes in which his *Last Judgment* is organized, including the windows; and on the other, by suggesting on the edges of his fresco that the sky, as it is stated in the sacred texts, can be a cloak, a cloth, in short an immense *sheet* unfurled by two richly colored archangels. As for James Turrell, he is neither ignorant of the vertiginous depth of the sky – he who dares incredible falls or upward swoops in his airplane – nor of the linguistic and fantasmatic proximity of the words *sky* and *skin.*[33]

No doubt Turrell has dreamed of an exhibition in the sky. Already in 1968 he created a *Skywriting Piece,* in collaboration with Sam Francis, using streamers of smoke from their planes. In a certain way, the sky appears to him as the strict – and symmetrical – equivalent of the enclosed spaces of the *Mendota Hotel:* at once a gigantic studio and a gigantic work. Places of experience in any case – paradoxical versions of the studio. Places where he can observe the optical inversion of the earth's curves, the texture of the clouds or the visual power of the wind.[34] No doubt Turrell dreams of falling infinitely through the sky, no doubt he dreams of sleeping there, dreaming there – perhaps dying there.

To Fall into the Fable of the Place

Let us remember – to bring the fable to its origins – how Moses dies, after his immense walk across the desert and his decisive stop before the summit of Mount Sinai. First he pronounces a long poem addressed to the heavens and to the earth. He invokes the desert. He invokes the presence of the

god on Sinai, and he speaks of the god as of a simple stone: "the rock that begat thee", the rock that nourishes an entire people.[35] Then he raises a hand to the sky. He speaks of the law, stated and graven on stone, as a source of life. Then the divine voice commands him: "Die in the mount wither thou goest up, and be gathered unto thy people" – gathered together in the very act of his with-drawal, of his renewed solitude.[36] Moses lowers his hand to the inhabitants of the earth to bless them, and climbs alone up Mount Nebo where, in one blow, God *makes him see* the land of his desire and *makes him die*, withdrawing him forever from the gaze and contact of humans.[37] There Moses discovered – or rediscovered, after Sinai – the *littoral* condition of visual experience, here once again given as visionary experience: a place of extremities and edges, a place of extreme mineralities open to the extremities of the sky.

Far, so far from the ancient prophets, James Turrell has also sought a *place of extremities* for his visual experiences. He did not walk for forty years in the Painted Desert of Arizona (fortunately for him), and he did not crisscross paths and tracks, as Richard Long does today, for example. He simply used the proceeds of a Guggenheim grant to buy lots of kerosene to launch his little Helio Courier plane on the tireless, determined search for the *deserted spot of election,* if I may say. After some seven months of continuous flights, the elected place – geodesically, fantasmatically, astronomically, aesthetically elected – was to appear to him in the form of a crater situated on Hopi territory, towering over an immense desert region. That was in 1974; and from that date onwards the artist has not ceased – and has not finished – devoting a great deal of his energy to transforming the volcanic site into a network of *viewing chambers.* Here would be constructed an entire field of sensing experiences, confronting and gathering the sky with the earth.[38]

What is a crater, if not the edge *par excellence* between the two symmetrical abysses which are the depths of the sky and the depths of the earth? The *Roden Crater* projects us towards the clouds, it is the single prominent point in the landscape from which it arises; at the same time, its disquieting power stems from below, for, though extinguished, it forms part of an active system of volcanoes. It is impossible, in this place, to ignore the daunting power of place. Yet additionally its very topological structure – an uprising hole, an emptying height – makes it a veritable heuristic field to experience all the possible *states of a place.* Architecturally corrected by materials drawn directly from the site (sand, silica, volcanic scoria, lava), the *Roden Crater* is conceived to give the spectator a very long trajectory of multiplying directionalities, of modulating atmospheric tonalities, of horizons inverting their curves, sinking or rising abnormally... In past times Leonardo made the eye the receptacle of the world, and observed that with the slightest of its movements everything changes: the color, the horizon, the sensation of distance.[39] The volcano worked by Turrell would be the architectural, monumental version of such an eye, opened to the world to see it constantly change, and to change with it.

What remains striking is that here the power of the place – still earth and already sky, still sky and already chasm – comes forth only through the *opening and the working of the frame,* of the edge. Before all human intervention, the *Roden Crater* is only nature, powerful and imposing, to be sure – but not yet a place. For that there must be the memory of the Hopis, which lends meaning to the least wrinkle on the horizon, which *informs* the desert distance, *orients* the colored fields of earth and sky. There must be the work of cutting carried out by James Turrell, who links back to the immemorial – and structural – law whereby limitlessness can only be *presented* in the frame of a strict architectural prescription. After all, this paradox merely states a situation shared by many strong artworks: their essential simplicity derives from a working process, which is complex and always dangerously balanced. (see *Crater Spaces / Roden Crater,* p. 156–179)

Thus Turrell's *Skyspaces* are never *simply* windows open to the sky, even if the simple act of looking at length at the sky provides the culmination of their architectonic structure. Indeed, extremely close attention must be paid to the physical structure of the joint-lines and to the thickness of the edges,

which gradually taper. And there must be – an absolutely fundamental element – the subtle play of relations between outside and inside light (artificial or otherwise, though for Turrell there is never anything but "the light", whether solar or reinvented, originating from metal or from gas[40]). There must also be an appropriate choice of paint for the walls and for the floor and a slight curving of the interior surfaces. One could say that Turrell has never ceased inquiring into limits and fabricating edges. From his very earliest works, in 1965–66, where he attempted to create *flat flames,* flames as flat as paintings,[41] all the way to his *Structural Cuts,* by way of his *Veils, Wedgeworks* and *Shallow Space Constructions*[42] – in effect, Turrell has never ceased producing paradoxical spaces in a play of non-graphic lines: *ontological traits,* in the sense where Heidegger could envisage the line as the work of a dialectic, indeed of a combat, and as a *working open,* the opening of an essential "stature" and luminosity.[43]

Tracing an edge, a frame, does not always mean enclosing or focusing on a thing to be seen. In Turrell's work, the frame is the place of a rite of passage between the heterogeneous conditions of visuality – and it is at the very place of this rite of passage that the place comes forth, the *chora* for which we are seeking words. Here, the clarity of the cut and of the angles serves, as one also sees in *Blood Lust,* to "blur" the space and to render limitless a nonetheless restricted space. It is quite evident that in "Through the Looking-Glass" (Lewis Carroll) it is the operation of the *through,* the effect of the hole and the traversal, that gives Alice the essential condition of the experience: to flow out, to *fall into the place.* And one will recall that Alice's step through took place at the very moment when the smooth, metallic plane of the mirror let go the reassuring precision with which it dispenses its duplication of visual things, to suddenly *turn blurry* and "melt away, just like a bright silvery mist".[44] Turrell's works constantly invite us not to enter the surrealist bazaar of dream images, but to stay within the very passage from visible space to the visual place – *through the looking-space.*

And if Turrell works with such stubborn rigor on the most "natural" condition of our vision, i. e. light, it is because perception itself – envisaged phenomenologically – does not cease to play on edges and passages, always leaving us in strangely troubled states. "It has been wrongly asserted that the edges of the visual field always furnish an objectively stable point", writes Merleau-Ponty. "The edge of the visual field is not a real line", he continues – rather it is a moment, a restless experience of *time to see.*[45] The gift that is proper to the sculptural work would be to use lines, partitions, and cuts to place us on an even footing with the essential depth of space, the visual depth that Merleau-Ponty sought to touch on with the magnificent word of *voluminosity:*

> "[…] we have to rediscover beneath depth as a relation between things or even between planes, which is objectified depth detached from experience and transformed into breadth, a primordial depth, which confers upon the other its significance, and which is the thickness of a medium devoid of any thing. At those times when we allow ourselves simply to be in the world without actively assuming it, or in cases of illness favoring this passive attitude, different planes are no longer distinguishable, and colors are no longer condensed into superficial colors, but are diffused round about objects and become atmospheric colors. For example, the patient who writes on a sheet of paper has to penetrate a certain thickness of whiteness with his pen before reaching the paper. This voluminosity varies with the color in question, and is, as it were, the expression of its qualitative essence. There is, then, a depth which does not yet operate between objects, which, *a fortiori,* does not yet assess the distance between them, and which is simply the opening of perception upon some ghost thing as yet scarcely qualified."[46]

The horizon, in the desert, would be the very operator of this opening, where frame and limitlessness go together, together producing this "ghost thing as yet scarcely qualified" which we call the faraway. The horizon is a joint-line, a stop-line in the visible of the desert. But at the same time it is a kind of living and phantom edge, capable of blurring our vision and suddenly "rising" to come "touch us". On the horizon also arise mirages, and even without them the horizon remains the privileged

place where desert rhymes visually with desire. From fixed points in the Painted Desert, the Hopi Indians have stared over centuries at the same horizon, to make its line, jagged with the cut of the mountains, into a veritable astronomical calendar.[47] The horizon thus became a zone symptomatic of celestial time, a *zone of time,* something that Husserl evoked with the same word in order to signify an originary knowledge – a *horizon knowledge* – in which all geometric production and all works of geometry are founded.[48]

This sole indication ought to permit us to escape, in the face of Turrell's work, from the system of critical evaluation which attempts immediately upon the completion of a work to place it or replace it in an inevitably preconceived history of art. Turrell is obviously inscribed in a history which will have to be written someday, that of minimalism – or of the debate with minimalism – and that of artists close or seemingly close to him, such as Robert Irwin and Douglas Wheeler. But what is important to grasp above all else is the essentially *anachronistic* use that Turrell makes of sculpture or architecture as modernist arts, and in any case as *geometric* arts. Turrell is inarguably a "geometric" artist. But he is neither a geometer of "polished" surfaces, of "smooth" joint-lines and "completed" forms, nor a geometer of pure axioms: [49] a *Skyspace* is not conceived ideally, it is tactfully adjusted, as one tunes a violin. Turrell is a geometer in quest of the place as a phenomenon – one should have to say, with Heidegger, as an *Urphänomen,* the submerging, perhaps anguishing ontological paradigm which opens to our vision in the very moment when the benchmarks of what we thought to be our visible world escape.[50] This place can only be conceived "axiomatically" against a background of limit-experiences involving the sky and the desert, sleep and awakening, childhood and knowledge. This place is perhaps nothing but a great *game* – but a game in the sense of Eugen Fink: a game with the world, a game as a figure of the world.

So many interpretations, already, have been applied to this work, and with so many contradictions, that we are obliged to suspect that the work itself contains some as-yet unmasterable complexity (unmasterable because the work is in progress, that is, in a fragile balance, whatever may already have been achieved). The interpretations have searched for signification even before inquiring into the particular logic that this art deploys with regard to all signification. Is it a "technological" art? Yes, because Turrell uses certain precision techniques; no, because Turrell does neither illustrates nor glorifies any technology.[51] Is it a "perceptualist" art? Yes, because it explores a field of perceptual phenomena; no, because it is free of any behaviorist ideology, and appears fundamentally as an art of *non-reflexivity* (how, indeed, could I *observe myself losing the sense* of spatial limits?[52]). Is it a "mystical" art? Absolutely not, if it limits itself to emptying spaces to produce places without names, without symbols, without slogans, without laws, without any function other than visual. Places which ought to invoke nothing other than the absence in which all desire to see places us. To draw the *Skyspaces* into a mythology of the heavens, into an iconographical symbolism or a religious syncretism (absurd to the point of suggesting links between the American Quakers and the Zen Buddhists) would mean denying precisely the fragile balance of the *fable of the place* which is seeking its elaboration here. As one can see, all these questions remain poorly posed.[53]

For if there is a place from which to respond to the ancient, dreamy injunction of the *Timaeus,* it is *outside the myth,* on the one hand, and *anachronistically,* on the other, that the fable must take its place there. Plato did not fear to demand that the place should shatter his own way of thinking, and this could form a model for us today – leaving shattered before each work the modes of thinking that was ours just before having laid our eyes upon it:

"This new beginning of our discussion of the universe requires a fuller division than the former; for then we made two classes, now [if we wish to understand the nature of the place] a third must be revealed. The two sufficed for the former discussion: one, which we assumed, was a pattern intelligible and always the same; and the second was only the imitation of the pattern, generated and visible. There is also a third kind which we did not distinguish at the time,

conceiving that the two would be enough. But now the argument seems to require that we should set forth in words another kind, which is difficult of explanation and dimly seen."[54] Turrell's work, because it concerns the place, because it invents places, perhaps also demands that we speak according to a "third genre of discourse".[55] A genre beyond the classical dualisms where history and modern art have placed us for so long. The classical Platonic dualisms still exist, still operate in our discourses: that which forms a pattern in contrast to that which forms an imitation, that which is intelligible in contrast to that which is sensible (indeed, that which is "intellectual" in contrast to that which is "sensual"), that which is immutable in contrast to that which changes. The word *fable* would here serve as an emblem for an anachronistic speech, an untimely speech refusing the dilemma between these two great genres of discourse which, in classical Platonism, are known as *logos* and *mythos*:[56] respectively, where art is concerned today, the positivist logic of time objectified into lines of progress, and the metaphysical myth of time frozen into pseudo-origins. Could a fable, voiding itself of its own affabulation, serve to say something about this place which is neither the literal nor the metaphorical? But a fable, even if it is divinatory, will inevitably fall short of lucidity, destined as it is to its place, as though to the zone, the time, where we slip over into sleep, gradually losing our capacity for waking thought.[57] It often happens, at the borders of sleep, that the vague image of a desert imposes itself upon the ego: gathered dunes that flatten as they recede, fluid yet still heavy. And this is nothing other than my body growing heavy with sleep. The image is never fixed, the dunes move slowly, transformed by the wind. And this is nothing other than the slowing rhythm of my breathing.

The first three chapters of this article were published in 1990 in the journal *Artstudio* (16, pp. 6–17). The four chapters included here were originally destined for the exhibition catalogue *James Turrell* (Le Confort Moderne, Poitiers 1991), which was never published.

Notes

1 Cf. J.-L. Nancy, "Mundus est fabula", *Ego Sum* (Flammarion, Paris 1979): 95–127, exposing the "fabulatory law" to which Descartes submits even the construction of the *cogito*.

2 Quoted by C. Adcock, *James Turrell: The Art of Light and Space* (University of Califonia Press, Berkeley–Los Angeles 1990): 196.

3 As one says *dining* room or *art* gallery. This is no doubt why Turrell renounced exhibiting in art galleries during those years, even prestigious galleries like Castelli in New York (cf. ibid.: 87–88). As though the very expression "art gallery", with the expectation and function it presupposes, already furnished the obstacle to any experience – I mean: the unprecedented experience – of a place to be discovered.

4 Quoted in ibid.: 36.

5 James Turrell has long been interested in the notion of *Ganzfeld* used in the experimental psychology of vision: it is a objectless colored field, absolutely homogeneous and occupying the peripheral totality of the visual field. The experience of the *Ganzfeld* is that of a light which progressively imposes its atmosphere, then its mass and compactness, finally its tactility.

6 After P. Fédida, "Théorie des lieux", *Psychanalyse à l'Université* XIV, 1989, 53: 3–4, and 56: 3–18.

7 Cf. L. Binswanger, "Le rêve et l'existence" (1930), trad. J. Verdeaux and R. Kuhn, *Introduction à l'analyse existentielle* (Minuit, Paris 1971): 199–225 (esp.: 199–202, 224).

8 Plato, *Timaeus*, 49a: " ... it *[the chora]* is the receptacle, and in a manner the nurse, of all generation".

9 Cf. B. D. Lewin, "Le sommeil, la bouche et l'écran du rêve" (1949), trad. J-B. Pontalis, *Nouvelle Revue de psychanalyse* 5, 1972: 216–19.

10 Cf. S. Freud, "A Metapsychological Supplement to the Theory of Dreams" (1915), *Standard Edition of the Complete Psychological Works of Sigmund Freud* (Hogarth Press, London 1953–74), vol. XIV. P. Fédida, "L'hypochondrie du rêve", *Nouvelle Revue de psychanalyse* 5, 1972: 225–38.

11 Cf. B. D. Lewin, "Le sommeil, la bouche et l'écran du rêve", art. cit.: 212–15, where he develops a theory of "blank dreams".

12 Cf. Leonardo da Vinci, *Traité de la Peinture*, trad. A. Chastel and R. Klein (Berger-Levrault, Paris 1987): 200 ("Bodies seen in the fog"), 281 ("But it seems to me that the variety [of tones] is infinite over a continuous surface and divisible in itself to infinity"), 201–4 (on "the color of the air"), 186 and 201 (on the "perspective of effacement" or *prospettiva di spedizione*, as distinguished from "linear perspective" and the "perspective of colors").

13 *Yield* is the title of a drawing by James Turrell for *First Light* (1989).

14 Cf. in particular the series of "heuristic" drawings intitled *Out of Corners* (1969), or *Music for the Mendota* (1970–71). In general, Turrell's graphic works answer this concern with exploring structures of transformations.

15 Cf. K. Halbreich, L. Craig, and W. Porter, "Powerful Places: an Interview with James Turrell", *Places* 1, 1983: 35.

16 Ibid.

17 Here is yet another trait that distances Turrell's works from a simple strategy of optical illusion. Trompe-l'oeil generally functions in tandem with distance, with the prohibition of touch, whereas Turrell's light-works aim, at bottom, to *touch us*. "Do you seek to create an illusionistic space?" he was asked. And he answers: "I like to create spaces which relate to what they really are, that is, light resting in a space". S. Pagé, "Entretien avec James Turrell", *James Turrell*, ARC-Musée d'Art Moderne de la Ville de Paris, 1983. Also see Turrell's comments on the tactility of light, quoted in C. Adcock, op. cit.: 2.

18 M. Merleau-Ponty, *Phenomenology of Perception* (Routledge & Kegan Paul, London / The Humanities Press, New York 1962): 282–83.

19 "Night doesn't fall. It rises", says James Turrell. Cf. K. Halbreicht, L. Craig and W. Porter, art. cit.: 37.

20 Cf. A. Adcock, op. cit.: 106–11.

21 M. Merleau-Ponty, op. cit.: 244.

22 Ibid.: 296–97.

23 Cf. M. Heidegger, "The Origin of the Work of Art" (1963), trad. A. Hofstadter, *Poetry, Language, Thought* (Harper and Row, New York 1975): 41–47.

24 Id., "L'art et l'espace" (1962), trad. F. Fédier and J. Beaufret, *Question, IV* (Gallimard, Paris 1976): 99, 104–5. On the efficacy of the void in art, also see H. Maldiney, *Art et existence* (Klincksieck, Paris 1985): 184–207.

25 M. Heidegger, "L'art et l'espace", art. cit.: 102–3. Id., "Building Dwelling Thinking" (1952), *Poetry, Language, Thought*, op. cit.

26 Cf. the very beautiful story related in C. Adcock, op. cit.: XX–XXIII.

27 It happens that the sky itself – its particularly radiant character on a given day – *decides* for the melancholic that the moment has come to commit suicide (after a lecture by Pierre Fédida).

28 Aristotle, *On the Heavens*, I, 9, 279a, trad. J. L. Stocks, *The Works of Aristotle,* (Encyclopedia Brittanica, Chicago/London 1952), vol. I, 370.

29 Ibid., I, 3, 269b–270a.

30 Ibid., I, 3, 270b and III, 2, 372a.

31 Id., *Meteorology,* I, 5, 342a–b, trad. E. W. Webster, *The Works of Aristotle*, op. cit., vol. II: 448–49.

32 Cf. The description given by G. Panza di Biumo, "Artist of the Sky", *Occluded Front: James Turrell* (The Museum of Contemporary Art, Los Angeles 1985): 64 (concerning another room in the Mendota using the sky): "After the tea we went into another room, which was completely empty. Some light came from below, from a slot near the floor with hidden neon inside. He asked us to sit on the floor on small cushions leaning against the wall. There was daylight coming from a square opening above the front wall, which balanced the artificial light. The sky that we could see was like a surface which appeared as a solid blue material, but at the same time empty. The color was not one seen in paintings; it was material and immaterial at the same time. In the beginning the opening was blue – the sky of southern California in the fall. / Turrell asked us to stay, to look and not to speak for about thirty minutes. After awhile the blue became darker and stronger, and the space inside the opening receded and gained depth. This feeling was not lasting; the sky became pale blue and lost its depth, appearing again like a surface painted with a light color, something solid and ready to come out of a frame. It was just the opposite of what we had seen before. We no longer had the feeling of being lost in an endless space; now something beautiful was nearby and real. Different colors began to appear in a slow but steady succession. The changes were fast enough to keep our attention on the opening. We went through the red, the orange, the bright gold, the dark gold, the yellow mixed with the green, the violet, which lasted longer, and finally the black, which became permanent and without change. We realized that the night had arrived."

33 Cf. C. Adcock, op. cit.: 158.

34 Cf. K. Halbreich, L. Craig, and W. Porter, art. cit.: 35. One recalls Leonardo's passion for the sky and his hundreds of writings *sul volo.*

35 *Deuteronomy*, 32: 1–31.

36 Ibid., 32: 48–50.

37 Ibid., 34: 1–6.

38 Cf. C. Adcock, op. cit.: 154–207. Cf. also C. Adcock and J. Russell, *James Turrell: The Roden Crater Project* (The University of Arizona Museum of Art, Tucson).

39 Cf. Leonardo da Vinci, *Traité de la peinture,* op. cit.: 162–68, 190–92, etc.

40 Cf. S. Pagé, "Entretien avec James Turrell", art. cit.: "There is only natural light. Whether you burn hydrogen in the sun, tungsten in a bulb, or whether you heat up a gas or some posphorus, all they can do is reveal their characteristic nature in the colors emitted. I adore them all."

41 Cf. C. Adcock, op. cit.: 5–6, where the difference between this work and the more symbolic or "ritual" attempts by Yves Klein are rightly underscored.

42 All these are Turrell's terms.

43 Cf. M. Heidegger, "L'origine de l'œuvre d'art": 70–72, 79–80.

44 Cf. L. Carroll, *Through the Looking-Glass.*

45 M. Merleau-Ponty, *Phenomenology of Perception*, op. cit.: 277.

46 Ibid.: 266.

47 Cf. E. C. Krupp, "Footprints to the Sky", *Mapping Spaces: A Topological Survey of the Work by James Turrell* (Blum, New York 1987): 30–39. J. M. Malville and C. Putnam, *Prehistoric Astronomy in the Southwest* (Johnson, Boulder 1989): 16–17.

48 E. Husserl, *L'Origine de la géométrie* (1936), trad. J. Derrida (PUF, Paris 1962/second ed. revised, 1974),: 207–8. Husserl's notion is commented on by J. Derrida, ibid.: 123.

49 To use the expressions of E. Husserl, op. cit.: 192–93 and 210–11. Turrell himself stresses this important fact: "I don't care about 'perfect' walls, surfaces, and edges. I just don't want them to get noticed." Quoted by C. Adcock, op. cit.: 45.

50 M. Heidegger, "L'art et l'espace," art. cit.: 100. Id., *L'Etre et le temps* (1927), trad. R. Boehm and A. de Waelhens (Gallimard, Paris 1964): 143.

51 Cf. James Turrell's nuanced position, in K. Halbreich, L. Craig, and W. Porter, art. cit.: 32, where he compares the technological activity of Western humanity to that of an ocean fabricating its coral reefs.

52 Whatever James Turrell himself, in this case, may say (quoted by C. Adcock, op. cit.), when he mimes the minimalist position, stating the idea of "seeing yourself see". His work sticks, in my opinion, to the more modest and apt expression of a "let you see", which prescribes no particular behavior.

53 Strangely, Rosalind Krauss, who usually asks good questions, has added an article to the catalogue of bad ones: is Turrell "postmodernist"? It's enough to look a little more than an instant at his works to discover traits which are massively opposed to any postmodernist ideology, for example: the refusal to produce citational references to the past; the non-serial, non-industrial character of his works; the relative solitude they demand of us, in all logic; the character of waiting and perceptual fragility they propose to us; and above all, the notable absence of the *exhilaration* of which Krauss speaks, referring to Turrell with a terminology provided by F. Jameson in reference to ... Andy Warhol. The adjectival form in general – "minimalist" or not, "postmodernist" or not – can only furnish the index of an overly hasty gaze, the reflex of a professional critic. The polemical aspect of Krauss's text remains perhaps justified, indeed courageous, on many points (the museographic situation, the theoretical situation). But its artistic target is certainly not the right one. Cf. R. E. Krauss, "The Cultural Logic of the Late Capitalist Museum", *October* 54, 1990: 3–17.

54 Plato, *Timaeus*, 48e–49a, op. cit.: 31.

55 Cf. J. Derrida, "Chôra", *Poikilia: Études offertes à Jean-Pierre Vernant* (Editions de l'EHESS, Paris 1987): 266.

56 Ibid.

57 P. Fédida, "Le Conte et la zone d'endormissement", *Corps du vide et espace de séance* (Delarge, Paris 1977): 155–91.

WERKGRUPPEN / WORK SERIES

1966–1998

PROJECTION PIECES

SHALLOW SPACE CONSTRUCTIONS

WEDGEWORK SERIES

THE MENDOTA

STRUCTURAL CUTS

SKYSPACES

SPACE DIVISION CONSTRUCTIONS

GANZFELD PIECES

DARK SPACES

AUTONOMOUS STRUCTURES

PERCEPTUAL CELLS

PERFORMANCE PIECES

CRATER SPACES

PROJECTION PIECES

1966–69

CROSS CORNER PROJECTIONS

Die frühesten Projektionsarbeiten entstanden 1966. Sie waren aus Licht „geformt", das von einem leicht veränderten Quarzhalogen-Projektor in eine Raumecke projiziert wurde. Die erste Arbeit (*Afrum-Proto*, 1966) bestand aus einem Rechteck, das durch die Projektion in eine Raumecke, aus der Distanz als Kubus wahrgenommen wurde, der über dem Boden, vermeintlich in der Ecke befestigt, zu schweben schien. Aus gewisser Entfernung gesehen, vermittelte diese Form den Eindruck von Festigkeit, wenngleich sie aus Licht gefertigt war. Bewegte man sich auf gleicher Höhe ein wenig zur Seite, so wurde diese Wirkung verstärkt, da sich der Kubus in seiner perspektivischen Verkürzung noch zu verdeutlichen schien. Ging man aber auf die Bildprojektion zu, so löste sie sich an einem gewissen Punkt auf. Man nahm nicht mehr ein Objekt im Raum, sondern das Licht als solches, als Wandbeleuchtung, wahr.

Diese ersten „Bilder" verfügten über eine ausgesprochen plastische Qualität, indem sie Licht in Materie zu verdinglichen schienen und physisch präsent machten. Dadurch wurde das gesamte Raumgefüge verschoben. Der Projektionsraum unterschied sich eindeutig vom architektonisch vorgegebenen Raumvolumen. Dieser neu geschaffene Raum entsprach in seiner Wirkung einem zweidimensionalen Bild, das eine dritte Dimension vorgibt. Hier allerdings wurde mit der Dreidimensionalität des Raumes illusionistisch verfahren. Dies bedeutet, daß sich diese in der Illusion evozierten Formen nicht unbedingt in eine klar definierte, dreidimensionale Form einlösen lassen.

Eine weitere Werkserie mit übereck gestellten Formprojektionen folgte. Die dafür verwendeten Xenon-Projektoren wurden mit Hilfe von Leonard Pincus entwickelt. Mit diesen Geräten konnten die Projektionen ohne Einbuße der Leuchtkraft vergrößert werden. Da Xenon-Licht als punktförmige Lichtquelle in Erscheinung tritt, wurde gleichzeitig die Scharfeinstellung verbessert. Diese Bilder vermittelten daher ein gesteigertes Gefühl an Dinglichkeit, da die Qualität der Transparenz und Oberflächentextur noch verfeinert worden war. Dieser Eindruck stellte sich gewissermaßen unweigerlich ein, da sich das Erscheinungsbild in einer realen, dreidimensionalen Ecke ausbreitete. Zudem ist jede ebenmäßig erleuchtete Lichtform, in ihrer Projektion auf eine Wand, optisch in einer anderen Ebene als die Wand selbst. JT

The earliest projection works began in 1966 and were formed by light projected across a corner from a slightly modified quartz halogen projector. The first image (*Afrum-Proto,* 1966) was essentially a rectangle projected across a corner in such a way that from a distance there appeared to be a cube floating off the floor, yet in some manner attached to the corner of the space. From a distance this shape had solidity, but appeared to be literally composed of light. Still at a distance, but moving to the side, one could further substantiate this impression because the cube seemed to reveal itself in perspective. Advancing toward it, the image would eventually dissolve to the point where you saw not the object in space, but the actual light on the wall.

The first images had a distinctive sculptural quality: the piece seemed to objectify and make physically present light as a tangible material. The space which these pieces occupied was definitely not the same as that which the room had without the image. The space generated was analogous to a painting in two dimensions alluding to three dimensions, but in this case three-dimensional space was being used illusionistically. That is, the forms engendered through this quality of illusion did not necessarily resolve into one clearly definable form that would exist in three dimensions.

A series of similar cross-corner forms was then created, using xenon projectors constructed with the help of Leonard Pincus. Use of the xenon projectors allowed the size of the projections to be increased without any loss of brilliance. At the same time, crispness of focus was gained because the xenon source is a point source. Throughout the series, the image had a sense of solidity because, in some manner, a quality of transparency and surface had been created. This was unavoidable since the image was formed across a corner actually existing in three dimensions, and because any evenly lit shape of light projected on the wall cannot ride on exactly the same plane as the wall.

JT

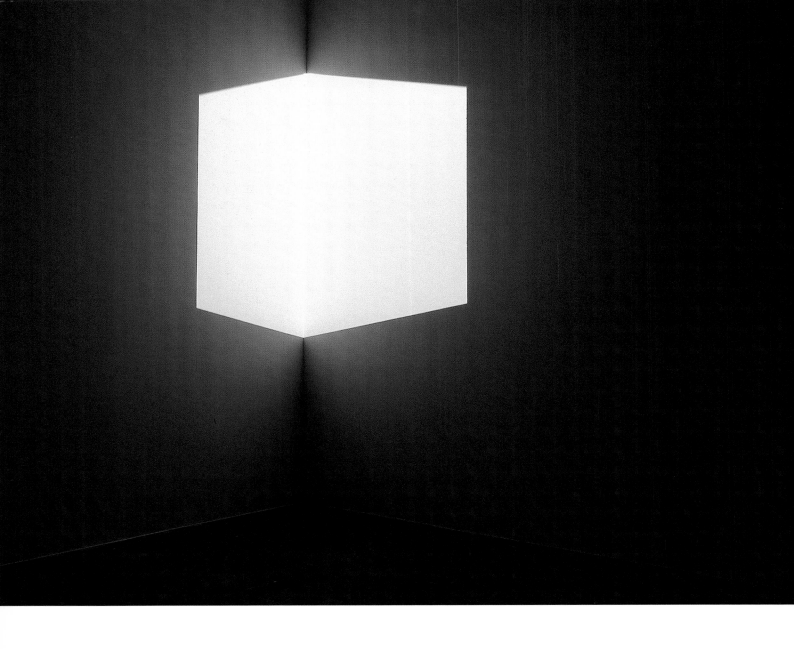

Afrum–Proto 1966

Projection Pieces

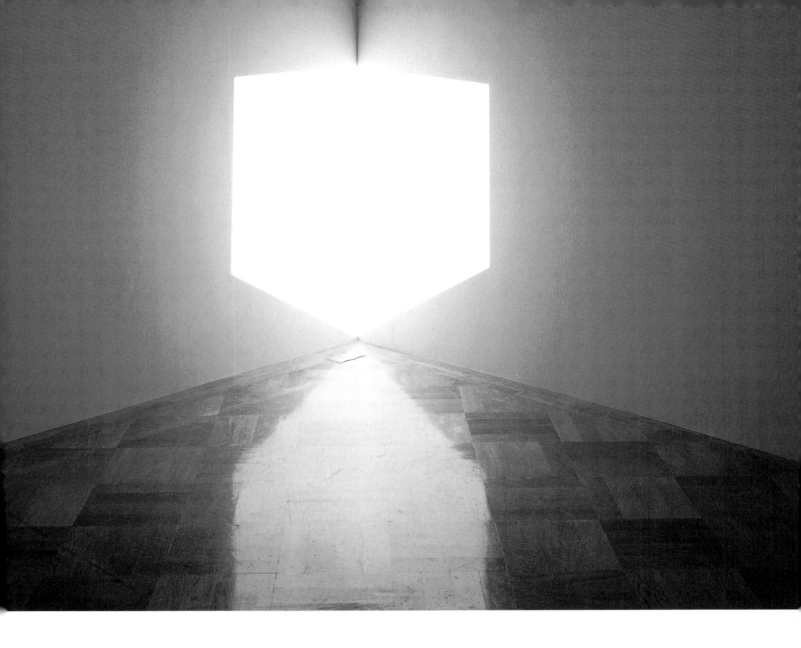

Munson 1967

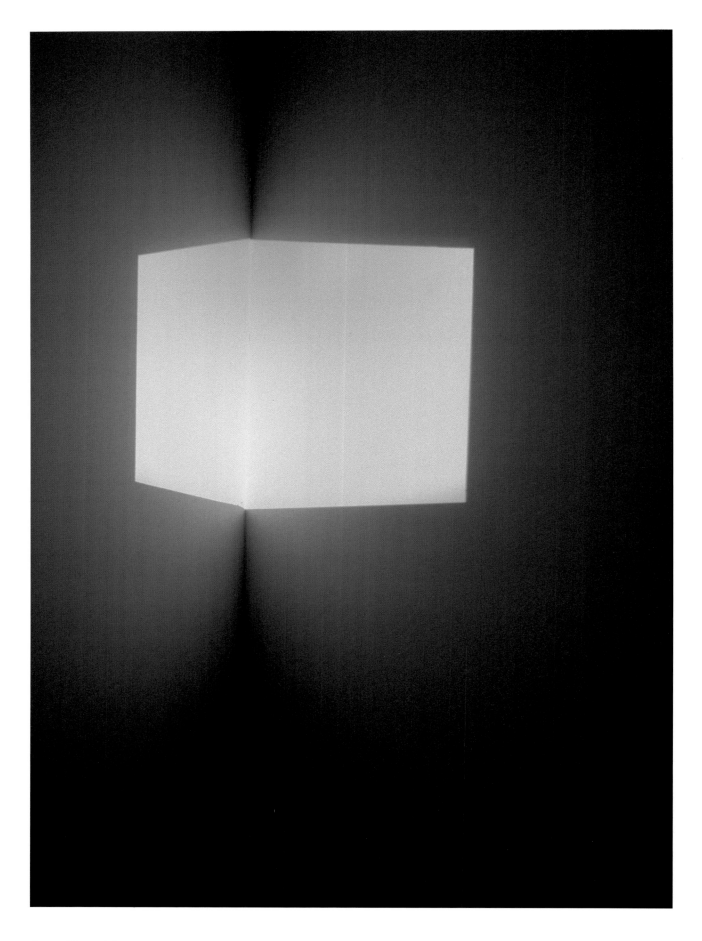

Catso, Blue 1967

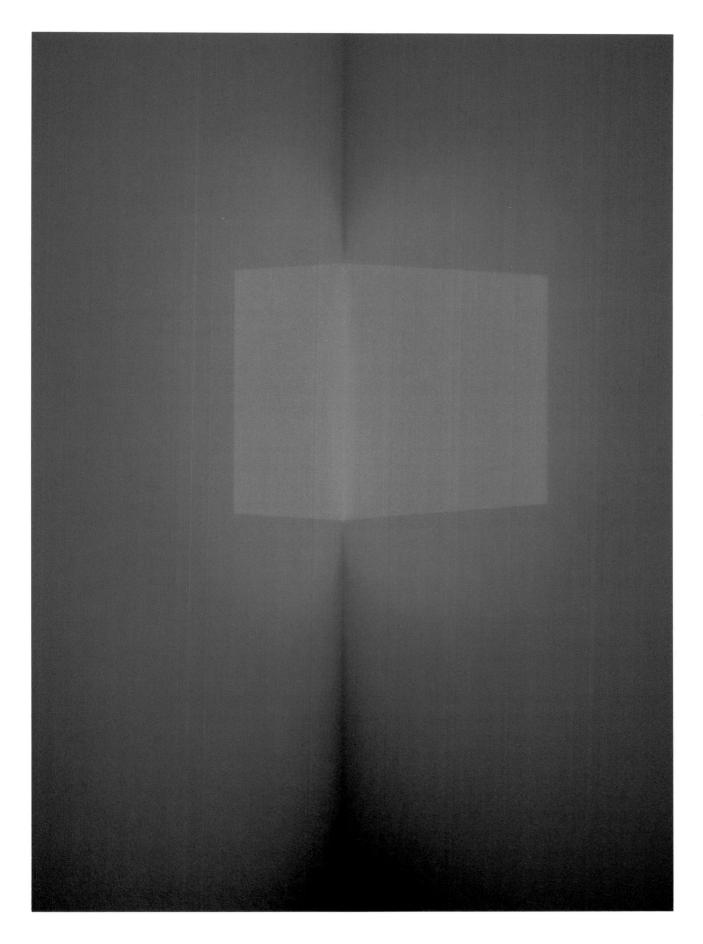

Catso, Red 1967

SINGLE WALL PROJECTIONS

Die Serie der *Projection Pieces* wurde mit Arbeiten, die meist auf eine flache Wand projiziert waren, fortgeführt. Die Intensität dieser Bildprojektionen schien die Materialität der Wandfläche aufzulösen, indem die „Bildfläche" als luzides Rechteck erstrahlte. Zuweilen war ein solches Lichtfeld als unendlich dünne Schicht wahrnehmbar, die sich um einige Zentimeter von der Wandfläche abhob. Andere Arbeiten dagegen erzeugten den Eindruck einer unbestimmten, unendlichen Raumtiefe jenseits der Wandfläche. Mit der das Bild umgebenden Wand wurde stets so verfahren, als stellte sie den traditionellen „Bildgrund" dar.

Diese einfachen, rechteckigen Bilder waren leicht vom Fußboden abgesetzt, als würden sie darauf ruhen. Entweder nahmen sie Bezug auf die gesamte Wandfläche oder sie endeten bündig in einer der Ecken. Diese Arbeiten hatten zum Ziel, die Wahrnehmung der festen Verankerung der Wände zu verändern. Stets hingen hier die qualitativen Veränderungen der Wahrnehmung architektonischer Begrenzung von der Distanz zwischen Betrachter und Bild und von dessen geradem oder schiefem Blickwinkel ab. Diese Arbeiten existierten an der unmittelbaren Grenze oder nur wenig innerhalb der Grenzen des physisch faßbaren Raumes. So veränderten sie das räumliche Bewußtsein des Betrachters, indem sie virtuelle oder imaginäre Räume entstehen ließen, die sich in der Annäherung auflösten. Es war ein Anliegen aller *Projection Pieces*, die Illusion überzeugend und flüchtig in einem zu gestalten. JT

As the *Projection Series* continued, most of the pieces were projected onto a single wall surface. The intensity of the images tended to dematerialize the wall so that it was perceived as a luminous rectangle. In some instances, this rectangle of light was seen as a non-dimensionally thin sheet of light that existed several inches in front of the wall surface, in other cases the image appeared as if you were looking into an indeterminate space that went through the wall. Each of these pieces dealt with the entire wall surrounding the image in such a way that the wall itself tended to function as the traditional "painting support".

These simple rectilinear images were usually placed slightly above floor level, resting on the floor level, crisply abutting the angle of an adjoining wall, or in combinations of these junctures. These pieces tended to modify the perception of the fixed position of the walls. In each piece the qualities of change in the physical limits of the gallery depended on your distance from the image and whether you looked at it straight on or from the side. All of these pieces existed at the limits or very slightly inside the limits of the physical space. They affected the viewer's awareness of the space and tended to create a hypothetical or imaginary space within the gallery that could be dissolved on approaching the image. In all the *Projection Pieces,* it was important that the quality of illusion be both convincing and dissoluble. JT

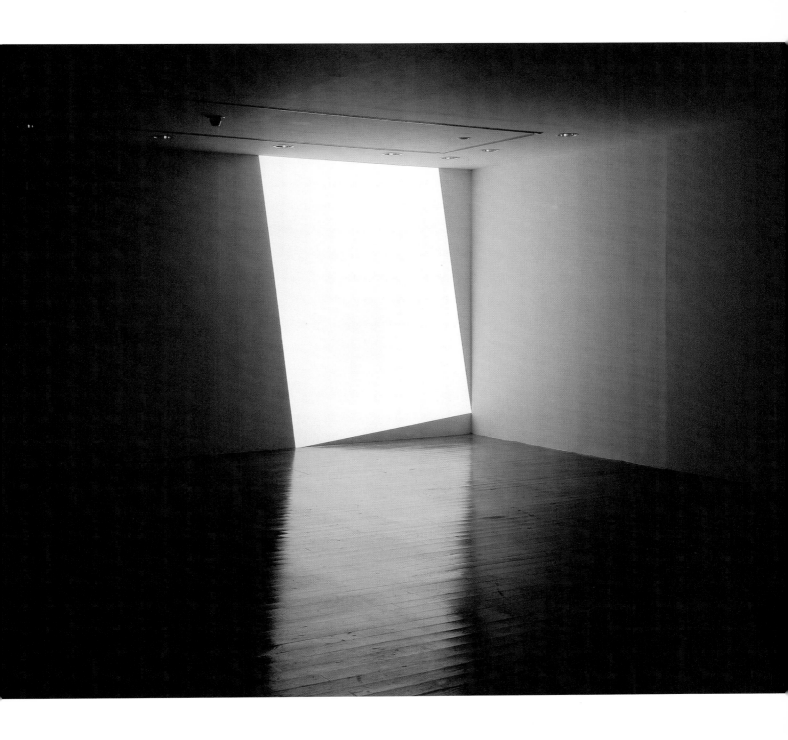

Decker 1967

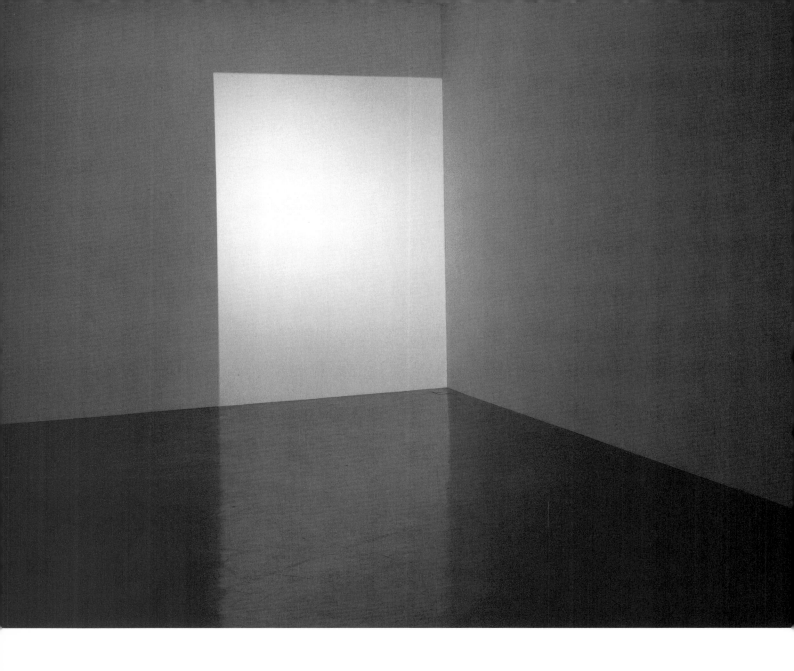

Fargo 1967

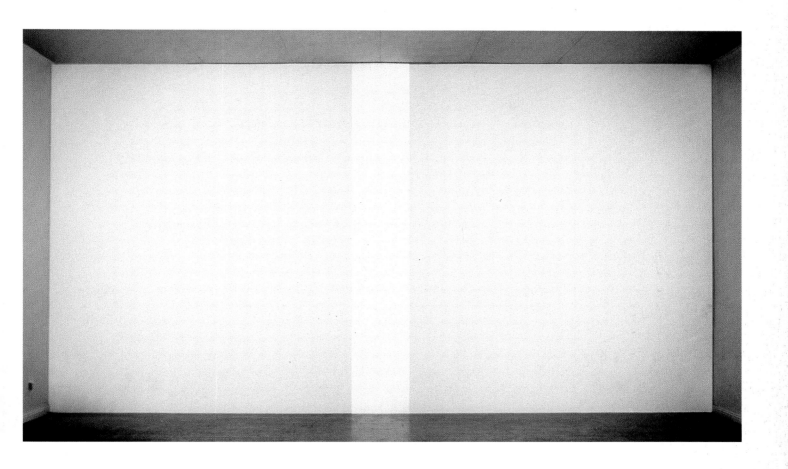

Amba 1968

Projection Pieces

FIRST LIGHT *1989 – 90* STILL LIGHT *1990 – 91*

Die Serie von Aquatinta-Drucken mit dem Titel *First Light* entstand 1989–90. Es war meine dritte Arbeit im Tiefdruckverfahren, nach *Deep Sky*, 1984 und *Mapping Spaces*, 1987. *First Light* beruht auf der ersten, 1967 begonnenen Serie der *Projection Pieces*. Jeder Titel der Reihe bezieht sich auf eine bestimmte Projektionsarbeit, obwohl nur einige tatsächlich realisiert wurden. *First Light* gibt die hellen Lichtformen wieder, die auf die Wandebene treffen. Die nächste Serie, *Still Light* von 1990–91, nimmt dies auf und untersucht die Wirkung des Lichtes auf den Gesamtraum. Im Gegensatz zu den scharfen Konturen der *First Light*-Serie geben die Drucke der *Still Light*-Serie die verschwommene, atmosphärische Wirkung der Abbildung wieder. Mit Hilfe des Druckers Peter Kneubühler gelang es mir, die Aquatintatechnik als die reinste und lichtempfindlichste Form der Radierung einzusetzen, eine Technik, die nicht auf Linien festgelegt ist, sondern statt dessen die subtilen, übergreifenden Farbtoneffekte ermöglicht, die für die Lichtarbeiten typisch sind. JT

In 1989–90, the *First Light* series of aquatint prints were produced. This was my third use of the intaglio process, following earlier suites, *Deep Sky* from 1984 and *Mapping Spaces* from 1987. *First Light* has as its subject the first body of light works, the *Projection Pieces*, begun in 1967. Each title within the series refers to a unique projection possibility, although only a few of these light spaces were actually realized. *First Light* reproduces the bright form of light as it contacts the wall plane. The next series, *Still Light* from 1990–91, continues this examination of the effect of the light projections by revealing the quality of light released into the space of the room. In contrast to the sharp definition of the *First Light* series, the *Still Light* prints evoke the misty atmospheric effect of the projection. With the help of printer Peter Kneubühler, the aquatint technique was used as the purest, most light-catching form of etching, one which could dispense with line, and instead allow for the subtle all-over tonal effects present in the light works. JT

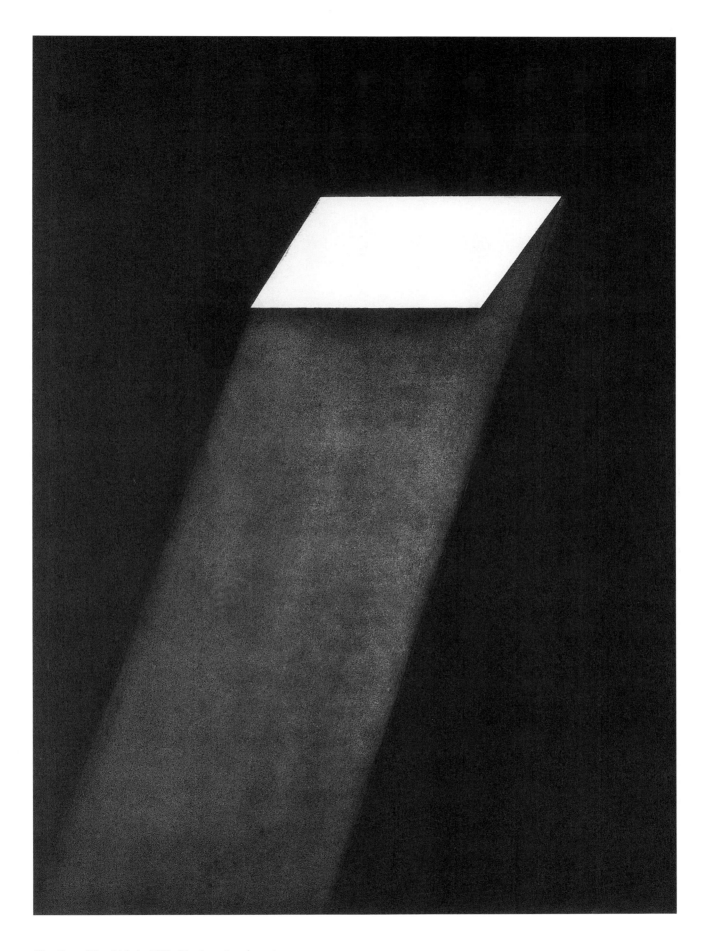

Meeting (First Light) 1989–90 Aquatinta / aquatint

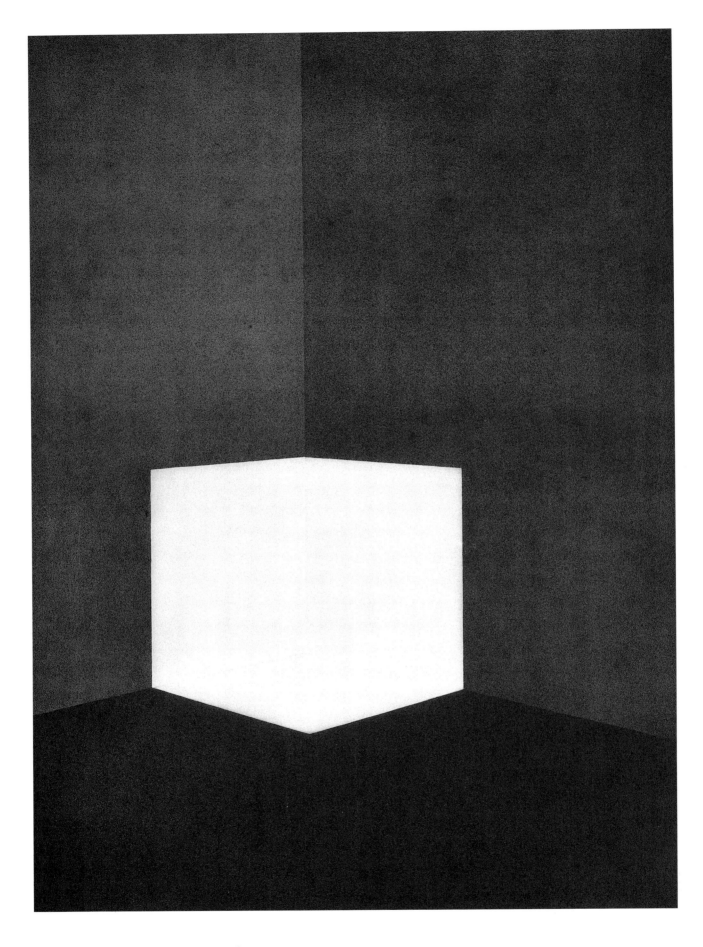

Squat (First Light) 1989–90 Aquatinta / aquatint

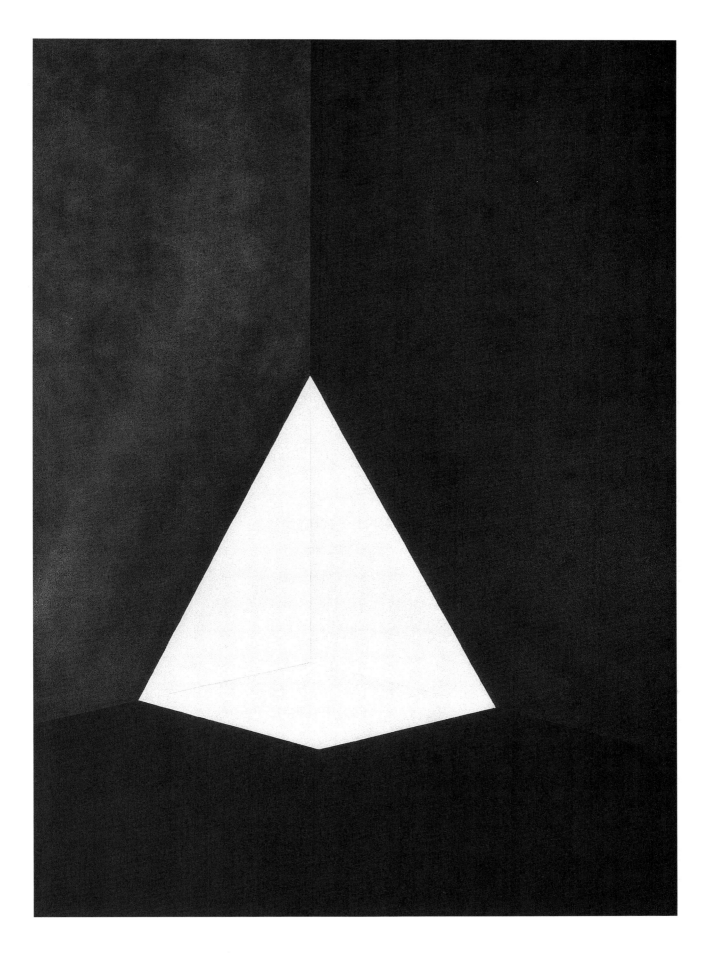

Alta (First Light) 1989–90 Aquatinta / aquatint

SHALLOW SPACE CONSTRUCTIONS

1968 – present

Die *Shallow Space Constructions* der Jahre 1968 und 1969 waren eine Weiterentwicklung der *Single Wall Projections*. Nun wurde vermehrt der architektonische Raum, in dem sich der Betrachter aufhält, berücksichtigt. In formaler Hinsicht knüpften die ersten Arbeiten dieser Serie unmittelbar an die *Projection Pieces* an, mit dem Unterschied, daß nun kein hypothetischer Raum sondern Realraum geschaffen wurde (z. B. ist *Ronin*, 1968 eine Weiterentwicklung von *Tollyn*, 1967 und *Raemar*, 1968 enstand aus einer Arbeit gleichen Namens). Zu diesem Zweck wurde im Raum, in variablen Abständen zur Stirnwand, eine Trennwand eingezogen, in der Öffnungen ausgespart blieben. Der abgegrenzte Hohlraum war mit Fluoreszenz-Licht ausgeleuchtet, das die Öffnung ausfüllte. Das „Bild" in der Wandöffnung wurde stets als flach wahrgenommen. Es erschien zweidimensional auf die Front der Trennwand angebracht und vermittelte ein Gefühl von Begrenzung. In *Ronin* zum Beispiel, wo die Öffnung des Hohlraumes formal der Projektion von *Tollyn* entsprach, berührte die schräg eingezogene Trennwand an ihrem einen Ende Ecke, Fußboden und Decke und endete vor der gegenüberliegenden Seitenwand, ohne daran anzustoßen. Dadurch blieb hinter der vertikalen Spalte ein lichtgefüllter Hohlraum ausgespart.

In anderen Arbeiten dieser Serie fließt das Licht über mehrere Kanten hinter der Trennwand hervor, was ein visuelles Schweben oder eine Neigung dieser Wand nach vorne oder hinten hin bewirkt. Es gab auch Räume, in denen mehr als eine Wand aktiviert wurde. Einige Werke arbeiteten sogar mit allen vier Seitenwänden, andere wiederum mit Boden und Decke. Wie in den *Projection Pieces* spielen sie mit der Veränderung der räumlichen Wahrnehmung des Betrachters, kehren nun allerdings die Illusion um. In den *Shallow Space Constructions* wirkt der reale, lichterfüllte Raum flach, scheint er trotz Dreidimensionalität zweidimensional. Der wahrnehmungsmäßig veränderte Raum ist jener außerhalb des belichteten Hohlraumes. Durch die Verfremdung räumlicher Grenzen, mittels der raumfüllenden Strahlkraft des Reflexionslichtes, wird der in der Illusion erzeugte, hypothetische Raum ident mit dem vom Betrachter betretenen Realraum. JT

The *Shallow Space Constructions* of 1968 and 1969, developed out of the *Single Wall Projections* but dealt to a greater extent with the architecture of the space occupied by the viewer. The first of these works related directly in form to the *Projection Pieces*, except that the space dealt with was not hypothetical but actual (for example *Ronin,* 1968 derived from *Tollyn,* 1967 and *Raemar,* 1968 related to a projection with the same titel). This was done by constructing a partition wall at various distances in front of an end wall of a room, with cuts through the constructed wall. Fluorescent light behind these partitions flooded the opening behind the partition wall. In many ways, the actual space looked flat from a distance, alluding to two dimensions with a sense of closure at the plane of the front of the partition wall. In *Ronin,* the shallow space equivalent of the projection *Tollyn,* the constructed wall abutted the existing wall, floor and ceiling at one end of the room with the exception of one wall, thereby creating an actual vertical space filled by light.

In other pieces of this series, light emanated from behind the partition on more than one side, seeming to visually cause the partition to float, or turn inward or outward. Rooms were made in which more than one wall of the space was activated. In some pieces, all four vertical walls were altered, and in others, the floor and the ceiling. Like the *Projection Pieces,* the *Shallow Space Constructions* play with the viewer's perception of space, but they reverse the illusion that occurred in the *Projection Series*: in the *Shallow Space Constructions,* the lighted actual space in three dimensions alludes to two, and the space activated is the space outside that which is directly lighted. The dimensionality of the physical limits of the space and the glow of the reflected light that permeates the entire room make the illusionistically worked, hypothetical space one with the room space. JT

Abb.: Seite / page 74, 75

My Brother's Window 1991 (geschlossen und geöffnet / closed and opened)

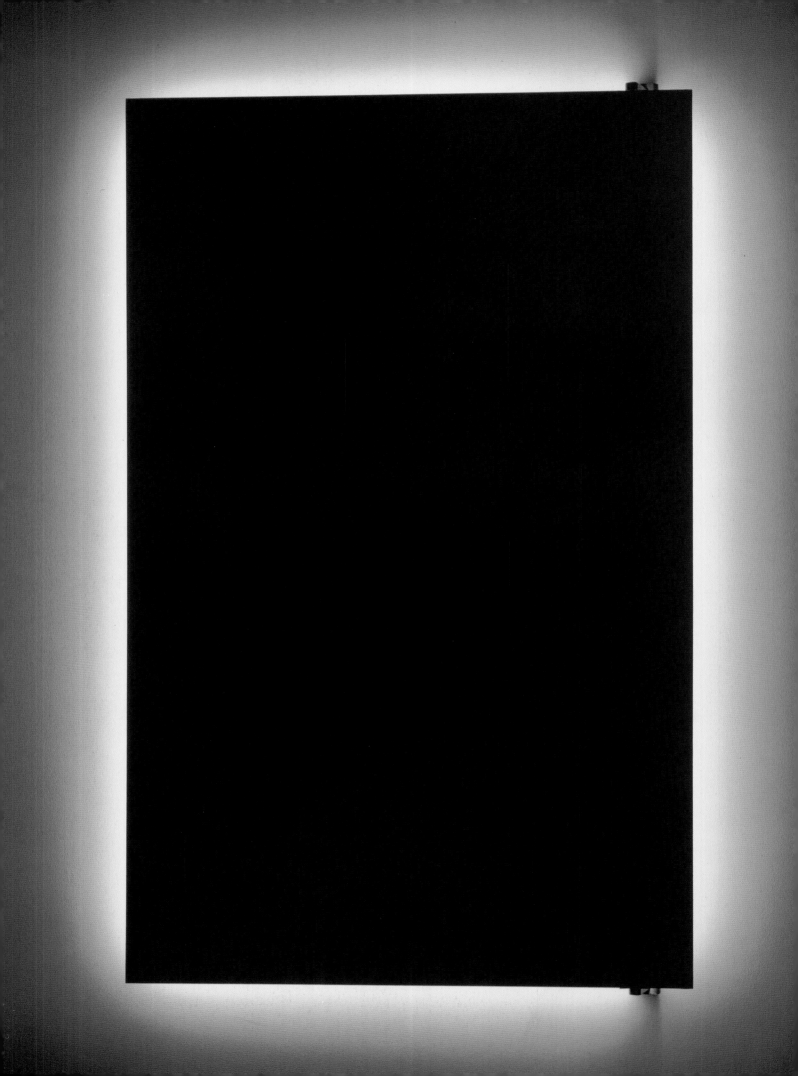

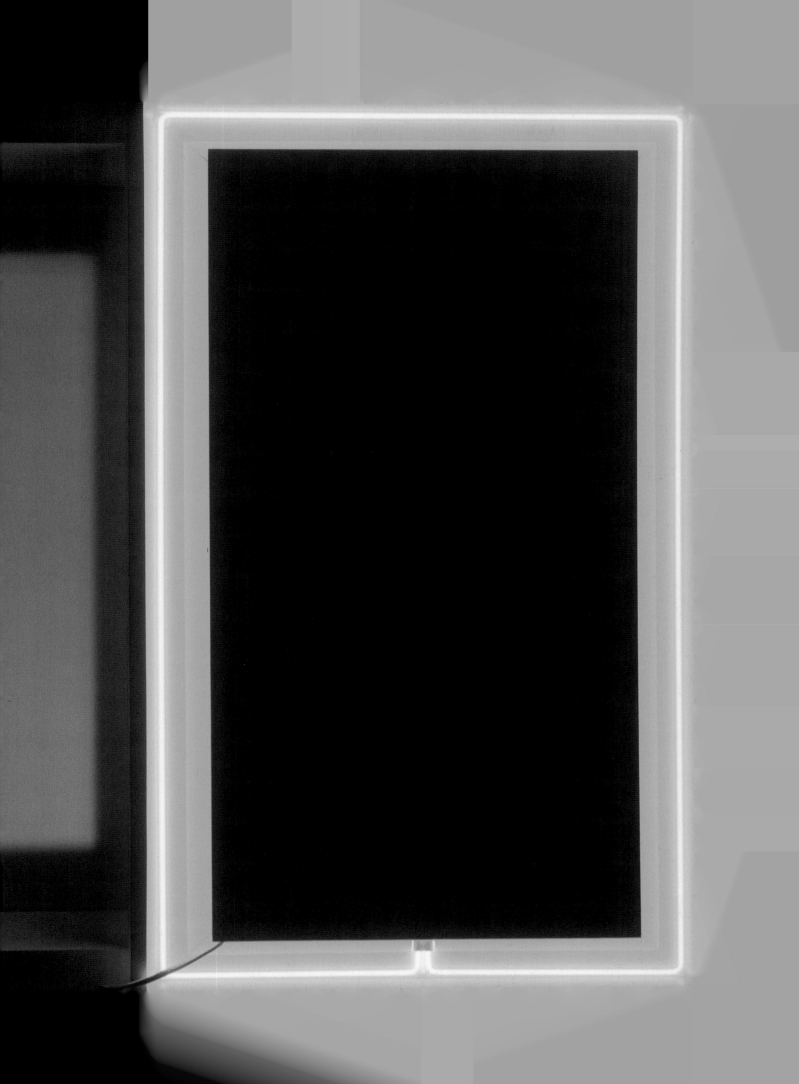

WEDGEWORK SERIES

1969–present

Die Werke der *Wedgework Series* gehen im wesentlichen aus weiteren räumlichen Umformungen der *Shallow Space Constructions* hervor. Mit der Verschiebung der Trennwand in den Raum hinein und ihrer gleichzeitigen Verkürzung setzen diese Arbeiten ein. Durch die keilförmige Anordnung der Trennwand und der im dazu entsprechenden Winkel an ihrem anderen Ende angebrachten fluoreszenten Lichtquelle, ließ das so gebündelte vorstrahlende Licht eine transparente Lichtwand entstehen. Sie erstreckte sich diagonal von der Kante zur gegenüberliegenden Seitenwand. Das erste Werk dieser Serie war *Lodi* (1969) und ließ sich direkt aus den Arbeiten *Joecar* und *Tollyn* von den *Projection Pieces* herleiten. Daraufhin entstand *Hallwedge*, ein Werk, das erstmals im keilförmigen Raum unterhalb der Treppe installiert wurde, die im *Mendota* ins Erdgeschoß führte. Ein ähnliches Werk wurde 1976 in einem Flur des Stedelijk Museum in Amsterdam eingerichtet. Weitere Arbeiten dieser Serie, die Sequenz von *Wedgework I, II, III* und *IV* ergaben sich aus der kontinuierlichen Verkürzung der Trennwand, die gleichzeitig zusehends zur Raummitte hin verschoben wurde. In *Wedgework IV* (1974) teilte die Trennwand den Raum in gleich große Hälften, so daß die Lichtwand den Raum in seiner Diagonalen durchschnitt. Diese Lichtwand wird als durchlässiger Film mit gläserner Oberfläche wahrgenommen, durch den der Blick in einen weiß-schimmernden Raum dringt. Von der Beschaffenheit der Lichtmischung hinter der Trennwand abhängend, weist die weißliche Lichtwand von ihren Kanten her mehrere Farbstufungen auf. Die Farben scheinen über ihrer Oberfläche in den Raum hinaus zu verströmen, erfüllen somit nicht den Raum dahinter. In der Mischung aller Lichttöne erscheint dieser weiß. In den späteren Versionen der *Spectral Wedgeworks* (*Milk Run II*, 1997) wurden verschiedene Farben gleichzeitig verwendet, so daß die Betrachterperspektive in Bezug zur Arbeit auf verschiedene Weisen manipuliert wird. JT

The *Wedgework Series* is essentially a result of spatial manipulations of the *Shallow Space Constructions*. By moving the constructed partition wall further into the room and shortening it, the *Wedgework* series began. Angling the non-abutted edge of the partition wall and positioning the fluorescent source at the angle, the image of the light that shone from one side of the partition created a transparent light screen that stretched diagonally from the edge of the partition to the point where the image edge lay along the side wall. The first piece in this series was *Lodi* (1969), which related directly to *Joecar* and *Tollyn* of the *Projection Pieces*. The next was called *Hallwedge*, first made in a space cut away from under the stairs leading to the basement of the *Mendota*. A piece similar to this was realized in a hallway at the Stedelijk Museum in Amsterdam in 1976. Further pieces, the sequences of *Wedgework I, II, III* and *IV*, were created by shortening the partition and moving it toward the center of the room. In *Wedgework IV* (1974) the partition was positioned equidistantly between the two end walls, and the light screen diagonally bisected the remaining half of the room. This screen was perceived as a transparent, filmy, glassy surface through which one looked into a space that appeared white. The sheet of white itself revealed various color differentiations from its edges inward, depending on the mix of the light behind the partition wall. The colors seemed to ride on the surface, out in space and not in the space behind; where the mix of color itself created the apparent whiteness. In the later versions of the *Spectral Wedgeworks* (*Milk Run II*, 1997) numerous colors are used in coordination so that the perspective of the viewer to the space is altered in several different ways.

JT

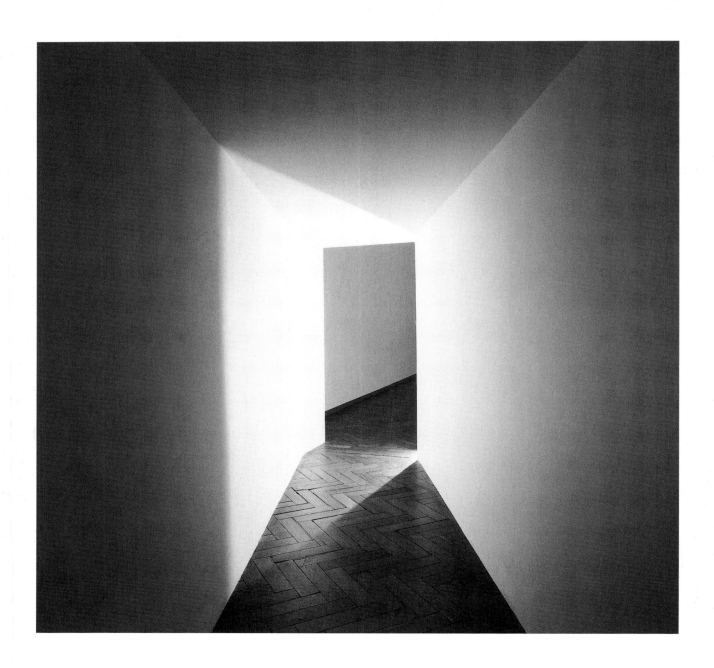

Hallwedge 1969

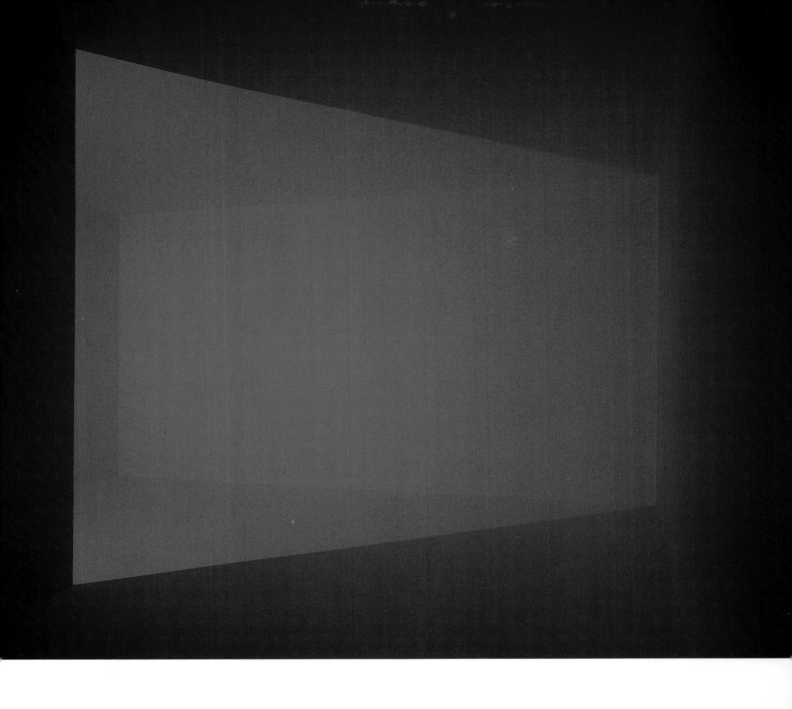

Wedgework IV 1974

Abb.: Seite / page 80, 81

Milk Run II 1997 (Spectral Wedgework)

Wedgework Series

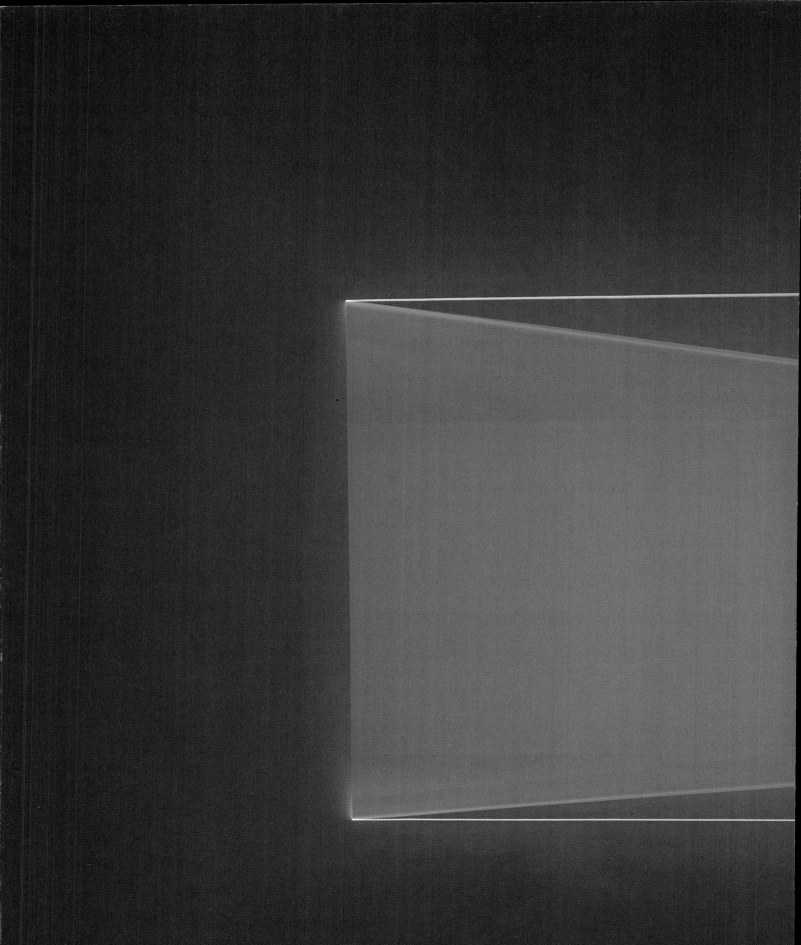

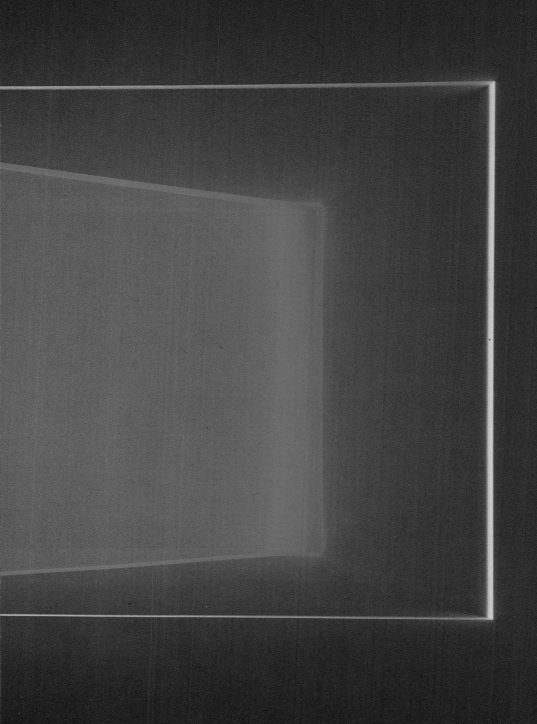

LEFT TO RIGHT

TRANSLUCENT TO TRANSPARENT

WEDGEWORK IV, 1974 FOR THE HAYWARD

RED FROM LEFT, WHITENS WITH BLUE, BLUE
LINE IN CORNER. SCREEN DISSOLVE LEFT
TO RIGHT, GOES TO TRANSPARENT.

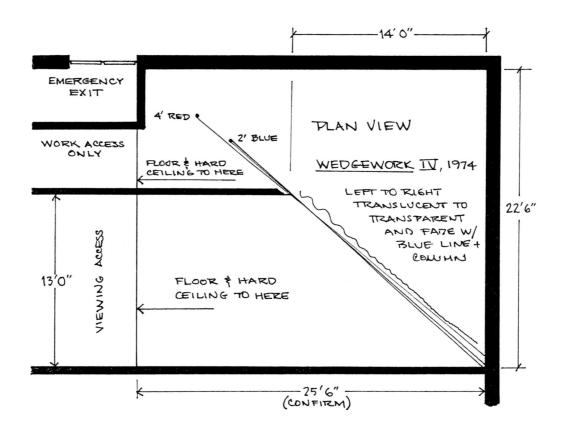

EMERGENCY
EXIT

WORK ACCESS
ONLY

4' RED

2' BLUE

FLOOR & HARD
CEILING TO HERE

PLAN VIEW

WEDGEWORK IV, 1974

LEFT TO RIGHT
TRANSLUCENT TO
TRANSPARENT
AND FADE W/
BLUE LINE +
COLUMN

VIEWING ACCESS

13'0"

FLOOR & HARD
CEILING TO HERE

14' 0"

22' 6"

25' 6"
(CONFIRM)

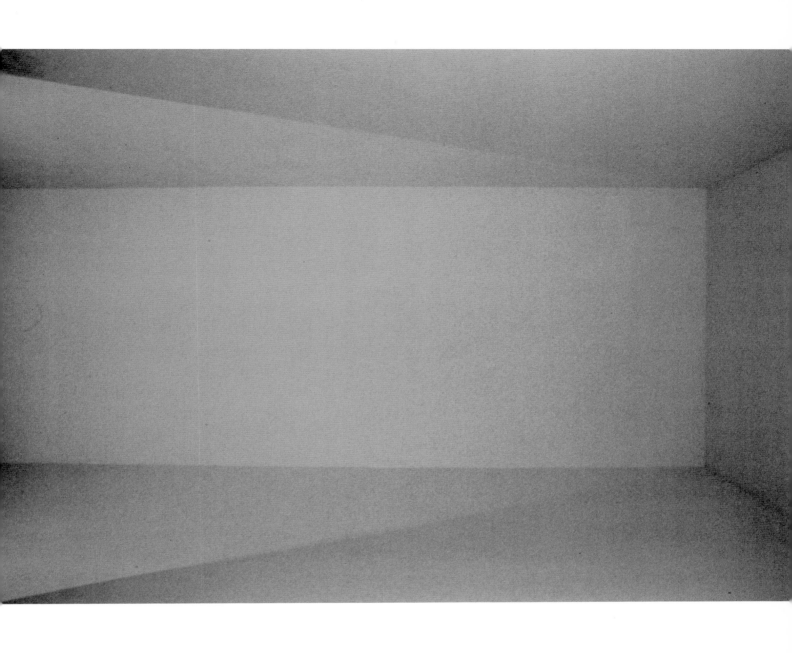

Wedgework III 1969

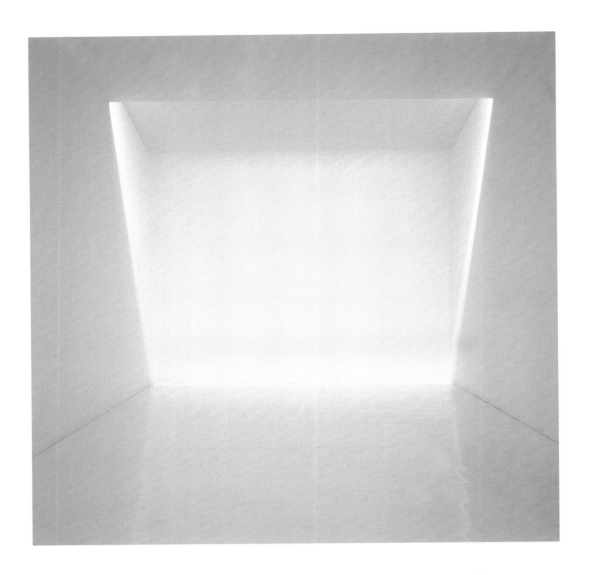

VEILS

Als eine Variante der Raumteilung durch künstliches Licht entwarf Turrell sogenannte *Veils*, von denen lediglich *Virga* 1974 für den italienischen Sammler Giuseppe Panza di Biumo realisiert wurde. Hierbei brachte Turrell fluoreszente Röhren hinter einer Deckenöffnung an und bezog darüber hinaus durch schräge Oberlichter Tageslicht in die Installation mit ein. Auf diese Weise entstand der Effekt eines diagonal in den Raum einfallenden transparenten Licht-Schleiers, der die Wahrnehmung des Raumes veränderte und ihn als ein verschobenes Rechteck erscheinen ließ.

As a variation on spatial division by means of artificial light Turrell created so-called *Veils,* though the only one that was actually realised was his Virga design of 1974 for the Italian collector Giuseppe Panza di Biumo. Turrell installed fluorescent tubes behind an aperture in the ceiling, while at the same time incorporating daylight cast through diagonal skylights. This created the effect of a transparent veil of light cast diagonally into the room, thus changing one's perception of it, so that it seemed like a rhomboid.

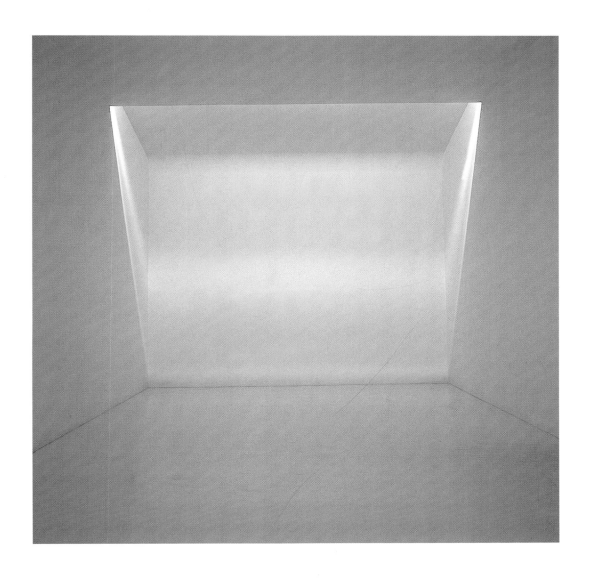

Virga 1974

Wedgework Series

THE MENDOTA

1969–74

MENDOTA STOPPAGES

Ende 1968, Anfang 1969 begann eine Arbeit, die sich die gesamte Dimensionalität des vom Betrachter besetzten Raumes und die Beziehung dieses Raumes zur Umgebung zunutze machte. Das Ocean Park Atelier wurde völlig verdunkelt, so daß kein Außenlicht hineindrang, und alle Decken- und Wandflächen speziell für die Arbeiten hergerichtet, die 1967 in der Ausstellung in Pasadena gezeigt wurden.[1] Dieser Raum eignete sich zwar hervorragend für die *Projection Pieces* und *Space Constructions*, es fehlte jedoch die Frische, die eine Öffnung zur Außenwelt mit sich bringt.

Farbe wurde von den Flächen der großen Fenster entfernt und Wände wurden herausgebrochen, um das Atelier zur Straßenkreuzung Main Street und Hill Street hin zu öffnen. Dies hatte zur Folge, daß tagsüber große Bereiche des Ateliers mit Sonnenlicht durchflutet waren. Nachts drang Licht aus den unterschiedlichsten Quellen des städtischen Umraumes in das Studio. Das einfallende Licht hatte gleichzeitig etwas Unheimliches und Kraftvolles, seine Beziehung zum Raum des Ateliers wies weder Form auf, noch ergab sie einen Sinn. Allein die Präsenz des Lichts und seine direkte Abhängigkeit von Dingen, die in der Umgebung vorgingen, waren jedoch höchst interessant. Durch die Veränderung der auf den Außenraum verweisenden Öffnungen und Umrisse des Ateliers wurde ein innerer Raum geschaffen, der durch seine Beziehung zum Licht des umgebenden Raumes definiert wurde.

Dieser Versuch, Licht aus einem umgebenden Raum einzubeziehen, brachte eine Arbeit mit dem Titel *Mendota Stoppages* hervor, die einen Tages- und einen Nachtaspekt hatte. Die Innenräume wurden durch Geschehnisse bestimmt, die in dem Raum, der das Atelier umgab, stattfanden. Sie waren abhängig davon, wie das Licht durch diverse Öffnungs- und Schließvorrichtungen einfiel und wie die Wände, der Boden und die Decke, die das Licht aufnehmen sollten, zueinander positioniert waren. Die Tagesansicht bestand aus zwei Arbeiten, die durch Öffnungen zu dem Raum, der sich zur Straße hin erstreckte, geschaffen wurden. Eine Arbeit war für die Winterseite der Tagundnachtgleiche konzipiert, die andere für die Sommerseite. Die Nachtansicht beinhaltete zehn Abfolgen, die nicht nur durch Öffnungen zum zur Straße liegenden Raum entstanden, sondern auch durch Öffnungen in einer Tür zu einem neben dem Atelier liegenden Raum. Das Betrachten des Nachtaspektes dauerte zwei bis vier Stunden. In dieser Zeit wurden nicht nur verschiedene Öffnungen betätigt, die Teilnehmer wechselten auch mehrmals ihre Position im Raum.

1 Pasadena Art Museum, California (9. Oktober – 9. November 1967), *Projection Pieces*

Die Zeichnung *Music for the Mendota* aus den Jahren 1970–71 zeigt die Abfolge der zehn Nacht- und zwei Tagesräume für beide Seiten der Tagundnachtgleiche, wie sie 1970 existierten. Im oberen Teil der Zeichnung werden die zehn Nachträume jeweils durch eine Reihe von Rechtecken in einer der numerierten Zeilen dargestellt. Das erste Rechteck links zeigt die Position der Teilnehmer in den beiden Räumen. Das zweite beschreibt die Richtung, aus der Licht in den Raum fällt und den Bereich, den es ausfüllt. In den verbleibenden Rechtecken sind die Positionen der Abdeckungen oder Öffnungen verzeichnet, die die betreffende Arbeit der Nachtansicht charakterisieren. Die beiden Arbeiten der Tagesansicht werden mit Hilfe des Einfallswinkels der Sonne dargestellt, von der Sommersonnenwende links über die Tagundnachtgleiche bis zur Wintersonnenwende rechts. Für die Sommerseite der Tagundnachtgleiche wird eine bestimmte Öffnung zur Straßenseite hin benutzt, für die Winterseite eine andere.

Im Erscheinungsbild ähnelt die Tagesansicht der Arbeit den *Projection Pieces:* Helles Licht zeichnete sich in einfachen Formen auf Wand- und Bodenoberflächen ab. Position und Gestalt dieser abgebildeten Formen veränderten sich langsam im Lauf eines Tages oder Jahres und damit auch die Eigenschaften des inneren Raumes. Dabei war der Nachtaspekt weitaus größeren Schwankungen unterworfen als der Tagesaspekt. Bei allen zehn Stücken der Nachtansicht kamen sowohl statische als auch bewegliche Lichtquellen zum Einsatz. In den ersten Stationen kamen hauptsächlich bewegliche Lichtquellen zum Einsatz, in den späteren fast keine. Erstere wiesen außerdem größere Öffnungen zum umgebenden Raum auf und enthielten daher mehr Licht. Mit dem niedrigeren Lichtniveau der späteren Stationen nutzte man die zunehmende Gewöhnung des Auges an die Dunkelheit und erreichte dadurch eine größere Farbsubtilität. Auch die Möglichkeiten für räumliche Sinnestäuschungen vervielfachten sich. Dies führte dazu, daß die wahrgenommenen Begrenzungen des Raums in keiner Weise mit den räumlichen Ausmaßen des Ateliers übereinstimmten. Auch die Zeit, die für die Betrachtung aufgewendet werden mußte, nahm von der ersten bis zur letzten Station stetig zu, da bei schwachem Licht die auf der Netzhaut des Auges nachhallenden Bilder verschiedene visuelle Auswirkungen hatten. So wurde in den letzten beiden Stationen die Beschaffenheit des Lichts im Raum körperlich spürbar und ging nahtlos in die Räume über, die durch bloßes Schließen der Augen erzeugt wurden.

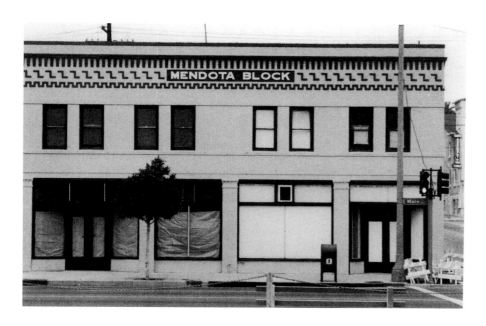

Mendota Hotel Ocean Park, California ca. 1970–72

Die *Mendota Stoppages* waren insofern wegweisend, da es sich um den ersten ortsspezifischen *Sensing Space* handelte – ein Raum, der mit einer Art inhärenten Logik oder Bewußtsein auf einen äußeren Raum reagiert, die wiederum durch seine Öffnung zum *Sensing Space* bedingt ist. Weiters wurde die visuelle Beschaffenheit solcher Räume untersucht – ihre Dichte, Feinstofflichkeit, der Ton und die Oberflächenbeschaffenheit, sowie der Punkt, wo sich der visuelle Unterschied zwischen „da draußen" und „hier drinnen" verlor. Die Auflösung der Grenze zwischen „da draußen" und „hier drinnen" war vergleichbar mit dem Eintauchen in einen Traum in wachem, bewußtem Zustand. Durch das *Mendota* entstanden Räume, in denen man in den Traum hineinsehen konnte, in denen man sich im Traum befand und hinaussah, und Räume, in denen man vollkommen im Traum versunken war. JT

In late 1968 and early 1969, a work began which used the full dimensionality of the space occupied by the viewer and its relationship to actual space outside it. The Ocean Park studio had been entirely closed off to outside light and all its ceiling floor and wall surfaces perfectly prepared for making the pieces shown in the 1967 Pasadena exhibition[1]. While this space was well suited to the *Projection Pieces* and the few wall construction pieces realized, it lacked the freshness that comes from an openness to the outside.

Areas of paint were removed from the large windows and the walls were removed to open the studio onto the surroundings, the corner of Main and Hill streets. This allowed bright areas of sunlight to enter the studio space during the day. At night, light from many sources in the urban landscape entered the space. The light that entered was both disconcerting and powerful; its relationship to the space of the studio had no form and made little sense. But the presence of the light itself, and its direct involvement with events occurring in the space outside, was intriguing. Working the openings onto the space outside, and altering the studio limits to accept the light coming through the openings, resulted in an interior space that was generated by its relation to light in the space outside of it.

This working with light from an outside space resulted in a piece entitled *Mendota Stoppages*. The piece had both a day and a night aspect. The spaces generated were made by the light events taking place in the space outside the studio, how the light from these events was allowed to enter through various opening and closing apertures, and how the walls, floor and ceiling were positioned to accept the light from these events. The day aspect of the work consisted of two pieces created by apertures opened into the space nearest the street. One piece was made for the winter side of the equinox and the other for the summer side. The night aspect consisted of ten pieces created not only by apertures opened into the space nearest the street, but also by apertures opened through a doorway into an adjoining space. The viewing of the night aspect took from two to four hours. During this time, different apertures were opened and the participants moved to various positions within the rooms.

The drawing *Music for the Mendota*, 1970–71, shows the progression of the ten night spaces and the two day spaces for either side of the equinox as they existed in 1970. Each of the night spaces is represented by a series of figures in one of ten numbered lines in the upper portion of the drawing. The first figure on the left depicts the position of the participants in the two spaces. The second figure indicates the direction from which light enters the space and the area into which it goes. The remaining group of figures depicts the positions of the stoppages or apertures which create that particular piece within the night aspect. Each of the two pieces of the day aspect is represented by the sun angles from summer extreme on the left, through equinox, to winter extreme on the right. For the summer side of equinox, one aperture in the near street space is used while another aperture is used for the winter side.

1 Pasadena Art Museum, California (9. October – 9. November, 1967), *Projection Pieces*

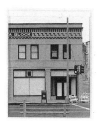

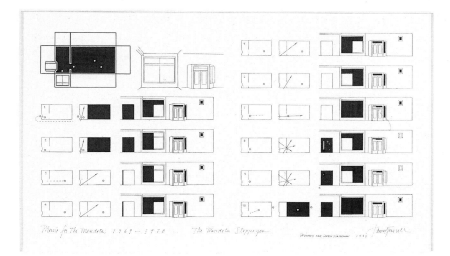

Music for the Mendota 1970–71

In appearance, the day aspect of the piece closely resembled the *Projection Pieces* in that simple forms of brilliant light were imaged on the wall and floor surfaces. The position and shape of these imaged forms slowly changed throughout the day and throughout the year. The change in shape and position of the image altered the spatial qualities of the interior space. The night aspect of the work had a greater range of variability than the day aspect. Each of the ten pieces in the night aspect used both stationary and moving sources of light. The earlier-seen pieces had a predominance of moving sources, whereas the later ones used almost none. The earlier-seen pieces also looked out onto larger amounts of outside space and thereby contained more light. The lower light levels in the later pieces used the increased adaptation of the eyes to dark, which allowed for greater color subtlety and increased the possibilities involved in spatial illusion. Due to this, the perceived confines of the space were in no way congruent with the physical confines of the room. Also, in proceeding from the first to the last night piece, time spent with each piece increased because of the many visual qualities generated by afterimage effects with prolonged viewing in low light conditions. In the last two pieces, the light quality in the space was physically felt and had a continuity with those spaces generated by merely closing your eyes.

The *Mendota Stoppages* was significant because it was the first site-specific sensing space – a space that responds to a space outside with a logic or consciousness formed by its look into that space. Also, the visual qualities within such spaces – their density, grain, tone, sense of surface, and where vision lost its distinction of being "out there" and "in here" – were explored. The dissolution of the line between the "out there" and "in here" was analogous to entering the dream in the conscious, awake state. Through the *Mendota,* the work consisted in making spaces in which you looked into the dream, spaces in which you were in the dream looking out, and spaces in which you were completely immersed in the dream.

JT

Mendota Stoppages 1969–74

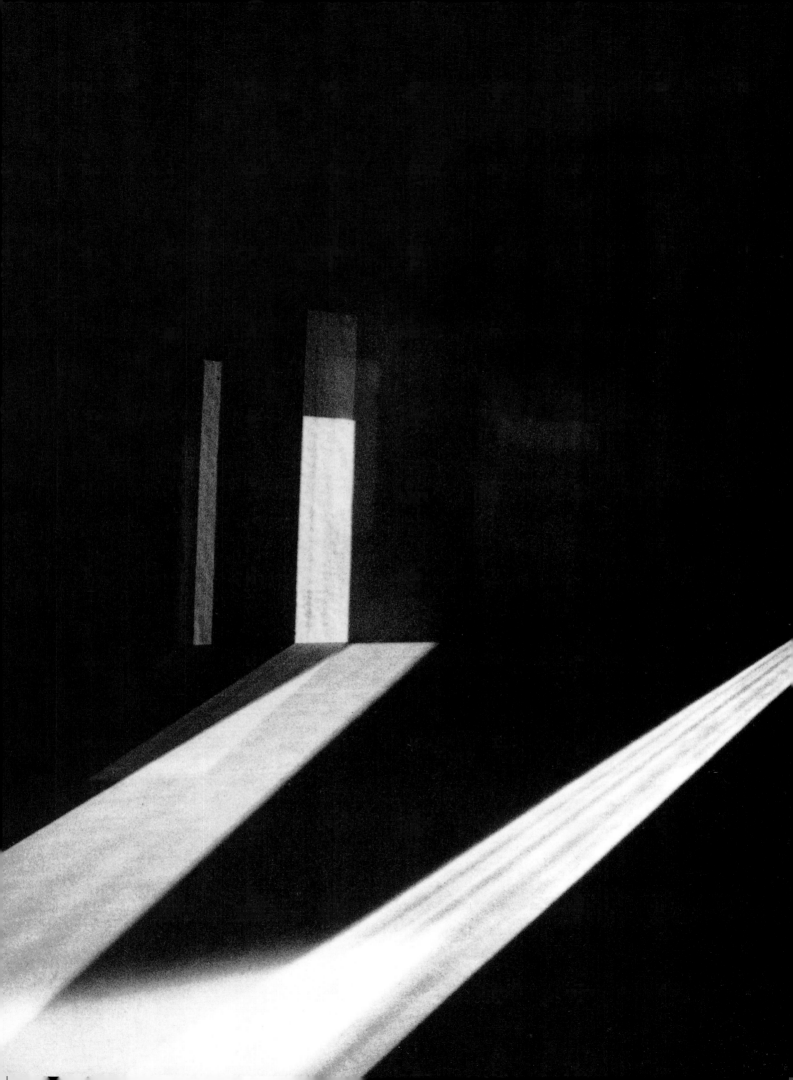

STRUCTURAL CUTS

1974–present

Mit dem Einbeziehen des Außenraumes und vor allem von Außenlicht durch das Öffnen der Innenräume bei den *Mendota Stoppages* wurde es naheliegend, anhand solcher Öffnungen die gegenseitige Durchdringung von Außen- und Innenraum zu beobachten. Zahlreiche Überlegungen zu den *Mendota Stoppages* sind in die Serie der *Structural Cuts* eingeflossen. Die Form der Öffnungen und die Art der Interaktion von Innen- und Außenraum orientierte sich allerdings eng an den Formen und Lösungen der *Projection Pieces* und *Shallow Space Constructions*. In den *Structural Cuts* sind die Öffnungen in der vertikalen Wandfläche zum Äußeren so beschaffen, daß die Schnittkanten möglichst dimensionslos erscheinen. Dadurch kommt der Außenraum in die Ebene der Wandausschnitte zu liegen. Transparenz, Farbe und Auflösung des in die Öffnungsfläche gebrachten Außenraumes werden durch die Lichtqualität des Innenraumes bestimmt, die im Verhältnis zum Licht des betrachteten Himmelsausschnittes bemessen ist. Das erste Werk dieser Art entstand im vorderen Raum des *Mendota* in Ocean Park und war ein modellhafter Prototyp für ein größeres Projekt, *Lunette* (1974), das dann in der Villa Panza in Varese (Italien) realisiert worden ist. JT

After having cut through to the space outside in the *Mendota Stoppages* to let light come through, it seemed obvious to deal with this actual space outside and its relation to the interior space when looking through the opening to the outside. The *Structural Cuts* is a series of works in which much of the thought and impetus came from the *Mendota*. However, the form of the cuts and the relationship of the actual space outside to the interior space were done in a way that related closely to the form of the *Projection Pieces* and the *Shallow Space Constructions*. In the *Structural Cuts*, openings are made in the vertical wall surface to a space beyond in such a manner that there is no thickness or dimensionality at the cut. Here, the front surface of the space outside is drawn up to the same plane as the wall that is cut. The degree of transparency of the front surface and the color and grain in the space outside depend on the light quality of the interior space in relation to the light quality of the sky space looked onto. The first of these pieces was realized in the front space of the *Mendota* in Ocean Park, and was a small model for a larger space, *Lunette* (1974), realized at Villa Panza in Varese, Italy.

JT

SKYLIGHTS

Die Serie der *Skylights* bedient sich des Lichts, das durch ein Oberlicht in einen darunterliegenden Raum einfällt. Dies ist mit dem Licht vergleichbar, das durch das Blätterdach eines Waldes rieselt und dessen Reflexionen den Waldboden erhellen. In der ersten Arbeit dieser Art, die in einem Museum entstand, *Hover* (1983, Musée d'Art Moderne de la Ville de Paris), wurde das Blau des Himmels als Kontrast zum gelb-weißen Glühlampenlicht im Innenraum gesetzt. In der Dämmerung färbte sich das Licht dunkelviolett und schien lediglich die Öffnung zu erfüllen und nicht auf den Wandflächen in Erscheinung zu treten. In *As Above* (1989, Musée d'Art Contemporain, Nîmes) wurde dieses Himmelslicht zwischen dünnen, weißen Gazestreifen mit Argon-Licht vermischt. Dies bewirkte, mit dem Wechsel des Tageslichts, eine Veränderung von Farbe und Intensität der gesamten Arbeit. JT

The *Skylight Series* deals with light through an opening into a space below. This is physically most closely analogous to the light that comes down through the leafy canopy of the forest and splashes off the forest floor underlighting the under-canopy space. In *Hover* (1983, Musée d'Art Moderne de la Ville de Paris), the first work of this series done formally in a museum setting, the blue of the sky was contrasted against the yellowish white of the interior tungsten fixtures. Towards the end of day, the light became quite deep violet and was seen to exist in the space beneath the opening, rather than on any surface. In *As Above* (1989, Musée d'Art Contemporain, Nîmes), this skylight was mixed with argon light between layers of thin white gauze tissue so that the change in daylight intensity changed the color as well as the intensity of the piece. JT

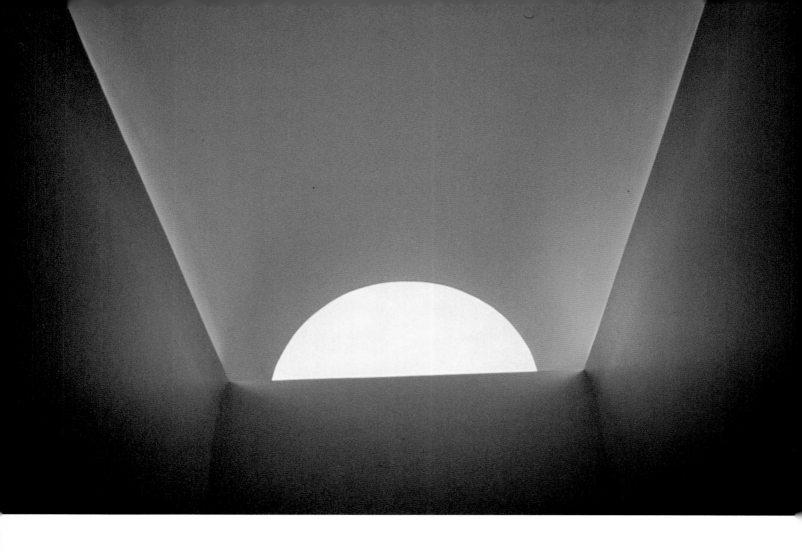

Lunette (Skywindow I) 1974

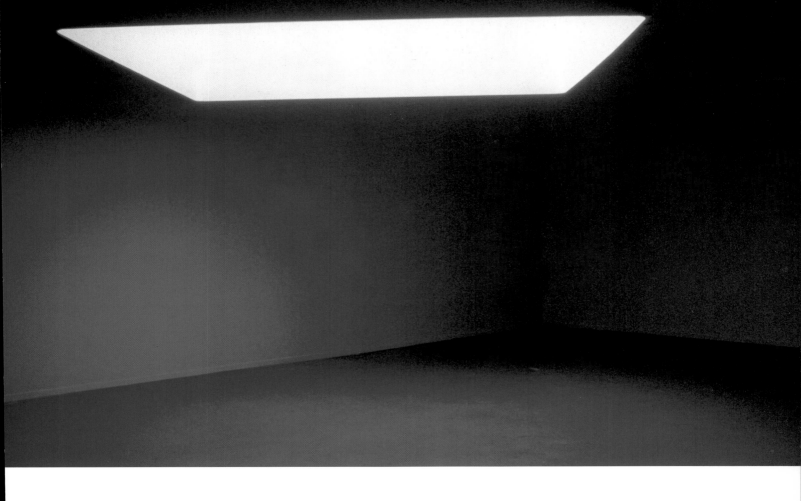

Hover 1983

Structural Cuts

SKYSPACES

1975–present

Die erste Arbeit der *Skyspaces* wurde im *Mendota Studio* in Ocean Park zuerst als Modell erarbeitet und konnte anschließend in der Villa Panza (*Skyspace I*, 1975) realisiert werden. Prinzipiell handelt es sich bei den *Skyspaces* um *Structural Cuts*, deren Öffnungen aber vollständig über der Horizontlinie liegen und die durch Decke und Dach, auch Satteldach, eingeschnitten wurden. Diese Arbeiten behandeln das Zusammentreffen von Innen- und Außenraum, indem der Himmel in die Fläche der Deckenöffnung heruntergeholt wird. Es entsteht ein Raum, der, obwohl ganz zum Himmel geöffnet, ein Gefühl von Geschlossenheit vermittelt. Es handelt sich um eine räumliche Begrenzung, die entlang der Schnittkanten als gläserner Film wahrgenommen wird, der sich über die Öffnung zu spannen scheint. Jenseits dieser transparenten Schicht, die sich je nach Bedingungen von Tageslicht und Sonneneinfall verändert, erstreckt sich eine unbestimmte Raumtiefe. Die *Skyspaces* haben einen Tag- und einen Nachtaspekt, wobei die wohl eindrucksvollste Veränderung während des Überganges von Tag zu Nacht erfahren wird. Während der Dämmerung erscheint die Öffnung als eine opak bemalte Fläche, den Blick in den Himmel verwehrend. In einigen *Skyspaces* ist das Lichtquantum bei Nacht so bemessen, daß die Wahrnehmung des Sternenhimmels verdunkelt wird. Dies ist mit nachts erleuchteten Städten vergleichbar, deren Emissionslicht die Atmosphäre erhellt und damit den Blick auf die Sterne verhüllt, oder der normalen Tageslichtsituation, die außer dem eigenen Planeten keinen anderen Stern zu erkennen gibt. Dieses Erhellen des nahen Betrachterraums bewirkt eine außerordentliche, weiche Dunkelheit innerhalb des Öffnungsfeldes. Bei anderen Versionen der *Skyspace Series* ist das Ausleuchten des Innenraumes bei Nacht geringer, was unterschiedliche Ausblicke in die Atmosphäre erlaubt. JT

First piece of the *Skyspace Series* was done in model form in the Ocean Park studio and its full-size realization at Villa Panza (*Skyspace I*, 1975). The *Skyspaces* are, basically, *Structural Cuts* that are completely above the horizon line. The openings of all *Skyspaces* cut through ceiling and roof, though the roof may be slanted. These pieces deal with the juncture of the interior space and the space outside by bringing the space of the sky down to the plane of the ceiling. They create a space that is completely open to the sky, yet seems enclosed. The sense of closure at the juncture appears to be a glassy film stretched across the opening, with an indefinable space beyond this transparency that changes with sky conditions and sun angles. The *Skyspaces* have both a day and a night aspect, and the greatest change over time is noticed at the juncture of day and night. Vision into the sky in twilight seems nearly impossible, since the opening appears as an opaquely painted surface on the ceiling. Some of the *Skyspaces* are made so that the amount of light in them at night is just enough to obscure vision of the stars. This is similar to when local city light at night illuminates the atmosphere and obscures the stars, or perhaps more closely analogous to the daytime lighting of the atmosphere which allows vision of no star save our own. The result of this lighting of the near, interior space is an extreme, soft blackness at the opening. Other versions of the *Skyspace Series* are not lit as much at night and allow varying degrees of vision through our atmosphere. JT

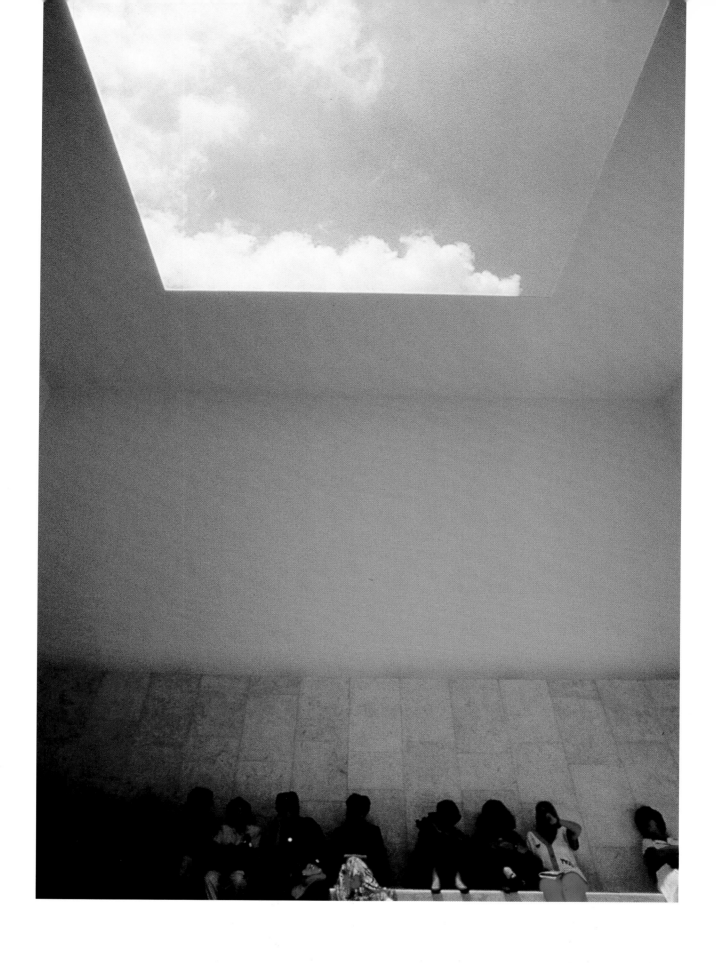

Space that Sees 1993

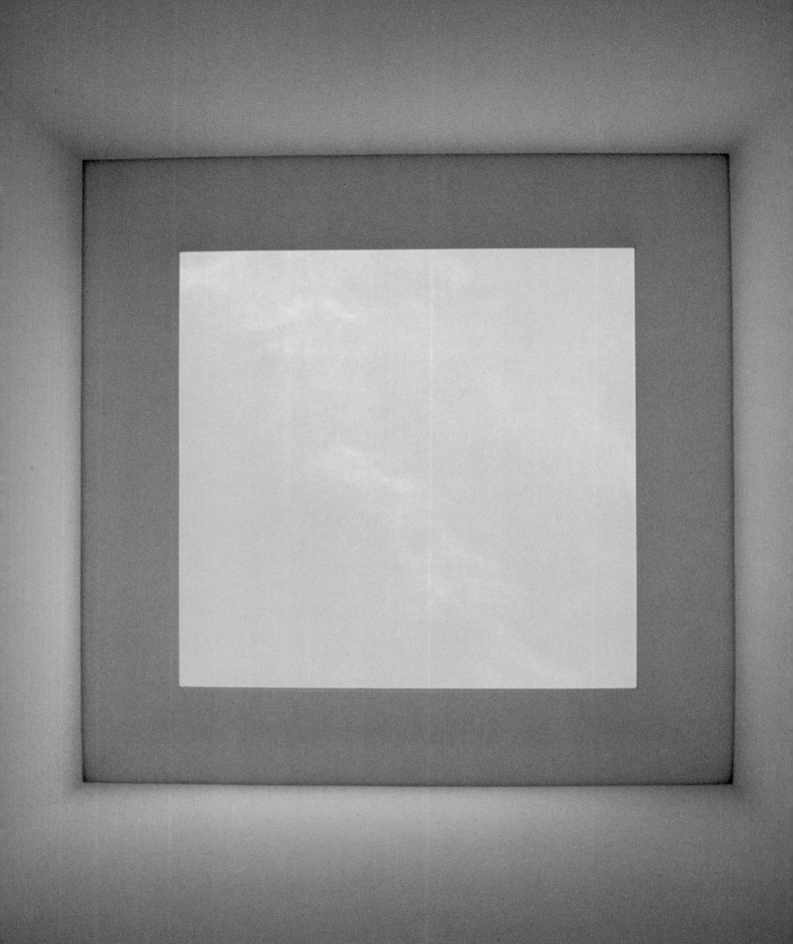

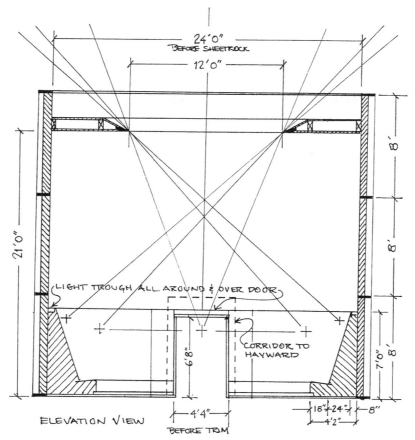

ELEVATION VIEW

BEFORE TRIM

AIR MASS, 1993 KILFANE GARDEN, Co KILKENNY, IRELAND

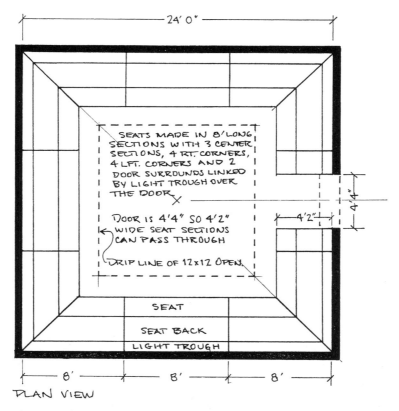

SEATS MADE IN 8' LONG
SECTIONS WITH 3 CENTER
SECTIONS, 4 RT. CORNERS,
4 LFT. CORNERS AND 2
DOOR SURROUNDS LINKED
BY LIGHT TROUGH OVER
THE DOOR

DOOR IS 4'4" SO 4'2"
WIDE SEAT SECTIONS
CAN PASS THROUGH

DRIP LINE OF 12×12 OPEN.

SEAT

SEAT BACK

LIGHT TROUGH

PLAN VIEW

AIR MASS, 1993 KILFANE GARDEN, Co KILKENNY, IRELAND

Skyspace I 1975

Abb. Seite / page 100, 101 **Air Mass** 1993

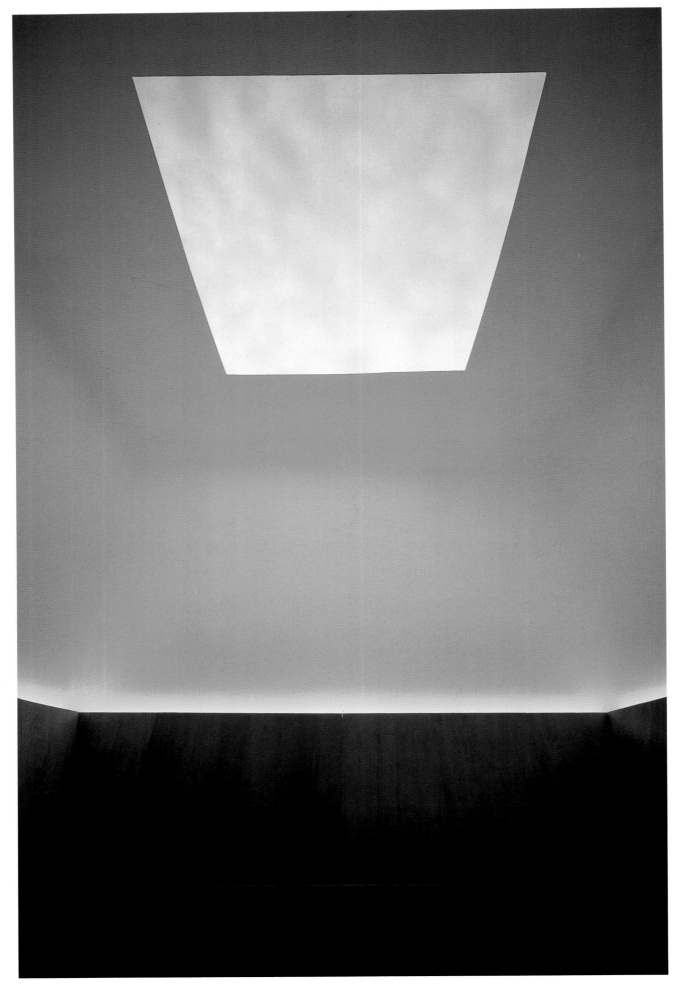

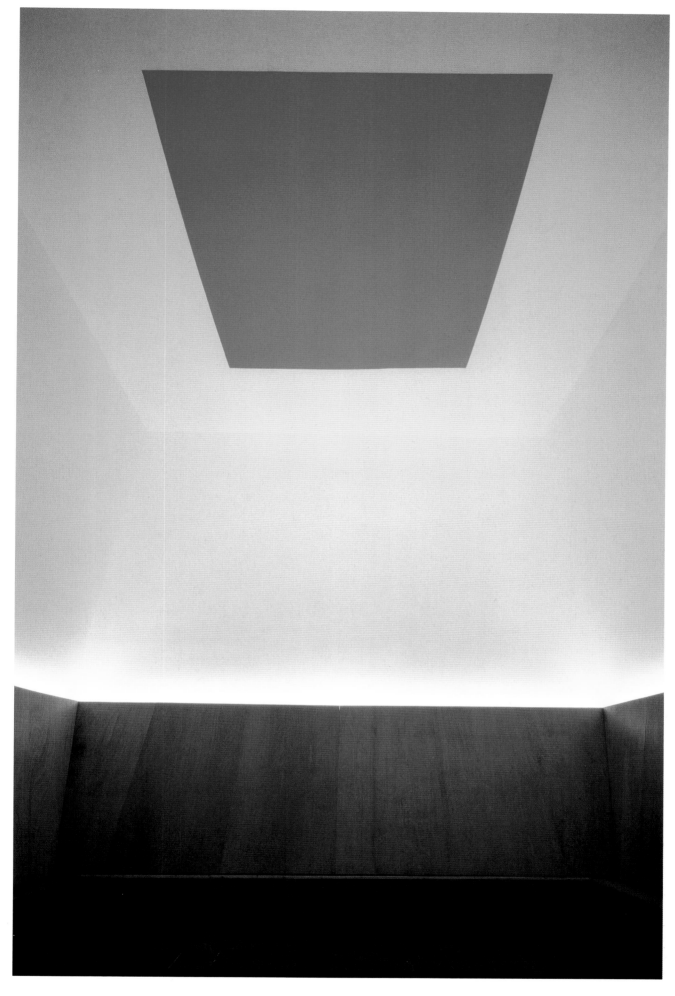

SPACE DIVISION CONSTRUCTIONS

1976–present

Die 1976 zum ersten Mal gezeigten *Space Division Constructions* entwickelten sich ebenfalls aus den Ideen, die schon in den *Mendota Stoppages* angelegt waren. Ausschlaggebend war die Erfahrung, daß nicht alle Räume nach außen hin geöffnet werden konnten. In diesen Fällen wird der eigentliche Innenraum zweigeteilt; die eine Raumhälfte wird zum *Sensing Space* (Wahrnehmungsraum), die andere zu jenem Raum, in dem man steht und aus dem man in die abgetrennte andere Hälfte hinausblickt (Betrachtungsraum). Diese Werke lassen sich insofern mit den *Wedgework Series* vergleichen, als auch hier eine Trennwand die vorgegebene Architektur unterteilt und die beiden daraus hervorgehenden, miteinander agierenden Teilräume vergleichbare Dimensionen haben. Auch zu den *Skyspaces* weisen sie eine Ähnlichkeit auf, da ebenfalls dieses Gefühl der Begrenzung der Wandfläche evoziert wird. Die *Space Division Constructions* sind jedoch durchwegs horizontal angelegt. JT

The *Space Division Constructions* first shown in 1976 also developed out of ideas in the *Mendota Stoppages*. Some of their impetus also derived from the fact that it is not possible in all cases to open up a room onto the space outside. In such a case, the room itself is then divided in two, one half to be the sensing space, the other to be the space looked out onto (viewing space). These works are similar to the *Wedgework Series* in that a partition wall is made in the room and the two resulting spaces are more equal in size. They also share a similarity with the *Skyspace Series* in their sense of closure at the plane of the wall, however, the *Space Division Constructions* are all horizontal. JT

PRADO SERIES

Die Wände des Betrachtungsraumes, der außerhalb des *Sensing Space* liegt, werden von einer Lichtquelle so ausgeleuchtet, daß kein direktes Licht in den anderen Raumteil überfließt. Im *Sensing Space* herrscht diffuses Licht, erzeugt durch die Reflexion der Wände des Betrachtungsraumes. Somit blickt der Betrachter aus der beleuchteten Raumhälfte in das „atmosphärische" Licht des *Sensing Space*. Aus der Entfernung wird das Zusammentreffen der beiden Lichträume als rechteckige Fläche wahrgenommen, die auf die Wand gemalt zu sein scheint. Die „flachen" Arbeiten dieser Serie sind mit einer großen Öffnung ausgestattet. Diese Öffnungsfront scheint aus der Distanz eine Fläche von leichtem Glanz und sehr feiner Körnung zu bilden. Nähert man sich dem *Sensing Space*, so beginnt sich die opake, dichte Oberflächenwahrnehmung langsam aufzulösen, um schließlich durchlässig zu werden und den Blick auf die dahinter liegende Raumhälfte freizugeben. Die Qualität des Lichts wirkt äußerst homogen und erscheint als ein grün-grauer bis blau-grauer Dunst. Dennoch behauptet sich der Eindruck einer transparenten Fläche und selbst wenn man auf sie zugeht, vermeint man eine gläserne, durchsichtige Haut zu durchblicken. Die Fläche scheint berührbar zu sein, als sei dahinter eine raumfüllende Atmosphäre „gestockt". Dieser Eindruck entsteht, wenn der Farbton optimal auf die Raumgröße abgestimmt ist. Dabei ist die Färbung ganz durch das Reflexionslicht des Betrachterraumes bestimmt. Der Raum des *Sensing Space* selbst ist mit reinem Titan-Weiß gestrichen, um das von außen eintretende Licht reflektierend in sich aufzunehmen. Wären die Wände dieses Raumes nicht mit Weiß, sondern mit einer Farbe gestrichen, so würde diese an den Wänden haften bleiben und sich nicht in der Atmosphäre ausbreiten können. Nur in einem weißen Raum, wo die Farbe als diffuses Licht aus einem äußeren Raum einfließt, scheint sie als körnige Fläche den Raum anzufüllen, wie dies im *Sensing Space* der Fall ist. So erfüllt das Licht den Raum.

Jedes Werk dieser Serie (begonnen mit *Laar*, 1976) handhabt die Öffnung und die Tiefe des *Sensing Space* anders. Diese sind auf die Stellung des Betrachters abgestimmt, als blicke man in einen Raum, der eigentlich in jenen Raum hineinsieht, in dem man sich selbst befindet. Dieses „Erblicken-des-Raumes-der-den-Betrachter-anblickt" hat eine tiefere Wahrnehmung der umgebenden Lichtqualitäten zur Folge. Durch das Zusammentreffen von beleuchtetem Betrachterraum und erleuchtetem Wahrnehmungsraum werden solche Lichtqualitäten im *Sensing Space* deutlicher zu Bewußtsein gebracht.

JT

The room outside the sensing space is lit by direct light on the walls, in such a way that no direct light enters the sensing space. The light in the *sensing space* is ambient light that comes totally from light reflected off the walls in the room outside. You are then viewing the piece from a space that is directly lit, looking into a space filled with ambient light. From a distance, the junction between the two spaces is seen only as surface and resembles a rectangle painted on the wall. The shallower pieces in the series are more open and, from a distance, this front surface seems to have a slight sheen and a very tight grain. Advancing toward the *sensing space*, the opaque surface will slowly yield, become transparent and open out to reveal another space. The quality of light in this other room is very homogeneous and appears as a green-gray to blue-gray mist. However, the transparent surface holds in its strength, so that even on approach there seems to be a glassy, transparent skin that is looked through. The surface seems physically tangible, and the space has a quality of having "gelled up". This occurs when the color tone is most appropriate for the spatial sizing. The tone of the light comes totally from the space outside of it, and the sensing space itself is painted a pure titanium white. This is done to make the space totally reflective of the light tone which enters it. The space must be painted white, for if the walls are painted any color, the color would seem to ride on the walls and not in the air. However, if the space is painted white, and the color arrives as ambient light from the space outside, then the color will seem to ride on the grain seen in the sensing space. That is, the light will inhabit the space.

Each piece in the series (started with *Laar*, 1976) has a different depth and size of opening, and the spaces are plumbed differently, according to the position of the viewer outside the *sensing space*. This is like looking into a space that is actually looking into the space you are in. The quality of looking-at-the-space-looking-at-you results in an understanding of the aspects of the light qualities that surround you. These aspects are more clearly objectified in the sensing space, by virtue of the contrast of the directly lit space you are in and the ambient space you are looking into being heightened at the juncture between the two. JT

CLOTH CEILING

DETAIL #1

THE "YIELD"

3'0"

6'0"

12'3"

EYE LEVEL

B T
 S

3'3"

FLOOR

EXISTING WALL – HAYWARD

13'4" INSIDE

10'0"

6'3"

3'3"

9'6"

ELEVATION VIEW

TRACE ELEMENTS FOR THE HAYWARD

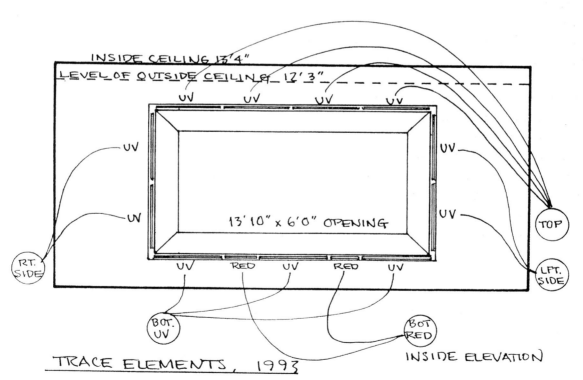

INSIDE CEILING 13'4"

LEVEL OF OUTSIDE CEILING 12'3"

UV UV UV UV

UV UV TOP

UV 13'10" x 6'0" OPENING UV LFT. SIDE

RT. SIDE

UV RED UV RED UV

BOT. UV BOT RED

INSIDE ELEVATION

TRACE ELEMENTS, 1993

LIGHTING AND DIMMER ARRANGEMENT SEEN FROM
INSIDE THE PIECE.

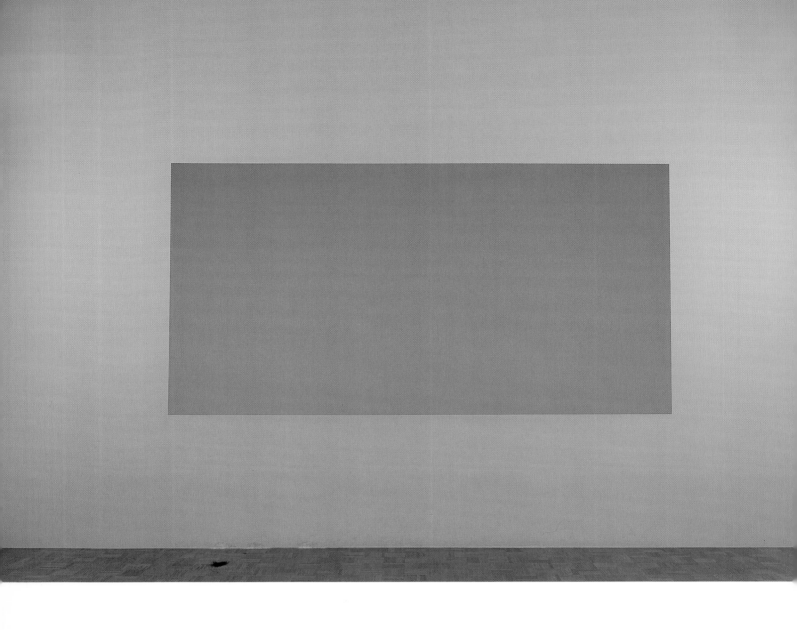

Acton 1976

Space Division Constructions

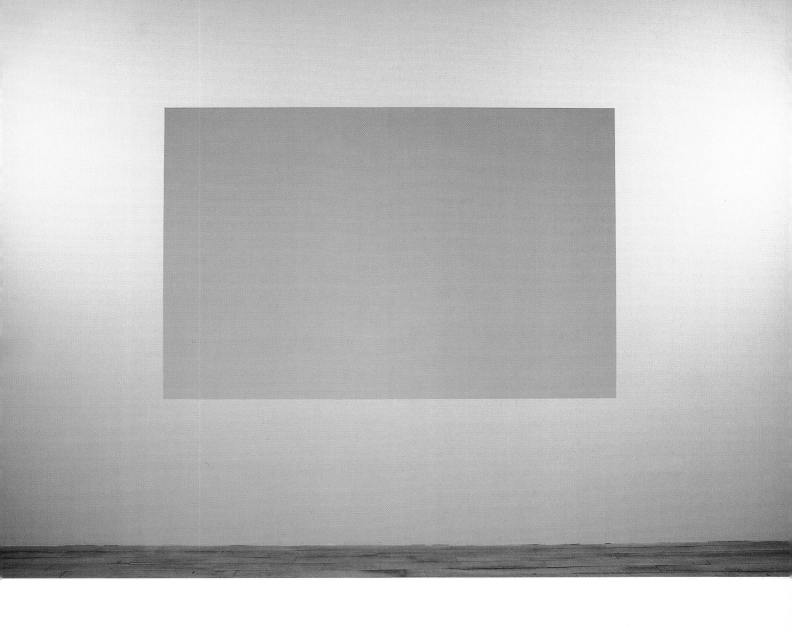

First Light 1990

Space Division Constructions

PHAEDO SERIES

Phaedo war die erste Arbeit dieser Serie und wurde 1980 in der Leo Castelli Gallery in New York ausgeführt. Diese Arbeiten gleichen in Form und Wahrnehmungserfahrung den *Prado Series*, nur daß hier eine geringe Menge Außenlicht in den *Sensing Space* eingelassen wird. Dieses atmosphärische Licht tritt durch ein Oberlicht (wie in der Castelli Gallery) oder durch ein Seitenfenster ein und wird durch einen kleinen Schlitz in unmittelbarer Nähe der Öffnung in den *Sensing Space* geführt. Das natürliche Licht bewirkt subtile Veränderungen der Lichtintensität und Farbe, entsprechend den wechselnden Lichtverhältnissen im Freien, die im Innern „gesehen" werden. Die extremste Veränderung unterliegt der Wende von Tag zu Nacht, wobei sich die Nachtsituation nicht von einer Arbeit der *Prado Series* unterscheiden läßt. Die Tagessituation dagegen gibt Veränderungen der Lichtintensität wieder, gemessen am Tages- und Jahresverlauf. Die Farben ändern sich dann je nach Wetter, Sonnenaufgang oder Sonnenuntergang. JT

The first piece in this series, *Phaedo,* was done at the Leo Castelli Gallery, New York in 1980. These pieces are similar in form and visual experience to the *Prado Series* except that a small amount of light from an outside source is allowed to enter the sensing space. This outside ambient skylight enters through a skylight (as at the Castelli Gallery) or a side window and passes through the partition wall, entering the sensing space through a slit just inside the opening. This light from outside produces slight intensity and color changes in the sensing space as it "sees" the changes outside. The gross change is from night to day, with the night aspect being indistinguishable from a *Prado Series* piece. The day aspect would reflect changes in intensity throughout the day and year, and color changes due to weather, sunrises, sunsets. JT

DANAE SERIES

Die erste Arbeit dieser Serie, *Danae*, wurde 1983 in der Mattress Factory in Pittsburgh, Pennsylvania, realisiert. In formaler Hinsicht unterscheiden sich auch diese Arbeiten nicht von den *Prado Series*, außer daß nun die Räume beidseitig der Trennwand augeleuchtet sind. Entsprechend den *Prado Series* beleuchtet auch hier das Glühlampenlicht die Seitenwänden des Betrachterraumes. Das Licht im *Sensing Space* (Wahrnehmungsraum) wird rückseitig um den Öffnungsrand angebracht und ist entweder Fluoreszenzlicht (wie z. B. bei *Danae*) oder Neonlicht (wie z. B. bei *Orca* oder *Kono*). Das Licht im Betrachterraum wird dabei gegen das Licht im *Sensing Space* ausgewogen, um das Verhältnis von Opazität und Grad der optischen Durchdringung zu kontrollieren. Die schwierigste Aufgabe liegt in der Abstimmung der Größe des *Sensing Space* auf den Farbton des Lichtes, damit die Farbe den Raum erfüllen und sich dabei zu üppig-sinnlicher Atmosphäre verdichten kann. JT

The first piece in this series, *Danae,* was installed at the Mattress Factory in Pittsburgh, Pennsylvania in 1983. Also these have the same form as the *Prado Series,* except there is light on both sides of the partition wall. As in the *Prado Series,* the light in the viewer's space is tungsten directed outward against the sidewalls. The light in the interior space is placed around the back side of the opening and is either fluorescent tube (as with *Danae*) or neon-type gas-filled tubing (e. g. *Orca, Kono*). The light in the viewer's space is balanced against the light in the sensing space to control opacity and penetration of vision into the sensing space. Most critically, though the sensing space itself must be sized in accordance with the color tone of the light, in order for the color to be seen as inhabiting the space, thereby creating a rich, sensuous, thickened atmosphere. JT

Danae 1983

Space Division Constructions

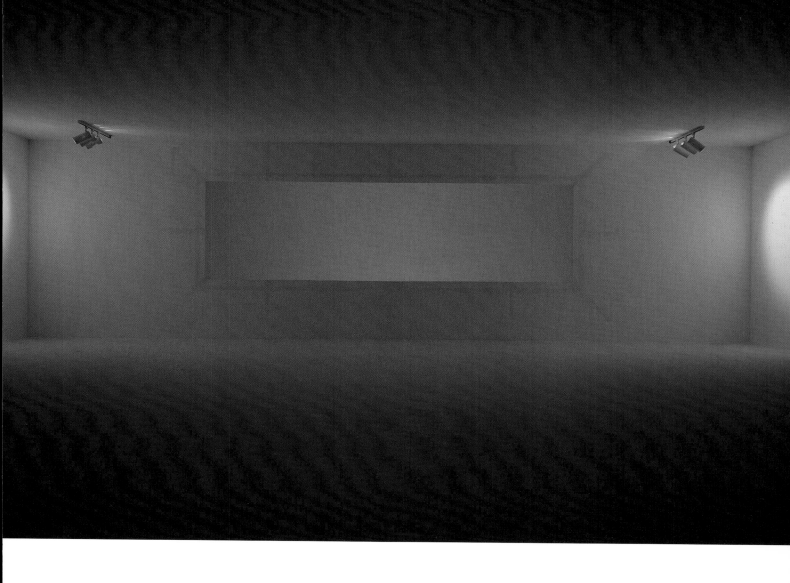

Sounding 1997

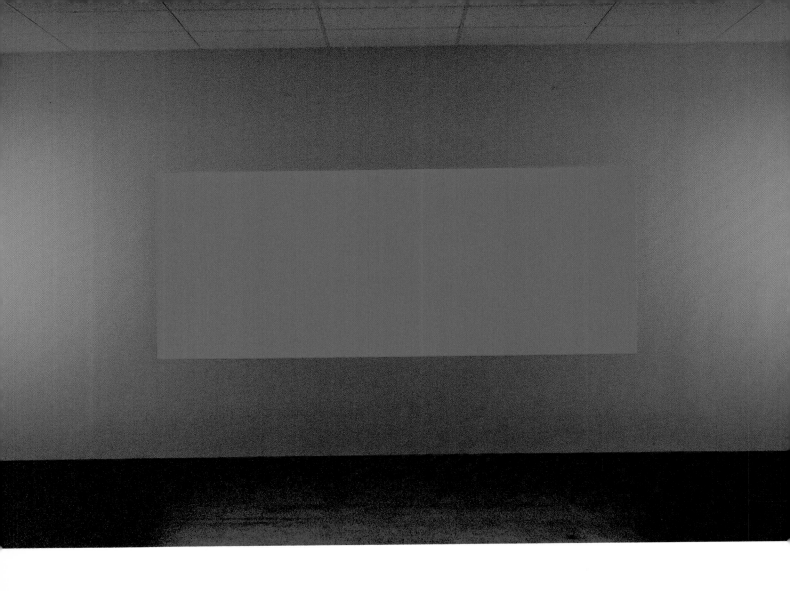

Trace Elements 1993

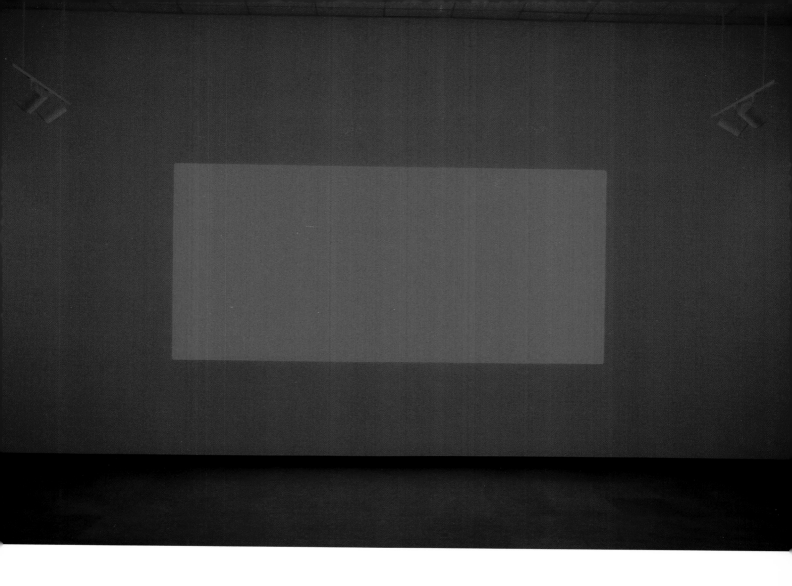

Last Breath 1990

Abb. Seite / page 114, 115 **Orca** 1984

Space Division Constructions

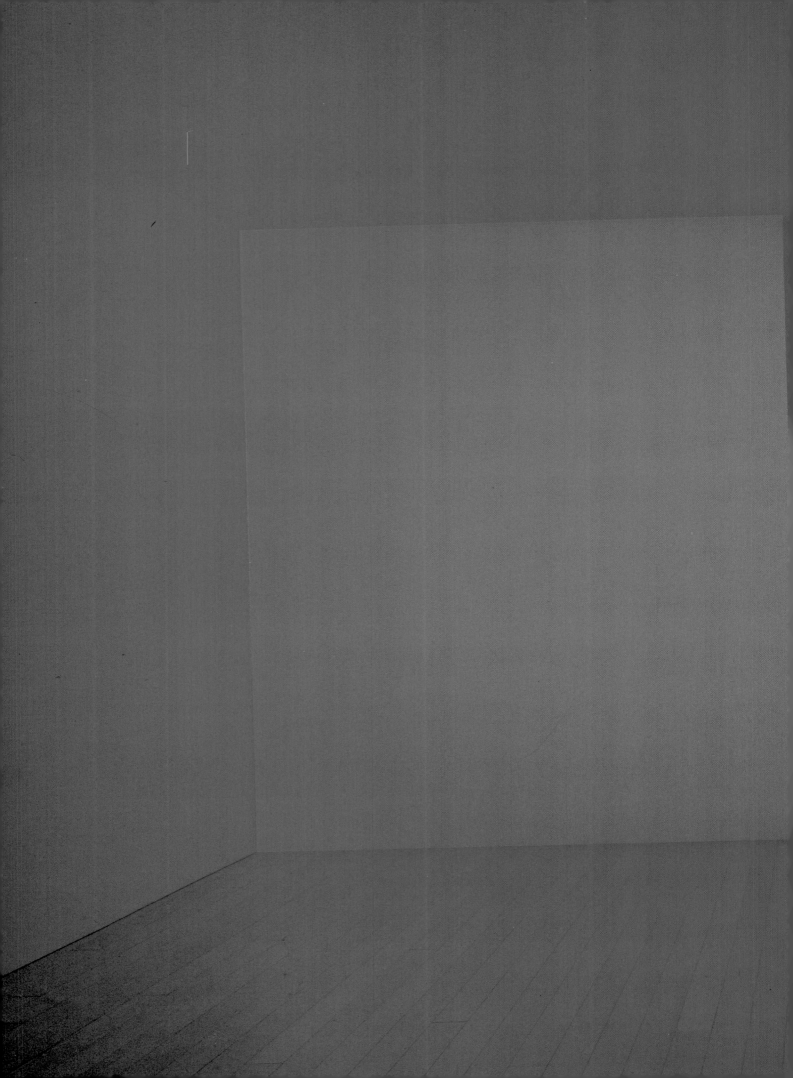

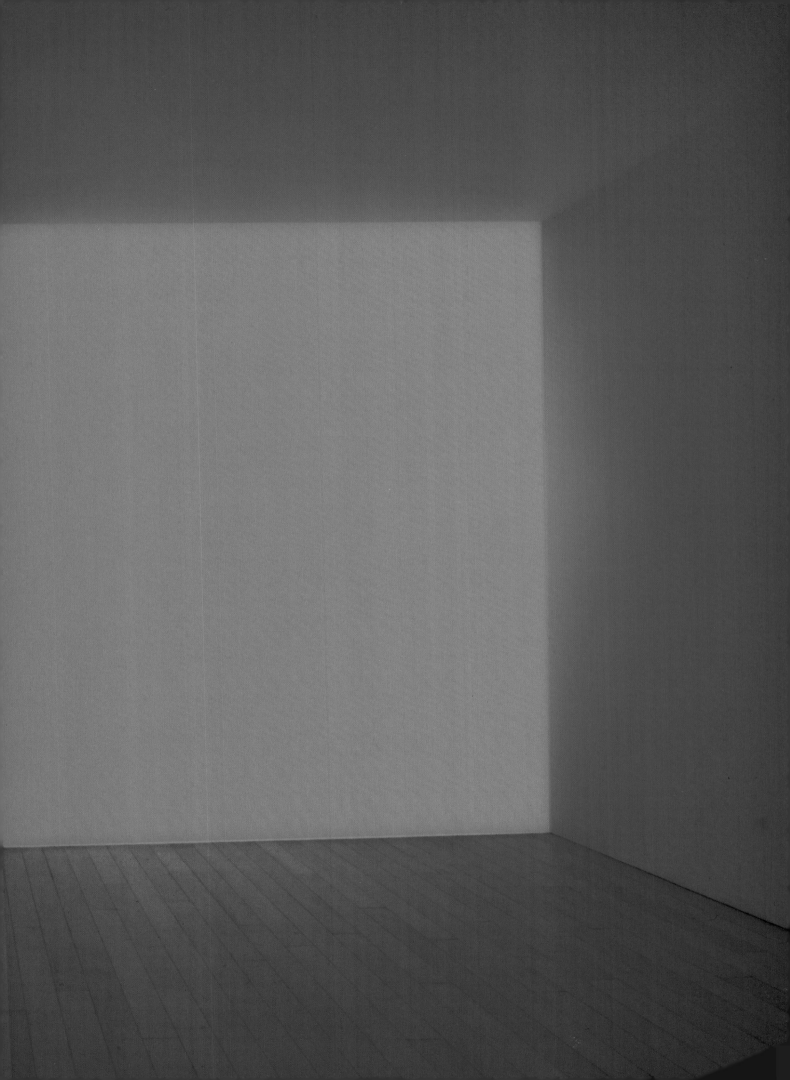

ARCUS SERIES

Arcus, die erste Arbeit dieser Serie, wurde 1989 in der Florida State University realisiert. Bei diesen Installationen handelt es sich um eine Verbindung der *Phaedo* und der *Danae Series*, da ihre spezifischen Lichttypen, das heißt Fluoreszenz-, Neon- und atmosphärisches Außenlicht, im Wahrnehmungsraum kombiniert sind und gegen das Glühlampenlicht im Betrachtungsraum abgewogen werden. Das Außenlicht fällt entweder durch ein Oberlicht (wie in *Arcus*) oder durch ein Seitenfenster ein (wie in *Slant Range*).

Die Atmosphäre in diesen Arbeiten ist komplex und veränderlich. Die mannigfaltigen Lichtquellen müssen sorgfältig auf die intensiven Licht- und Farbveränderungen abgestimmt werden, wie sie durch das Außenlicht verursacht werden können. Bei der Nachtsituation (genau genommen der Erscheinungsform der *Danae Series*) bildet sich in der Öffnung der Trennwand eine undurchlässige Fläche, deren Atmosphäre besonders verdichtet erscheint, insbesondere entlang der Ränder. In Einklang dazu tendiert der Tagesaspekt zu einer weitaus größeren Transparenz, die mit überraschenden Farbveränderungen einhergeht, wobei ein Farbton um so blasser weißlich erscheint, je mehr Farbe dem Mischlicht zugesetzt ist. Entscheidend dabei ist die Dimensionierung des *Sensing Space*. Die Arbeiten der *Danae Series* verfügen über einen größeren Spielraum, um das entsprechende Volumen zu erreichen, das einem einfachen Farbton Raum- und Lichtfülle verleiht. Ein sorgsames und genaues Einmessen des Volumens wird dagegen bei der großen Variationsbreite des Farbtons in Werken der *Arcus Series* nötig, um eine vollständige Auflösung des atmosphärischen Eindruckes zu verhindern.

Wie die meisten anderen Arbeiten, hängen auch diese Räume in hohem Maße vom Standpunkt des Betrachters ab. Bei zunehmender Annäherung wird die wahre räumliche Dimension der vermeintlichen Fläche offenbar. Diese Verflüchtigung der Illusion gleicht dem suchenden Blick nach Spiegeln hinter der Bühne, um lediglich festzustellen, daß gar keine da sind. Die Art der hier erzeugten Illusion gleicht mehr einer Vergegenständlichung. Die aufgeworfene Frage nach ihrem tieferen Wesen, dem koan, läßt sich nicht durch die unterschiedliche Wahrnehmung der Arbeit lösen, sondern durch die Erfahrung der Gleichzeitigkeit, die sich durch die Bewegung im Raum einstellt. Die Unmittelbarkeit der physischen Präsenz und der taktile Reiz des Lichtraumes sowie seine sich ändernden Erscheinungsformen lassen ihn zu einem Traum werden, der neben dem Wachzustand einhergeht. JT

The first piece in this series, *Arcus,* was installed at Florida State University in 1989. These pieces are simply a combination of the *Phaedo* and the *Danae Series.* That is, they have fluorescent or neon tube type light inside, outside ambient light coming either from a skylight (as with *Arcus*) or a side window (as with *Slant Range*) into the sensing space, all balanced against tungsten light in the viewer's space.

In these works the atmosphere is complex and changeable. The varied sources must be carefully balanced against the extremes of intensity and color possible because of the outside light. The tendency in these works is for the night aspect (strictly speaking, the *Danae* aspect) to be rather opaque at the opening with a high degree of thickness to the atmosphere, especially towards the sides. Coupled with this, the day aspect tends to be more transparent with surprising changes in color (remembering that the more color that is mixed in additive light, the more "white" a tone is achieved). Here the problem of sensing-space sizing is crucial. Straight *Danae Series* works have more latitude in achieving a correct volume for the simple color tone to reside within. The variation possible in an *Arcus Series* piece requires a careful tempering of the volume to keep the sense of atmosphere from disappearing completely.

Like most of the other works, these pieces are highly sensitive to your position, and on approach tend to dissolve to reveal their existence. This is like looking behind the stage to find the mirrors, only to discover there are none. Here the quality of illusion that is utilized really seems to be more one of materialization, and the koan that is posed is most easily understood not by seeing the piece as first one thing and then another, but by seeing the piece open to yield its other aspects through moving in the space outside it. The power of the physical presence and tangibility of the light-filled space and its changing sense of existence tend to make it feel like the dream that coexists with the awake state. JT

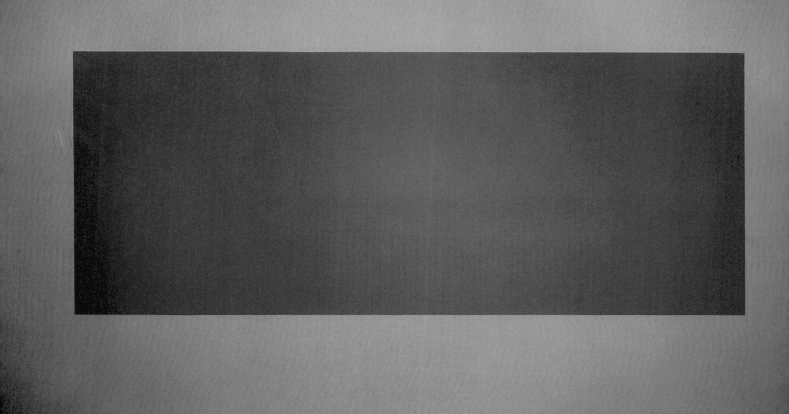

Arcus 1989

Space Division Constructions

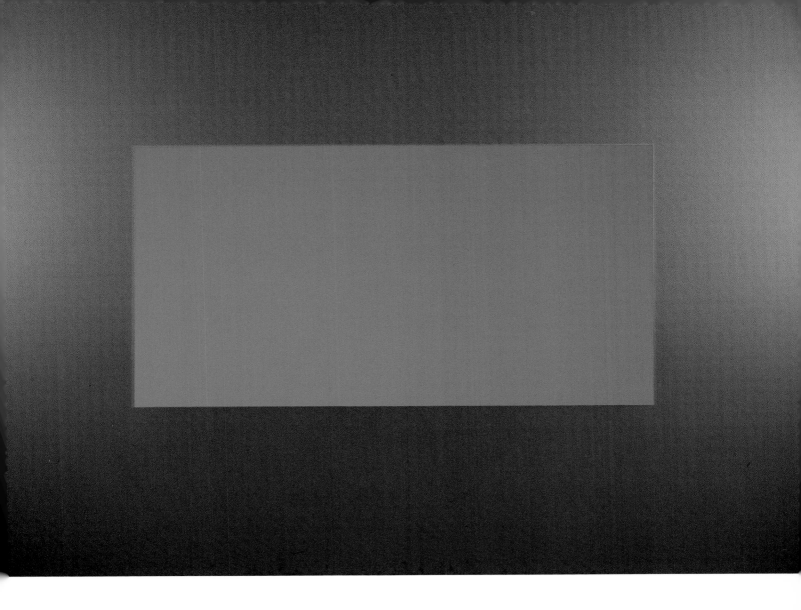

Side Look 1992

Space Division Constructions

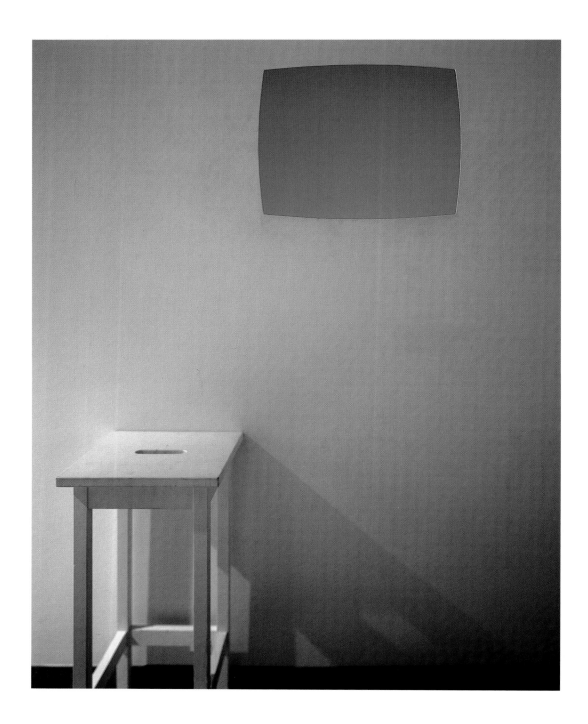

MAGNETRON SERIES

Hi-Test gehört zu den neuen *Magnetron Series,* in denen Turrell mit neuartigen Mitteln an das Konzept der Öffnung herangeht. Die Lichtquelle in diesen Werken ist ein Fernsehbildschirm mit wechselndem Programm. *Hi-Test,* die erste *Magnetron*-Arbeit, ist im Mondrian, einem Hotel im kalifornischen West Hollywood, installiert. Auf allen Etagen des Hotels ist im Flur vor dem Auf-zug eine Arbeit zu sehen. Die Öffnungen weisen Größe und Form eines Standard-Bildschirms auf, und das Licht in den kleinen *Sensing Spaces* dahinter kommt von einem Fernseher, der direkt unter der Öffnung auf dem Boden senkrecht liegt. Der Fernseher empfängt auf jeder Etage ein anderes Programm, und der Besucher stellt bald fest, daß jeder Kanal seine eigene Farbpalette sendet.

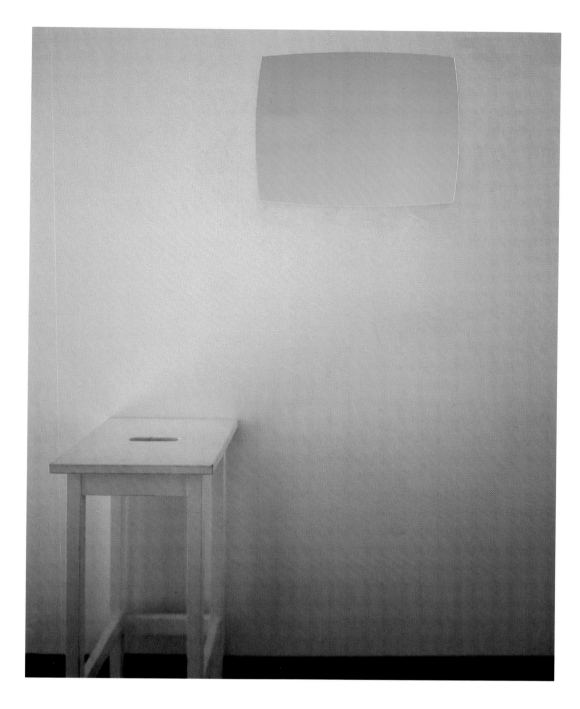

Hi-Test 1997

Hi-Test is part of the new *Magnetron Series* that take the aperture concept in a different direction. In these works the light source is a television set with varying programming. *Hi-Test,* the first *Magnetron* work is permanently installed at the Mondrian, a hotel in West Hollywood, California. On each floor of the Mondrian in the elevator lobby is a small aperture work. The openings are the size and shape of a standard television screen, and the light in the small sensing spaces beyond is created by a television placed on the floor inside the space, just below the aperture. On each floor the television is tuned to a different channel, and the viewer soon discovers that each network broadcasts its own unique range of colors.

Space Division Constructions

GANZFELD PIECES

1968–present

Ganzfeld Pieces heißen jene Arbeiten, wo sich der Betrachter in einem Raum befindet, der mit gleichförmigem Licht angefüllt ist. Die äußerst homogene Behandlung der Wandfläche steigert ihre lichtaktive Qualität. Die Raumtiefe und Lichtintensität sowie Ton und Sättigung der Farbe bestimmen das Ausmaß der atmosphärischen Aufladung mit farbigem Licht, das direkt in die Augen des Betrachters zu dringen scheint.

Die erste Arbeit an *Ganzfeld*-Räumen fand am Pomona College im Rahmen von psychologischen Wahrnehmungsstudien statt. 1968 und 1969 wurde der Umgang mit solchen Räumen innerhalb des *Art and Technology Program*, in Zusammenarbeit mit dem Los Angeles County Museum, wieder aufgenommen. Fortgesetzt wurden sie 1970 im *Mendota Studio* und 1971/72 in einem Raum, der im Pomona College eingerichtet wurde.

Die frühen Werke dieser Serie entsprechen den *Space Division Constructions* insofern, als es ebenfalls „sensible" Räume – *Sensing Spaces* – sind, die auf eine außenstehende Lichtquelle reagieren. Der Unterschied zu diesen liegt jedoch darin, daß sich der Betrachter nun im eigentlichen *Sensing Space* befindet. Er betritt ihn, und in einigen Fällen sitzt er auch darin. Manchmal sind diese Werke als Sequenz angelegt, die Raum für Raum durchschritten wird. Die erste Anordnung dieser Art war *City of Arhirit* (1976), eine Abfolge von vier Räumen im Stedelijk Museum in Amsterdam. Jeder Raum wurde von Außenlicht erleuchtet, das hinter dem Betrachter durch ein kleines Fenster in die Räume eindrang. Der Lichteinfall wurde so modifiziert, daß ein homogenes, fahles Farbfeld entstehen konnte. Die durch das Außenlicht bestimmte Qualität des Innenlichtes war entsprechend den Veränderungen von Tages- und Jahreszeit oder von atmosphärischen Einwirkungen unterworfen. Damit variierte nicht nur die Lichtintensität von Raum zu Raum infolge der Außenbedingungen (wenn beispielsweise eine Wolke vorbeizog), sondern selbst der Farbton des Lichtes befand sich in stetem Fluß. Entsprechend den Gesetzmäßigkeiten eines homogenen Lichtfeldes verblaßt die Intensität der Farbwahrnehmung nach einiger Zeit. Beim Übergang von einem Raum zum nächsten überlagerten sich nachwirkende retinale Reize mit der Farbstimmung des anschließenden Raumes.

Jüngere Arbeiten, besonders jene aus der Serie der *Operating Rooms*, beschäftigen sich wieder mit dem *Ganzfeld*-Aspekt. In ihrer Art stehen sie Arbeiten nahe, die 1969 im Rahmen der *Art and Technology* Ausstellung[1] geplant wurden. Im besonderen knüpfen sie an die im *Project 1.15.69* diskutierten Räume an, in welchen der Betrachter, auf einer hydraulischen Hebevorrichtung, einem Altar oder Bett liegend, von unten in den *Ganzfeld*-Raum eingeführt wird. In solchen Räumen wird der Betrachter auf der Unterlage angeschnallt, was ihn eine stationäre Position einnehmen läßt. Es ist diese Vorrichtung, die ihn in die Atmosphäre des *Ganzfeld* hebt. Einige der jüngsten Beispiele der Serien der *Autonomous Structures* oder der *Perceptual Cells* umfassen ebenfalls den Aspekt eines *Ganzfeldes*. Ihr Unterschied und ihre neue Dimension allerdings liegt im Umstand, daß diese Räume nicht mehr in eine vorgegebene Architektur eingebaut werden. Sie sind einer autonomen architektonischen oder plastischen Struktur inkorporiert, die in einer bestimmten Weise einen Bezug zum Innenraum herstellt. JT

1 Art and Technology, in Zusammenarbeit mit Robert Irwin und Edward Wortz, Los Angeles County Museum of Art, California, 1969

The works in which the viewer stands in the space that is completely filled with homogeneous light are called the *Ganzfeld Pieces*. In these pieces, the room you are in has surface which is as completely homogeneous as possible in its light quality. Depending on the depth of the physical space, the hue and saturation of the color, and the scale of light intensity, the air in the space seems physically charged with colored light and to come right up against your eyes.

The first work with *Ganzfeld* spaces took place at Pomona College in studies on perception. Work with these spaces was again undertaken for the *Art and Technology Program* in collaboration with the Los Angeles County Museum in 1968 and 1969. The work was furthered at the *Mendota* in 1970 and in a specially constructed room at Pomona College in 1971/72. The pieces in this series are somewhat similar to the Space Division Constructions in that they are sensing spaces where the light comes from outside, the difference being that the viewer is now in the sensing space. Sometimes these pieces are arranged sequentially so that you can walk from one space into another. The first grouping of this sort was *City of Arhirit* (1976), a series of four spaces realized at the Stedelijk Museum in Amsterdam. Each room was lit by outside light that entered through a small window behind the viewer. The light was controlled in passing through this window so as to create a homogeneous field of pale color in each of the rooms. Because the light outside determined the quality of light in the rooms, the interior light varied according to the time of day, the day of the year, and the atmospheric conditions. Not only did the intensity in each of the rooms vary with outside light changes (perhaps a cloud passing overhead), but the color itself appeared to be constantly in flux. As in a normal homogeneous field, color begins to fade after a few minutes of viewing. In moving from one space to the next, the retinal afterimage of the previous room was mixed with the color present in the new space.

More recent pieces, particularly those in the *Operating Room Series,* reconsider the *Ganzfeld* aspect. They show similarities in nature to the work planned for the 1969 show *Art and Technology.*[1] They continue especially the *Project 1.15.69* of spaces there discussed, where the observer enters a *Ganzfeld* space from below while lying down on a hydraulically lifted support, altar or bed. In these spaces the viewer is prone or in some way stationary for the sensing. The support raises the viewer into the *Ganzfeld* atmosphere. Several of the latest examples of *Autonomous Structures* and *Perceptual Cells* deal also with a *Ganzfeld* aspect. Their difference and new dimension lies in the fact that these spaces are not built into pre-existing architecture but are contained within an autonomous structure that in some manner relates to the space inside. JT

1 Art and Technology, in collaboration with Robert Irwin and Edward Wortz, Los Angeles County Museum of Art, California, 1969

City of Arhirit 1976

City of Arhirit war sowohl im Stedelijk als auch im Whitney Museum zu sehen. In der Installation im Stedelijk empfanden die Besucher die Störung des Gleichgewichts als so stark, daß sie auf Händen und Knien durch die Ausstellung krochen. Man ging zuerst durch einen Raum, der sich bald zu verdunkeln schien, denn ohne Form läßt sich Farbe nicht halten. Nach Verlassen des ersten Raumes, der hellgrün war, blieb auf der Netzhaut des Auges ein rosaroter Eindruck zurück. Der nächste Raum war rot, und man betrat ihn mit diesem Rosarot, es war einfach beeindruckend. Ich setzte also eine Raumfolge ein, um die nachhallende Farbe mit der Farbe, die man gleich sehen würde, zu mischen, auch im Bewußtsein, daß der Farbeindruck sich ständig verdunkeln würde. Die Besucher hatten den Eindruck, als ob jemand ständig das Licht an- und ausmachte, obwohl sie nur eine Folge von vier Räumen durchquerten, die auf diese Art und Weise beleuchtet waren. Wir mußten schließlich einen Weg in den Boden schneiden, aber selbst dann fiel es manchen schwer aufrecht zu stehen. Die Aufsichtspersonen befestigten zwei Punkte an der Wand und trugen Brillen mit dicken Gläsern, so daß sich zwischen den Punkten ein Horizont einstellte. Bei der Ausstellung der Arbeit im Whitney Museum fielen tatsächlich ein paar Leute hin. Danach fing ich an, Installationen zu machen, die man nicht betreten mußte, sondern in die man hineinschaute. JT

City of Arhirit was at the Stedelijk and then at the Whitney. In the Stedelijk installation, people got down on their hands and knees and crawled through it because they experienced intense disequilibrium. You went through one space and then it seemed to dim because you can't hold color without form. So as you left the first room that was pale green your eyes developed a pink afterimage. The next room you entered was red, and you came into it with this pink, and it was just startling. So I used a progression of space to mix the afterimage color with the color you were about to see, also knowing that the color, after you were in it awhile would begin to dim. People felt someone was turning the lights up and down on them the whole time, when actually it was just them walking through a succession of four spaces that were lit in this manner. We finally had to cut a path into the floor, but even then people had trouble standing. The guards put two dots on the walls and wore thick glasses so they could actually have a horizon made between the two dots. Then when the work was at the Whitney, some people actually fell. So from then on I began to do pieces that you didn't enter, but that you looked into. JT

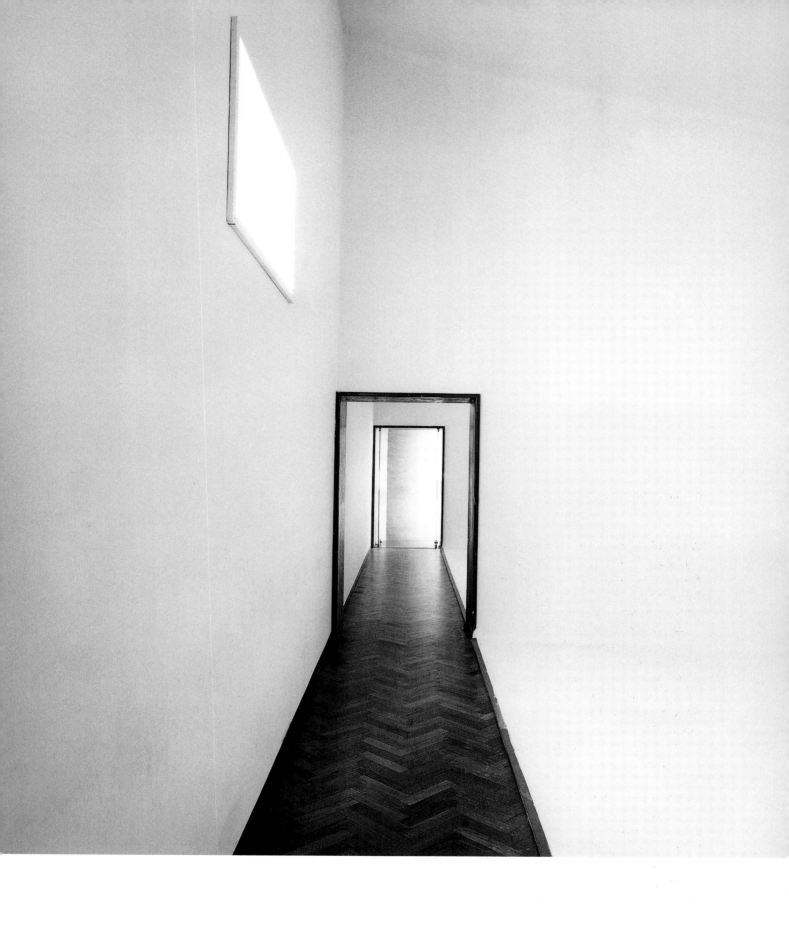

City of Arhirit (Stedelijk Museum, Amsterdam) 1976

DARK SPACES

1983–present

Beim Betreten des Raumes herrscht völlige Dunkelheit. Man ertastet sich den Stuhl und setzt sich hin. Die nachhallenden Bildreize, die man von draußen mitbrachte, halten während der ersten Minuten an. Mit der Anpassung des Auges an die Dunkelheit verflüchtigen sich diese Bilder. Nach ungefähr zehn Minuten vermag das Auge das im Raum vorhandene Licht wahrzunehmen. Größe, Umriß und Farbe des Lichtes stehen in Relation zum Sehen des Zapfen- (Farbsehen) und des Stäbchenbereiches (Sehen der Dunkelheit) der Netzhaut. Die meisten dieser Lichterscheinungen verflüchtigen sich, wenn man sie fixiert, stellen sich aber leicht wieder ein, wenn man den Blick frei gleiten läßt. Das Lichtquantum ist außerordentlich gering gehalten, um die Schwelle zwischen dem äußeren Sehvermögen und dem inneren Sehen (dem imaginären Sehen im Traum) ins Bewußtsein zu bringen. Erst nach dieser etwa zehnminütigen Eingewöhnungszeit setzt die eigentliche Arbeit ein.

Die Überlegungen zu den *Dark Spaces* begannen 1969–70 im *Mendota Studio*. In der neunten und zehnten Nacht-Station der *Music for the Mendota* wurde mit diesen Aspekten erstmals gearbeitet. Das erste, eigentlich eigenständige Werk, *Pleiades*, wurde 1983 in der Mattress Factory (Pittsburgh, Pennsylvania) realisiert. Dieser Titel verweist auf die Schwierigkeit, die sieben Schwestern dieser Sternkonstellation am nächtlichen Himmel ausfindig zu machen, wenn das Auge direkt darauf gerichtet ist. Die einzelnen Sterne sind leichter auszumachen, wenn der Blick die Konstellation bloß streift. In der Arbeit *Pleiades* wird gerade diese Schwelle von Farb- und Hell-/Dunkelwahrnehmung im Wechsel von gedämpftem, aber sattem Rotlicht zu Blaulicht genutzt.

Die *Walking Dark Spaces*, die man abschreitet anstatt sitzend in sie hinein zu blicken, entstanden aus dem Erlebnis, bei besonders dunklen Nächten vom *Roden Crater* abzusteigen. Einzelne Salbeibüsche verbreiteten im schattenfreien und weichen Licht des mondlosen Sternenfirmaments einen zarten Schimmer. Es war wie während eines Nachtfluges über kleine Schäfchenwolken. Diese Kraterabstiege erstreckten sich über circa 5 Kilometer und endeten beim Flugzeug auf dem Grund der Wüste. Die erste Installation, die in Anlehnung an dieses Erlebnis geschaffen wurde, war *Jadito's Night* und ist 1985/86 im Museum of Contemporary Art in Los Angeles gezeigt worden. Die zweite Arbeit war *Meso*, die 1986 im Hirshhorn Museum (Washington) ausgestellt wurde.

Die meisten Menschen haben vergessen, wie sie zu sehen lernten. Diese Trägheit, zum Beispiel beim Fernsehen, unseren Wahrnehmungsvorgang zu hinterfragen und uns von der Voreingenommenheit des Sehens zu befreien, wird besonders dann bewußt, wenn wir mit völlig unbekannten

und neuen Eindrücken konfrontiert werden. Bei rasch wechselnder Bildsequenz beispielsweise, löscht das Gehirn die nachhallenden Reize des vorangehenden Bildeindruckes. Das von neuartigen Bildreizen überflutete Gehirn findet aber demzufolge keine Anhaltspunkte, Vorangegangenes in der Überlagerung zu löschen, was allerdings nicht bedeutet, daß es dies nicht trotzdem versucht zu tun. In solchen Momenten sieht man sich dem Sehen des von uns selbst erzeugten Sehens konfrontiert. Dadurch setzen wir ein sehendes Sehen in Gang. Dieses Phänomen ähnelt der Frage nach dem Ursprung von Licht, das in luziden Träumen vorherrscht. JT

On entering the space, you encounter total blackness. You feel for the seat and sit down. In the first five minutes, the reminiscence of the images you brought with you persists. As dark adaptation begins to take place, these images begin to fade. After about ten minutes, it begins to be possible for the eye to respond to light that is actually present. The size, shape and color of the light is in relation to that seen between cone (color) vision and rod (night) vision. Most of the images, if stared at, tend to disappear but easily reappear when looked at askance. The light levels are extremely low, to allow the juncture between the seeing from without and the seeing from within (imaginatively generated seeing like the dream) to become apparent. This period after the ten minutes wait is when the work begins.

The work on the *Dark Spaces* began at the *Mendota* in 1969–70. In the ninth and tenth night stoppage of the *Music for the Mendota* this aspect was worked with. The first formal piece done by itself was realized at the Mattress Factory (Pittsburgh, Pennsylvania) and called *Pleiades* (1983). In *Pleiades* the title refers to the difficulty that is encountered in counting the seven sisters of the constellation *Pleiades* when looked at directly. It can be noticed that if you look slightly off the constellation, there is greater ease in resolving the individual stars. In the piece *Pleiades* the junction between rod and cone vision is exploited through a change from a very dim but rich red light to blue light.

The *Walking Dark Spaces* came as a result of walking down the volcano *(Roden Crater)* on dark, partially starry nights. Here individual sage bushes, when lit with the soft, no-shadow light of the 180° starry sky with no moon, would give a tender glow much like that experienced when flying above small puffy alto cumulus clouds at night. These walks of necessity usually covered 1 1/2–2 miles. This was in order to come off the crater and find the plane at the bottom on the desert floor. The first piece similar to this experience was entitled *Jadito's Night* and was shown at the Museum

of Contemporary Art, Los Angeles, 1985–86. The second of these was *Meso* shown in 1986 at the Hirshhorn Museum, Washington.

Most of us have forgotten how we learned to see. This laziness in recognizing prejudiced perception becomes apparent when, as with TV, we are no longer provided with expected seens. For instance, when you look at an image and then quickly move the eye to another image, the brain erases the after-image of the first. Without the known image, the brain has no clue of how to erase. This however does not mean that it will not attempt to do so. Thereby confronting one with seeing how we see. It is seeing seeing that we generate. This is not unlike asking where the light comes from in the lucid dream.

JT

Blind Sight 1992

Dark Spaces

Blind Sight 1992

Blind Sight bezieht sich auf einen Zustand, der, hervorgerufen durch ein Trauma oder eine Dysfunktion, bewirkt, daß Menschen mit Augenlicht tatsächlich nicht sehen können. Mich interessiert das Sehen, das im Inneren stattfindet. Im luziden Traum besitzt man einen schärferen Sinn für Farbe und Luzidität als mit offenen Augen. Mich interessiert der Ort, wo das imaginative Sehen und das Sehen der Außenwelt sich treffen, wo es schwer ist, zwischen dem Sehen von innen und dem Sehen von außen zu unterscheiden. Das Bild ist nur insofern von Interesse, als es das Sehen von innen auslöst. Dieses Sehen findet am Rande des Zapfenbereichs der Netzhaut statt und bewegt sich in Richtung auf den Stäbchenbereich, der wiederum für das Sehen, über das man völlige Kontrolle hat, verantwortlich ist.

Der Eingangskorridor von *Blind Sight* steigt langsam an und führt zu einer auf Raumachse liegenden Öffnung. Die drei Windungen des schwarz bemalten Korridors eliminieren jegliches Außenlicht. Das dichte und greifbare Gefühl einer völligen Schwärze läßt den Betrachter zögern weiterzugehen. Passiert man die axial ausgerichtete Tür, kommt man zu einem erhöhten, balkonähnlichen Aufbau, wo sich zwei bequeme Stühle als endgültige Position zur Beobachtung der Dunkelheit anbieten. Im Idealfall ist die Augenhöhe des Betrachters mit der Höhe des projizierten Lichts identisch. Unter dem Balkon befindet sich ein Projektor in der Mitte der Raumachse. Zu sehen ist ein nach dem Zufallsprinzip angeordnetes Nicht-Muster aus sehr schwachen Lichtpunkten, die, betrachtet man sie, nachdem die Augen sich etwa zehn Minuten lang an die Dunkelheit gewöhnt haben, zu verschwinden scheinen und nur einen flüchtigen, peripheren Eindruck hinterlassen. Eine verblüffende Netzhautreizung stellt sich ein, ein Verwechseln des inneren, mentalen Lichts und des wahrgenommenen Lichts. JT

Blind Sight refers to a state evoked by a traumatic experience or dysfunction which causes people with regular eyesight to actually not see. I'm interested in the seeing that takes place inside. In a lucid dream, you have a sharper sense of color and lucidity than with your eyes open. I'm interested in the point where imaginative seeing and outside seeing meet, where it becomes difficult to differentiate between seeing from the inside and seeing from the outside. The image is only of interest in that it effects seeing from the inside. This seeing takes place on the edge of the cone area in the retina. It progresses towards the rod area, which, in turn, is responsible for the seeing over which one has complete control.

In *Blind Sight*, a corridor slopes gently upwards ending at an opening in the axis of the room. The three turns of the black painted corridor entirely eliminate the remaining incoming light. The dense and tactile feeling of an intensive blackness make the observer hesitate to continue his way. Stepping through the axial setting of the doorway, one reaches a heightened structure similar to a balcony, where two comfortable chairs provide the final position for the observation of the darkness. The eye-level of the viewer ideally suits the height of the projected light. A projector is installed underneath the balcony in the center of the axis of the room. There is a randomly distributed non-pattern of very dim light spots, which when looked at after ca. 10 minutes of dark adaptation, seem to disappear leaving only a fleeting vision in the periphery. A startling retinal irritation is felt, mixing up the inner light of mind and the light of perception. JT

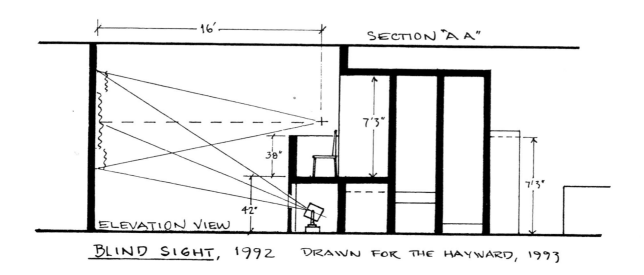

SECTION "A A"

16'

7'3"

38"

7'3"

42"

ELEVATION VIEW

BLIND SIGHT, 1992 DRAWN FOR THE HAYWARD, 1993

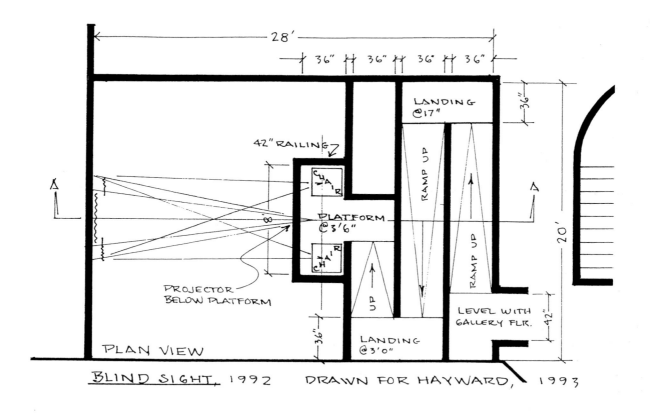

28'

36" 36" 36" 36"

LANDING @17"

36"

42" RAILING

CHAIR

PLATFORM @3'6"

RAMP UP

RAMP UP

20'

PROJECTOR BELOW PLATFORM

CHAIR

UP

36"

42"

LEVEL WITH GALLERY FLR.

PLAN VIEW

LANDING @3'0"

BLIND SIGHT, 1992 DRAWN FOR HAYWARD, 1993

Dark Spaces

AUTONOMOUS STRUCTURES

1986–present

CUBES, PYRAMIDS, COLUMNS, AND VAULTING SERIES

Die *Autonomous Structures* entstanden aus der Notwendigkeit, Räume, die für die Realisierung von Arbeiten vorgesehen waren, radikal verändern zu müssen. Beim Fehlen der Möglichkeit, bestehende Bausubstanz aufzubrechen oder auszuhöhlen, wurde ein vollständiger Neubau geradezu vorteilhaft. Arbeiten dieser Art nahmen mit dem *Roden Crater*, dem Plan für Panzas *Chapel of Light* (1977) und dem Entwurfsprojekt für die *Domain Clos Pegase Winery* (1984) ihren Anfang. Einen ebenfalls wichtigen Hintergrund bildeten die verschiedenen Projekte, die 1969 für das *Art and Technology Program* ausgearbeitet worden waren.

Die erste dieser Serie zuweisbare Arbeit ist *Second Meeting*, das ursprünglich für die Ausstellung im Museum of Contemporary Art in Los Angeles (1985) gemacht wurde und sich heute in der Einstein Collection befindet. *Second Meeting* verfügt im Gegensatz zu *Meeting* über eine eigenständige Baustruktur in Form eines freistehenden Kubus', der für die Arbeit bestimmt ist. *Meeting* dagegen war 1980–86 in die Räume des P.S.1 eingebaut worden, wo das Dach in der Art der *Structural Cuts* aufgebrochen wurde. Die ersten Serien der *Autonomous Structures* umfaßten *Skyspaces* innerhalb von Kuben, die *Cubes Series*. Weitere Serien bergen die *Skyspaces* im Innern von stumpfen Pyramiden oder im oberen Ende von Säulenschäften, wie das in den *Pyramids* und *Columns Series* der Fall ist. Mit den Arbeiten der *Vaulting Series* wurde der Ausformung des Himmelsraumes eine neue Dimension hinzugefügt: Anstelle des flachen In-Erscheinung-Tretens kann nun die sphärische Wölbung des Himmels beobachtet werden. JT

The *Autonomous Structures* grew out of the need for spaces in which the works radically altered the useful possibilities of the original form. In the absence of possibilities of cutting and holing out normal structures, building them specially became advantageous. This work started with projects like *Roden Crater*, the plan for Panza's *Chapel of Light* (1977) and the design project for *Domain Clos Pegase Winery* (1984). Also various projects for the *Art and Technology Program* in 1969 form a background of great importance.

However, the first work identified as part of this series is *Second Meeting* originally made for the exhibition at the Museum of Contemporary Art, Los Angeles, in 1985 and now to be seen at the Einstein Collection in Los Angeles. The work *Meeting* was built at P.S.1 in 1980 to 1986 and there the roof was opened in a manner closely related to the *Structural Cuts Series*. *Second Meeting*, was similar to the P.S.1 piece except that the structure was made on its own. Here the structure, a cube, is separate and made solely for the piece inside.

The first series of *Autonomous Structures* were *Skyspaces* within cubes, the *Cubes Series*. Other series imbed *Skyspaces* in truncated pyramids or at the top of columns, as in the *Pyramids* and *Columns Series*. Work with the space of the sky has been extended further beyond the flat working of the sky, as in the *Skyspaces,* to a full domed shaping in the *Vaulting Series*. JT

GANZFELD

Ganzfeld Pieces sind im Innern der Sphären und Halbkuppeln von *Autonomous Structures* vorgesehen. Die *Basilicas*, *Spheres* und *Spaceship Series* erzeugen in Baukörpern, die Stupas ähneln, die Atmosphäre eines homogenen *Ganzfeld*. In den Stupas wird der Aufbau des Makrokosmos allegorisch dargestellt. Die Stupa kann meist nicht betreten werden. Das Eintreten in den Inneraum eines *Ganzfeld* verändert in vielfältig physischer Weise die Wahrnehmung, im Vergleich zu den gewohnten Wahrnehmungsmustern. In diesen *Ganzfeld*-Räumen ist die Möglichkeit gegeben, daß sich imaginäre Vorstellungsräume über die Grenzen des architektonischen Raumes hin öffnen. Ähnlich dem Hören von Musik werden Dimensionen möglich, die den aktuellen Raum sprengen. Die *Autonomous Structures* erzeugen, sowohl unter dem Aspekt eines *Skyspace* als auch eines *Ganzfeld*, die subtilsten Wahrnehmungsphänomene. JT

Within *Autonomous Structures*, *Ganzfeld Pieces* such as spheres and half-domes are planned. The *Basilicas*, *Spheres* and *Spaceship Series* enclose a *Ganzfeld* atmosphere in structures that bear relation to stupas. In the stupas, the structuring of the cosmic universe is allegorically presented through its constructed form, which is usually not entered. Entering the inner space of a *Ganzfeld Piece* transforms the perceptional experience in various physical ways compared to one's perception outside. In the *Ganzfeld* interiors it is possible that hypothetical or "imaginative" space extends beyond the architectural confines entered. This is similar to music that, when listened to, can seem to generate a dimension bigger than the room you are in. The *Autonomous Structures* either with a *Skyspace* or *Ganzfeld* aspect not only imbed but shelter within them a subtle way of perceiving. JT

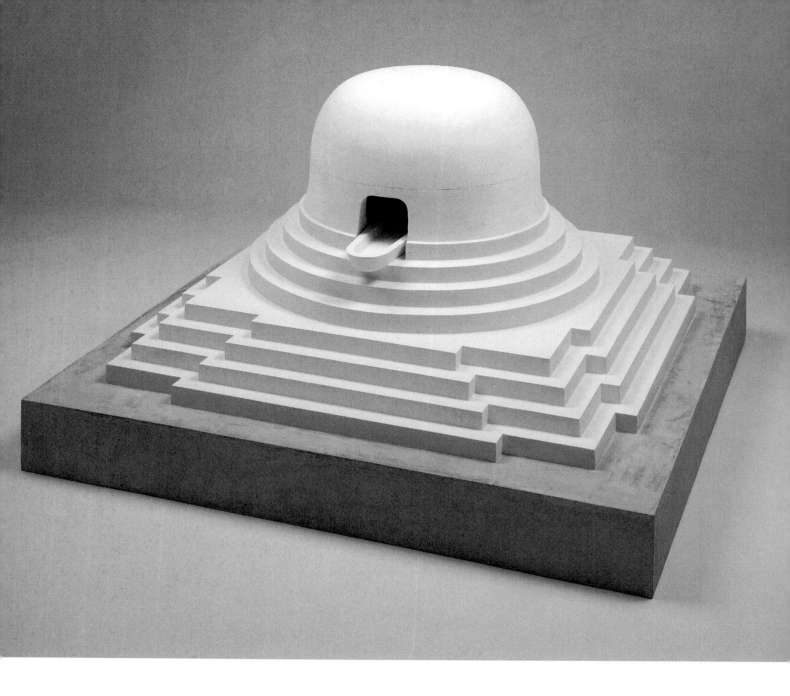

Transformative Space: Milarepa's Helmet 1991

Modell / model

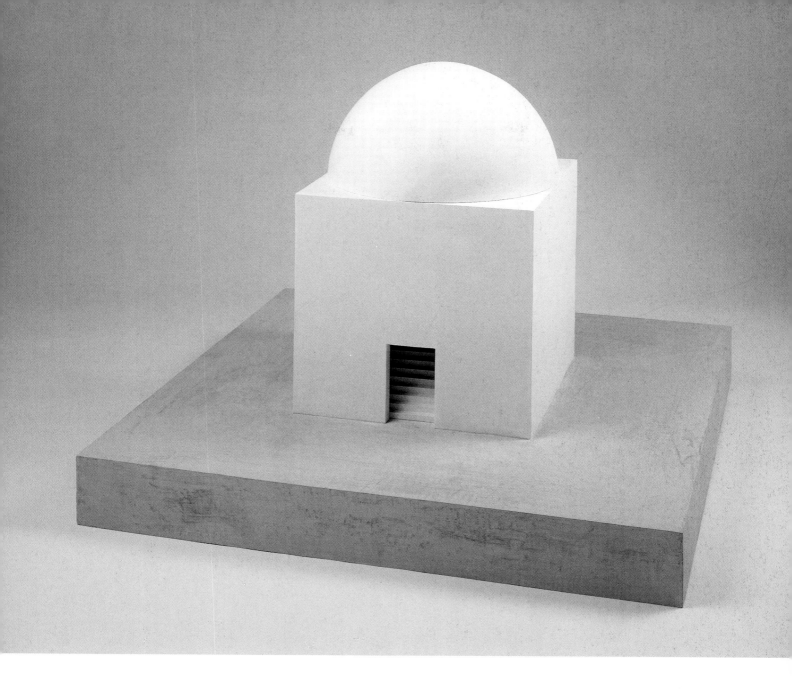

Transformative Space: Third Day 1991

Modell / model

WATER PIECES

Eine weitere Gruppe von Arbeiten, die einen *Skyspace*-Aspekt aufweisen, verbindet Licht mit Wasser und bezieht Räume ein, die nur unter Wasser schwimmend erreicht werden können. Ihre Form läßt sich von Wasserbecken ableiten. In der konzeptionellen Vorarbeit am *Roden Crater* sah ich mich erstmals mit Grundwasser konfrontiert, das von der Kratermulde herunterfloß. Dieses in der Wüste selten vorhandene und deshalb wertvolle Element besitzt in seiner lichtreflektierenden und -absorbierenden Qualität eine besondere Bedeutung. Im *East Space* wird ein Wasserbecken unter der Öffnung plaziert sein, das mit schwarzem Obsidian ausgekleidet ist. Die spiegelnde Oberfläche wird genau auf die Höhe der Horizontlinie und auf Augenhöhe des Betrachters zu liegen kommen. Am Krater wird der *Upper Fumarole Space* ein weiteres, im Raum zentriertes Wasserbecken enthalten. Hier sind Wände und Boden mit Obsidian ausgelegt, wobei der „Snowflake-Obsidian" der Bodenplatten an den Sternenhimmel erinnern soll. Ein Aspekt liegt in der sinnlich wahrnehmbaren Qualität. Das Treibenlassen in diesem Bad wird zu einer entrückten Wahrnehmung führen, die sich ganz auf das innere Licht der Gedanken konzentriert. Der andere Aspekt dagegen nutzt das Wasser in seiner leitenden Qualität. Es verstärkt die Resonanzen der Wüste und empfängt die Geräusche von weitentfernten astronomischen Quellen des Alls.

Die erste Arbeit dieser *Water Pieces*, *Heavy Water*, wurde 1991 in Poitiers (Frankreich) realisiert. Der Betrachter kann den völlig abgegrenzten Raum nur durch Tauchen erreichen. Licht im Wasser offenbart sich als Substanz. Der Durchgang durch das lichterfüllte Wasser erhält den Charakter einer Reinigung, bevor man den Raum zwischen Wasserspiegel und Himmel erreicht. Im Innern senkt sich der Himmel auf die Fläche der Raumöffnung. So wie Wasser den Grund des Raumes anfüllt, so erstreckt sich darüber ein Meer aus Licht und Luft. Dem Betrachter wird eine effektiv physische Betätigung im Akt des Entkleidens und Tauchens in das lichterfüllte Wasser ermöglicht. Ein anderer Gesichtspunkt des Elements Wasser liegt in der Ruhe seiner Spiegelungen. In vielfältiger Weise war dies im *Irish Sky Garden* und in den *Grotto Series* geplant. In den Teichen des *Irish Sky Garden* hätte sich der Himmel zu Füßen des Betrachters gelegt. Die Wolken unter sich zu sehen, verstärkt das Gefühl selbst im Himmel zu sein. JT

Still other works in this type engendering a *Skyspace* aspect involve light into water and spaces entered through passage under water. These works deal with forms originating from pools. The conceptional work at *Roden Crater* for the first time had to deal with the natural ground water, coming down from the crater bowl. This rare and precious element in the desert has special significance in its light-reflecting and -absorbing qualities. In the *East Space* a pool will be placed underneath the opening. It is lined with black obsidian. Its reflecting surface will be levelled to the horizon line and the eye level of the viewer. Still at the crater a central pool in the *Upper Fumarole Space* will contain water. Here the walls and the floor are covered with obsidian. The particular "snowflake" obsidian layers of the floor refer to the sky on starry nights. One aspect is the sensory quality. Floating in the bath will engender a remote perception, focused on the inner light of mind. Whereas the other aspect makes use of the water's sound-receptive quality, amplifying the incoming sound of the desert and the noise and light from far distant astronomical sources.

The first of these *Water Pieces, Heavy Water,* has been realized 1991 in Poitiers, France. The visitor entered the totally self-inclosed *Skyspace* only by diving under water and surfacing inside the space. Light in water reveals itself as substance. One is cleansed by the passage through the light inhabited-water before arriving in the space between sky and water. Here sky is brought down to the top of the space one is in. And water fills the bottom of the space, as does the ocean of air fill the top.

The assumed commitment of the viewer is physically actualized by his disrobing and diving into the light-inhabited water. Another aspect of water is its peaceful, reflecting quality. This aspect was to be involved in various ways in the *Irish Sky Garden* and the *Grotto Series*. In the ponds of the *Irish Sky Garden* the sky should have been brought into the surface of the water below you. Having clouds below you strengthens the feeling of being in the sky. JT

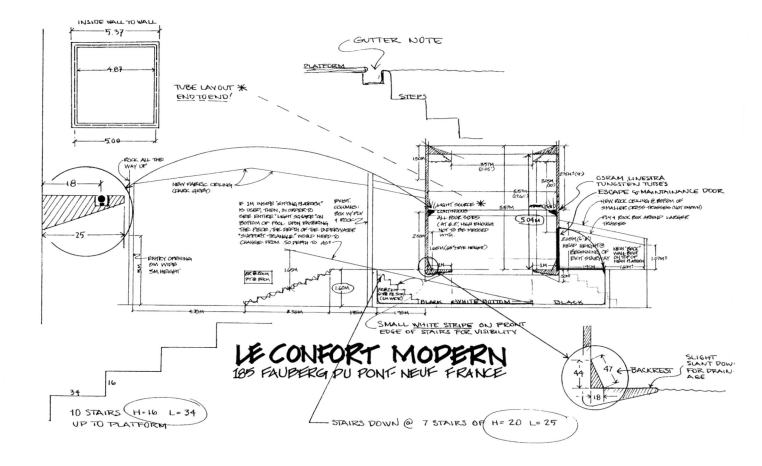

Heavy Water 1991

Heavy Water wurde 1991 für Le Confort Moderne, Poitiers, realisiert und besteht aus einem Wasserbecken oder *Waterspace*, etwa zehn Meter lang und zehn Meter breit, das sich in einem kubischen Gebäude mit einem *Skyspace* im Dach befindet. Im *Waterspace* scheint ein etwa drei Meter mal drei Meter langes Rechteck über dem Wasser zu schweben. Um die Arbeit richtig zu erleben, müssen die Teilnehmer ihre Kleider aus- und die speziell angefertigten Badeanzüge anziehen, die Turrell für diese Arbeit entworfen hat. So gekleidet, tauchen die Schwimmer ins Wasser und unter das Rechteck in der Mitte. Dort erreichen sie eine Plattform, von der sie durch eine Öffnung den Himmel betrachten können.

Heavy Water was realized 1991 for Le Confort Moderne, Poitiers, and consists of a swimming pool, or *Waterspace*, measuring 35 by 35 feet inside a perfect cube, with a *Skyspace* overhead. In the Waterspace a 17 by 17-foot shaft seems to hover above the water. To fully experience the *Waterspace*, participants must shed their ordinary clothing and don the specially designed bathing costumes that Turrell created for the work. So garbed, the participants dive into the water and under the center shaft. There they reach a platform from which they can see the sky through an aperture.

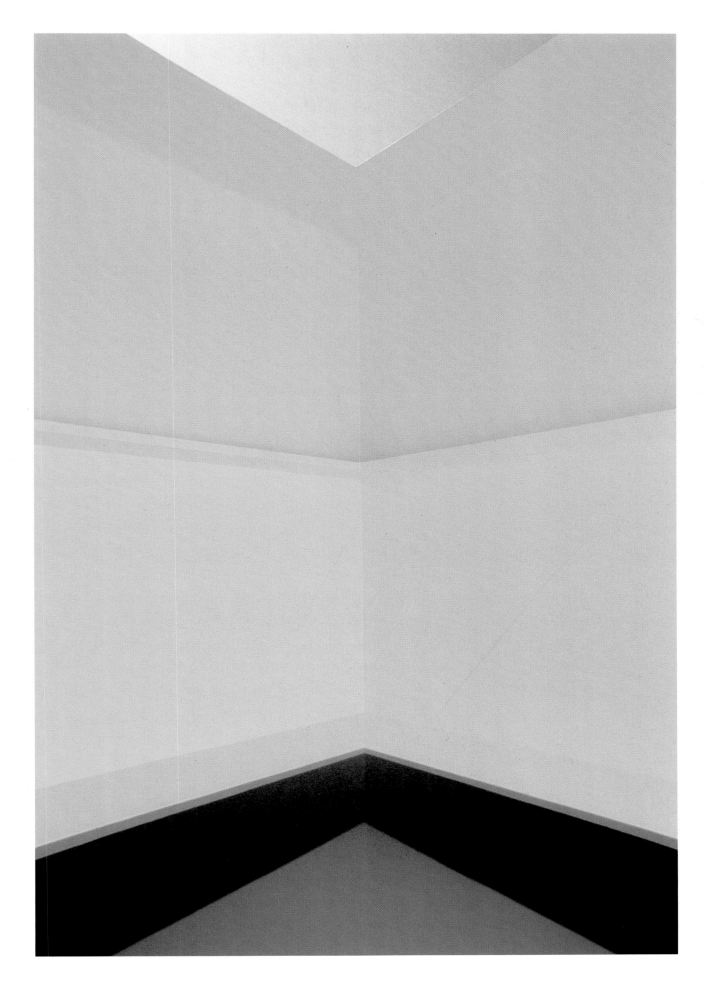

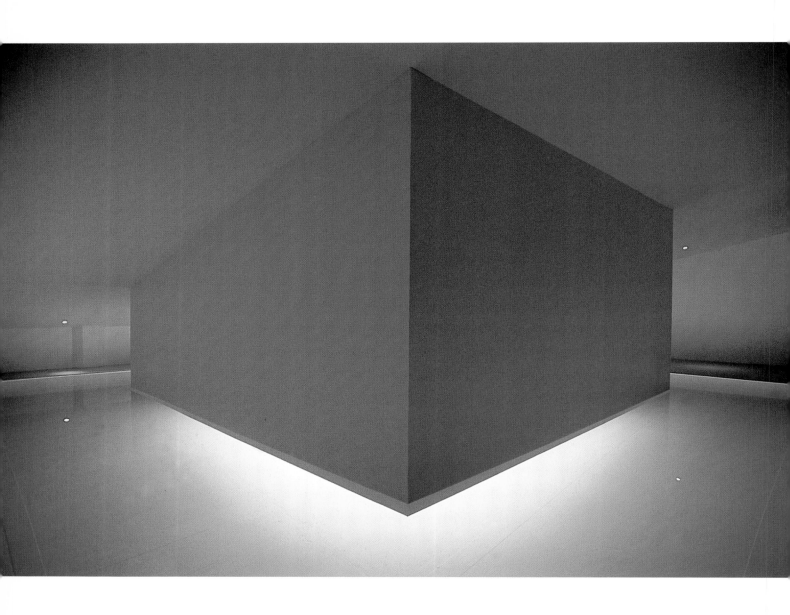

Heavy Water 1991

Autonomous Structures

PERCEPTUAL CELLS

1991–present

Obwohl diese Werke in mehreren Aspekten eine Verwandtschaft zu den *Autonomous Structures* aufweisen, so sind sie doch von viel geringerer Größe und weder an einen bestimmten Raum noch Ort gebunden. Es handelt sich um mobile Installationen, die in normalen Räumen aufgestellt werden können. Die kleinsten Arbeiten dieser Gruppe sind die *Telephone Booths*. Auf dem Prinzip einer Telefonzelle beruhend, begibt sich der Betrachter in einen kleinen Raum, wo er sich buchstäblich in einer „Zwischenzeit" *(time out)* aufhält. Die unmittelbare Realität wird zurückgelassen, um mit einer Person in einer entfernten, relativ verschiedenen Realität in Kontakt zu treten. Der Gedanke von Clark Kent, der eine Telefonzelle betritt, um als Superman herauszutreten, ist nicht weit davon entfernt. All diesen Räumen ist eine skulpturale Dinglichkeit oder einfache architektonische Struktur gemein, die man nur zum wahrnehmenden Erleben betritt. Die Umschreibung als Zelle verweist auf die Einzigartigkeit des Erlebnisses einer einzigen lebenden Zelle, auf die Abgeschiedenheit der Zelle eines Mönches und auf den Versuch, eine Erfahrung, wie jene im Gefängnis, festzuhalten. Eine Anspielung auf die geheimen, verschwörerischen Erfahrungen innerhalb einer terroristischen Gruppierung oder politischen Zelle ist ebenfalls damit in Verbindung zu bringen. JT

These works although very close to various aspects of the *Autonomous Structures* are much smaller in scale and not bound to a specific place or space. They become more like straight installation works, ones which can be set up in a reasonably sized space. The smallest of these works are the *Telephone Booths*. These are based on a principle in which one steps into a telephone booth, a small space, a virtual, physical time-out from the nearby reality in order to communicate with someone in a distant reality. Also, these works are not too far from the idea of Clark Kent stepping into the phone booth to emerge as Superman. All these spaces share the physical distinction of having thingness, like sculpture or simple architecture that one enters solely in order to experience. "Cell" as in the single living cell refers to the singularity of experience, to enclosure as in the monk's cell and to the capturing or holding of an experience as in the prison cell; also to the conspiratorial nature of a secretly shared experience as in the terrorist or political cell. JT

Düsseldorfer Light Salon 1992

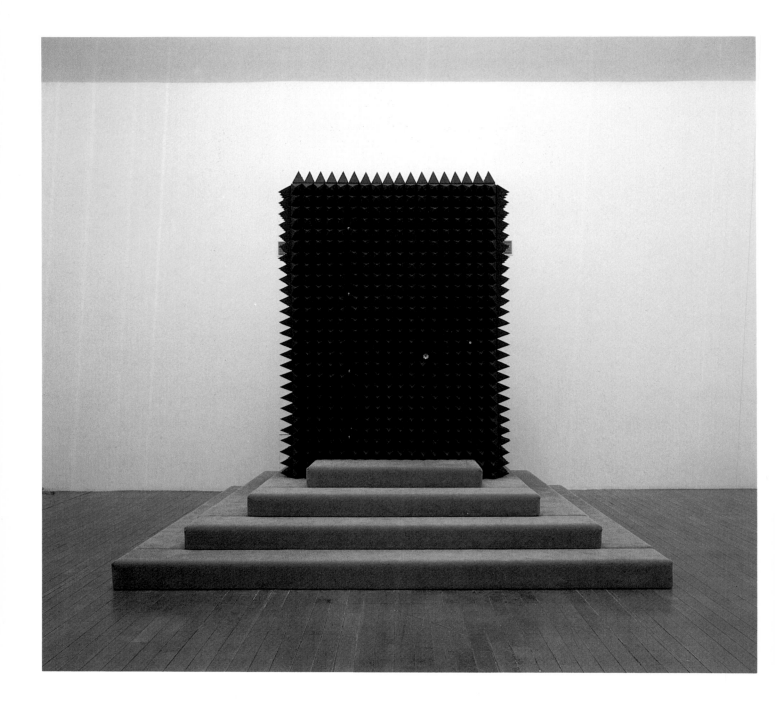

Soft Cell 1992

Soft Cell steht auf einer treppenförmigen Plattform. Ihre Außenwände sind mit einem schwarzen Schaum-
stoff verkleidet, der eine schallisolierende Wirkung hat. Durch die Tür gelangt man in einen ähnlich ausge-
kleideten Innenraum, der einen der Tür zugewandten Stuhl beinhaltet. Sobald sich die Tür hinter dem
Betrachter schließt, ist kein Laut mehr zu hören, weder von außen noch von innen, lediglich die vom Kör-
per verursachten Geräusche. Setzt er sich auf den Stuhl, geht das Deckenlicht aus, und es ist vollkommen
dunkel im Raum. Nach zehn oder fünfzehn Minuten beginnen die Augen, sich an die Dunkelheit zu gewöh-
nen, und erst dann wird das rote Glimmen eines kaum wahrnehmbaren Lichtstrahls an der direkt gegenü-
berliegenden Wand sichtbar. Zunehmend wird sich der Betrachter seiner inneren Geräusche – Herzklopfen
und Atmen – und des wechselnden Gefühls nachlassender und wieder zunehmender Sehkraft bewußt. Soft
Cell ist Einzelhaft und unendlicher Raum zugleich, der nicht für Klaustrophobische oder Ungeduldige geeig-
net ist.

Solitary 1992

Soft Cell stands on a stepped platform, its exterior walls covered with a porcupinelike skin of black anechoic foam. Entering through the door, one sees an interior cloaked with similar foam and a chair facing toward the door. When the door is closed behind the viewer, there is no sound from within or without save that generated by one's body. Sitting on the chair turns off the ceiling light, plunging the chamber in complete darkness. After ten or fifteen minutes, eyes begin to light-adjust, and only then does the red blush of a barely perceptible beam of light become visible on the wall directly ahead. By now the viewer has become aware of internal sounds, heartbeat and breathing, and the sensation of sight diminishing and then returning. Not for the claustrophobic or the impatient, *Soft Cell* is both solitary confinement and infinite space.

Perceptual Cells

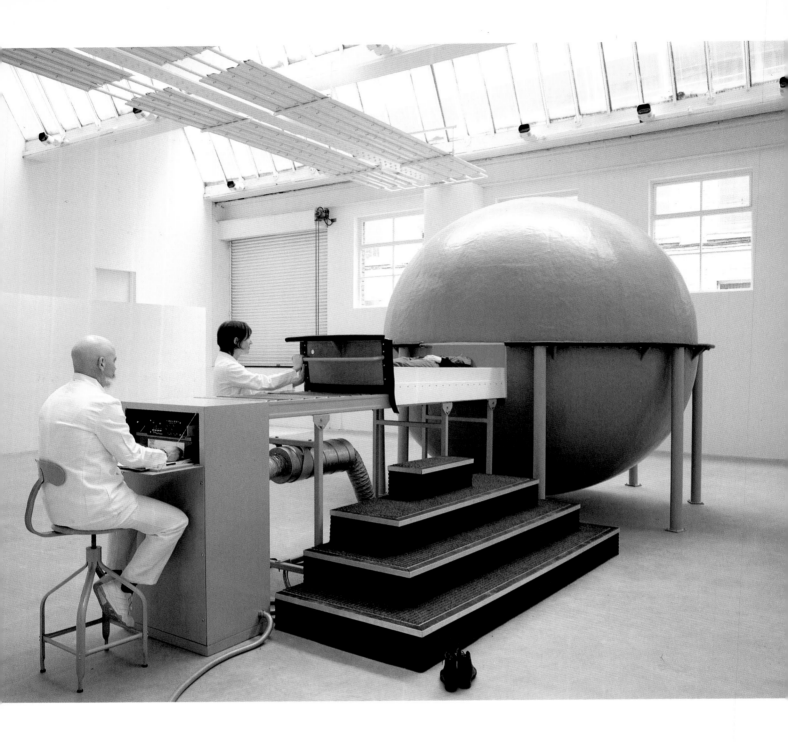

Gasworks 1993

Ähnlich wie bei *Alien Exam*, eine Arbeit, die 1991 realisiert wurde, konfrontiert *Gasworks* den Besucher mit einer kontrollierten Laborsituation. Um für den Besucher die intensive Erfahrung eines *Ganzfeld* zu ermöglichen, wählte Turrell für beide Arbeiten eine liegende Betrachterposition. Während bei *Alien Exam* lediglich der Kopf in die Lichtkuppel des *Ganzfeld* eintaucht, wird in *Gasworks* der ganze Körper auf einer Liege horizontal in einen runden Tank eingeführt und in einer Sphäre von Licht umhüllt. Somit werden auch lichtempfindliche Stellen der Haut am Körper aktiviert, um die Farbe und die Kraft des Lichts in einer gesteigerten Form zu erfahren. Der Betrachter befindet sich in einem Zeitraum von 15 Minuten in einer isolierten Situation, die zu traumartigen sowie auch zu halluzinativen Grenzerfahrungen führen kann.

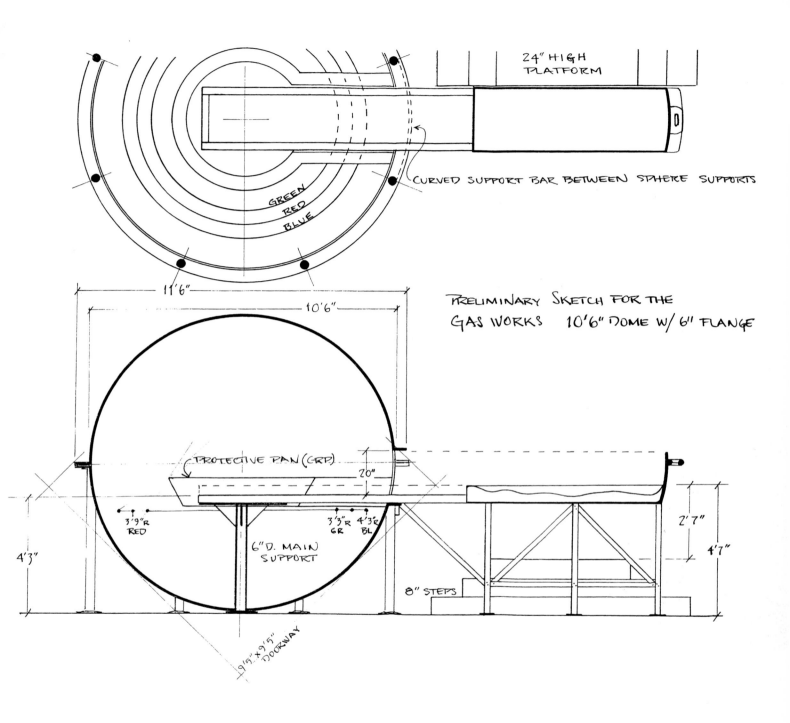

24" HIGH
PLATFORM

CURVED SUPPORT BAR BETWEEN SPHERE SUPPORTS

GREEN
RED
BLUE

PRELIMINARY SKETCH FOR THE
GAS WORKS 10'6" DOME W/ 6" FLANGE

11'6"

10'6"

PROTECTIVE PAN (GRP)

20"

3'9"R
RED

3'3"R 4'3"R
GR BL

6" D. MAIN
SUPPORT

2'7"

4'3"

4'7"

8" STEPS

9'5" x 9'5" DOORWAY

As in *Alien Exam,* a work realized in 1991, *Gasworks* confronts the viewer with a controlled laboratory situation. In both works, Turrell intended to provide the viewer with an intense *Ganzfeld* experience by requiring him to lie down to view the work. In *Alien Exam,* it is only the head which is immersed into a *Ganzfeld* light dome, in *Gasworks,* the entire body, positioned horizontally on a stretcher, is inserted into a round tank and surrounded by a complete sphere of light. In this manner, light-sensitive areas of the skin all over the body are activated, resulting in a heightened perception of color and light intensity. For a total of 15 minutes, the viewer is immersed in an isolated situation which may induce dream-like or hallucinatory experiences of perception.

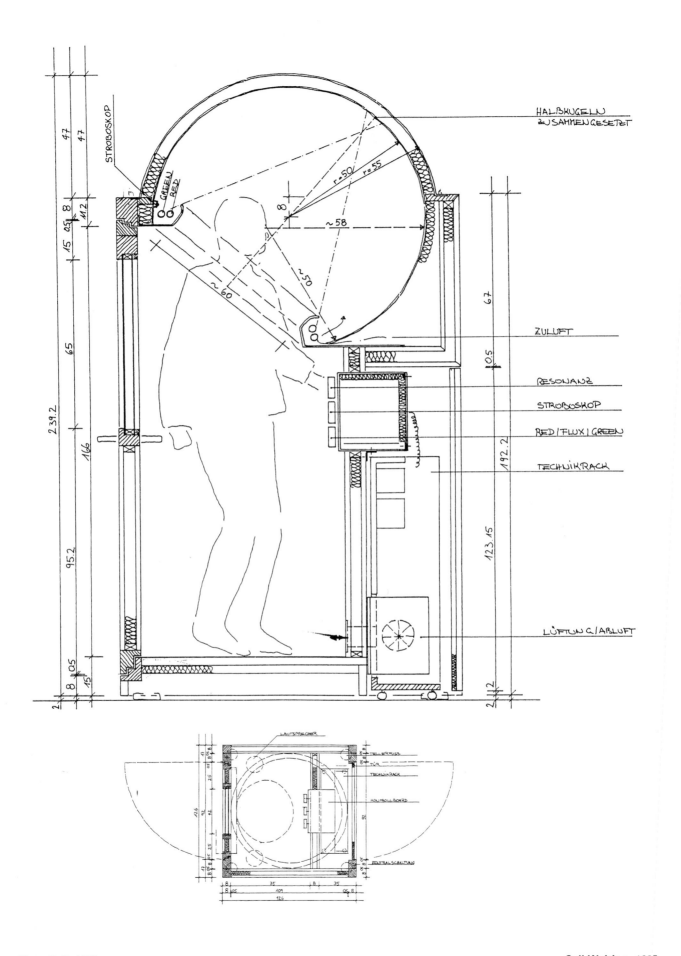

Close Call 1992 **Call Waiting** 1997

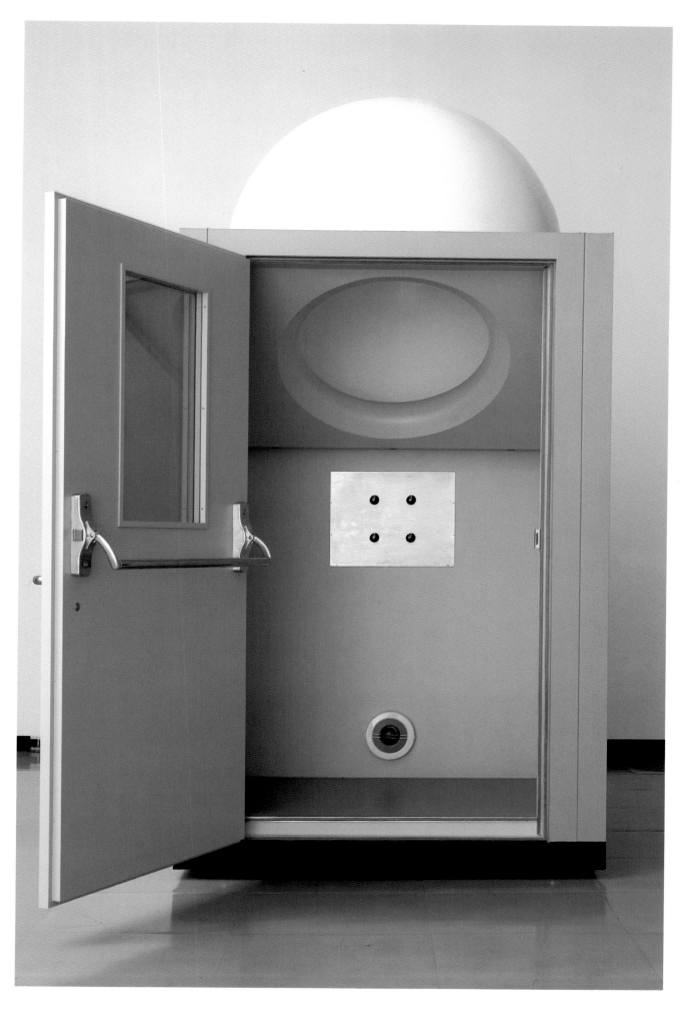

Call Waiting 1997

Die *Telephone Booths* sind eine Weiterentwicklung der 1991 realisierten Arbeit *Change of State*. Es handelt sich um sehr kleine, bewegliche Objekte, die zur *Perceptional Cell Series* gehören und in die man ähnlich wie bei einer Telefonzelle durch eine Tür oder Öffnung an der Seite eintritt. Sie sind für eine Person konzipiert, die stehend in der Zelle Platz findet. Die Wahrnehmungseindrücke werden durch eine Mischung von Licht und Klang manipuliert: das kaum hörbare Geräusch von wehendem Wind. Das Objekt ist aus bemalten, schalldicht versiegelten Spanplatten gebaut, die Kuppel besteht aus undurchlässigem Plastik und verhindert, daß Licht von außen eindringt. Blaue und rote Neonröhren, die konzentrisch zum Rand der Kuppel angeordnet sind, erzeugen ein gleichmäßiges Farbfeld ohne Schatten. In der Zelle befinden sich drei Knöpfe, mit denen der Betrachter die Intensität des Rots oder Blaus oder beider Farben verändern kann, indem er die Knöpfe auf- oder zudreht. Die gewählten Farben können außerdem heller oder dunkler eingestellt werden. Die Zellen sollen parallele Wirklichkeitsempfindungen vermitteln: Die Ab- oder Eingeschlossenheit in einem engen Raum im Gegensatz zu der undefinierbaren Wahrnehmung des individuell steuerbaren inneren Lichts.

The *Telephone Booths* are based on the work *Change of State*, realized in 1991. They are very small mobile pieces, part of the *Perceptional Cell Series,* that are entered much like a telephone booth by a side door or opening. They can be experienced individually by standing inside the piece. Perception is manipulated by a combination of light and sound: barely audible sound of wind passing by. The structure is built of painted plywood and is provided with soundproofing. The dome is made of opaque plastic and hinders the entry of any outside light. Light from blue and red neon tubes in concentric order around the rim of the dome creates an even shadowless color-field. Using three knobs inside the booth the observer can change the intensity of the red or the blue or both by turning the colors up higher or down lower and the colors of choice can also be lightened or darkened. The principle behind these booths is to generate parallel sensations of reality: the enclosure in this narrow space or confinement as opposed to the undefinable perception of the individually adjustable inside light.

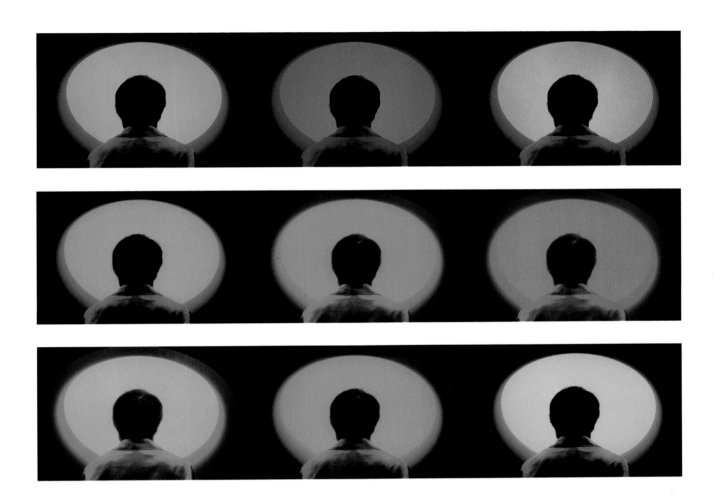

Perceptual Cells

PERFORMANCE PIECES

1968–present

Aus der Zusammenarbeit mit Künstlern entstanden in loser Folge insgesamt fünf *Performance Pieces*, die Turrells weitgefaßtes Spektrum seiner künstlerischen Arbeit verdeutlichen. Für das Tanzstück *Severe Clear* (1985) und die Oper *To Be Sung* (1994), entwarf er jeweils die gesamte Szenographie. *Skywriting* (1968), *All in the Sky* (1989) und *Body in Flight* (1990) sind *Performance Pieces*, die den Luftraum als Leinwand oder Bühne benutzten, um ihn mit farbig ephemeren Ornamenten und räumlichen Luftbildern, die mit Flugzeugen und Fallschirmspringern realisiert wurden, zu durchdringen.

A loosely connected series of altogether five *Performance Pieces,* realized in collaboration with other artists, illustrates Turrell's open-ended artistic range. For the dancing piece *Severe Clear* (1985) and the opera *To Be Sung* (1994), the entire stage setting was conceived by Turrell. *Skywriting* (1968), *All in the Sky* (1989) and *Body in Flight* (1990) are *Performance Pieces* that turned the air space into a screen or stage filling it with colorfully ephemeral ornaments and spatial visions involving airplaines and parachuters.

Skywriting 1968

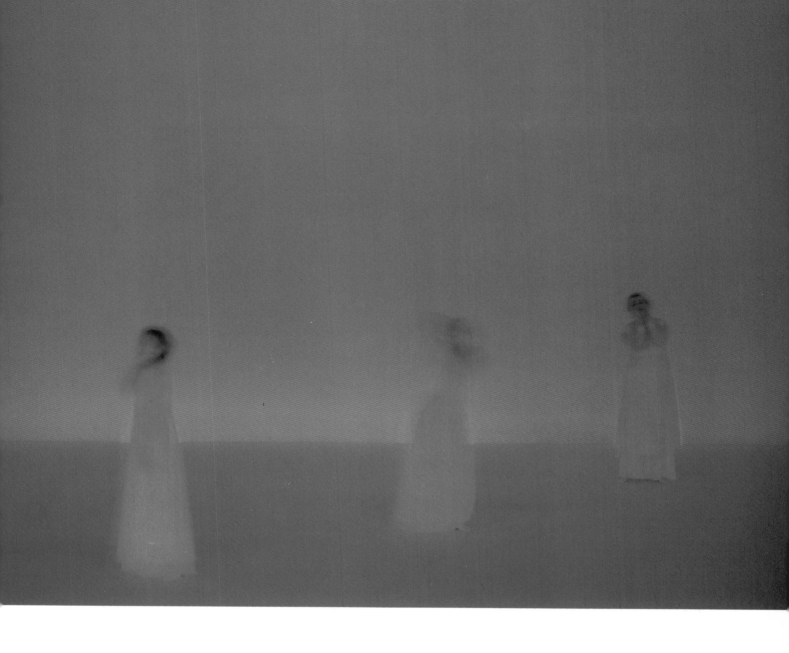

To Be Sung 1994

Für die Oper *To Be Sung* konzipierte James Turrell in enger Zusammenarbeit mit dem französischen Komponisten Pascal Dusapin Szenographie, Kostüm und Maske, die die übliche Trennung von Bühne, Musik und Inszenierung im Darstellungscharakter einer Oper aufhob. *To Be Sung* basiert auf einem Text von Gertrude Stein, „A Lyrical Opera Made by Two", in dem es weder Anfang, Mitte, noch Ende gibt, sondern der nur auf dem Rhythmus einer rein akustischen Rhetorik beruht. Diese offene Struktur des Textes, die Dusapins Komposition verarbeitete, verband Turrell mit der abstrakten Qualität des Lichts, das den Bühnenraum durchdrang.

For the opera *To Be Sung,* both scenery and costumes as well as make-up were conceived by James Turrell in close co-operation with the French composer Pascal Dusapin, thus eliminating the usual separation of stage, music and production in the realization of an opera. *To Be Sung* is based on a text by Getrude Stein, "A Lyrical Opera Made by Two", which has neither beginning, middle nor end, but relies only on the rhythm of a purely acoustic rhetoric. Turrell links this open structure of the text, as represented by Dusapin´s composition, with the abstract quality of light washing the stage.

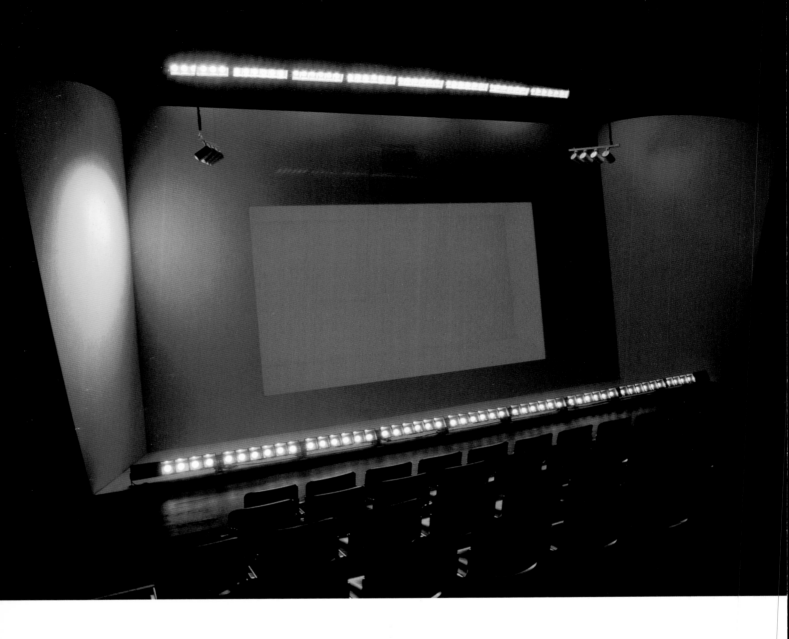

To Be Sung 1994

CRATER SPACES

RODEN CRATER

Die beim Fliegen erlebten Räume und die Arbeit an den *Skyspaces* weckten den Wunsch, mit weiten Räumen zu arbeiten und dabei den Himmelsraum in seiner Wölbung zu erfassen. In den *Skyspaces* wird ein Stück des Himmels heruntergeholt und gegen die Öffnung des Innenraums gesetzt. Die *Skyspaces* sind zwar völlig offen, und doch geht es eigentlich um das Gefühl der Schließung, das sich an der Stelle, wo der innere Raum und der Raum des Himmels aufeinander-treffen, einstellt. Die Darstellung des Himmels variiert von flach und opak bis unbestimmt und durchsichtig. Die Grenzen in diesem Raum nehmen kaum Gestalt an, mit Ausnahme derjenigen, die atmosphärische Ursachen haben.

Steht man in einer weiten Ebene, empfindet man den Himmel nicht als grenzenlos, sondern als definierbare Form, die ein Gefühl der Umschließung vermittelt. Dies wird nicht selten als Him-melsgewölbe bezeichnet. Legt man sich hin, scheint sich die Form zu ändern. Offensichtlich sind diese Begrenzungen also formbar. Um mit den Begrenzungen des Himmelsraums und seiner wahr-genommenen inneren Ausdehnung zu arbeiten, wurde nach einem halbkreisförmigen, konkaven Raum gesucht, der etwa 150–350 Meter über einer Ebene lag. Der Raum sollte sich in einer Ebene befinden, so daß die Wölbung des Himmels von Anfang an spürbar war. Ich legte außer-dem Wert auf die Kraterform, die man so gestalten kann, daß sich Veränderungen in der Wahr-nehmung der Größe und der Gestalt des Himmels ergaben. Die Höhe über der Ebene war wichtig, weil sich durch die leicht konkave Krümmung zur Erde hin – etwas, das von Piloten im Tiefflug wahrgenommen wird – das Gefühl einer Wölbung des Himmels beim Austritt aus dem Krater-raum erhöhte. Außerdem suchte ich speziell nach einem hochgelegenen Ort, der nur selten von einer Wolkendecke bedeckt war, so daß das tiefere Blau des Himmels das Gefühl der Geschlos-senheit des Himmelsgewölbes am Boden des Kraters noch verstärkte. Diese Bedingungen waren entweder bei einem einzelnen Aschekegel oder einem Tafelberg gegeben.

Alle westlichen Staaten wurden überflogen, um einen entsprechenden Ort zu finden. Die Suche selbst beeinflußte wiederum meine Überlegungen zu diesem Projekt und lieferte neue Ideen für zukünftige Arbeiten. Die Wahl fiel schließlich auf den *Roden Crater*, einen Vulkan am Rande der Painted Desert. Auch die Form des Vulkans und seine Umgebung wirkte sich auf die Konzeption der Arbeit aus. Meine Wahl fiel ganz offensichtlich auf diese geologische Formation, weil sie nicht nur meine Voraussetzungen erfüllte, sondern auch, weil der Vulkan selbst eine beein-druckende Präsenz besitzt. Anstatt die Landschaft nach Plan umzugestalten, wurde nun beschlos-sen, mit der Umgebung zu arbeiten. Der Ort ist ein Vulkan und wird es auch bleiben. Die not-

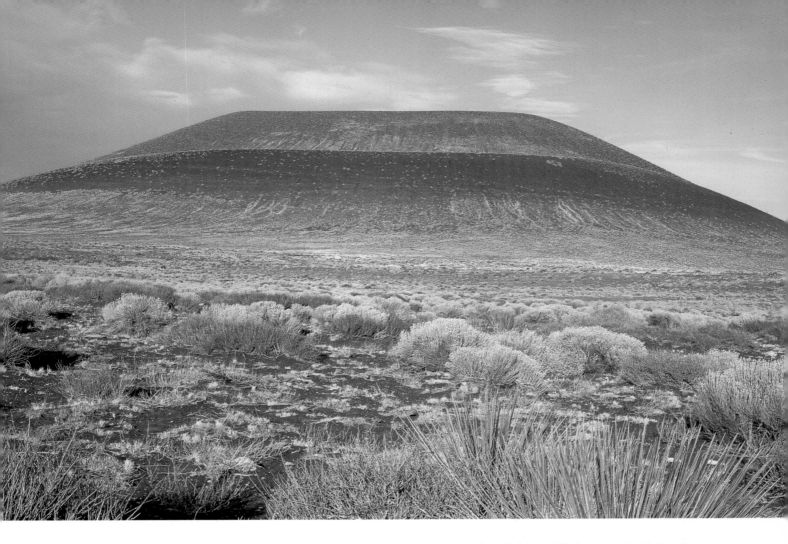

Roden Crater bei Sonnenuntergang bevor Erdschatten ihn überziehen, Südwestansicht / at sunset just before the earth's shadow covers it, from southwest

wendigen Veränderungen werden die gewünschte Erfahrung herbeiführen und verstärken. Möglicherweise bedeutet dies auch, daß die Arbeit ohne Anfang und Ende existiert.

Der *Roden Crater* kann von Westen über die flache Ebene der Painted Desert erschlossen werden. Die Straße windet sich im Halbkreis um die Nordseite des Kraters herum und führt im Nordosten in einer Art Hohlweg hinauf. Geht man diesen zu Ende, erreicht man einen Weg, der an dem kreisförmigen unteren Ring der Fumarole an der nordöstlichen Seite des Kraters entlangführt. Der ebene Weg befindet sich etwa 80 m über der Wüste. Ein Blick auf die Ebene vermittelt einen ersten Eindruck der Ausdehnung des Raumes. Von hier aus führt ein Pfad auf der Seite der Fumarole weiter nach oben. Das obere Ende der Fumarole befindet sich ungefähr 90 m über dem unteren Rand, und dieser Höhenunterschied bewirkt eine weitere Ausdehnung des Raumes. Am oberen Ende der Fumarole werden mehrere Räume eingerichtet, die eine Auseinandersetzung mit dem Himmelsraum und den verschiedenen dort stattfindenden Ereignissen ermöglichen. Diese Räume bieten auch einen gewissen Schutz bei Übernachtungen oder längeren Aufenthalten vor Ort. Jeder dieser Räume ist selbst eine Arbeit, und wo möglich werden die Übergänge zwischen den einzelnen Räumen gestaltet, so daß Ereignisse am Himmel eine Veränderung der Räume mit sich bringen. Die Logik ähnelt der der *Mendota Stoppages*, allerdings ergeben sich sowohl die Tages- als auch die Nachtaspekte ausschließlich aus dem, was sich am Himmel ereignet. Einige Ereignisse sind täglich zu beobachten, andere halbjährlich in jeweils gleichem Abstand von den Sonnenwenden, wieder andere sehr selten. In allen Fällen bewirken sie Veränderungen der räum-

lichen Eigenschaften. Von den Räumen am oberen Ende der Fumarole führt ein Tunnel hinauf zum Krater. Der Tunnel ist etwa 350 m lang und so ausgerichtet, daß der am südlichsten Punkt untergehende Mond über der Öffnung steht. Der Tunnel hat die Form eines halbkreisförmigen Bogens von knapp 3 m Durchmesser und 3 m Höhe und ermöglicht volle Sicht auf die Mondscheibe, wenn die entsprechende Konstellation erreicht ist. Beim Hinaufgehen durch den Tunnel ist nur Himmel zu sehen.

Vom Tunnel gelangt man zum Kraterraum, indem man einen dazwischen liegenden Raum durchquert, der an die *Skyspaces* erinnert. Der Raum vermittelt den Eindruck, als wäre er mit einer flachen, durchsichtigen Membran bedeckt. Stufen führen hinaus, ohne daß der Eingang den Blick auf den Himmel vom Tunnel aus versperrt. Passiert man die flache, durchsichtige Ebene, weicht das Gefühl der Eingeschlossenheit dem einer gewölbten Membran innerhalb der Weite des Himmels.

Der Kraterraum soll das Erlebnis der Himmelswölbung unterstützen und begreifbar machen. Dies wird durch die Form des Kraters, die Größe des Raumes und die Höhe des neuen Horizonts über dem normalen Horizont erreicht. Wenn man die Mitte des Kraters verläßt und an der Innenseite hinaufsteigt, sind Veränderungen im Gefühl und der Größe dieses „Innenraumes" zu spüren. Dabei wird natürlich mehr und mehr Raum außerhalb des Kraters erfahren, als anfänglich beim Betreten des Kraters von der Halle aus spürbar war. Wie stark sich dieses Gefühl ändert, hängt vom jeweiligen Anstiegswinkel ab. Steigt man die Innenseite bis zum Rand hinauf, löst sich der gewölbte Himmel schließlich vom Kraterrand und dehnt sich aus bis zum Horizont. Die ganze Weite des Raumes wird empfunden, wenn der Kraterrand erreicht ist. JT

The spaces encountered in flight, and the work of the *Skyspaces*, brought about the desire to work with larger amounts of space and a more curvilinear sense of the sky space and its limits. The *Skyspaces* work with limited amounts of the sky space brought down to and against the rectilinear limits of the interior space. Though they are completely open, the *Skyspaces* deal with a sense of closure of the interior space at the juncture with the space of the sky. The space of the sky is dealt with in a manner that ranges from flat and opaque to indeterminate and translucent. There is little shaping of the limits within this space, except of those which occur due to atmospheric conditions. You can note, when standing on an open plain, that the sky is not limitless and has definable shape and a sense of enclosure, often referred to as celestial vaulting. Then, when lying down, you can note a difference in the sense of shape. Clearly, these limits are malleable. To work with the limits of the space of the sky and its sense of interior sizing, a hemispherically shaped, dished space, about 400 to 1,000 feet above a plain, was sought. It was necessary that this space be on a plain so that some preliminary sense of celestial vaulting could be experienced. A crater-shaped space was desired so that it could be formed to effect changes in the perception of the size and shape of the sky. The height above the plain was important, so that the slight quality of concave curvature to the earth experienced by pilots at low altitudes would increase the sense of celestial vaulting after you emerged from the crater space. A high-altitude site with infrequent cloud cover was also sought, so that the deeper blue of the sky could be utilized to support a close-in sense of celestial vaulting while in the bottom of the crater. Either a solitary cinder cone or a butte would satisfy these requirements. All the Western states were flown, looking for possible sites. The search itself altered many ideas regarding the piece and also generated ideas for future works. *Roden Crater,* a volcano on the edge of the Painted Desert, was decided upon. The form of the volcano and its surroundings also changed my thinking about the piece. Obviously, this particular geological feature was selected not only because it met the requirements for the work, but also because the volcano itself is a powerful entity. Rather than impose a plan upon the landscape, it was decided to work in phase with the

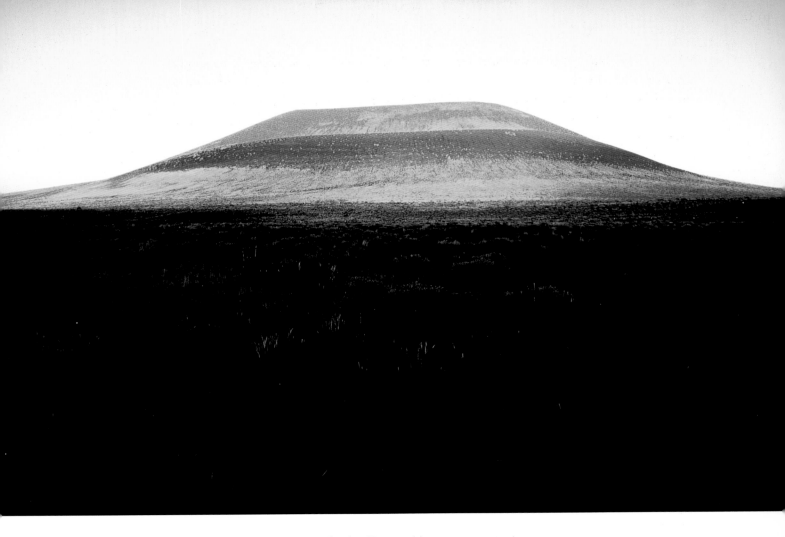

Roden Crater Sonnenuntergang über dem Kraterrand / sunset over crater rim

surroundings. The site is a volcano, and will remain so. But it will be worked enough so that the desired experience will be heightened and ordered. This could also allow the piece to exist without beginning or end.

To experience the piece, the site is approached from the west, driving across the flat plain of the Painted Desert. The road makes a half circle on the north side of the crater and comes up a ravine on its northeast side. Walking to the top of this ravine, you reach a walkway that follows the circular malapai rim of the fumarole on the northeast side of the crater. This level walkway is approximately 250 feet above the plain. Viewing the plain from here gives the first sense of expansion of space. From here, a trail proceeds up the side of the fumarole. The top of the fumarole is approximately 180 feet above the malapai rim, and this change in height also results in expansion of space. In the top of the fumarole will be located several spaces which work with the space of the sky and different events that occur in it. These spaces will also afford some protection for overnight or extended stays at the site. Each of these spaces is in itself a piece, and whenever possible, passage from one space to another is worked so that events in the sky effect changes in the space. The logic is similar to the *Mendota Stoppages,* but in day and night aspects the piece is completely performed by events that occur in the sky. Some of the events that occur in the spaces happen daily, some semiannually, equidistant from the solstices, and others occur very infrequently. In each case, the events produce

changes in the spatial qualities. From these spaces on the top of the fumarole, a tunnel proceeds up into the crater. The tunnel extends 1,035 feet and is aligned to capture the southernmost moonset. The shape of the tunnel, a semicircular arch 81/2 feet in diameter and 9 feet tall, will allow full vision of the lunar disc when this alignment is achieved. Proceeding up the tunnel, you will be able to see only sky.

The entrance from the tunnel into the crater space is made through an intermediate space which is similar to the earlier *Skyspaces*. The space at the top of this chamber creates a sense of flat closure of transparent skin. Steps proceed out of this chamber in such a way that the entrance does not occlude vision of the sky from the tunnel. Passing through the flat, transparent plane, the sense of closure recedes to a curved skin within the larger space of the open sky.

The crater space is formed to support and make malleable the sense of celestial vaulting. This is accomplished by the shaping of the crater, the size of this space, and the height of the new horizon above the normal horizon. Changes in the sense of the shape and size of this interior space are experienced as you move out from the center of the crater and up the inside. This naturally begins to include more of the space outside of the crater than experienced when first entering from the chamber. The rate at which this sense changes is determined by the change in slope. As you proceed up the inside slope toward the rim, the celestial vaulting will no longer attach to the crater rim, but will expand out to the far horizon. The largest amount of space is experienced when you reach the rim of the crater.

JT

Roden Crater Schematic Site Plan Roden Crater, Schematischer Lageplan

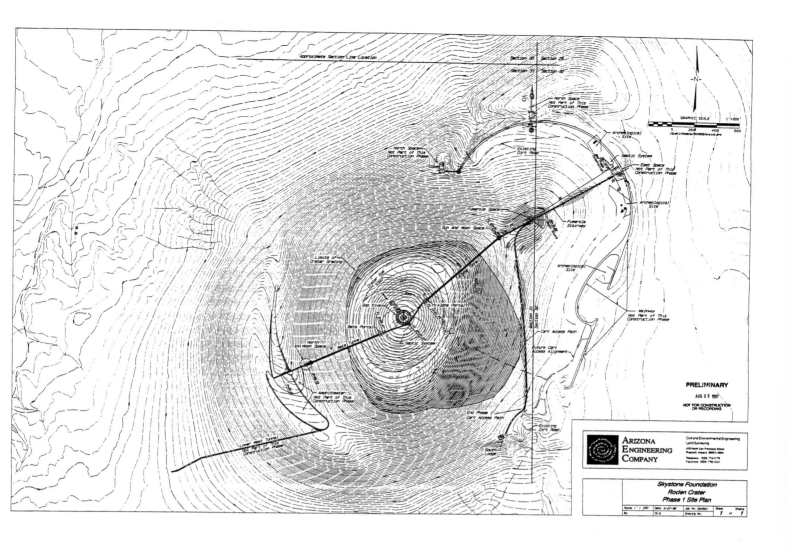

Roden Crater Phase 1 Site Plan Roden Crater Lageplan, Phase 1 1997

Die erste Bauphase am *Roden Crater*, zwischen 1997 und 2000, beinhaltet die weitere Ausrundung der Kraterform, wozu bereits 345.000 Kubikmeter Erde umgeschichtet wurden. Weitere Maßnahmen umfassen den Bau der *South Lodge*, des Verbindungstunnels zum *Sun and Moon Space*, dessen Realisierung, die Anbindung an den zentralen Kraterraum, durch den in nordöstlicher Richtung verlaufenden *East Alpha Tunnel* und die Errichtung des *East Alpha Tunnel Portals*. Die erste Phase wird mit der Fertigstellung des *Eye of the Crater* abgeschlossen. Die *Fumarole Spaces*, der *South Space* und *North Moon Space* sowie die am Rand des Nebenkraters liegenden Räume, wie beispielsweise der *East Space* und das im südwestlichen Bereich des Vulkans liegende *Amphitheater* werden erst in späteren Bauabschnitten realisiert.

The plans for the first building phase of *Roden Crater*, between 1997 and 2000, include the further reshaping of the crater bowl – 450,000 cubic yards of earth have already been rearranged – and the realization of the *South Lodge*, a connecting passageway to the *Sun and Moon Space*, its realization, connection to the central crater space by means of the *East Alpha Tunnel*, which runs in a northeastern direction, and the *East Alpha Tunnel's Portal*. The first building phase will end with the completion of the *Eye of the Crater*. The *Fumarole Spaces*, the *South Space* and the *North Moon Space* as well as the chambers on the edge of the secondary crater, such as the *East Space* and the *Amphitheater* in the southwestern part of the volcano, are meant to be realized in a later phase.

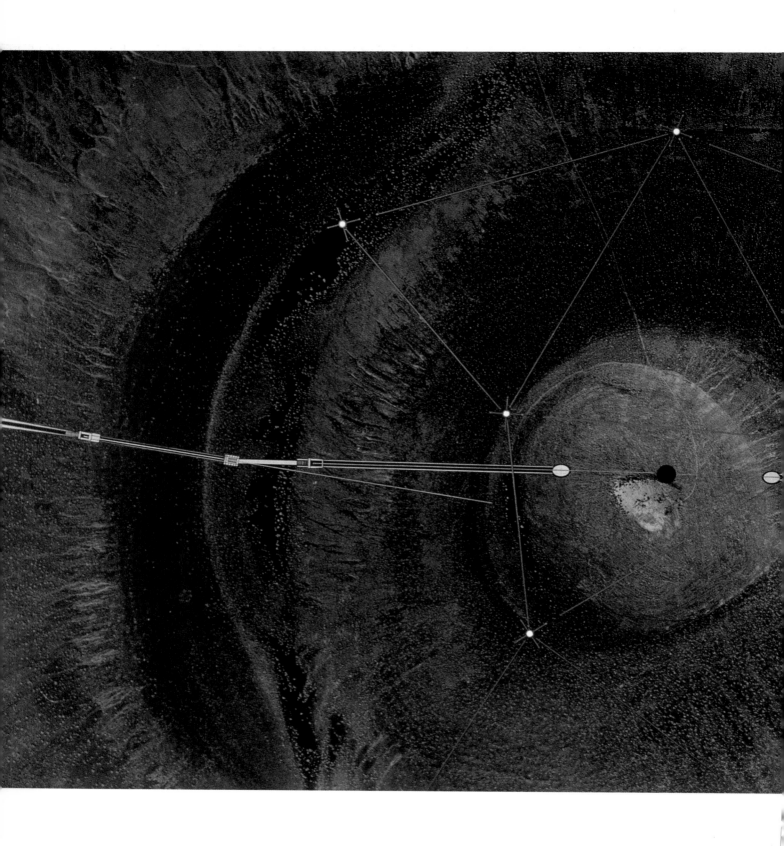

Roden Crater Site Plan Roden Crater Lageplan 1992

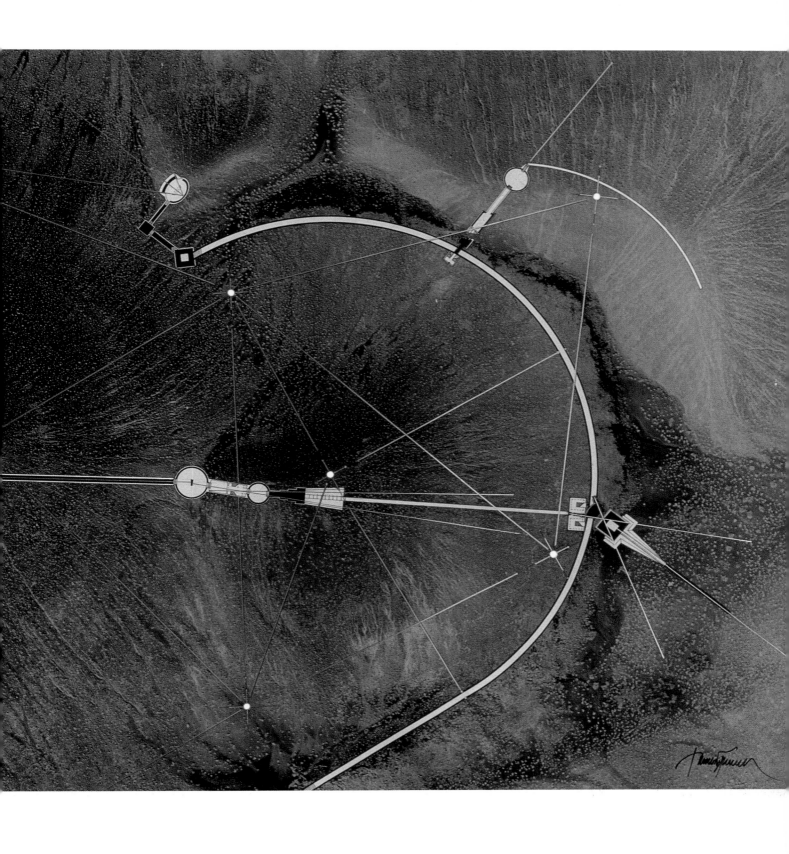

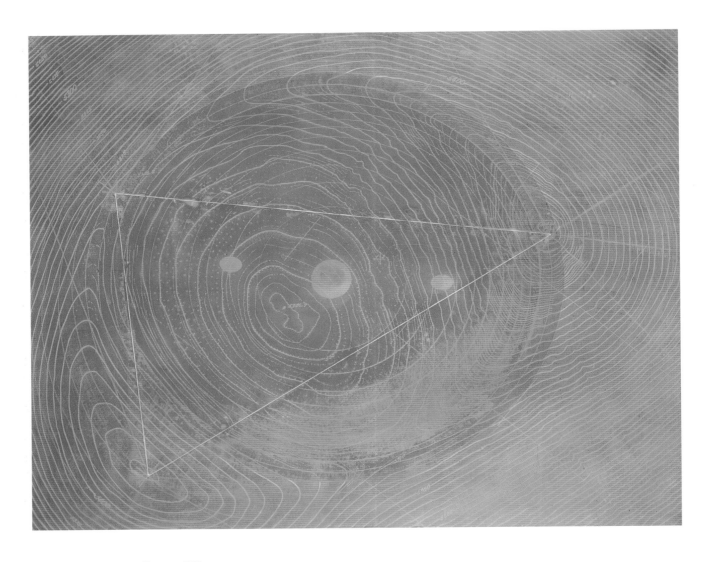

Central Crater Zentralkrater 1993

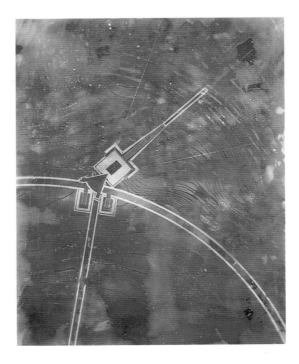

East Space Östlicher Raum 1993

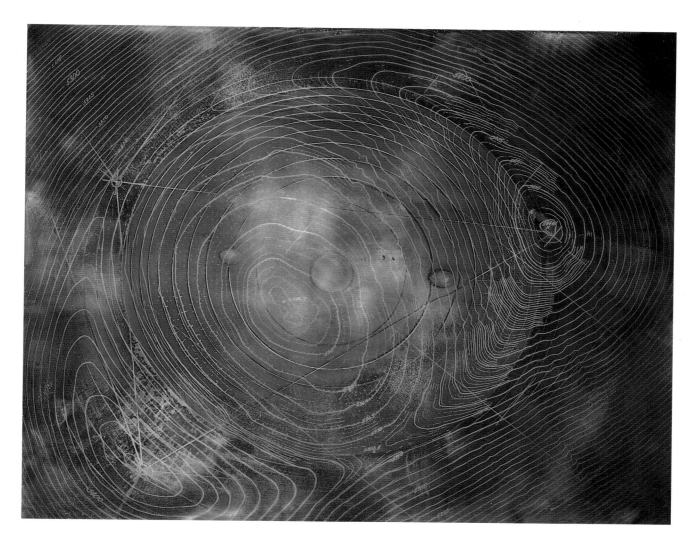

Blue Central Crater Blauer Zentralkrater 1993

Crater After Shaping Kraterform nach Ausrundung 1993

Cardinal Spaces on Fumarole II
Haupträume der Fumarole II 1993

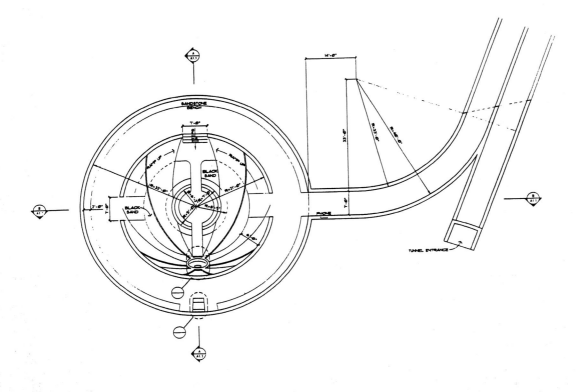

South Space Floor Plan Südlicher Raum, Grundriß 1998

Der *South Space*, von Turrell als *Saros Chamber* bezeichnet, dient zur Beobachtung bestimmter astronomischer Konstellationen, auf denen vermutlich auch die Anordnung vieler alter Steindenkmäler wie z. B. Stonehenge beruht. Das Sarosmuster, mit dessen Hilfe sich zukünftige Eklipsen errechnen lassen, basiert auf einer rein zufälligen, komplexen Beziehung zwischen Sonne, Erde und Mond. Es beruht auf der 18,61 Jahre dauernden *Saros*-Periode, die sich aus der Veränderung der Schnittpunkte der Mondumlaufbahn ergibt. Das gesamte Sarosmuster beinhaltet etwa 70 Mondfinsternisse in einem Zeitraum von 870 Jahren und 50 Sonnenfinsternisse in 1.200 Jahren. Während die Besucher in dieser Kammer sind, können sie diese nördliche Sternenkonstellation beobachten und die Rotation der Erde entlang ihrer Rotationsachse körperlich spüren. Der *South Space* ist sehr ähnlich zu Tycho Brahes Observatorium, außer daß die Türen weiter geöffnet sind.

Turrell refers to the South Space as the Saros chamber because it is conceived in terms of sighting the kinds of astronomical alignments that presumably informed the arrangement of many ancient monuments such as Stonehenge. The Saros is a pattern which results from a fortuitous and complex relationship between the sun, earth and moon and therefore allows observers to predict future eclipses. The Saros is related to the 18.61 year cycle involved in the regression of the nodes of the moon's orbit. The overall Saros pattern entails approximately 70 lunar eclipses during a span of 870 years and 50 solar eclipses during a period of 1,200 years. While being in this chamber visitors can observe the north polar alignment and feel the rotation of the earth physically along the axis of the earth's rotation. The South Space is very similar to Tycho Brahe's naked-eye observatory except that the doors are wider open.

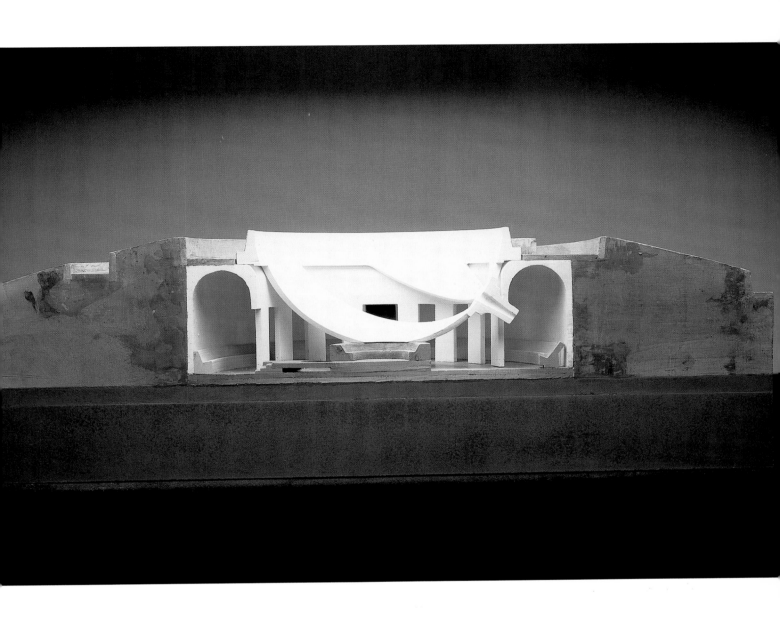

South Space Südlicher Raum 1998

2-teiliges Modell / model in 2 parts

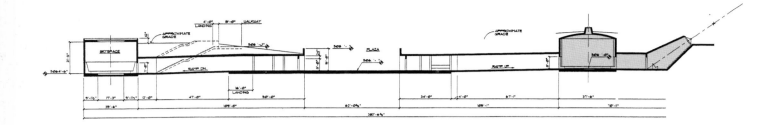

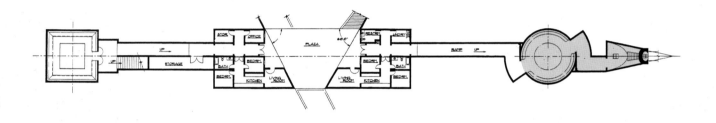

North Space Nördlicher Raum 1997
Auf- und Grundriß / elevation and plan view

Am oberen Ende der Eingangsschlucht angekommen, betritt der Besucher eine keilförmige Struktur, die
über den Sattel führt, der von der Esplanade und dem Kamm, der die Nordseite des Kraters einfaßt, geformt
wird. An diesem Punkt kann sich der Besucher nach links wenden und eine Treppe zu einem Pfad auf der
Höhe der Esplanade hinaufsteigen. Ebenfalls linker Hand führt eine Rampe zu einem zylindrischen Raum,
dem *Kiva Space*, mit einer runden, zentrierten Öffnung und einer daran angeschlossenen Kammer – *Polaris*
–, der mit einer Camera-obscura-Linse ausgestattet ist, die tagsüber Wolkenmuster auf einen kreisförmigen
Bereich am Boden projiziert. In Winternächten, wenn die Ekliptik hoch am Himmel verläuft, wird sehr
feines Mondlicht oder Licht von den helleren äußeren Planeten wie Jupiter und Mars auf den Boden pro-
jiziert, wenn diese am Himmel vorbeiziehen. Der *North Space* soll auch die Genauigkeit der Tagundnacht-
gleichen anzeigen – die allmähliche Verschiebung des Polarsterns aufgrund der Neigung der Erdachse. Von
einer sitzenden Position im hinteren Teil des Scheitelpunkts oder einer stehenden Position in der Mitte des
Raumes können Besucher die Treppe hinauf in Richtung des Polarsterns Polaris schauen. Auf einer rein
gedanklichen Ebene bildet die Kante der Tür den exakten Rahmen für einen Zyklus, der in 25.800 Jahren
vollendet wird. Genau in der gegenüberliegenden Richtung liegt, ebenfalls durch eine Rampe zugänglich,
ein quadratischer Raum mit einem *Skyspace*, der obwohl die Sonne wandert, tagsüber mit relativ gleich-
mäßigem Licht, ähnlich einer idealen Ateliersituation beleuchtet sein wird. Über eine Treppe gelangt der
Besucher ebenfalls auf die Höhe der Esplanade und weiter am Krater entlang zu den anderen Kammern.

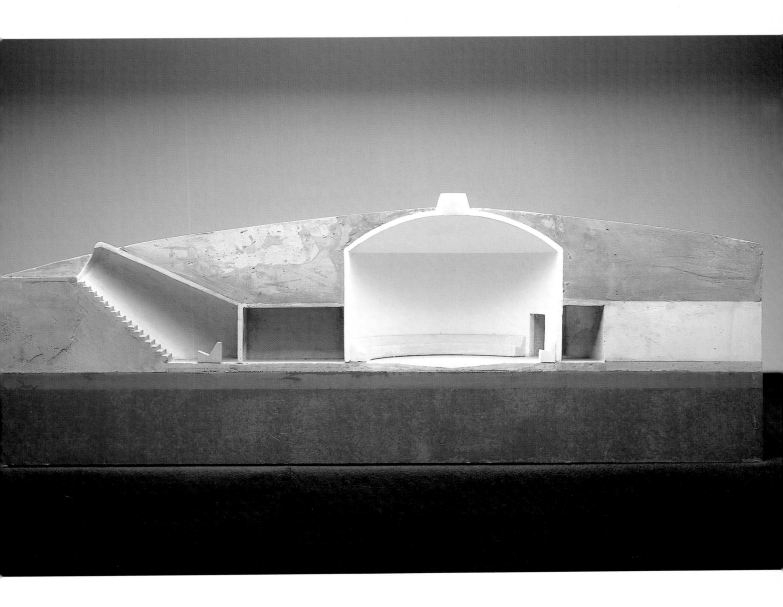

North Space Nördlicher Raum 1998
2-teiliges Modell / model in 2 parts

When viewers arrive at the top of the entrance arroyo, they will enter a wedge-shaped structure bridging the saddle formed by the esplanade and the ridge that cups the northern side of the crater. At this juncture, they can turn left and walk up stairs to a walkway at the level of the esplanade. Also to the left, a ramp leads up to a cylindrical room, the *Kiva Space,* with a round opening in the center and an adjoining chamber – *Polaris* –, fitted with a camera obscura lens that during the day, will project cloud patterns onto a circular area of the floor. At night during the winter when the ecliptic is high in the sky, very subtle light from the moon and perhaps the brighter outer planets – Jupiter and Mars – will be projected onto the floor as these bodies pass overhead. The North Space is also designed to indicate the precision of the equinoxes – the gradual shift in the position of the North Star due to the wobble of the earth's axis. From either a sitting position near the back part of the apex or a standing position in the center of the space, viewers can look up through the stairwell in the direction of the pole star, Polaris. At what is essentially a conceptual level, the sharp edge of the doorway will frame a cycle that requires 25,800 years to complete. Just in the opposite direction and also accessible via ramp is a square room with a *Skyspace,* which, despite of the sun's movement, is evenly supplied with light all day, similar to an ideal studio situation. A staircase leads the viewer up to the esplanade level and further along the crater to the other chambers.

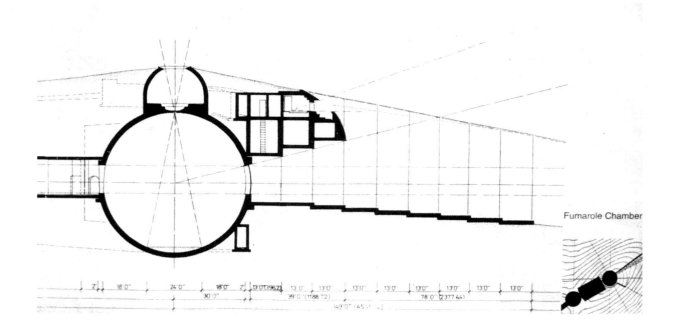

Fumarole Chamber

Fumarole Space Fumarole-Raum 1996
Aufriß / elevation view

Der *Fumarole Space* ist ein runder Raum, der sich direkt hinter dem keilförmigen Eingang befindet und eine große, linsenförmige Öffnung aufweist. Zusätzlich gibt es eine Öffnung, die es ermöglicht, den südlichsten Sonnenaufgang zu beobachten, der durch den *Fumarole Space* bis in den *Sun and Moon Space* scheint. Diese Öffnung besitzt außerdem eine Blende, die so ausgerichtet werden kann, daß der tägliche Sonnenaufgang in einem Zeitraum von 35 bis 40 Minuten in den Raum projiziert ist. Turrells Entwurf sieht vor, daß durch einen Schlitz in der Decke schwaches Licht eindringt. Nachts ist der Raum sehr dunkel, nicht unähnlich den Innenräumen der *Dark Spaces*. Eine der interessantesten Eigenarten dieses Raums ist äußerst subtil und bei Sonnenuntergang zu beobachten, dann, wenn sich der sogenannte Zwielichtbogen entwickelt, oder was Turrell gelegentlich als „Nachtaufgang" bezeichnet: „Entgegen allgemeiner Auffassung und den üblichen dichterischen Umschreibungen fällt die Dunkelheit der Nacht nicht herab, sondern sie steigt auf wie ein Nebelschleier." Die Wände sollen mit einer Mischung aus Gips und Wüstensand verputzt und dann mit demselben Sand abgeblasen werden. Rückstände dienen als Bodenbelag. Durch die sorgfältige Präparierung und Gliederung der Oberflächen möchte Turrell verhindern, daß sich die Wahrnehmung des Betrachters an die Größe und Form des Raums anpaßt. Ein weiterer Vorschlag Turrells für den *Fumarole Space* ist, in der Mitte des Raumes eine große Zisterne zu bauen. Das Becken als *Sensing Space* soll sowohl Licht aufnehmen als auch Signale von anderen Teilen des elektromagnetischen Spektrums empfangen. Der ganze Raum mit Ausnahme der Öffnung soll mit einem Faradayscher Käfig umfaßt werden, der unerwünschte Funksignale herausfiltert. Signale könnten dann nur durch die obere Öffnung eindringen, so daß sich der Raum in ein kleines Radioteleskop verwandelt, das in der Lage ist, elektromagnetische Schwingungen von solchen Quellen wie Quasaren und Seyfert-Galaxien zu empfangen. Außerdem soll der gesamte *Fumarole Space* Geräusche aus der direkten Umgebung empfangen, möglicherweise auch von den Grand-Falls-Wasserfällen des Little Colorado River etwa vier Meilen östlich des Kraters.

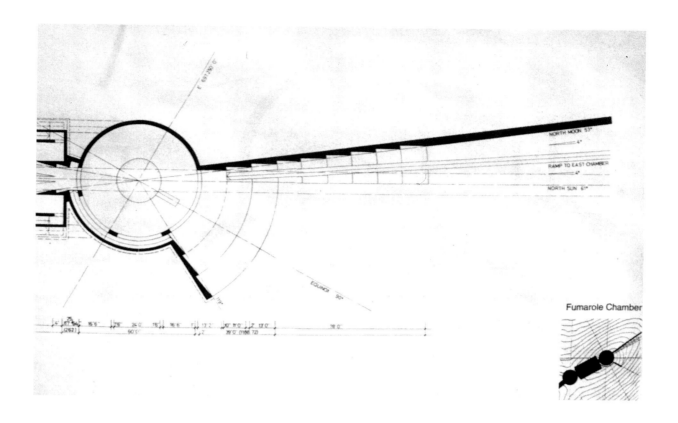

Fumarole Chamber

Fumarole Space Fumarole-Raum 1996
Grundriß / plan view

The *Fumarole Space* is a round chamber to be located just behind the wedge-shaped entrance structure and will have a large oculus-shaped aperture. There is also an aperture which allows a viewing of the furthest south sunrise which will pass through the *Fumarole Space* to the *Sun and Moon Space*. In addition this opening contains a diaphragm which can be adjusted to image everydays sunrise in the space for 35 to 40 minutes. Turrell's design calls for a small amount of light to enter through the slit in the ceiling and at night the space will be very dark, much like the interiors of the *Dark Spaces*. But still one of the most interesting qualities envisioned for this chamber is quite subtle and will occur at sunset during the development of the twilight arch, or what Turrell sometimes calls the "nightrise": "Contrary to popular opinion and the poet's standard verse, the night does not fall; it rises like a veil." The wall of the chamber is to be surfaced with plaster mixed with specific sands from the nearby desert and then to be sandblasted with the same sand. The residue will be left as a covering for the floor. By carefully preparing and organizing the interior surface, Turrell can prevent viewers from accommodating perceptually to the size and the shape of the space. Another proposal Turrell made for the *Fumarole Space* is to construct a large cistern in the center of this space. The pool is designed both to function as a *Sensing Space* holding light and to receive signals from other parts of the electromagnetic spectrum. The entire chamber, except for the aperture, is to be surrounded by a Faraday cage designed to filter out extraneous radio noise. Signals will thus be able to pass only through the upper opening allowing the space to act as a small radio telescope receiving radio waves from such sources as quasars and Seyfert galaxies. In addition to that the entire *Fumarole Space* will receive sound from the immediate external environment possibly from the Grand Falls located on the Little Colorado River about 4 miles east of the crater.

Sun and Moon Space Sonnen- und Mondraum 1997
Auf- und Grundriß / elevation and plan view

Die Räume auf der Höhe der Esplanade beziehen sich hauptsächlich auf die Sonne, mit einigen wichtigen Ausnahmen, insbesondere dem *North Space*, der sich mit der Genauigkeit des Polarsterns befaßt. Auf der nächsten Ebene des Kraters nehmen jedoch der Mond und andere astronomische Objekte eine zentrale Rolle im Wechselspiel von Licht und Raum ein.

Der *Sun and Moon Space* ist durch unterirdische Rampen zugänglich und besitzt einen runden Querschnitt. Die Sichtachsen der beiden Zugänge treffen jeweils senkrecht auf entsprechend ausgerichtete Oberflächen eines weißen Monoliths, der in der Mitte des Raumes steht. Die Zugangstunnel sind mit einer Lochkamera ausgestattet, die Bilder der Sonne und des Mondes auf eine der beiden Steinflächen projizieren. Alle 18,61 Jahre, wenn der Mond seine südlichste Deklination erreicht, wird sein Bild im Innern des Raumes zu sehen und seine großen Krater klar zu erkennen sein. Die Projektionen der Sonne sind jährlich zweimal zu den Sonnenwenden zu erleben. Die Oberflächentextur der Sonne, die mit schwarzen Punkten durchsetzt ist, wird ebenso klar hervortreten, wie die dort permanent ablaufenden Protuberanzen. Ein wirklich scharf konturiertes Bild wird bei beiden Projektionen nur für ca. zwei Minuten auftreten, ansonsten ist der *Sun and Moon Space* allein mit gleichmäßig scheinendem, unfokussierbarem Licht angefüllt und weist den Charakter eines *Ganzfeld* auf. Um eine Strahlwirkung der projizierten Planetenbilder zu erreichen wird der Raum mit schwarzem und weißem Stein verkleidet und der Boden mit schwarzem Sand bedeckt sein.

The spaces at the level of the esplanade interact predominantly with the sun, although there are important exceptions to this rule, particularly in terms of the *North Space*, which deals with the precision of the pole star. At the next level of the crater, however, the moon and other astronomical objects become central to the crater's interactive network of light and space.

The *Sun and Moon Space,* a space with a round cross-section, may be accessed via underground ramps. The visual axes of the two entranceways run perpendicular to respectively placed surfaces of a white stone in the middle of the room. Each access tunnel functions as a camera obscura projecting the images of sun or moon onto one or the other side of the stone's surface. Every 18.61 years, when the moon reaches its southernmost declination, its image, including the vast craters, will be visible inside the room. Sun projections may be experienced twice a year, at the time of the solstices. At those times, the surface texture of the sun, which is riddled with black dots, will be just as clearly visible as ongoing protuberances. The contours of both images will stay sharp for about 2 minutes only, the remaining time the *Sun and Moon Space* will be awash with an even, unfocussed light of the *Ganzfeld* type. The space will be lined with black and white stone and the floor covered with black sand in order to make the projected images of the planets glow.

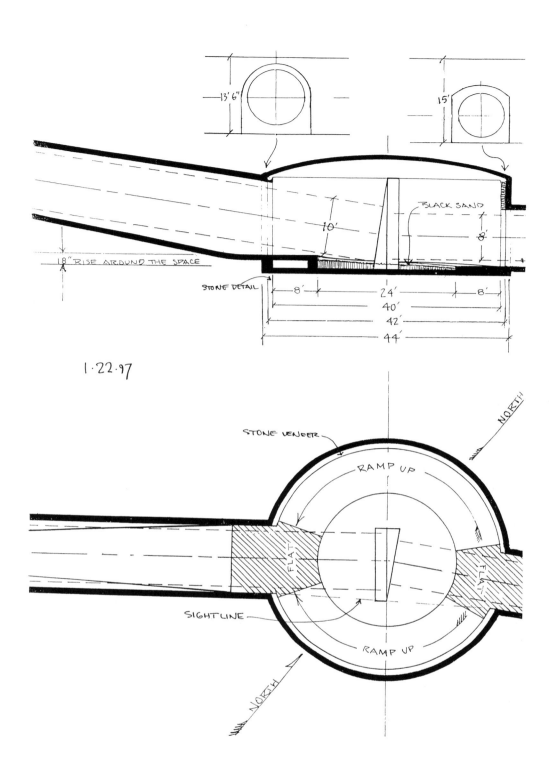

13' 6"

15'

BLACK SAND

10'

8'

18" RISE AROUND THE SPACE

STONE DETAIL

8' 24' 8'

40'

42'

44'

1·22·97

STONE VENEER

RAMP UP

NORTH

FLAT

FLAT

SIGHTLINE

RAMP UP

NORTH

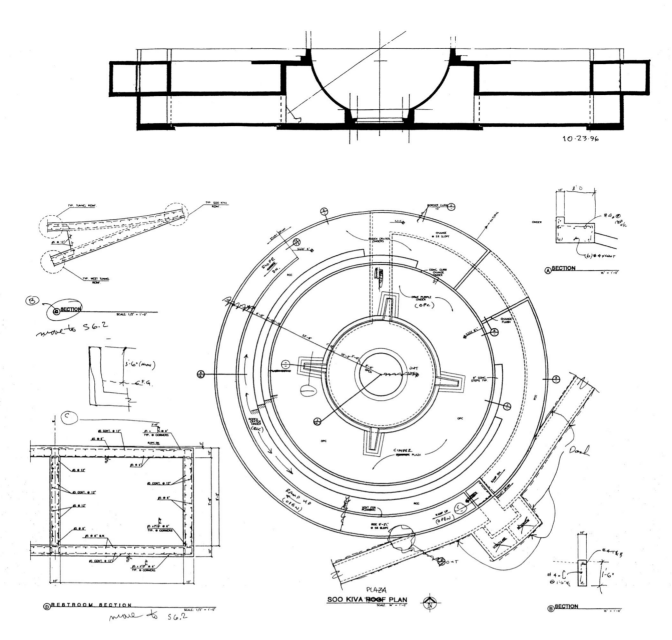

10-23-96

Eye of the Crater Auge des Kraters 1997
Auf- und Grundriß / elevation and plan view

Einer der interessantesten Räume beim Krater soll in der Mitte der Mulde entstehen. Das *Eye of the Crater* wird genau über der Magmaschicht errichtet. Wie Messungen mit dem Echolot ergeben haben, beginnt diese etwa 13 Meter unter dem Boden des Kratertrichters. Der plastische Raum ist als konkave Halbkugel gedacht, die als Observatorium für Beobachtungen mit dem bloßen Auge dient. An der tiefer liegenden Seite des Raumes sollen verschiedene Plattformen Besuchern die Beobachtung astronomischer Ereignisse ermöglichen. Die flache Bepflasterung entlang des äußeren Randes der Kammer wird mit vier horizontalen Steinbänken mit Kopfstützen ausgestattet, die dem Betrachter helfen sollen, die optimale Liegeposition für die Beobachtungen der Himmelwölbung zu finden.

One of the most interesting spaces at the crater is designed for a position at the center of the bowl. The *Eye of the Crater* will be located just above the magma core, which echo soundings indicate to be about 38 feet below the floor of the crater bowl. The sculptural space is conceived as a concave hemisphere that will function as a naked-eye observatory. Various platforms of the north underside of the space are designed to allow viewers to sight astronomical events. For the effect of the celestial vaulting a flat pavement around the outside perimeter of the chamber is designed to have four stone reclining benches with headrests to help viewers find the best positions for lying down and observing the sky.

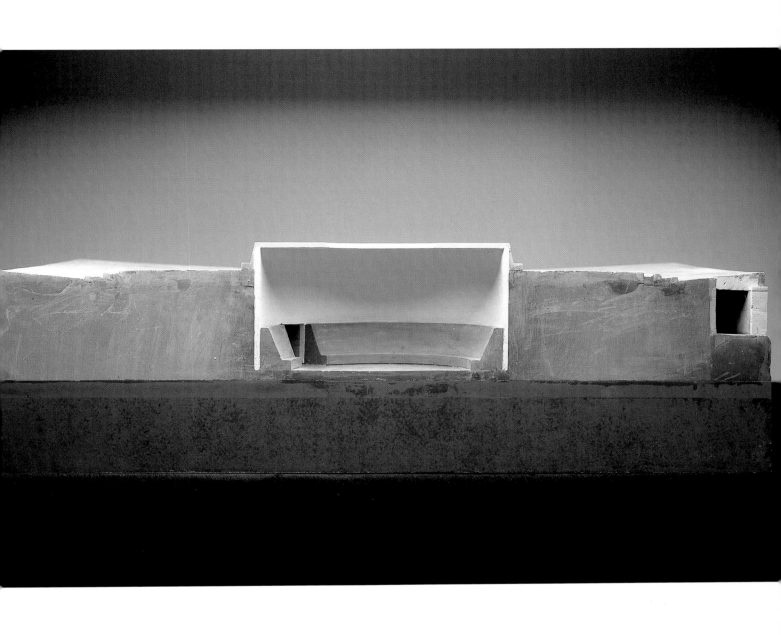

Eye of the Crater Auge des Kraters 1998

2-teiliges Modell / model in 2 parts

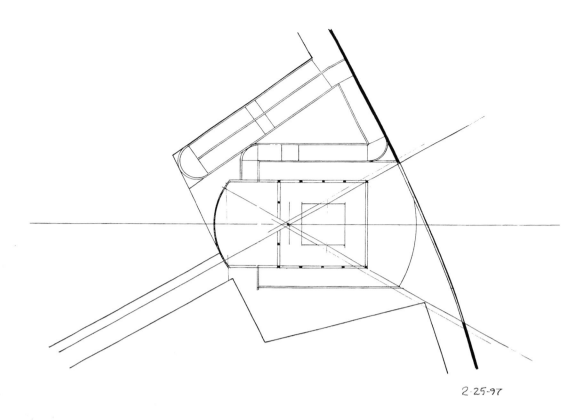

2·25-97

East Space Östlicher Raum 1996
Auf- und Grundriß / elevation and plan view

Der *East Space* ist auf die Painted Desert ausgerichtet und besteht aus einer komplexen Gruppe von miteinander verbundenen Kammern. Die Erschließung erfolgt über eine weitläufige Plaza. Von dort steigen die Besucher entlang einer Treppe zu einem quadratischen Zimmer hinunter, das von einer Kolonnade umrahmt wird. Das Arrangement ist von seinem architektonischen Prinzip her vergleichbar mit den *Skyspaces Meeting* und *Second Meeting*. Die Kammer ist aber nicht künstlich beleuchtet, sondern ausschließlich mit Sonnenlicht durchstrahlt. Durch die nach Osten gerichtete Raumöffnung sieht der Betrachter zuerst ein reflektierendes Wasserbecken, das so angelegt ist, daß das Wasser über eine Schwelle fließt und die Wasseroberfläche als Spiegel fungiert. Von einem Punkt im hinteren Teil des Beckens aus gesehen, bestimmt die Öffnung die beiden äußersten Positionen der Sonnenwenden. Wenn die Sonne aufgeht, scheint sie durch den engen Gang zwischen dem viereckigen und dem sich anschließenden, keilförmigen Raum, und es entsteht ein *Wedgework*. Die vom *East Space* ausgehenden Treppen führen über den Rand der Öffnung und von dort in die Wüste hinunter zu einem Punkt, der einen interessanten Blick zurück auf den imposanten Vulkan bietet.

The *East Space* is oriented toward the Painted Desert and consists of a complex group of interconnected chambers. Viewers initially come to a wide plaza and from there proceed down a stairway into a square chamber with a colonnade sourrounding it. Its general architectural arrangement is comparable to such *Skyspaces* as *Meeting* and *Second Meeting,* but rather than having artificial light inside, this chamber is to be powered wholly by sunlight. The viewer's first view through the east-facing aperture of the space is across a reflecting waterpool. The water in this pool is designed to flow over an edge and to act as a mirror. When sighted from a position near the back of the reflecting pool the aperture of the space fixes the limits of the solstitial extremes. As the sun comes up, its light shines trough the narrow passage between the rectangular and the adjacent wedge-shaped space and generates a *Wedgework.* The *East Space* is designed to have stairs leading over the edge of the aperture and from there out into the desert sloping down to an interesting vantage for looking back at the huge volcano.

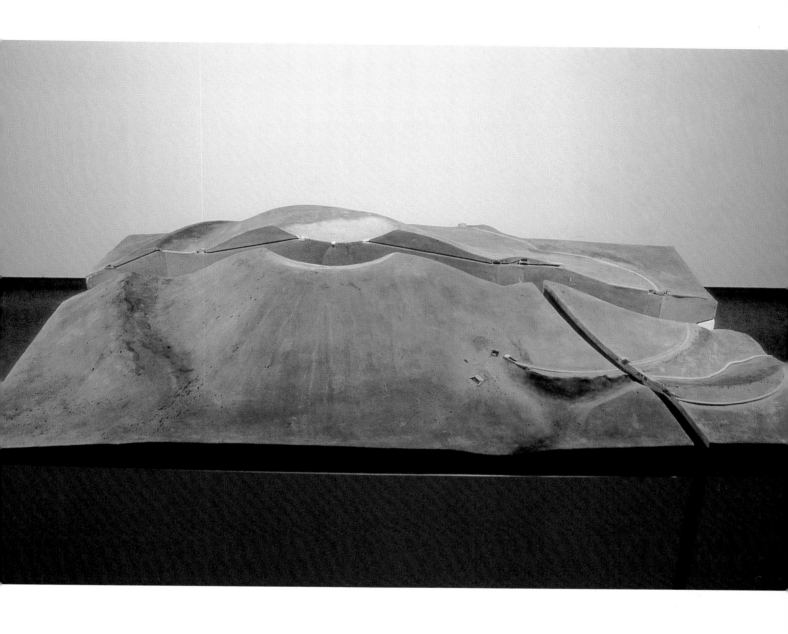

Roden Crater 1987

3-teiliges Modell / sectional model

T-12 Triptych ca. 1983

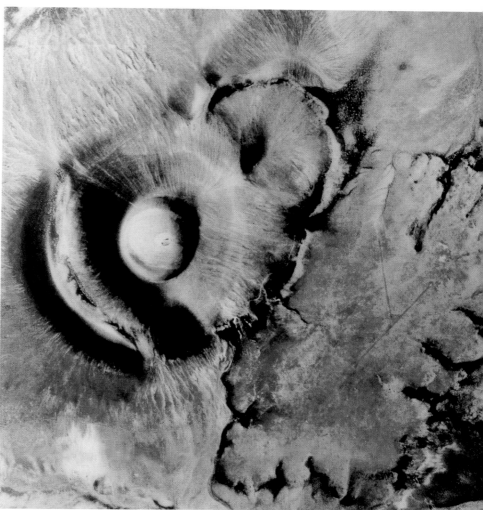

CELESTIAL VAULT IN KIJKDUIN

Auf einer der Gerölldünen von Kijkduin wurde eine ellipsenförmige, dreißig Meter breite und vierzig Meter lange Mulde geschaffen. Ein Erdwall von etwa fünf Meter Höhe umschließt die Mulde und versperrt die Sicht auf die Umgebung. Um in diesen künstlichen Krater zu gelangen, muß man mittels einer hölzernen Treppe die Düne hinaufsteigen und anschließend einen sechs Meter langen Betontunnel durchqueren, der sich in den Krater öffnet. Die Innenseite der Mulde wurde mit Gras bepflanzt, und in der Mitte befindet sich eine riesige Bank aus hellgelbem Stein, groß genug, daß zwei Leute darauf liegen können. Auf einer anderen, etwas höheren Düne weiter oben steht eine zweite Bank. Von diesem Punkt aus hat man völlig freie Sicht, es bietet sich ein Panorama von Meer, Sand und Dünen, die unfaßbare Weite des Himmels darüber. Diese Bank ist ebenfalls groß genug, daß zwei Leute darauf liegen können.

Bei dem viel kleineren Krater in Kijkduin bestimmt der Erdwall des Kraters die Form des Himmelsgewölbes. Änderte man die Form des Walls, erschiene der Himmel anders. Eine kreisförmige Öffnung würde die Wölbung deutlich flacher erscheinen lassen. Ein würfelförmiger Raum mit einer quadratischen Öffnung würde den Himmel völlig abflachen. Diese Wirkung ist sehr deutlich in meinen *Skyspaces* zu beobachten.

Ich denke auch, daß der Himmel als ein Gewölbe erscheint, dessen Höhe geringer ist als der Abstand, den man zum Horizont hat. Aber ich wehre mich gegen die Formulierung, daß das „nur" ein Eindruck ist. Es ist, was wir wirklich sehen. Die Abflachung des Himmels ist unsere Wirklichkeit. Die Tatsache, daß es sich um eine Wirklichkeit handelt, die wir selbst schaffen, tut der beobachteten Wirklichkeit keinerlei Abbruch. Die Welt besteht nicht aus einer Reihe von festgelegten Tatsachen, wir selbst konstruieren die Wirklichkeit mit Hilfe unserer Beobachtungen. Wir erschaffen die Welt um uns herum, merken aber nicht, daß wir dies tun. Im allgemeinen sieht man nicht, wie Licht einen Raum füllt, wir sind uns der materiellen Eigenschaften des Lichts nicht bewußt. In meiner Arbeit wird deutlich, daß der Akt der Beobachtung Farben und Raum erzeugen kann. Aber es ist nie „nur" ein Eindruck, den man erhält, die Augen erleben das Licht tatsächlich in seiner körperliche Präsenz, und es ist auch präsent.

Mit etwas Übung kann man seine Schätzung, wie groß diese augenscheinliche Abflachung des Himmels ist, verbessern. Und durch eine sich stetig verbessernde Schätzung von Entfernungen im Raum lernt man mehr über seine eigenen Fähigkeiten als Beobachter im Raum. Die Kunst zu schätzen ist ein wichtiger Teil des Sich-bewußt-Seins, wie Beobachtung die Wirklichkeit formt. Man kann lernen, Entfernungen zu schätzen. Dies gehört zu jeder Pilotenausbildung. Man kann

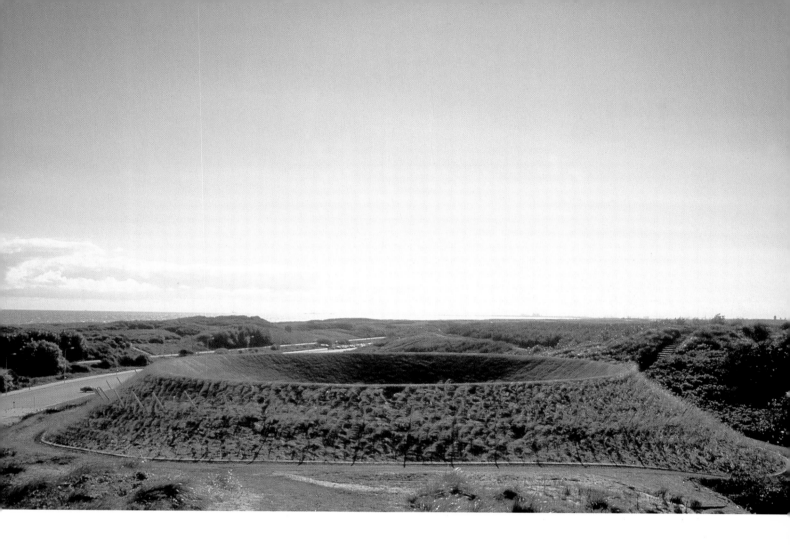

Celestial Vault in Kijkduin 1996
Krater in Dünenlandschaft / crater in the dunes

Entfernungen eigentlich nur sehen, wenn man fliegt. Fliegt man z. B. über den *Roden Crater*, sieht man seine wahre Ausdehnung. Es ist ein Eindruck, den man zurück zur Erde bringt und nicht vergißt. Die Welt verändert sich dadurch für immer. Ohne die Erfahrung des Fliegens ist es sehr schwierig, größere Entfernungen zu schätzen. Besucher des Kraters schlagen nicht selten vor, einen kleinen Spaziergang zum Little Colorado River zu machen, ein Fluß, der nicht weit weg scheint. Sie wollen mir kaum glauben, wenn ich ihnen sage, daß er in Wirklichkeit sehr viel weiter weg ist, kommen aber bald selbst darauf, wenn sie ihn nach einer anderthalbstündigen Wanderung immer noch nicht erreicht haben. Wir haben es hier in der Tat mit dem gleichen Problem zu tun – dem Vertrautsein mit einem bestimmten Maßstab. Vom Himmel aus kommen einem Leute wie Ratten vor, die sich einen Weg durch das Labyrinth suchen. Auf der Erde ist man im Netz einer kleinen Welt gefangen. Am Himmel verändert sich der Maßstab dieser Welt. Die Orientierung verändert sich, und es hat nicht viel zu bedeuten, daß man sich in diesem Netz auskennt. Dies kann sogar gefährlich werden.

At the top of one of the rubbled dunes at Kijkduin a bowl was constructed in the form of an ellipse, thirty meters wide and forty meters long. An earthen wall of approximately five meters high encloses the bowl and deprives one of the surrounding view. In order to arrive at this artificial crater, you must first walk up the dune on a series of wooden steps and then go through a concrete tunnel, 19.5 feet long, that ends up in the crater. The inclination of the bowl has been sown with grass with a monumental bench in soft yellow stone in the middle, large enough for two people to lie on. Another

bench is located on top of a slightly higher dune a little further up. There is a totally unhindered view from this point; a panorama unfolds over the sea, beach and dunes, with an immense expanse of sky above. This bench is also large enough for two to lie on.

In the much smaller crater at Kijkduin, the earthen wall of the crater determines the form of the celestial vault. If you would change the form of the earthen wall, you would observe the sky differently. A circular opening would greatly flatten the vault-like effect. A space in the form of a cube with a square opening flattens the sky completely. You can observe that effect very clearly in my *Skyspaces*. I agree that the sky appears to be a vault whose height above you is much less than the distance between you and the horizon. But I object to the formulation that this is 'no more' than an impression. Because this is what we really see. The flattening of the sky is our reality. Just because this is a reality that we create ourselves, does not take away from the reality of the observation. The world is not a predetermined given set of facts, we construct the world with our observations. You create the world around you, but you are not aware that you are doing so. You generally do not see light filling space, we are not aware of the material nature of light. In my work, you become aware that the act of observing can create color and space. But it is never 'just' an impression that you get, your eyes actually experience light as physically present, and present it is.
Estimating the measurement of the apparent flattening of the sky can be improved with practice. And through a continued improvement in your estimation of the distances in space, you also learn more about your own observational abilities in space. The art of estimation is an important part of the knowledge of how observation forms reality.
You can learn to estimate distances. A pilot is trained to do this. You can only really see distances when you are flying. You can see the true expanse of the area flying above Roden Crater. You take this experience back to the ground and you never lose it. Your world has been permanently changed. Without the experience of flying it is extremely difficult to estimate large distances. Visitors to the crater often suggest taking a walk to the Little Colorado River, a river that does not appear very far away. They can hardly believe it when I tell them that it is a lot further away than it looks. But they come to realize it themselves after one and a half hours of walking without having reached the river yet. In fact, we are dealing here again with the given: being familiar with a particular scale. From the sky, you see people moving like rats seeking their way through a maze. On the ground you are a prisoner caught in the web of a small world. In the sky, the scale of that world changes. Your orientation changes, knowledge of this web does not mean much. That knowledge can even be dangerous for you.

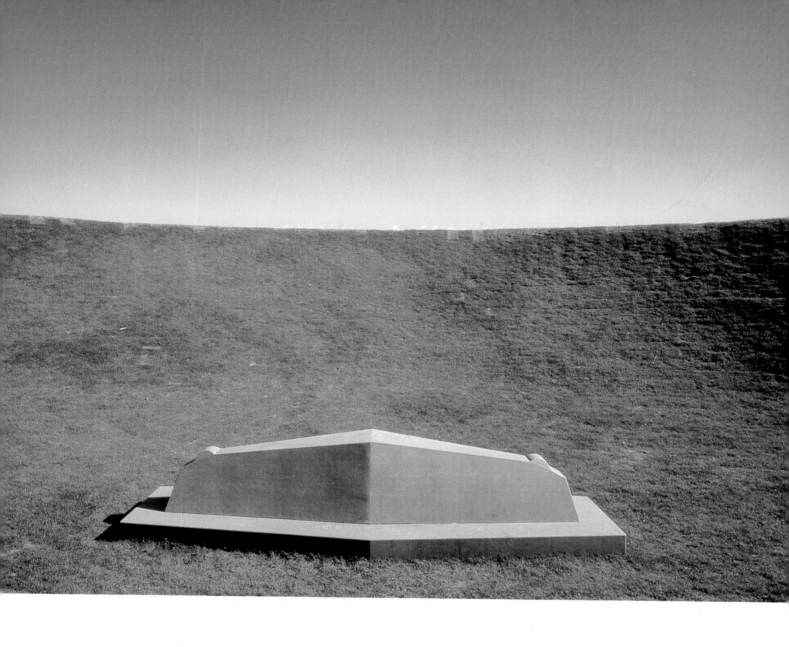

Celestial Vault in Kijkduin 1996

Liegefläche / reclining bench

IRISH SKY GARDEN

1989–91

1989 besuchte James Turrell zum ersten Mal den Südwesten Irlands und das Gelände der Liss Ard Foundation südlich von Cork. Das Liss Ard ist ein ehemaliges Ringfort, das auf prähistorische Siedlungsformen dieser Region verweist. In einem Zeitraum von zwei Jahren entwarf Turrell ein Konzept für die Schaffung diverser Observationsräume in der Landschaft, das in seinen Dimensionen vergleichbar mit dem *Roden Crater Project* ist. Turrells Pläne für den *Sky Garden* berücksichtigen die Topologie des Liss und die Höhenlinien des Geländes ebenso, wie die schnell wechselnden Witterungsverhältnisse und Himmelsphänomene, die für das Klima Irlands typisch sind. Aus den Formen des Terrains arbeitete Turrell vier unterschiedliche architektonische Strukturen heraus: einen elliptisch geformten Krater, einen sanft gerundeten Hügel, eine Pyramide und eine hofartige Umfriedung, die teilweise durch Sichtachsen miteinander verbunden und über Treppen oder unterirdische Tunnel zugänglich sind. Die drei geplanten, ausgeformten Erhebungen, Krater, Hügel und Pyramide bergen in ihrem Inneren je eine zentrale Kammer von elliptoidem, zylindrischem oder kubischem Volumen, die als *Sensing Spaces* spezifisch auf Himmelsphänomene ausgerichtet sind und einen Tages- und Nachtaspekt besitzen. Die Kraterform ermöglicht, tagsüber die domartige Wölbung des Himmels zu erfahren, die sich nachts zu einer umfassenden sternenbesetzten Sphärenwirkung ausweiten kann. Dieser Eindruck der Wölbung ist innerhalb der beiden anderen geplanten Räume zunehmend verändert und verflacht. Die innere Farbigkeit dieser Räume wird in der Wahrnehmung zwischen dunklem Violett und Schwarz changieren. Innerhalb der Pyramide wird der Himmel, wie bei den *Skyspaces*, komplett flach und physisch nahe erscheinen, der nachts als dichte Fläche schwarzen Samtes den Raum nach oben abschließt.

In Turrells *Irish Sky Garden* werden die äußere und innere Welt miteinander verwoben: „Das Wichtige ist, daß das Innere nach außen und das Äußere nach innen gekehrt ist – in dem Sinn, daß die Grenze zwischen der irischen Landschaft und dem Himmel verändert bzw. erweitert wird. Letztlich formen oder bearbeiten wir den Himmel. Seine räumlichen Grenzen zu dehnen heißt, an den Grenzen des Selbst zu arbeiten. Es ist unwichtig, ob die Bildebene körperlich oder ledig-

Der *Irish Sky Garden* wurde, nach mehreren Überarbeitungen der Sichtachsen, sowie der Lagerung und Gestaltung der einzelnen Stationen im Gelände des Liss Ard, Ende 1991 mit baureifen Plänen abgeschlossen und nicht realisiert.

Nach dem Konkurs von Veith Turskes Galerie in Zürich, zog James Turrell seine Urheberschaft von diesem Projekt zurück. Teilbereiche des *Irish Sky Garden* wurden jedoch seither realisiert, weder unter Turrell's Leitung noch gemäß seinen Plänen.

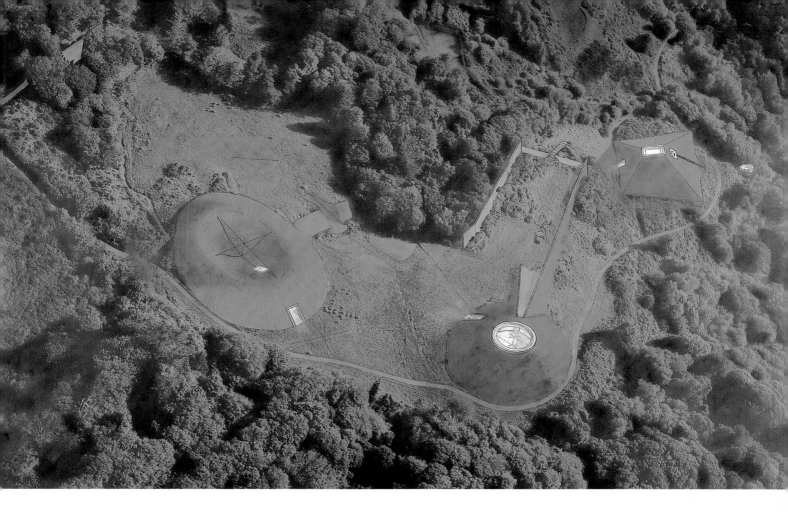

Irish Sky Garden 1991
Lageplan / overall site plan

lich visuell durchbrochen wird. Es handelt sich um dieselbe Art von Grenze, ob sie körperlich oder mit den Augen vollzogen wird. Aus diesem Grund ist die Landschaft als Allegorie des Denkens wie das Formen des Himmels mittels der Umgestaltung der Landschaft, die ihn umgibt. So gesehen, schaut man nicht so sehr in einen Garten hinein, als daß man aus ihm herausblickt." JT

In 1989, James Turrell visited Southwestern Ireland and the site of the Liss Ard Foundation, just south of Cork, for the first time. Liss Ard is a former ring fort, indicating prehistoric settlements in this region. In the two years to follow, Turrell designed a concept for various observation spaces imbedded in the landscape – the dimension of the overall project comparable to the _Roden Crater._ Turrell's plans for the _Sky Garden_ take into account both the topology of the Liss and the contours of the terrain, as well as the everchanging weather conditions and celestial phenomena characteristic for the Irish climate.

In correspondence to natural land forms, Turrell conceived four different architectural structures: an elliptical crater, a mound, a pyramid and a yard-like enclosure. Some of these were to be lined up on a visual axis and accessed by means of stairs or underground tunnels. The three planned, artificially shaped elevations – crater, hill and pyramid – each enclose a central chamber of either ellipsoidal, cylindrical or cubical volume. As _Sensing Spaces,_ these chambers were to accomodate specific celestial phenomena and include a day and night aspect. In the day, the crater form was to provide the possibility of experiencing the dome-shape of celestial vaulting, which may have extended at night to an all-over starlit spherical effect. In the other rooms planned, the impression of vaulting

would be increasingly transformed and flattened, with the color within the room alternating between purple and black. In the pyramid, the sky would appear completely flat and physically close, like a dense blanket of black velvet covering the space from above, as in the *Skyspaces*.

Turrell's concept of the *Irish Sky Garden* perceives of the inner and outer world as interacting in quite a number of ways: "The qualities of inside out and outside in are important in the manner that the boundary of Irish landscape to the sky is worked or made malleable. In the end, we are gardening or tending the sky. Making malleable the physical boundaries is analogous to working the boundaries of self. It is unimportant whether the picture plane is passed through physically or merely with the penetration of vision. It is the same quality of border whether accomplished physically or through the eyes. For this reason landscape as allegory for thought becomes this tending of the sky through the shaping of the landscape which borders it. In this sense you are not as much looking into a garden as you are looking out from one." JT

After several re-workings of the visual axes as well as placement and design of the individual stations on the site of Liss Ard, the concept of the *Irish Sky Garden* was completed at the end of 1991, including detailed building plans. It was not realized.

James Turrell removed his authorship from the project after Veith Turske bankrupted his gallery in Zurich. The portion of the *Irish Sky Garden* that was built, was done so without Turrell's direction and not precisely to his plan.

Crater Spaces

Michael Rotondi

EINE REISE IN DIE WÜSTE, THE PAINTED DESERT

1994 besuchte ich James Turrell an seinem Arbeitsplatz in einem Hangar auf einem kleinen Flug-
platz in Flagstaff, Arizona. In diesem rein zweckorientierten Bau, der im Grunde lediglich aus
einem überdeckten Stahlrahmen bestand, waren Atelier, Büro und Bibliothek sowie ein kleines
Flugzeug untergebracht. Das Flugzeug diente dazu, das Gelände des *Roden Crater* aus der Luft zu
vermessen und Topographie und räumliche Gegebenheiten dieses Teils der Painted Desert genau
zu kartographieren. Die Zeichnungen waren ausführlicher, als es jede schriftliche Beschreibung
dieses ungewöhnlichen Ortes je hätte sein können.

Offiziell war ich angereist, um den Stand des Projekts zu begutachten und daraufhin einem pri-
vaten Sponsor eine Empfehlung auszusprechen. Baupläne und eine vorläufige Kostenschätzung
lagen bereits vor, und meine Aufgabe war, sie vom Standpunkt eines Architekten aus zu beur-
teilen. Ich kannte das Projekt seit vielen Jahren und hatte mich bereits damit und mit den *Earth-
works*, die in den späten sechziger und den siebziger Jahren entstanden, auseinandergesetzt. Diese
Projekte waren von der Größe und vom Umfang her ungeheuerlich. Sie veranschaulichten die
Größenunterschiede, die zwischen der Weite der Landschaft, in die sie eingebettet waren, und
dem Menschen bestehen. Einige dieser Konstrukte konnte man bewohnen, und sie beschworen
eine Art Urerinnerung an die alten Stätten bestimmter erdverbundener Kulturen in Irland, Eng-
land, Mexiko und Peru herauf. Zwar waren Absicht und Bedeutung eine andere, unsere Körper
waren sich dessen aber nicht bewußt. Sie spürten das, was unsere Vorfahren gespürt haben müs-
sen, selbst wenn sich unsere Gedanken unterschieden. Aber Denken hält an Orten wie diesen
nicht lange an. *Roden Crater* sollte der Inbegriff eines *Earthworks* werden. Er wird auch zu den
bedeutenden Werken der Architektur zählen.

Turrell erzählte uns Geschichten aus seinem Leben, sprach über seine Interessen und sein Projekt
und redete ununterbrochen, was immer ihm in den Sinn kam, aber in bedächtigem Ton, so daß
für jeden von uns Raum blieb. Ich hörte zu und ließ meine Augen über die Regale seiner Biblio-
thek wandern. Seine Geschichten schienen den Inhalt der Bücher, deren Titel ich überflog,
zu veranschaulichen: Bücher über Volkssagen, Philosophie, Naturwissenschaft und Geschichte,
zusammengefaßt zu einer großartigen Geschichte der Vergangenheit, Gegenwart und Zukunft
menschlicher Erfahrung. Was er erzählte, war eine Beschreibung und Erklärung seines Lebens-
werks, insbesondere seiner Motivation und des Potentials seines größten Projekts, *Roden Crater*.
Ich habe mit den Jahren gelernt, daß das Vermächtnis der Architektur darin liegt, daß sie dem
Leben Form verleihen kann, wenn die Integrität erdachter und geplanter Ideen im Zuge ihrer

baulichen Umsetzung erhalten werden kann. Die wichtigsten Aspekte dieser Projekte sind uralt:

Ordnung – Eine schlüssige Beziehung zwischen Ort und „Gebäude", und ihre gemeinsame Beziehung zum Himmel.

Raum – Die Dimension und Proportion der Räume im Hinblick auf den sich bewegenden und ruhenden Körper.

Form – Die Form des Gebäudes in bezug auf Form und Raum des Geländes.

Struktur – Der sichtbare oder unsichtbare Umgang mit der Schwerkraft.

Material – Die Idee, daß Licht das primäre Material darstellt, bedeutet, daß Beton, Stahl, Holz usw. „dematerialisiert" werden müssen.

Konstruktion – Es liegt eine inhärente Logik im Bau bestimmter Arten von Gebäuden auf abschüssigem Gelände an entlegenen Orten. Diese Logik beeinflußt nicht nur die Kosten, sondern auch die Ästhetik.

Die Pläne, die ich gesehen habe, waren genau und sorgfältig ausgearbeitet. Sie waren so angelegt, daß die Teile in ihrer Beziehung zum Ganzen gut zu erkennen waren. Die Einteilung in Zonen entsprach der, wie sie später zwischen Räumen und Wegen in der zukünftigen Gesamtkonstruktion bestehen wird. Bei dieser Art von Zeichnung handelt es sich um visuelle Anweisungen für Dritte, die nicht notwendigerweise in der Lage sein müssen, die endgültige Absicht des Projekts zu verstehen oder zu würdigen.

Darüber hinaus verstecken sich in den Zeichnungen Informationen über räumliche Erfahrungen, die sich im Raum zwischen der konzeptionellen Natur orthographischer Zeichnungen, die eine Idee darstellen, und der auf der Wahrnehmung basierenden ganzheitlichen Erfahrung des Körpers, der sich im Raum bewegt, verbergen. Die Zeichnungen schienen dieser Tatsache Rechnung zu tragen.

Über den Ort

Als wir die weite, offene Landschaft durchquerten, verflüchtigten sich meine Gedanken zusehends. Die Hinfahrt vermittelte genug Abstand, um die Erinnerung an die Stadt zu verdrängen. Pflanzliche und steinerne Strukturen bedeckten die Erde, die ockerfarben oder rot, dann wieder schwarz erschien.

Der Himmel war klar und weit, der Horizont von keinerlei Landschaftsformationen unterbrochen. Die Nachmittagssonne bewegte sich auf den westlichen Horizont zu, und die Farbe ihres Lichts veränderte sich, als der Krater ins Blickfeld kam. Seine Größe und sein Umfang waren beeindruckend. Er schien mit einer Geschwindigkeit zu wachsen, die größer war als die, mit der wir uns näherten. Dies überraschte mich. Die weite, ebene Landschaft, die ihn umgab, unterstrich seine perfekte Kegelform und Höhe. Mir kam in den Sinn, daß diese Konstruktion unsichtbar sein würde. Dies widersprach vielleicht der Intuition, aber wir wußten, daß es möglich war; Turrell hatte so etwas zuvor bereits gemacht. Wir würden das, was wir suchten, nicht sehen können – die Dinge um uns herum. In diesem Moment würden wir uns vielleicht über die Art und Weise bewußt, wie wir sehen, und wenn wir darauf vorbereitet wären, könnten wir anfangen, in uns hineinzusehen – denn jeder von uns ist anders. Letztlich ist der Beobachter der BEOB-ACHTETE – ein Leitgedanke spiritueller Lehren und der Quantentheorie.

Die Architektur wird ein transparentes Medium sein, das beim Betreten der Räume spürbar wird. Die Intention ist, das Eintreten in das Licht wahrnehmbar zu machen. Licht ist das Baumaterial, sowohl in bezug auf das Konzept als auch auf die Erscheinung. Turrell selbst hat einmal gesagt, daß Licht ein Material mit greifbaren Eigenschaften ist, die man fühlen kann. Wahrnehmung ist Objekt und Ziel zugleich. Das Projekt wurde nicht als ein Eingriff konzipiert, das dem Land übergestülpt wird. Es entsteht aus dem Land und seiner Beziehung zum Himmel heraus.

Dies ist ein sehr alter Gedanke, der bereits unzählige Male verstanden und realisiert wurde, von autochthonen Völkern, deren erdverbundene Technologien hochentwickelte astronomische und astrologische Kenntnisse einschlossen. So schrieben die Lakota-Indianer aus den amerikanischen Great Plains ihr Wissen über die Sterne bereits vor 2.700 Jahren nieder, wie Legende und Tatsachen bezeugen. Dieses Wissen hatte vor der Ankunft der Europäer sowohl praktische Anwendungen als auch spirituelle Bedeutung. Es führte sie, als sie von Osten nach Westen in die Black Hills von South Dakota und nach Wyoming zogen, dann nach Norden und schließlich hinunter in die südlichen Ebenen. Sie folgten dem Büffel und den Sternen. Ihr Weg und ihre Ruheplätze (Lager) spiegelten die Bewegung der Sonne, des Mondes und der Sterne – oder des Himmelsvolkes – wider. Auch die Beziehung von Erde und Himmel hatte praktischen Sinn und eine tiefe spirituelle Bedeutung. Sie waren unauflöslich miteinander verknüpft. Der Nachthimmel gab Aufschluß über die Lebensgeschichte und den Platz des Menschen auf der Erde. Dieselben Geschichten legten auch unsere Pflichten als Statthalter der Erde dar. Licht war das Medium allen Lebens. Die Lakota glaubten, daß wir aus dem Licht der Sterne geboren sind, daß das Licht Schöpfer aller Materie und Lebewesen ist. Sie entwickelten ganz intuitiv ein eigenes Verständnis der Physik und Metaphysik des Lichts. Das Universum des Großen Schöpfers beinhaltete das Reich der Materie und des Geistes, und der Platz des Menschen in ihnen verlangte, daß er beide Reiche kannte und nutzte.

Eine ganze Reihe von Künstlern und Schamanen haben ihre Ziele selbst bestimmt und verfolgt. James Turrells Ziel ist es, Physik und Metaphysik des Lichts durch direktes Experimentieren zu ergründen; man könnte ihn daher auch als experimentellen Gelehrten bezeichnen. Er hat dies auf unterschiedliche Weise getan: Zuerst in kontrollierbaren Situationen, in denen Raum und Licht konstant sind und die einzige Variable darin besteht, wie es gesehen und interpretiert wird. Dann in vorhandenen Räumen, die Öffnungen zum umgebenden Raum aufweisen und unverändert bleiben, aber durch das von den Öffnungen geformte Licht und dem täglich wiederkehrenden Lauf der Sonne immer neu definiert werden. Und schließlich durch die neuen Konstruktionen, die so gestaltet und präzise darauf ausgerichtet sind, daß sie das Licht der Sonne und bestimmter Ereignisse am Himmel auffangen. Es handelt sich hier um eine instrumentalisierte Architektur, nicht um bloße Bauten. Ihre Größenordnung ist dem Menschen angemessen, der zum Spürmolekül wird, das das Wissen der Sphären in den unterschiedlichen Farben des Lichts aufnimmt, im Lauf eines Tages, eines Monats, einer Jahreszeit, eines Jahres. Das menschliche Molekül ist keineswegs nebensächlich in diesem Prozeß. Als Bewußtsein des Geschehens spielt es eine sehr wichtige Rolle. Dieses Geschehen läßt uns etwas nie zuvor Gesehenes sehen und zeigt uns, wie wir sehen und was dies alles bedeutet: Eine körperliche und sinnliche Erfahrung, die eine tiefere Bedeutung beinhaltet, eine zeitgenössische Form einer uralten Beziehung.

Die Welt mag sich am Ende als rational erweisen, aber ihre Strukturen sind komplexer und mannigfaltiger als die, die sich unseren Sinnen unmittelbar offenbaren. Eines Tages in der nahen Zukunft, wenn wir die lichtdurchfluteten Räume von James Turrells *Roden Crater* betreten können, werden wir von dem, was uns gegenübersteht, erweckt, und wenn wir uns nicht abwenden, sondern unseren eigenen Möglichkeiten öffnen, wird sich unsere gewohnte Art zu sehen für immer verändern.

Michael Rotondi

TRIP TO THE PAINTED DESERT

In 1994, I went to meet James Turrell in Flagstaff, Arizona at his workplace in a hangar at a small air-port. This utilitarian steel framed and skinned building was where his studio, office and library were along with his small plane. The plane was his means of surveying the site of the *Roden Crater* from above and documenting precisely, the topography of land forms and spatial conditions of this part of the Painted Desert. The drawings were as rich as any text that might describe this extraordinary site. I was there officially to review the status of the project in order to make a recommendation to a private funder. Construction drawings and a preliminary cost estimate were now completed and my task was to assess them from the vantage of an Architect. I had known of this project for many years and had studied it along with Earthworks conceived and built throughout the late 60's and 70's. These projects were large in size and scope. They mediated the scale differences between the vastness of the landscape they resided in and in humans. Some of these constructions could be inhabited evoking the deep cellular memory of ancient places of the Earth based cultures of Ireland, England, Mexico and Peru. The purpose intended and meanings were different but our bodies did not know this. They felt the same things that the Ancient ones must have felt but perhaps our thoughts were different. But thinking did not last very long in places like this. *Roden Crater* was going to be the quintessential Earthwork. It will also be among significant Architectural work.

Turrell told us stories about his life, his interests, and his project in a continuous stream of words spoken extemporaneously but with a deliberate cadence that created a space for each of us to inhabit. I listened as my eyes moved across the shelves of his library. His stories seemed to be extracting the words from each of the books I was reading the title of. Books on Folktales, Philosophy, Science, and History were unified into one grand story of the past, present and future human experience. These stories described and explained his life's work and in particular the motivation and potential for his biggest project of all, *Roden Crater.*

I learned over the years that the promise of Architecture was that it could give form to life. If the ideas conceived and modeled could be kept intact as they become a reality through construction, the main aspects of this type of project are age old.

Order	– A coherent relationship between the site and 'Building' and together their relationship to the sky.
Space	– The dimension and proportion of the spaces as the body moves and rests.
Form	– The form of the building in relationship to the form and space of the land.
Structure	– The means by which gravity is dealt with, visibly or invisibly.

Material – The idea that light will be the primary material means that concrete, steel, wood, etc., will have to be 'dematerialized'.

Construction – There is an inherent logic in constructing certain types of buildings on a sloping site in a remote place, this logic influences both cost and aesthetic.

The construction drawings that I saw were precise and thorough. They were laid out in a way that made it possible to comprehend the parts in relationship to the whole. The drawings were zoned as the overall construction will be zoned between chambers and paths. These types of drawings are visual instructions to a team of others who do not necessarily understand or appreciate the final intent of the project.

They also contain the hidden information of spatial experience enciphered in the space between the conceptual nature of orthographic drawings that represent thought and the perceptual nature of the full experience of the body moving within space. These drawings seemed to understand this fact.

To the Site

All of my thoughts continually evaporated as we moved across the vast open landscape. The drive was in distance enough to leave the memory of the city behind. The texture of the plants and rocks overlaid the changing color of ocher, red and black earth.

The sky was clear and wide; uninterrupted by any land forms. The mid afternoon sun was moving toward the Western horizon and changing the color of its light as the crater came into view. The size and scale of it was impressive. It seemed to be growing in size at a rate greater than the speed which we approached it. This surprised me. The flatness of the land around it served as a datum for the perfect conical shape and height. I thought, this construction must be invisible. This might seem counter-intuitive, yet we knew it was possible since Turrell had done this before. We would not be able to see what we were looking for – things around us. At that moment, maybe we would become aware of how we see and if we are prepared we can begin to see inside ourselves, for each of us is different. After all, the observer is the OBSERVED. This is a precept of spiritual teaching and quantum theory.

The Architecture will be a transparent medium that can be felt as one enters the spaces of it. What is intended is to sense entering into the light of the space. Light is conceptually and phenomenally the material of construction. As Turrell has stated, light is the material with tangible qualities that can be felt. Perception is the object and the objective. The project was not conceived as something being placed on the land. It emerges from the land and its relationship to the sky.

This is an ancient notion understood and constructed many times by the Indigenous communities who developed earth-based technologies that incorporated sophisticated knowledge systems of astronomy and astrology. The Lakota of the great plains of America began writing their star knowledge 2,700 years ago according to fact and legend. This knowledge had both practical application and spiritual meaning prior to the arrival of the Europeans. It guided them as they migrated in a clockwise manner East to West into the Black Hills of South Dakota into Wyoming and then heading North in an easterly direction and then down to the Southern part of the plains. They followed the buffalo and the stars. Their path of movement and their places of rest (encampment) mirrored the movement of The Sun, The Moon and The Stars, or The Sky Nation. The relationship of The Earth and Sky had both practical significance and profound spiritual meaning. They were interdependent. The night sky held the stories of life in the universe and the place on Earth that humans occupied. These stories also told of our responsibilities as Stewards of The Earth. Light was the medium of life. They believed that we are born out of the The Light of The Stars. That light is the maker of all material and living things. Intuitively, they developed their own understanding of both the

physics and metaphysics of light. It was after all, The Great Creator's universe materially and spiritually and the place of humans within both called for knowledge and the practice of both realms. Some Artists and Shamans have directed themselves for the end they have chosen. James Turrell has chosen to explore the physics and the metaphysics of light by way of direct experimentation. He is an experimental scholar. He has done this in several ways. First, in controlled environments. The space and the light remain constant. The variable is how it is seen and interpreted. Second, in a found space that has openings to the outside space which remains constant and is apparently reconfigured by the light shaped by openings and the diurnal cycle of the sun. Third, are the new constructions that are shaped and oriented with precise alignments to intercept the light of the sun and of specific celestial events. This is an Architecture of instruments, and not merely buildings. It is of a scale appropriate to humans becoming the sensing molecules that receive the information of the spheres in the various colors of light, diurnally, monthly, seasonally, annually. The human molecule is not incidental in this process. It is critical in that we are the consciousness of the event. This event allows us to see what we have not seen before and in turn makes us aware of how we see and what this all means. A physical and sensuous experience out of which emerges (hopefully) a profound meaning

A contemporary form of an ancient relationship.

The world may prove to be rational in the end, but its structures are more complex and varied than those immediately revealed to our senses. Sometime in the near future, when we can enter the lighted chambers of James Turrell's *Roden Crater,* we will be awakened by what confronts us and if we do not turn away and instead open ourselves up to our own possibilities, then our habitual ways of seeing will be forever transformed.

LICHTARCHITEKTUR /
ARCHITECTURE OF LIGHT

1977–1998

CHAPEL OF LIGHT, Varese, Italy

MEDITATION HOUSE, Niigata, Japan

BACKSIDE OF THE MOON, Honmura, Japan

LIVE OAK FRIENDS MEETING, Houston, USA

MAK SKYSPACE, Vienna, Austria

WOLF, San Francisco, USA

VERBUNDNETZ GAS AG, Leipzig, Germany

PERFORMING LIGHTWORKS, Bregenz, Austria

MAK FACADE, Vienna, Austria

LICHTARCHITEKTUR

Im Verlauf der letzten 20 Jahre beschäftigte sich Turrell, neben dem *Roden Crater Project,* mit einer Reihe von unterschiedlichsten, architektonischen Projekten. Einige, vor allem die frühen Entwürfe der 70er Jahre, verblieben meist in einem Entwurfszustand und wurden nicht realisiert. Dennoch ist ein konzeptioneller Einfluß dieser Arbeiten auf die Projekte der 90er Jahre vorhanden und bilden so insgesamt eine in sich geschlossene Werkgruppe. Gedanklich stehen die Skizzen, Pläne und abgeschlossenen Arbeiten in engem Bezug zu den *Mendota Stoppages,* als daß sie den architektonischen Raum nicht als funktionalen, undurchlässigen Korpus sondern als transformativen Ort auffassen, der als *Sensing Space* in relationaler Korrespondenz mit seiner Umwelt existent ist. Turrells Arbeit mit vorhandener Architektur (z. B. *Performing Lightworks,* Bregenz 1997) behandelt die Ambivalenz von Gegenstandsbegrenzung und Gegenstandsbedeutung, indem er Licht als Randverstärker der architektonischen Volumina einsetzt und dabei ihre Ordnung und Dimensionalität aufbricht. Die durch Turrells Lichtinstallationen stattfindende Auflösung von materialen Grenzen, bedeutet und zwingt Architektur anders zu denken: als Fragment der Zeit und wandelbare, ephemere Erscheinung durch Licht. Das Sehen und die physische Erfahrung von Raum eröffnet eine elementar sinnliche Begegnung mit architektonischen Strukturen, befreit von überkommenen, begrifflichen Vorstellungen. Turrell begreift darüber hinaus Raum als elementare Voraussetzung allen Gemeinwesens in der Auffassung vom „Haus als erstem All"[1], das durch das Öffnen des Baukörpers mit eingelagerten *Skyspaces,* den Innenraum in einer unmittelbaren Verbindung zum Außen aktiviert.

„In bezug auf Architektur fällt besonders auf, daß es heute im allgemeinen um Formen und nicht um Räume geht. Es werden Räume erzeugt, indem man Formen bildet und sich dann irgendwie um das Licht kümmert. Das kann natürlich kein Zusammenspiel von Raum und Licht ergeben, und die Plazierung der Öffnungen, durch die das Licht einfällt, ist entweder vollkommen willkürlich oder ergibt sich durch die gewünschte Aussicht oder die gewünschte Lichtmenge. Es kommt selten vor, daß das Licht den Raum belebt, aktiviert – den Raum mit Atmosphäre füllt. Was unsere Städte betrifft, halte ich es für einen der größten Fehler, daß man die Nächte erleuchtet und so das Universum unserer Wahrnehmung entzieht. Sobald man uns mit Licht umgibt, verhält es sich genauso, wie wenn man in einem Haus die Lichter einschaltet: man sieht nicht mehr in die Nacht hinaus. Und indem man uns den Blick auf die Sterne nimmt, verstellt man uns einen ganz starken psychologischen Zugang zu einem größeren Raumempfinden. Diese Aspekte scheinen mir für die Architektur relevant zu sein. Mir geht es um Kunst, nicht um Architektur, auch wenn es bei dem was ich tue, um die strukturelle Erschaffung von Realität geht. Meine Tätigkeit ist am ehesten mit Arbeiten im akustischen Bereich zu vergleichen, mit der Planung von Bühnen und ähnlichen Dingen. Es hat sich gezeigt, daß die Akustik eine viel größere Kunst ist, als man je angenommen hat. Für mich ist Lichtarchitektur irgendwie ähnlich." JT

1 Gaston Bachelard, *Die Poetik des Raums,* S. 31

ARCHITECTURE OF LIGHT

Over the last 20 years, Turrell has worked on a variety of architectural projects aside from the spaces for the *Roden Crater Project*. Some of them, especially his early concepts from the seventies, were never realized beyond the drafting phase. Conceptually, these works nevertheless foreshadow the projects of the nineties and may be considered to form a complete group of works. Intellectually, the sketches, plans and finished works are closely related to the *Mendota Stoppages* that they do not deal with the architectonic space as a functional, impermeable body but as a place of transformation which, as a *Sensing Space,* exists through and in its correlation with its surroundings. Turrell's work with existing architecture explores the ambivalence of the boundaries and meaning of objects, using light as a means to reinforce the margins and borders of architectural bodies and thus breaking up their structural order and dimensionality. The dissolution of material boundaries effected by Turrell's light installations (e. g. *Performing Lightworks,* Bregenz 1997) does not merely present but enforces a new kind of architectural thinking: as a fragment of time and a changeable, ephemeral appearance through light. Seeing and the physical experience of space paves the way for an elementary, sensual encounter with architectonic structures, free of conventional conceptual notions. Turrell sees space as the elementary condition for all common living, not unlike the idea of "the house as the first universe"[1], which, by opening its structural corpus with imbedded *Skyspaces,* activates the inside in its immediate relation to the outside.

"One of the things in architecture is that, generally, people are making forms and not spaces. People make space by making forms and then stick the lights in. That doesn't get you the working of light into space and often the openings – the way light is let into a space – are completely arbitrary or oriented toward a view or the amount of light to come in. It is rarely done in the way that light activates the space and makes it alive – so that you get space filled with atmosphere. In terms of urban situations, one of the biggest mistakes is that by using light to lite the night we close off our perception of the universe. As you put light around us – it's just like having the lights on inside of a house – you don't see into the dark. This lack of vision to the stars really cuts off our very powerful psychological access to a larger sense of territory. These things might be something for architecture. I am involved in art, as opposed to architecture, although what I do is a structuring of reality by building. I think my work could be the closest to someone who works in acoustics, who is designing stages and things like that. Acoustical engineering turns out to be much more of an art than we have ever expected it to be. For me, building with light is a little bit along the same lines." JT

1 Gaston Bachelard, *Die Poetik des Raums*

Chapel of Light 1977

Im Jahre 1977 arbeitete Turrell auf Verlangen von Giuseppe Panza di Biumo Entwürfe für eine katholische Kirche aus. In diesen Plänen sind eine Reihe von *Skyspaces* in der Form eines lateinischen Kreuzes ange-ordnet. In der Dämmerung sollten Betrachter die Möglichkeit haben, von festgelegten Standorten aus die Veränderung der Himmelsfarben zu beobachten, oder sich im Haupt- und Querschiff oder Chorraum von *Skyspace* zu *Skyspace* zu bewegen. Der Entwurf ermöglicht dem Betrachter nicht nur aus dem Innern der *Skyspaces* zum Himmel hinaufzusehen, sondern auch auf eine Art Tribüne zu steigen und von dort in die Säle hinunterzuschauen. Von dieser Perspektive hoch oben erscheinen die Räume mit einer Art *Ganzfeld*-Licht gefüllt. Die *Chapel of Light* wurde bisher nicht verwirklicht.

In 1977, Turrell worked out preliminary designs for a Catholic church at Giuseppe Panza di Biumo's behest. In these plans a Latin cross structure incorporates a number of interrelated *Skyspaces*. During twilight transi-tions, viewers would be able to watch the sky change color from stationary positions or engender additional changes by moving from *Skyspace* to *Skyspace* in the nave, transept, and choir areas of the church. The church is designed so that viewers would not only be able to look up at the sky from inside the *Skyspace* chambers, but would also be able to walk up to a kind of tribune area and look back down into the chambers from above. From this high perspective, the spaces would be filled with *Ganzfeld*-quality light. The *Chapel of Light* has not been realized.

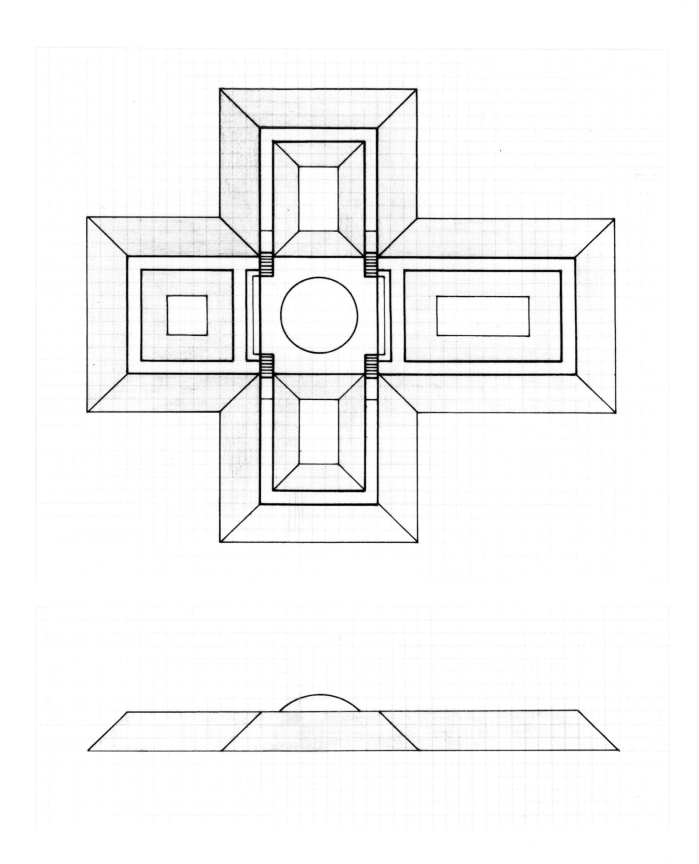

Meditation House (Niigata, Japan) 1998

Das *Meditation House* gehört zu der Reihe von Turrells Architekturprojekten, die als spirituelle Gemein-schaftshäuser konzipiert sind. Strukturell greift es die äußere Form und Gliederung der traditionellen, japa-nischen Bauweise auf. Im Dach des *Meditation House* ist ein *Skyspace* eingelagert, das das Haus bis zu seiner unteren ersten Geschoßhöhe mit Licht durchdringt. Turrells Kenntnis und Faszination von japanischer Kul-tur und Brauchtum spiegelt sich in seinem sensiblen Umgang diesen Raum zu bilden, der die Philosophie des Zen-Buddhismus reflektiert und im Gegensatz zum abbildhaften Sehen die sinnliche Erfahrung eines nicht fokussierten, rahmenlosen, inneren Sehens in den Mittelpunkt stellt.

The *Meditation House* belongs to a series of architectural projects conceived by Turrell as spiritual meeting houses. Its outer form and structure rely on Japanese building traditions. The roof of the *Meditation House* incorporates a *Skyspace* which supplies the whole building with light, down to the first floor. Turrell's knowl-edge and fascination for Japanese culture and traditions is illustrated by his sensitive treatment of this space. Inspired by Zen Buddhism, it is centered around the sensual experience of a non-focussed, meditative inner seeing as opposed to an outgoing image-oriented perception.

Pavilion for "Backside of the Moon" (Honmura, Japan) 1998–99
Architektur / architecture: Tadao Ando

Seit 1992 verfolgt das Naoshima Contemporary Art Museum ein Ausstellungskonzept zu Natur, Architektur und Kunst auf den Inseln der Seto Inland Sea. Die aus der Kooperation zwischen dem japanischen Architekten Tadao Ando und Turrell entstehende Arbeit ist die Zweite einer Reihe von permanenten Installationen im Stadtraum von Honmura, die innerhalb des 400 Jahre alten, historischen Bezirks des Jizohji-Tempels realisiert werden soll. Für *Back Side of the Moon,* eine *Space Division Construction,* ist ein längsrechteckiger Pavillon aus Holz geplant, ein Material, das Ando sonst sehr zurückhaltend einsetzt. Die Größenverhältnisse und räumliche Strukturierung des Pavillons sind auf die Erfordernisse der Lichtarbeit abgestimmt und verleihen ihr eine räumliche wie zeitliche Präsenz. Der Eintritt in den Lichtraum wird durch einen Gang außerhalb des Pavillons vorbereitet, der zwischen Außen und Innen vermittelt und zu den Resten eines Gemäuers führt; dem ehemaligen Wohnsitz eines Shinto-Priesters. Das Projekt soll japanische Tradition und Spiritualität mit zeitgenössischer Kunst und Architektur verbinden.

The Naoshima Contemporary Art Museum has been working with the concept "nature, architecture and art" on the Seto Inland Sea islands since 1992. The work, a joint project by Turrell and the Japanese architect Tadao Ando, is the second in a series of permanent installations in the residential area of Honmura and is intended for the 400-year-old historical area of the Jizohji temple. For *Back Side of the Moon,* a *Space Division Construction,* the plan is to build an oblong, rectagular pavilion made of wood, a material Ando has scarcely used in the past. Both the scale and spatial structure of the pavilion are tailored to the requirements of the light work, providing it with spatial and temporal presence. The passage down the lenght of the pavilion leads to the entrance at the back. The passage also acts as mediator between the outside and the inside and leads to the remnants of an earthen wall, the former residence of a Shinto priest. The project intends to reconcile Japanese tradition and spirituality with contemporary art and architecture.

Architecture

SECTION THROUGH MEETINGHOUSE

0 5' 10' 20'

1. Porch
2. Foyer
3. Meeting room
4. Reading room

Live Oak Friends Meeting (Houston, USA) 1995–99
Architektur / architecture: Leslie K. Elkins Architecture

Im Januar 1999 wird das *Live Oak Friends Meeting* in Houston den Grundstein für ein neues Gemeinschafts-
haus legen, dessen Pläne von Turrell zusammen mit Leslie K. Elkins Architecture erarbeitet wurden. Es han-
delt sich um ein Gebäude im ortsüblichen Stil, das in einer Wohngegend gelegen, traditionelle Quäker-
Elemente, zeitgenössische Formen sowie umweltfreundliche Architektur zu verbinden sucht. In der Mitte
des Gebäudes ist ein zentral angelegter *Skyspace* (ermöglicht durch ein Schiebedach) geplant.

In January of 1999, the *Live Oak Friends Meeting* of Houston will break ground on a new meeting house that
Turrell has collaborated on with Leslie K. Elkins Architecture. Situated in a tree-laden residential neighborhood,
it will be a contemporary vernacular building, mindful of Quaker history as well as of contemporary and
environmental needs. It will feature a centrally located *Skyspace* (made possible by a rectractable roof) right
at the heart of the meeting house.

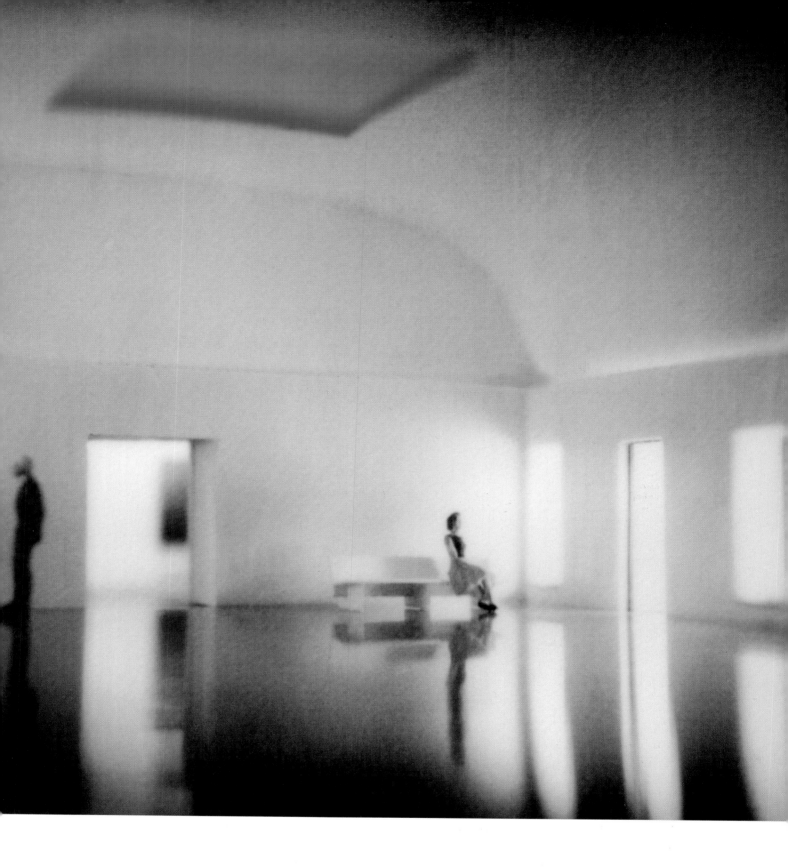

Meeting Room (CAD-Simulation) 1998

Architecture

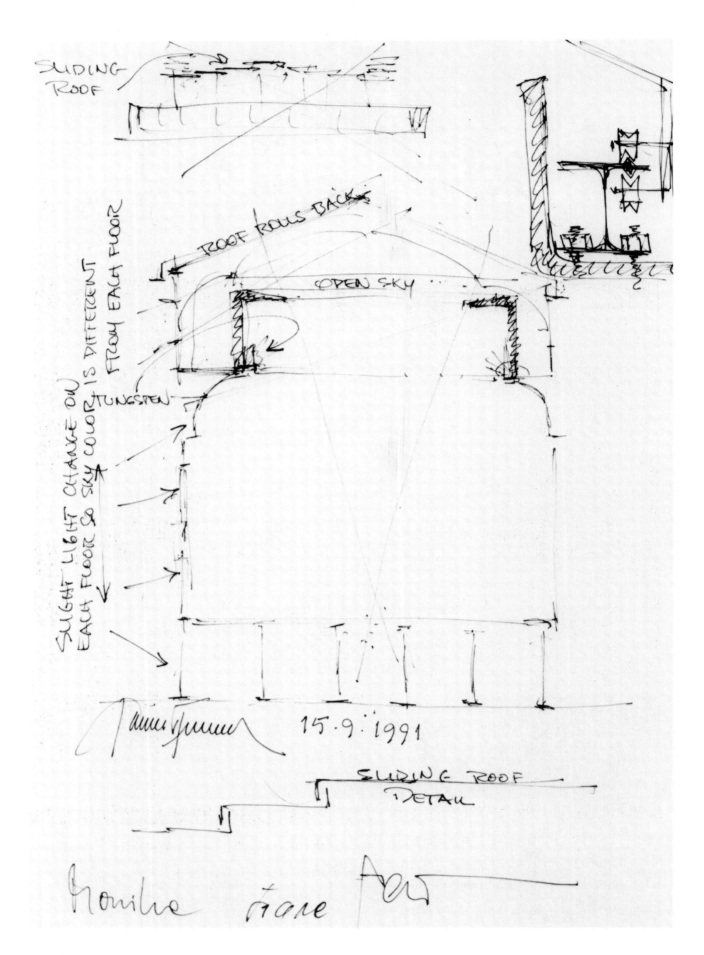

SLIDING ROOF

ROOF ROLLS BACK

OPEN SKY ...

SLIGHT LIGHT CHANGE ON EACH FLOOR SO SKY COLOR IS DIFFERENT FROM EACH FLOOR

TUNGSTEN

15·9·1991

SLIDING ROOF DETAIL

MAK Skyspace 1991

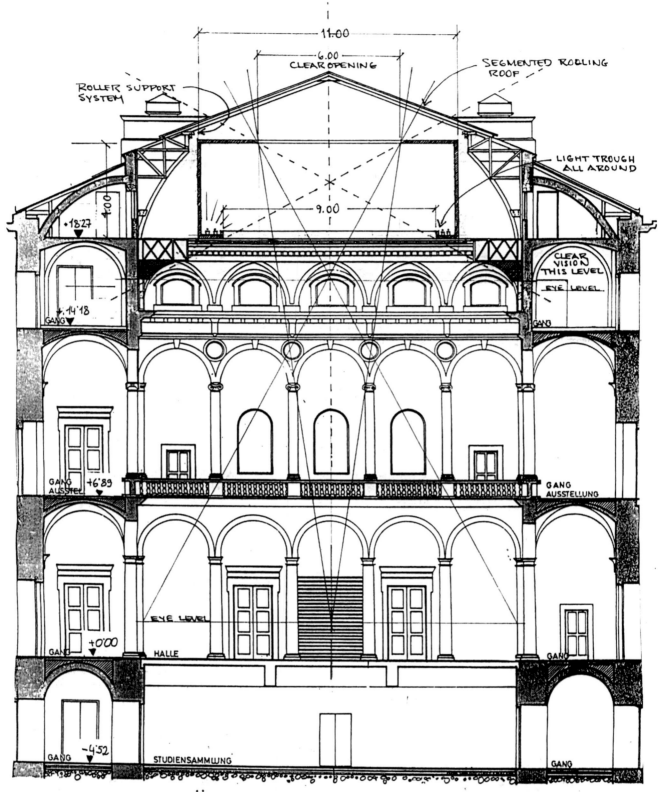

11.00

6.00
CLEAR OPENING

SEGMENTED ROLLING
ROOF

ROLLER SUPPORT
SYSTEM

LIGHT TROUGH
ALL AROUND

9.00

4.00

+18.27

CLEAR
VISION
THIS LEVEL

EYE LEVEL

+14.18

GANG

GANG

GANG
AUSSTEL

+6.89

GANG
AUSSTELLUNG

EYE LEVEL

+0.00

GANG

HALLE

GANG

GANG

-4.52

STUDIENSAMMLUNG

GANG

SKYSPACE FOR: ÖSTERREICHISCHES MUSEUM FÜR ANGEWANDTE KUNST
WIEN, AUSTRIA JAMES TURRELL 14.10.1991

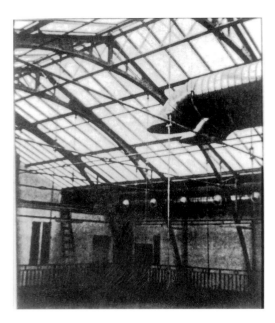

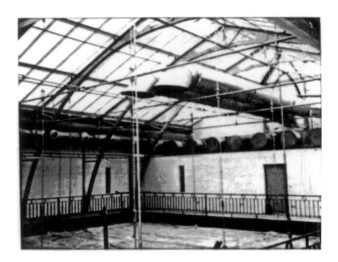

MAK Skyspace (Vienna, Austria) 1991

Entwurf für die Säulenhalle, nicht realisiert / proposal for the Main Hall, unrealized

1991, im Zuge der Generalsanierung des MAK, enstand ein Entwurf für ein *Skyspace*, das den Innenraum der Säulenhalle mit Außenlicht durchfluten sollte. Wie im Aufriß zu sehen, ist für das *Skyspace* ein Einschnitt in die Deckenkonstruktion vorgesehen, der mittels einer hydraulischen Schließvorrichtung (rolling roof) aktiviert werden kann. Der Lichteinfall durch die vorhandene Glasdecke ist genau auf die Dimensionen des Innenraumes und eine entsprechende Augenhöhe abgestimmt, so daß das Mezzanin wie die zwei Hauptgeschoße mit jeweils unterschiedlichen Lichtphänomenen in Farbigkeit und Intensität während des gesamten Tagesverlaufs ausgefüllt werden.

In 1991, in the course of the renovation of MAK, James Turrell proposed a *Skyspace* which was to flood the interior of the Main Hall with light from the outside. As the draft shows, the *Skyspace* involved an opening in the ceiling which was to be activated by means of a hydraulic rolling roof. The light admitted through the existing glass roof is tailored to the dimensions of the interior space and a suitable eye level, infusing both the mezzanine and the two main floors with light phenomena of varying colors and intensity during the day.

Wolf (Capp Street Project, San Francisco, USA) 1984
Temporäre Außeninstallation / temporary installation

1984 nahm Turrell an einem Projekt des Capp Street Project teil, in dessen Rahmen Künstler aufgefordert wurden, ortsspezifische Arbeiten zu realisieren. Turrell installierte im Innern eines Gebäudes fluoreszierendes, blaues Licht, das durch Fenster und schmale Schlitze nach außen drang. Die tageszeitlichen Unterschiede der inneren Lichtwirkung im Verhältnis zum Außenlicht erhielten dabei eine besondere Qualität im Zusammenwirken mit der reflektierenden Metallfassade des Gebäudes. Nachts veränderte Turrell zusätzlich die Straßenbeleuchtungen, so daß das Gebäude in einem leuchtend tiefen Grün erstrahlte. Die konzeptionelle Nähe von *Wolf* zu den ersten Arbeiten im *Mendota* ist offensichtlich, dennoch umgekehrt in seiner Realisation und Wirkung: das bei *Wolf* nach außen dringende Licht gestaltete den urbanen Raum als *Sensing Space*, der in Korrespondenz mit der starken physischen Präsenz des lichterfüllten architektonischen Korpus trat und besonders nachts das Außenraumgefühl des Betrachters in das eines Innenraums verkehrte.

Wolf 1984
Tages- und Nachtansicht / day and night

In 1984, Turrell took part in one of the Capp Street Projects that called for artists to create site-specific works. Turrell installed in the inside of the building fluorescent blue lights which shone to the outside through windows and small apertures. The relationship between inner and outer light that appeared in the course of the day took on a special quality as the light interacted with the reflecting metal facade of the building. At night, Turrell also altered the street lighting in a way that the building seemed to be in a deep green light. There is an obvious conceptual affinity to the first pieces ot the *Mendota*, but realization and effect are different: In *Wolf*, the light escaping to the outside transformed the urban space into a sensing space which interacted with the strong physical presence of the light-filled structure and turned the viewer's outside feeling into an inside feeling, particularly at night.

 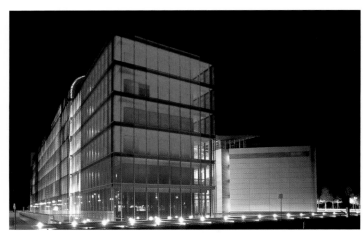

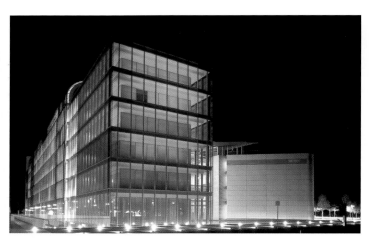 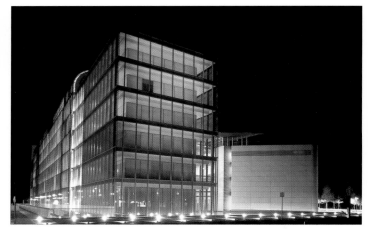

Hauptverwaltung der Verbundnetz Gas AG (Leipzig, Germany) 1997
Permanente Außeninstallation / permanent installation
Architektur / architecture: Becker Gewers Kühn & Kühn, Berlin

Zusammen mit dem Architektenbüro Becker Gewers Kühn & Kühn entwickelte Turrell für den Verwaltungsturm der *Hauptverwaltung der Verbundnetz Gas AG* ein Beleuchtungskonzept, das an das Energiekontrollsystem des Hauses angeschlossen ist. Dieses „intelligente" System reagiert selbsttätig auf seine äußere Umgebung wie Lichtverhältnisse, Klima und Witterung und stimmt sie auf den Energiebedarf und die Beleuchtung im Haus ab. Die illuminierte Glasfassade steht so in einem steten und direkten Wechselspiel zu den Bedingungen des Außenraumes, so daß im Zuge der Abenddämmerung das Lichtspiel der Farbmischungen von Zartrosa über Orange und Rot bis zu unterschiedlichsten Blautönungen beginnt.

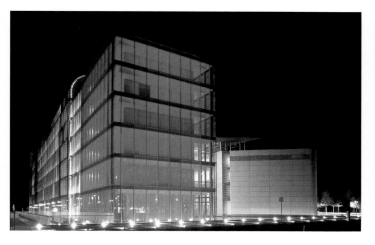
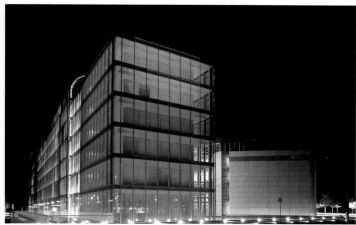

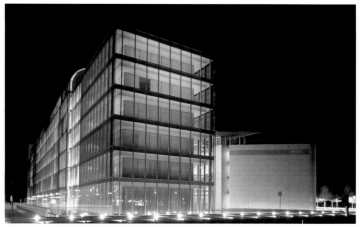
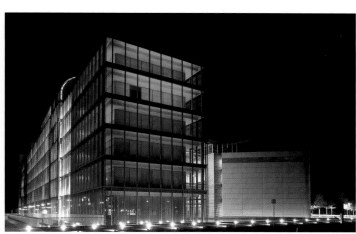

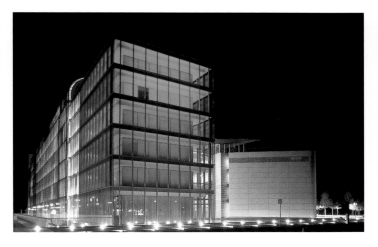
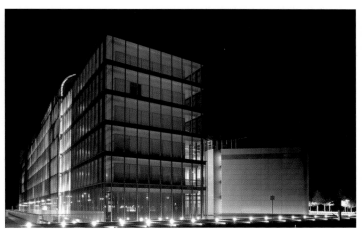

For the administrative tower of the *Central Headquarters of the Affiliated Gas Companies Network* building, Turrell and the architecture firm Becker Gewers Kühn & Kühn developed a lighting concept which is connected to the energy control system of the house. This "intelligent" system reacts automatically to surrounding factors such as light, climate and temperature, adjusting both the energy requirements and lighting of the house accordingly. The illuminated glass facade thus interacts directly with exterior conditions and, as dusk sets in, produces an installation of colored lights ranging from pale pink to orange to red to various shades of blue.

Performing Lightworks (Kunsthaus Bregenz, Austria) 1997
Temporäre Außeninstallation / temporary installation

Im Rahmen der Eröffnungsausstellung des Kunsthaus Bregenz im Juli 1997, realisierte Turrell eine Lichtin-
stallation, die die gläserne Fassade des Museums bespielte und das gesamte Gebäude in einen transluziden
Körper verwandelte. Wie bei Turrells permanenter Arbeit in Leipzig bestand die Qualität der Bregenzer
Installation in einer Einbindung des Lichts in den architektonischen Rahmen der Glasfassade. Turrell
beschrieb in seinem Entwurf die Abstimmung und Wirkungsweise des Bregenzer Projekts: „Der Raum
zwischen der inneren Struktur und der Fassade wird durch eine Serie von farbigen Lichtern erleuchtet. Jede
dieser Serien wird durch eine Computersteuerung einzeln und unabhängig kontrolliert. Die Lichtinstalla-
tion geht um das gesamte Gebäude herum und wird den Baukörper gleichmäßig in Licht tauchen. Der
geplante Effekt ist, daß die Farbe oder die Farben in ständiger Bewegung sein werden, entweder wie ein
Wasserfall am Gebäude hinuntergleiten oder über die transluzenten Oberflächen hinaufblitzen. Manches
wird gleichzeitig geschehen, zu anderen Zeiten werden diese Effekte einzeln auftreten." JT

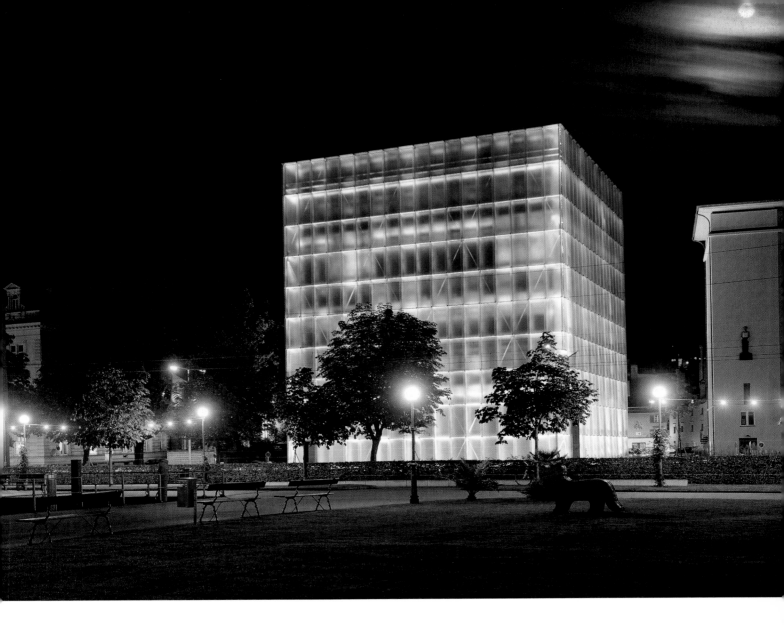

For the opening exhibition of the Kunsthaus Bregenz in July 1997, Turrell created a light installation which made use of the glass facade of the museum and turned the whole building into a translucent body. As with Turrell's permanent work in Leipzig, the Bregenz installation relied on the idea of coupling the lighting with the architectural frame of the glass facade. Turrell described the synchronization and effect of the Bregenz project in his proposal: "The space between the interior structure and the facade will be lit by a series of colored lights, each series of which are controlled by a computer lighting board to function independently. The lighting will be around the entire perimeter of the building and will wash the structure evenly. The effect will be that the color or colors will be in motion either cascading down the surface of the building or flashing up the translucent surfaces. Some of this will occur simultaneously, at other times the effect will be individual." JT

MAK-Fassade MAK Facade 1998

Entwurf für eine permanente Außeninstallation / proposal for a permanent installation

1998 erarbeitete James Turrell für das MAK, Wien, in Zusammenarbeit mit Peter Noever, einen Entwurf für eine permanente Lichtarbeit, die darauf ausgerichtet ist, die Fassaden der beiden Museumsgebäude, einschließlich der Gartenseite, in den Farbspektren von Blau und Rot zu illuminieren. Die Beleuchtung sieht vor, die Fensteröffnungen mit einem gleichschimmernd hellen Blau gänzlich zu füllen, so daß ähnlich wie bei Wolf (1984) die MAK-Gebäude von einem inneren Licht erfüllt sind und die massive Ziegelsteinfassade in ihrer statischen Geschlossenheit durchdrungen wird. Dazu verlaufen entlang der Gesimse der einzelnen Geschoße blaue und rote Lichtbänder, die die horizontalen Konturen linear nachzeichnen. Ausgehend vom Straßenniveau, strahlen weiße Lichtquellen die Fassade flächig an und erzeugen, abhängig vom Winkel des auftreffenden Lichts, einen regelmäßigen Schattenwurf, der durch das blaue und rote Kathodenlicht koloriert wird. Im Gegensatz zur üblichen weißen Halogenbeleuchtung, die die Raumwirkung der Architektur abflacht und verzerrt, wird sie aus der exakten Ableitung der vorhandenen Dimensionen verstärkt wahrzunehmen sein. Ein Leitgedanke des Entwurfs resultiert aus der prominenten Lage des MAK an der Wiener Ringstraße. Mit dem Bauabschluß des kompletten Straßenzugs im Jahr 1865, waren entlang des Rings eine Reihe von öffentlichen Gebäuden in der Stilvielfalt des Historismus entstanden. Der Entwurf Turrells für die Beleuchtung der MAK-Fassade nimmt den Museumskomplex, der 1871 fertiggestellt wurde, auf signifikante Weise in die Reihe der anderen historischen Gebäude auf. Ohne einen direkten materiellen Eingriff in die denkmalgeschützte Fassade vorzunehmen, artikuliert der Entwurf Turrells, im Sinne einer zeitgenössischen Ikonographie, sowohl die Architekturgeschichte dieses Hauses als auch seine inhaltliche Aufgabe als Institution für die Kunst.

In 1998, James Turrell and Peter Noever cooperated in developing a permanent lightwork for the MAK in Vienna. The work is designed to illuminate the facades of both museum buildings, including the garden front, in the color scales of blue and red. The illumination is to flood the window openings with an evenly shining pale blue to fill the buildings with an inner light, not unlike in Wolf (1984), that permeates the static monumentality of the solid brick front. Blue and red light bands will run along the cornices of each story, emphasizing their linear outlines. From the street level, white light sources will wash the whole surface of the facade in light. Depending on the angle of the light, this will result in evenly spaced shadows that are filled with color by the blue and red lines of cold cathode light. In contrast to the usual white halogen lighting systems which tend to flatten and distort the spatial appearance of architecture, the spaciality will be reinforced by the exact articulation of existing dimensions. The concept was inspired by the prominent site of the MAK on the Ringstraße in Vienna. The entire street, inaugurated in 1865 after a huge building effort, features a number of prominent public buildings in the variety of styles typical for historism. Turrell's concept for the illumination of the MAK Facade places the building complex, which was finished in 1871, into a meaningful context to the other historical buildings. In the sense of a contemporary iconography, Turrell's concept articulates both the historic architecture and its function as an institution of art without materially changing the building structure.

Paul Virilio

SEHEN OHNE ZU SEHEN

Angesichts des massiven Einbruchs der neuen Technologien der *computergesteuerten Wahrnehmung,* der Entwicklung der ON LINE CAMERA in Internet, übertreffen sich alle darin, „die großen Männer zu loben", die der Menschheit die globale Ausweitung ihres Sehens bzw. die Virtualisierung des Raumes durch Verdoppelung der Realität ermöglichen, und zwar nicht mehr zwischen den „Tiefen" und den „Höhen" der Stereo-Hifi, sondern diesmal zwischen dem „Wirklichen" und dem „Virtuellen", wodurch sie eine STEREO.REALITÄT einführen, deren *Lautstärke,* das „Relief" alles der plötzlichen Fernübertragung der Information verdankt...

Es ist jedoch seltsam, daß heute niemand über den anderen Aspekt dieser Revolution der Kommunikation spricht, nämlich dem Auftreten der SEHMASCHINE vor bereits etwa zwanzig Jahren – diesem Computer zur Erkennung von Formen und Figuren, der sich zuerst im Besitz der US AIR FORCE befand, für die Produktion (und wiederholte Verwendung) der CRUISE MISSILES, mit ihrem Trägheitsnavigations-Leitwerk, ihrem Radarpeilungssystem, der Geländeerkundung, der Verwendung der Objektantastung durch GPS-Satellit und schließlich, in der letzten Phase ihrer Entwicklung, dem Einsatz einer „Sehmaschine", durch die der Automat seine Einschlagstelle genau auswählen kann.

Diese sogenannte UMRISSERKENNUNGS-Methode wurde zuerst in der Industrie entwickelt, um die Herstellung von Fabrikationsteilen zu erleichtern, und in der Folge auf andere, weitaus kompliziertere Arten der optischen Ortung ausgeweitet, im Bereich der Eintrittsüberwachung von Geheimlabors, Zentralbanken, vor ihrer generellen Verwendung in mehr oder weniger bekannten Anwendungsgebieten...

Dadurch konnte die Technologie dem unbelebten Gegenstand nach dem Tastsinn, dem Gehör und dem Selbstantrieb auch das Sehvermögen verleihen und setzte ein panisches Phänomen des OPTISCHEN DENUNZIANTENTUMS in Gang, indem es nicht mehr nur um die Weiterleitung unüberprüfter Kolportagen oder Telefonabhörungen, sondern diesmal um die plötzlich Entdeckung der Scheinpräsenz von bis dahin, trotz ihrer Ausstattung mit diversen Detektoren, „blinden" Maschinen ging.

Das OBJEKT auf diese Weise, mit den sinnlichen Funktionen des SUBJEKTS im beklemmenden Rahmen der kybernetischen Revolution auszustatten, heißt die Büchse der Pandora einer *endlosen Perspektive* und eines systematischen Eindringens zu öffnen, die bei weitem über die Bedrohungen der ersten von Norbert Wiener angeprangerten Kybernetik hinausgehen. Das heißt, den Bereich einer, für das *Mineralreich* des Metalls dieser Maschinen, programmierten Optik so zu

öffnen, daß die geschlossenen Kreisläufe der Elektrooptik die verschiedenen Wahrnehmungsarten des *Tierreichs* verdoppeln – dieser rätselhaften Vielfalt des Sehens bei den lebenden Arten. Wie kann man annehmen, daß ein derartiges „ästhetisches" Ereignis nicht sogar den Begriff der OBSZÖNITÄT an sich in Frage stellt? Bei einem Tier drückt sich das Erkennen nämlich durch zahlreiche Zeichen des stillschweigenden Verstehens aus - man muß dabei nur an den Hund des Odysseus denken, der den Helden bei seiner Rückkehr aus Troja als einziger wiedererkannte – aber bei den optischen „Einfanggeräten " der neuen „Sehmaschinen" ist die Indifferenz der Software garantiert: nicht die geringste gefühlsmäßige Beteiligung oder Interferenz ist zwischen dem Auge des Meisters und der Frequenz der instrumentalen Abbildung des Automaten[1] herzustellen. Erinnern wir uns hier an den warnenden Satz Paul Klees: *„Jetzt beobachten mich die Objekte".* Wie soll man malen, während die Bildtechnik des Computers zuschaut und im geheimen eine Interaktion aufbaut… *Aug' um Auge,* das geistige Bild gegen das instrumentale Bild, der *Zufall des Sehens* wird bald den des Lebens, der perzeptiven Vitalität des Subjekts ergänzen..

Wie kann man annehmen, daß ein derartiges Ereignis nicht die Kunst, die Ästhetik und ihre Philosophie in Frage stellt, die Geschichte der kulturellen Anstrengungen zur Interpretation des Sehens, die Phänomenologie …

Ebenso wie die *Weltraumbeobachtung* nach der Erfindung des Teleskops nicht unverändert fortbestehen konnte, werden die für das Auge bestimmten Kunstformen nicht überleben, ohne nacheinander ihre kulturellen Attribute angesichts der *automatischen Präsentation* der Sehmaschinen zu verlieren; die digitale Optik des Computers stellt dabei eine grobe Interferenz zur analogen Optik des Betrachterauges dar.[2]

„Einfanggeräte" nennt man diese zahllosen „Sensoren", diese „Detektoren", die heute den elektro-akustischen und elektro-optischen Roboter- und Automatenmarkt überschwemmen. *Es geht vor allem um das Einfangen!* Um Seelenraub, REFLEXARTIGE SELBSTVERSTÜMMELUNG der Empfindungen, denen gegenüber die Humanität des Subjekts nicht lange geschützt bleiben wird.

1 *Siehe hier die psychologische Rolle von SM!LEY im Internet, diese kleinen Figuren, die versuchen, Gefühle zu simulieren.*
2 *Siehe bereits die Frage der Stellung des Schiedsrichters gegenüber der Video-Überwachung des Spiels, beim Fußball…*

Paul Virilio

SIGHT WITHOUT EYESIGHT

Beneath the unfurling of new technologies of *computer-aided* perception, the development of ON-LINE CAMERAS over the Internet, everyone is rushing to "play the great man", to join those who allow humanity to globalize its vision, in other words, to virtualize space by doubling reality, no longer between the "bass" and the "treble" of stereophonic high fidelity, but this time between the "actual" and the "virtual", insisting on a STEREO REALITY whose volume, whose "relief", owes everything to the sudden mutation of information into waves...

Yet it is strange that no-one today debates over the other aspect of this communications revolution represented, for almost twenty years now, by the appearance of the SEEING MACHINE, the computerized recognition of forms and figures possessed by the US AIR FORCE, after the realization (and rapid utilization) of the CRUISE MISSILE, with its gyroscopic center, its radar terrain monitoring system, its use of GPS satellite positioning, and at the terminal phase of its course, the deployment of a "vision machine" allowing the automaton to choose its precise point of impact.

First developed in industry to facilitate the fabrication of machine parts, this practice of so-called CONTOUR RECOGNITION was later to be extended, in the secret labs of the central banks, to more sophisticated types of optical detection in the area of intruder surveillance, before being widely employed in other, more-or-less well-known sectors of activity.

Techno-science is now able to offer the inanimate object not only the senses of touch and hearing and the capacity to move on its own, but also the sense of *sight*. Thus it has triggered off a panic phenomenon of OPTICAL SPYING, not only prolonging the uncontrolled flow of rumors and telephone bugging, but this time adding the impromptu discovery of the appearances of presence, for machines which were formerly "blind" despite their array of diverse detectors.

In the oppressive framework of the cybernetic revolution, giving the OBJECT the sensorial functions of the SUBJECT means opening up the Pandora's box of an *endless perspective* and a systematic intrusion that stretches far beyond the threats of early cybernetics denounced by Norbert Wiener. It means opening up the field of an optics programmed for the *mineral kingdom* of these metal machines, whose closed electro-optical circuits would thus double the different varieties of perception in the *animal kingdom* – the enigmatic diversity of vision among the living species.

How could one suppose that such an "aesthetic" event would not bring into question the very notion of OBSCENITY (?) With an animal, recognition is expressed by various signs of complicity – just recall Ulysses' dog, the only one to recognize the hero upon his return from Troy. But with the optical sensors of the recent "vision machines", the indifference of the program is guaranteed: no com-

plicity, no emotional interference can spring up between the master's eye and the frequency of the automaton's instrumental imagery.[1]

Here let us remember the premonitory phrase of Paul Klee: *"Now objects perceive me."* How can one paint, when the computer's imagery contemplates and secretly interacts ... *Eye for eye,* mental image versus instrumental image, *the accident of sight* prepares to complete that of life, of the subject's perceptual vitality.

How could one suppose that such an event would not bring into question art, aesthetics and its philosophy (?), the history of the cultural efforts to interpret sight, phenomenology...

Astronomical observation could not continue unaltered after the invention of the telescope, and neither can the arts of *ocular representation* survive without losing their cultural attributes one by one, before the *automatic presentation* of the seeing machines; for the digital optics of the computer interfere gravely with the analogue optics of the witness's eye.[2]

In French we use the word *capteur* to speak of the innumerable sensors and detectors that now crowd the markets of robotics and of electro-acoustic, electro-optical automatons. The idea is *capture above all!* Predators of the soul, REFLEX SELF-MUTILATION of the sensations – the subject's humanity will not long remain unscathed.

1 See the psychological role of the SMILEY on the Internet network, those little figures that try to simulate emotions...
2 See what has already happened to the status of the referee with the video surveillance of games in football...

Daniel Birnbaum

AUGEN & EINE ANMERKUNG ZUR SONNE



Die Gesetze der Optik, die sich durch Studium
in uns entwickeln, lehren uns zu sehen.
Paul Cézanne

Es gibt zwar nicht Phänomenologie,
wohl aber phänomenologische Probleme.
Ludwig Wittgenstein



Vorbemerkung

29. Oktober 1998: Ich fliege nach New York, um mir James Turrells Ausstellung in Chelsea anzu-
sehen.[1] Um 7 Uhr geht in Stockholm die Sonne auf. Das Flugzeug startet, gleißendes Licht. Ich
schließe die Augen und versuche, mir über seine Arbeiten Gedanken zu machen. Seit meinem
letzten Versuch, etwas über ihn zu schreiben, habe ich meine Meinung ein wenig geändert: Bei
seinen Werken geht es nicht nur um Sehen. Es geht nicht ausschließlich um die Augen. Es geht
ebenso sehr um den Körper.

Wenn die Augen nicht mehr sehen, fällt der Körper. Man denke z. B. an jemanden, der in die
Sonne starrt. Nach Georges Bataille ist die Geschichte von Ikarus solch ein solarer Fall. Geblen-
det – und ohne Flügel – fällt er in den Abgrund: „So gesehen ist der Ikarus-Mythos besonders auf-
schlußreich. Die Sonne hat eindeutig zwei Seiten: eine, die Ikarus' Aufstieg wohlwollend
bescheint, und eine zweite, die, als Ikarus ihr zu nahe kommt, das Wachs zum Schmelzen bringt
und damit sein Scheitern und seinen abgrundtiefen Fall zur Folge hat."

Wenn man keine Gegenstände vor Augen hat, verliert der Körper die Orientierung. Ist es nicht
genau das, was einige von Turrells Installationen zeigen? Er selbst sagt über seine Arbeit *City of
Arhirit*, die vor Jahren in Amsterdam und New York[2] zu sehen war:

> „In der Installation im Stedelijk empfanden die Besucher die Störung des Gleichgewichts
> als so stark, daß sie auf Händen und Knien durch die Ausstellung krochen. Man ging zuerst
> durch einen Raum, der sich bald zu verdunkeln schien, denn ohne Form läßt sich Farbe
> nicht halten. Nach Verlassen des ersten Raumes, der hellgrün war, blieb auf der Netzhaut
> des Auges ein rosaroter Eindruck zurück. Der nächste Raum war rot, und man betrat ihn mit
> diesem Rosarot, es war einfach beeindruckend. Ich setzte also eine Raumfolge ein, um die
> nachhallende Farbe mit der Farbe, die man gleich sehen würde, zu mischen, auch im
> Bewußtsein, daß der Farbeindruck sich ständig verdunkeln würde. Die Besucher hatten den
> Eindruck, als ob jemand ständig das Licht an- und ausmachte, obwohl sie nur eine Folge
> von vier Räumen durchquerten, die auf diese Art und Weise beleuchtet waren. Wir mußten
> schließlich einen Weg in den Boden schneiden, aber selbst dann fiel es manchen schwer
> aufrecht zu stehen."

Was ist so interessant an dieser Beschreibung? In erster Linie die Beziehung zwischen dem geblen-
deten Auge und dem fallenden Körper. Wenn das Auge nicht fokussieren kann und die Orien-

tierung verliert, stürzt die Erfahrung des Körpers und des Selbst ins Chaos. Das ist genau das, womit sich Phänomenologen von Husserl bis Merleau-Ponty beschäftigt haben – unter dem Begriff „kinästhetische Erfahrung".

Husserl, der häufig als Philosoph des Auges bezeichnet wird, ist in Wahrheit der Denker, der sich am gründlichsten mit dem Körper auseinandergesetzt hat. Kein anderer Philosoph dieses Jahrhunderts hat in diesem Maße auf die Bedeutung des körperlichen Selbstbewußtseins hingewiesen: ohne körperliches Selbstgefühl gibt es kein geistiges Bild des Objekts, und ohne bewußte Beziehung zum tatsächlichen Objekt existiert kein stabiles Körpergefühl. Es sieht also aus, als ob eine phänomenologische Untersuchung – philosophisch oder künstlerisch – notwendigerweise nicht nur das Auge, sondern auch den Körper einschließen müßte. Leute, die in Turrells Installationen hinfallen: Phänomenologie.

Augen

Es kommt nicht sehr oft vor, daß ich allein bin, *wirklich* allein. Ich meine damit nicht nur die bloße Abwesenheit anderer Personen. Auch die mich umgebenden Gegenstände repräsentieren eine Welt, die völlig von zwischenmenschlichen Beziehungen geprägt ist: Gespräche, Auseinandersetzungen, Zeit, die man zusammen verbracht hat. Ich mag zwar allein zu Hause sein, bin aber doch nicht *allein*.

Zuweilen kommt es jedoch vor: Ich wache mitten in der Nacht in einem stockdunklen Hotelzimmer in einer fremden Stadt auf – allein. Ich befinde mich in einer Landschaft aus Schnee und Nebelschwaden in den Österreichischen Alpen, es sind keine anderen Skifahrer in der Nähe. In meinem Blickfeld nur flimmerndes Weiß – ich bin allein.

Diese Erfahrungen gehen einher mit einem vagen Gefühl der Unsicherheit über die eigene Existenz. Wo bin ich? – Wer bin ich? Nur kurz, dann ist alles wieder normal, die Welt, die ich mit vielen anderen teile, kommt wieder zum Vorschein.

Ein drittes Beispiel: Ich gehe an einem kalten Februarmorgen zu Fuß durch das Soho-Viertel von New York. Die Straße ist voller Leute und Autos, aber die Galerie ist leer. Ich gehe einen dunklen Flur entlang und biege mehrmals um die Ecke. Kein Lichtstrahl fällt in den Raum, der sich ganz hinten am Ende des Gangs öffnet. Völlige Einsamkeit.

Ich höre ein kaum wahrnehmbares Brummen aus einem anderen Teil des Gebäudes. Langsam kommt Licht ins Dunkel, zuerst schwach, dann immer deutlicher. Ist es einfach da, um mich herum, oder kommt es aus mir, aus meinen Augen? Was ist innerhalb, was außerhalb? Beginnt das, was wir als „Ich" bezeichnen, hinter unseren Augenlidern?

Diese Gedanken wurden von einer Installation von James Turrell inspiriert: *Frontal Passage*, ausgestellt in der Barbara Gladstone Gallery im Februar 1994. Ich sehe sie mir mehrmals an. Wenn andere Besucher flüstern und sich im Gang drängeln, gehe ich gar nicht erst hinein, sondern komme später wieder. Selten hat mich ein Kunstwerk so fasziniert. In der heutigen Kunstszene kommt es nicht oft vor, daß eine Arbeit mich so existentiell berührt. Turrells *Frontal Passage* ist eine davon – beim ersten Mal und jedesmal aufs neue.

Worum geht es bei Turrells Arbeiten? Um Licht und Wahrnehmung, könnte man sagen. Richtiger wäre allerdings: Seine Kunst *ist* Licht und Wahrnehmung.[3] Turrells Arbeiten stellen nichts dar außer sich selbst: Licht und Dunkelheit, Raum und Wahrnehmung. Bei seinen Installationen handelt es sich nicht um Objekte zur ästhetischen Betrachtung, vielmehr spielen sie mit dem, was unsere Wahrnehmung bedingt. Diese Art von Kunst ist frei von allem Gegenständlichen. Es geht nicht um das, was wir vor Augen haben, sondern um das, was sich *dahinter* befindet – um das, was Sehen voraussetzt und die Grenzen der Wahrnehmung.

„Es gab keinen Gegenstand, nichts außer einer Beziehung zum Himmel", sagte der italienische

Sammler Panza di Biumo nach einem Besuch bei Turrell in Santa Monica.[4] Turrell hat die Grund-
prinzipien seiner künstlerischen Auseinandersetzung mit natürlichem und künstlichem Licht
lange vor seiner ersten Galerie-Ausstellung entwickelt: Licht, an eine Wand projiziert, Him-
melslicht, das durch Jalousien dringt, ein architektonischer Raum, der einen zweiten beleuchtet.
Bei Turrells Arbeiten geht es um die Fähigkeit des Lichts, einen Raum auszufüllen und ihn mit
Sehen zu durchtränken.

Auf diese Weise wird das Sehen an sich sichtbar – man sieht sich sehen. In Turrells Worten: „Ich
interessiere mich sehr dafür, wie ein Raum einen zweiten wahrnimmt. Es ist, als ob man sieht, wie
jemand sieht. Objektivität entsteht durch Abstand. Leert man einen Raum von allem Sehen,
wird es möglich, ‚sich selbst sehen zu sehen'. Dieses Sehen, diese Leerung, erfüllt Raum mit
Bewußtsein."[5]

Das Sichtbare

Walter Benjamin beschreibt in einem Dialog mit dem Titel „Der Regenbogen" eine tiefere Art
des Sehens: „So war es in meinen Träumen, ich sah nur. Alle anderen Sinne waren vergessen,
verschwunden. Ich selbst existierte nicht, und auch nicht mein Intellekt, der ja aus Bildern, die
ihm die Sinne liefern, Schlüsse über die Natur der Dinge zieht. Ich war nicht jemand, der sah,
sondern das Sehen selbst. Und ich sah keine Gegenstände, nur Farben."[6] Benjamin spricht von
einer Art des Sehens, die so intensiv ist, daß die sehende Person völlig in den Hintergrund tritt,
im Akt des Sehens und Sichtbarmachens aufgeht. Dieses Traum-Sehen kann sowohl Ausgangs-
punkt für eine Auseinandersetzung mit der Bedeutung von Sehen und Farben in der Philosophie
sein als auch für eine philosophische Betrachtung des Kunstwerks an sich.

Maurice Merleau-Ponty hat mehr als alle anderen Philosophen die Malerei an den Anfang seiner
Betrachtungen gestellt. In „L'Oeil et l'Esprit" [Auge und Intellekt] schreibt er in bezug auf künf-
tiges Denken: „Die Philosophie, die noch aussteht, ist die, die den Maler beflügelt – nicht dann,
wenn er sich über Gott und die Welt äußert, sondern dann, wenn seine Sichtweise Gestus wird,
wenn er, in Cézannes Worten, ‚malend' denkt."[7] Bei Merleau-Ponty haben wir es nicht mit
einem Philosophen zu tun, der sich auch für Malerei interessiert und Werke von Cézanne und
Klee brillant zu analysieren weiß, sondern um eine Denkweise, die in ihren Grundfesten von der
Malerei inspiriert ist und für die das gleichzeitig passive und kreative Auge des Malers als Modell
der Philosophie dient: Der Maler empfängt und stellt die sichtbare Welt auf eine ursprünglichere
Art und Weise dar als der reflektierende Philosoph. Die Malerei verschafft uns Zugang zu einer
tieferen Art des Betrachtens, verschüttet durch Philosophie und Alltäglichkeit, eine Art des
Sehens, die der rigiden Trennung in ein betrachtendes Subjekt und eine betrachtete Welt vor-
ausgeht: „Das Sichtbare im alltäglichen Sinn hat seine Ursprünge aus den Augen verloren. Es ist
begründet auf eine völlige Visibilität, die es wiederzugewinnen gilt, die die in ihr gefangenen
Geister freisetzt. Und wie wir wissen, haben die Künstler der Moderne weitere freigesetzt. Durch
sie kam so manch neuer Ton in den offiziellen Kanon der Mittel, die uns zum Sehen zur Verfü-
gung stehen."[8]

Es wäre leicht, Merleau-Pontys Idee einer „totalen Visibilität" – einschließlich des Sehenden und
dessen, was er sieht – als bloße poetische Phantasie abzutun, ähnlich des oben erwähnten Traum-
bildes Benjamins. Dies würde jedoch bedeuten, die Konsequenz und Folgerichtigkeit seines
Ansatzes zu verkennen, mit dem er die Konzeptualität der klassischen Phänomenologie zugun-
sten einer Auffassung von „Visibilität", die der Rezeptivität des finiten Subjekts vorausgeht,
hinter sich zu lassen versucht.

Unser Denken muß die Unterscheidungen, die die traditionelle Philosophie geschaffen hat, über-
winden und sich auf eine ursprünglichere Ebene besinnen, wo die Pole überlieferter Dichotomien

(Körper und Seele, Auffassungen und Begriffe, Subjekt und Objekt) noch nicht getrennt, sondern in einer Art „primordialer Ambivalenz" vereint sind.

Dort wo die Philosophie versagt, wendet sich Merleau-Ponty der Malerei zu. In der Malerei wird das Sein aufgenommen und sichtbar gemacht, denn „der Maler, was immer er auch sein mag, wendet während des Malens eine magische Theorie der Wahrnehmung an".[9] Malen ist eine metaphysische Handlung. Es ist eine Art maßloses Sehen, das über das, was unmittelbar vorhanden ist, hinausgeht, um anhand von Farbe und „Traum-Linien" die verborgenen Aspekte des Seins aufzuzeigen. Die Wahrheit der Malerei liegt tiefer als alle mimetischen Erfordernisse. Es geht um uranfängliche Offenheit – um Geschehnisse, die das Sein an sich betreffen.

Zweifellos sind diese Gedanken von Martin Heideggers Auffassung von der Urwahrheit als *Lichtung* inspiriert – dem Zusammenspiel von Offenheit und Geschlossenheit, Licht und Dunkel. Nach Heidegger manifestiert sich dieses Spiel, das älter ist als jede weltliche Objektivität, in der Kunst: in griechischen Tempeln, in der Tragödie, in Hölderlins Gedichten. Merleau-Ponty überträgt diese Gedanken auf die Malerei – auf Cézannes Bildern erscheint die ursprünglichste „Visibilität".

Was hätte Merleau-Ponty über James Turrells objektlose Lichtinstallationen gesagt – seine *Wedgeworks* und *Dark Spaces*. Handelt es sich bei diesen subtilen Manipulationen von Licht und Raum nicht um ein Mittel, sich mit der Urform der „Visibilität", der Erscheinung an sich, auseinanderzusetzen? In Turrells eigenen Worten: „Meine Arbeiten haben mit Licht zu tun, in dem Sinn, daß Licht präsent, vorhanden ist. Die Arbeit ist aus Licht gemacht. Es geht nicht um Licht oder eine Abbildung davon, es ist Licht. Licht ist nicht etwas, das offenbart, sondern selbst Offenbarung." Hier werden keine Objekte dargestellt, nichts offenbart – die Arbeiten selbst sind Offenbarung. Licht und Dunkel, Dunkel und Licht: *Lichtung*.

Auge und Sprache

„Das Sehen des Malers ist ein fortlaufender Prozeß" – die metaphysische Bedeutung, die Merleau-Ponty der Malerei zuschreibt, stellt gewisse Ansprüche an die Kunst, die dieser heroischen Position genügen muß. Seine Definition der Wesensart der Malerei lehnt sich ganz offensichtlich an die der frühen Moderne an, und durch den Wert, den er der Unmittelbarkeit und Authentizität des bildnerischen Ausdrucks beimißt, schließt er ganze Teile avantgardistischer Kunst des 20. Jahrhunderts von vornherein aus. Cézannes Auffassung von Farbe als „Punkt, an dem unser Geist und das Universum sich treffen" und Klees archaische Farbkleckse, die „älter sind als alles andere, Botschafter der Dämmerung", sind es, die sein Verständnis von Kunst prägen. Merleau-Pontys Mythologie des Ursprünglichen ist keineswegs unumstritten. Postuliert man beispielsweise ein anderes Verständnis von Kunstwerk und künstlerischer Kreativität, gerät seine gesamte kunstphilosophische Konstruktion ins Wanken. Wie empfängt Marcel Duchamp das Geschenk des Seins? Wo zeigt sich ursprüngliche „Visibilität" im Dadaismus? Es handelt sich dabei um Fragen, die die Anwendbarkeit einer phänomenologischen Kunstphilosophie auf eine Kunst betreffen, die sich bewußt von dem Begriff des Ursprünglichen und der Forderung nach Authentizität distanziert hat.

Als Duchamp ein Jahrzehnt nach Cézannes Tod die Malerei als *retinal* (zu sehr an die Retina gebunden) ablehnt und sich statt dessen linguistischen Experimenten zuwendet, rebelliert er gegen eine Kunstauffassung, die dem Auge eine privilegierte Stellung zubilligt. In ähnlicher Weise hinterfragt Wittgenstein in „Bemerkungen über die Farben" die Priorität des Sehens in der Philosophie, in dem er die Abhängigkeit visueller Begriffe von einem Zusammenspiel der Worte aufzeigt. Die Autonomie des Visuellen war in diesem Jahrhundert immer wieder starken Anfechtungen ausgesetzt. Bevor wir uns unter diesem Gesichtspunkt mit Turrells Lichtinstallationen

befassen, soll kurz eine Anschauung zur Sprache kommen, die vielleicht die bis heute schlagkräftigste Kritik der Idee des „ursprünglichen Blicks" darstellt: Wittgensteins späte philosophische Betrachtungen.

„Denn über die Begriffe der Farben wird man durch Schauen nicht belehrt", lautet einer von Wittgensteins radikalsten Sätzen.[10] Nein? Wie gelingt es uns dann, Zugang zu der Bedeutung der Farbbegriffe zu finden? Wittgensteins Antwort ist: dadurch, daß wir ihre Anwendung untersuchen. Sein Werk „Bemerkungen über die Farben", verfaßt als Randbemerkungen zu Goethes Farbenlehre, will aufzeigen, daß auch die Art, wie wir Farbe erfahren, von einer tieferen Diskursivität, einem Spiel (oder einem Zusammenspiel) der Worte abhängt, das den Rahmen liefert, innerhalb dessen visuelle Konzepte mit Bedeutung ausgestattet sind. Seine Bemerkungen über Farbe sind eng mit seiner Kritik an der Priorität des Sehens verknüpft, die er in anderen Texten aus derselben Zeit, allen voran „Über Gewißheit", entwickelt. Eine seiner Hauptstrategien besteht darin, den Beweis zu führen, daß die traditionelle (kartesianische) Auffassung von positivem Wissen als primärem Beweis – als einer Art von Sehen – falsch ist. Was ist offensichtlicher als die Bedeutung des Wortes „rot" und daß sich diese aus der reinen Wahrnehmung der betreffenden Farbe ableitet? Wittgensteins Bemerkungen über Farbe zielen in erster Linie darauf ab, uns auf Probleme beim intuitiven Verständnis von Farbwörtern aufmerksam zu machen. Eine akribische Untersuchung konkreter Situationen, in denen Farbkonzepte Anwendung finden, entspricht ganz der Shakespeareschen Formel, zu der Wittgenstein sich bekennt: „Ich lehre dich die Unterschiede" („König Lear"). Es geht ihm nicht um die Formulierung einer philosophischen Theorie über Farbe und Sinneswahrnehmung, sondern darum, die grundsätzlichen Probleme zu isolieren. Wittgensteins Ziel ist nicht, die Frage „was ist Farbe" zu beantworten, er versucht vielmehr, den (linguistischen) Zusammenhang zu definieren, der in einem bestimmten Fall den Gebrauch von Farbkonzepten vorschreibt. Ein Wort (so auch ein Farbbegriff) erhält seine Bedeutung nur in Verbindung mit einer komplexen Struktur linguistischer Muster. Etwas wie das Wesen der Farbe existiert nicht – Farbe kann vieles sein.

Traumräume

„Wenn man nur fünf Bezeichnungen für Farbe kennt, sieht man nur fünf Farben", behauptet Turrell.[11] In welcher Beziehung stehen seine künstlerischen Projekte zu den oben kurz erläuterten Anschauungen? Wenige Künstler arbeiten so intensiv mit Visualität und Licht wie Turrell. Sein Ausgangspunkt ist jedoch nicht eine vorgefaßte Meinung über menschliches Sehen, er untersucht vielmehr dessen Grenzen. Was ist Licht, was ist Raum, was ist Sehen? Turrells Installationen radikalisieren die visuelle Situation, bringen die menschliche Wahrnehmung an ihre äußersten Grenzen. Wenn irgendein Künstler heutzutage die Bezeichnung Phänomenalist verdient hat, ist es Turrell.

In seiner Betonung des Sehens steht Turrell Merleau-Ponty nahe, für dessen Philosophie er sich nach eigenen Aussagen sehr interessiert. Die konkrete Umsetzung, mit der er sich befaßt, zeigt aber auch eine deutliche Affinität zu Wittgenstein, der in „Bemerkungen über die Farben" schreibt: „Es gibt zwar nicht Phänomenologie, wohl aber phänomenologische Probleme." Wenn wir wissen wollen, was weißes Licht ist, hilft uns ein allgemeines Gesetz nicht weiter, wir müssen ganz konkret untersuchen, wie sich Licht in bestimmten Fällen verhält: seine Transparenz, sein Glanz, seine Fähigkeit, einen Raum zu füllen. Genau dies tun Turrells Arbeiten, während sie gleichzeitig verblüffende Räume erzeugen.

Es ist nicht leicht, die philosophische Relevanz von Wittgensteins manchmal allzu prosaischen Bemerkungen über Farbe nachzuvollziehen. Eine typische Bemerkung lautet etwa so: „Von zwei Stellen meiner Umgebung, die ich, in einem Sinne, als gleichfarbig *sehe*, kann mir, in anderem

Sinne, die eine als weiß, die andere als grau erscheinen. In einem Zusammenhang ist diese Farbe für mich weiß in schlechter Beleuchtung, in einem andern grau in guter Beleuchtung. Dies sind Sätze über die Begriffe 'weiß' und 'grau'."[12]

Vielleicht sollten Turrells Installationen als Versuche gelten, dieser Art von nüchterner Beobachtung eine materielle Form zu verleihen, indem sie – was auch zutrifft – reine visuelle Beziehungen darstellen, die durch ihre Radikalität seltsame psychologische Effekte kreieren: Licht wird greifbar. Es nimmt eine „körperliche" Form an and wird auf merkwürdige Weise visuell – man verspürt den Wunsch, die Hand auszustrecken und es anzufassen. Es handelt sich hier nicht, wie Turrell selbst bereits erklärt hat, um eine Frage von Illusionismus, sondern um konkrete Präsenz. Extreme Nüchternheit erzeugt hier eine einzigartige Form von Poesie.

Die visuelle Reinheit von Turrells Installationen entzieht uns der gemeinsamen, vertrauten Welt. Wir sind allein mit diesen Lichtphänomenen, genauso allein wie angesichts der unermeßlichen Weite der Wüste oder der Unendlichkeit des Himmels. Es handelt sich hier nicht um das Licht des Alltäglichen, sondern um das Licht der Träume und der Phantasie. Mit wissenschaftlichen, rationellen Mitteln erreicht Turrell die Wahrnehmung von etwas Außergewöhnlichem, etwas Unbekanntem. Er erklärt sein Anliegen so: „Ich suche das Licht, das uns in Träumen erscheint, und die Räume, die aus diesen Träumen zu kommen scheinen und die denen, die sie bewohnen, vertraut sind."

Als ausgebildeter Pilot kennt Turrell dieses Licht und diese Räume aus einer Höhe von mehreren tausend Fuß und in extremen Landschaftsformen. Aber jeder von uns hat irgendwann einmal diese Art von intensiven Gefühlen erlebt: angesichts offener Weiten, des Himmels, bestimmter Meereslandschaften. Dies sind die Augenblicke, wenn Licht und Leere uns andersartig und fremd vorkommen und ein starkes Gefühl von Präsenz vermitteln.

Turrell bezieht in seine Arbeiten die endlosen Dimensionen der Natur mit ein: Sternenlicht und die unermeßliche Weite des Himmels. Sein ungewöhnlichstes Projekt, *Roden Crater* in Arizona, wird an einem Ort realisiert, der geradezu von diesen nicht-menschlichen Größenverhältnissen beherrscht wird. Ein erloschener Vulkan dient als Ort für völlig neuartige Experimente mit Zeit und Raum.

Das Erstaunliche an Turrells Arbeiten ist jedoch, daß er diese intensiven Gefühle überall in künstlichen Räumen entstehen lassen kann: In Santa Monica, Manhattan oder im Freihafen von Stockholm – wo immer es ihm gelingt, dasselbe, seltsame Licht und dasselbe Gefühl der Einsamkeit zu inszenieren.

Gehen Sie hinein. Verlieren Sie sich.

Eine Anmerkung zur Sonne

Auf meinem Rückflug nach Europa sehe ich wieder die Sonne. Sie ist ungeheuer hell, und ich denke an die berühmten Worte aus der Bhagavadgita: „Wenn das Licht von einer Million Sonnen am Himmel aufleuchten würde, wäre das wie die Erscheinung des Allmächtigen." Ich versuche mich darin, spontan eine kleine Theorie der Sonne zu entwickeln. Eine Theorie für James Turrell und Olafur Eliasson, Lichtvisionäre:

Das Gegebene: Die Sonne verbreitet ihre Energie ohne etwas dafür zu verlangen. Die Strahlen dieses sich selbst verzehrenden Himmelskörpers erreichen die Erde und wandeln sich in pflanzlichen, tierischen und menschlichen Wesen in Lebenskraft um. Ein stetig wachsender Energieüberschuß entsteht: Übersättigung. Früher oder später muß die Explosion stattfinden. Eine Energie muß verbraucht werden, in einem Akt der Überschreitung und des Überflusses. Dies ist, in wenigen Worten, Georges Batailles Kosmologie: Die Sonne ist obszön und verschwenderisch: „Man könnte noch hinzufügen, daß die Sonne mythologisch auch als Mann, der sich selbst die

Kehle durchschneidet, dargestellt wurde, oder als anthropomorphes Wesen ohne Kopf. All dies führt zu der Feststellung, daß der Gipfel der Erhöhung in der Realität mit einem plötzlichen Fall ungeahnten Ausmaßes verwechselt wird." Diese antiplatonische Kosmologie stellt alle Hierarchien von Licht, Wahrheit und dem Guten auf den Kopf. Die Sonne, ursprünglich Abbild des Guten und Symbol der Mutter aller Ideen, wurde verunglimpft und gedemütigt. Die Distanz zwischen Plato und Bataille ist ungeheuer groß und winzig klein zugleich: Die Platonischen Metaphern sind noch in Gebrauch, haben sich aber umgekehrt. Die Sonne ist nicht mehr das Auge, sondern der Anus. Die Sonne erstrahlt nicht mehr in der himmlischen Weite der Wahrheit, sondern am Grunde des Grabes: „Die Sonne, am Grund des Himmels liegend wie ein Skelett am Boden einer Grube…"

Diese Entwicklung und Umkehrung hat verschiedene Stadien durchlaufen:

1. Platonismus, Christentum: Die Sonne scheint noch hoch am Himmel.

2. Romantik: Die Sonne wird schwarz. Es ist ein nächtliches Phänomen (Novalis).

3. Nietzsche: Die Sonne muß als Plural gesehen werden. Wir sind alle „tanzende Sterne" – der Übermensch ist die Sonne, die kommt.

4. Surrealismus, Bataille: Die Sonne ist verdorben, das Auge geblendet.

5. Die Sonne der Zukunft…?

Augen wurde 1994 im Katalog *James Turrell* (Magasin 3, Stockholm) veröffentlicht. Die *Vorbemerkung* und *Eine Anmerkung zur Sonne* verfaßte Birnbaum für diese MAK-Publikation.

Anmerkungen

1 Barbara Gladstone Gallery, New York (31. Oktober – 23. Dezember 1998).
2 *Jim Turrell: Light Projections and Light Spaces*, Stedelijk Museum, Amsterdam (09. 04. – 23. 05. 1976). *James Turrell: Light & Space*, Whitney Museum of American Art, New York (22. 10. 1980 – 01. 01. 1981).
3 Siehe Julia Brown, Interview mit Turrell, in: *Occluded Front*, The Lapis Press, Los Angeles 1985, S. 13 ff.
4 Giuseppe Panza di Biumo, „Artist of the Sky", in: *Occluded Front*, S. 65.
5 *Occluded Front*, S. 25.
6 „Der Regenbogen. Gespräch über Phantasie", Suhrkamp, Frankfurt am Main 1989, Bd. VII:I, S. 19–26.
7 „L'Oeil et l'Esprit", in: *Art de France*, Bd. I, 1, Januar 1961. Zitiert nach „Eye and Mind", in: *The Primacy of Perception*, Northwestern University Press, Evanston 1964, S. 178.
8 Ebd., S. 167.
9 Ebd., S. 187.
10 Ludwig Wittgenstein, „Bemerkungen über die Farben", in: *Werkausgabe*, Bd. 8, Suhrkamp, Frankfurt am Main 1997, S. 28.
11 Zitiert in *Craig Adcock, James Turrell: The Art of Light and Space*, University of California Press, Berkeley 1990, S. 73.
12 „Bemerkungen über die Farben", op. cit., S. 22–23.

Daniel Birnbaum

EYES & NOTES ON THE SUN

Optics, that develops in us as we study,
teaches us to see.
Paul Cézanne

There is no such thing as phenomenology,
but there are indeed phenomenological problems.
Ludwig Wittgenstein

Preface

October 29, 1998: I fly to New York to see James Turrell's show in Chelsea.[1] Sunrise in Stockholm, 7 a.m. The plane takes off, and the light is dazzling. I close my eyes and try to think about his art. I have, to some extent, changed my mind since last time I tried to write about him: his art is not only about vision. It's not exclusively about the eyes. It's just as much about the body.

When your eyes get lost, your body falls. Think for instance of someone staring into the sun. The solar fall is, according to Georges Bataille, what the Icarus story is all about. Blind-folded – and without wings – he falls into the abyss: "The myth of Icarus is particularly expressive from this point of view: it clearly splits the sun in two – the one that was shining at the moment of Icarus elevation, and the one that melted the wax, causing failure and a screaming fall when Icarus got to close."

When you can't see any objects, your body loses its orientation. Isn't this what some of Turrell's installations show? These are his own words about *City of Arhirit*, presented many years ago in Amsterdam and in New York:[2]

> "In the Stedelijk installation, people got down on their hands and knees and crawled through it because they experienced intense disequilibrium. You went through one space and then it seemed to dim because you can't hold color without fold. So as you left the first room that was pale green your eyes developed a pink afterimage. The next room you entered was red, and you came into it with this pink, and it was just startling. So I used a progression of space to mix the afterimage color with the color you were about to see, also knowing that the color, after you were in it a while, would begin to dim. People felt someone was turning the lights up and down on them the whole time, when actually it was just them walking through a succession of four spaces that were lit in this manner. We finally had to cut a path into the floor, but even then people had trouble standing."

So what's so interesting about this description? Primarily the relation between blinded eye and falling body. When the eye can't focus and loses track, the bodily experience and self-experience becomes chaotic. This is what phenomenologists, from Husserl to Merleau-Ponty, have studied under the title "kinaesthetic experience". Husserl, often seen as a philosopher of the eye, is in fact one of the most profound thinkers of the body. No other philosopher in this century has in the same way stressed the importance of bodily self-awareness: without bodily self-sensing there is no mental representation of objects, and without a conscious relation to objects in the world, there is no stable body-awareness. Thus, it would seem that a phenomenological investigation – be it philosophical or artistic – must by necessity include not only the eye, but also the body. People falling in Turrell's installations: phenomenology.

Eyes

It does not happen very often that I am alone, *really* alone. The mere absence of other people is not enough to create the condition I am thinking of. The objects which surround me evoke a world completely determined by human relationships: discussions, conflicts, time spent together. Though alone in my home, I am still not *alone*.

It has happened, though: I wake up in the middle of the night in a pitch-dark hotel room in a strange town – alone. I am immersed in snow and mist in the Austrian Alps; no other skiers are near by. My field of vision is reduced to one single white dazzling totality – I am alone.

A vague sense of uncertainty as to one's own existence accompanies these experiences: Where am I? – Who am I? Soon everything is back to normal; the world I share with everyone else asserts itself once more.

A third example: I am walking through Soho in New York on a cold February day. Plenty of people and cars in the streets. But the gallery is empty. I walk down a black corridor which bends several times so that no light reaches the room which opens up at the very back. Absolute blackness, silence. Total solitude.

A barely perceptible drone coming from another part of the building can be heard. Slowly light appears, faintly but increasingly clearly. Is it outside me or does it come from within my own eyes? What is inside and what is outside? Does that which we refer to as "I" begin behind our eyelids?

It is an installation by James Turrell that inspires these ponderings: *Frontal Passage*, shown at Barbara Gladstone Gallery in February 1994. I return to it many times. If other visitors whisper and crowd in there I refrain from entering and come back later. It has not happened very often that I have been so possessed by an artwork. It does not happen very often in today's art world that a work has such an existential impact on me. Turrell's *Frontal Passage* affects me in such a way – the first time and every time I return.

What is Turrell's art about? About light and perception, one feels tempted to answer. Perhaps it would be more correct to say: his art *is* light and perception.[3] Turrell's works do not represent anything. They are themselves: light and darkness, space and perception. His installations manipulate the conditions of our perception rather than present objects of aesthetic contemplation. This is art liberated from all objects. It is not about what is before, but rather what is *behind* our eyes – about the preconditions of seeing and the limits of perceptions.

"There was no object, nothing but a relationship to the sky", the Italian collector Panza di Biumo observed after having visited Turrell in Santa Monica.[4] Well before he exhibited at a gallery, Turrell had developed the basic principles governing his artistic investigation of natural and artificial light: light projected onto walls, celestial light filtering through shutters, one architectonic space lighting up another. Turrell's art is about the ability of light to fill up a space and saturate it with seeing.

Thus, seeing itself becomes visible – you see yourself see. In Turrell's words: "I am really interested in the qualities of one space sensing another. It is like looking at someone looking. Objectivity is gained by being once removed. As you plumb a space with vision, it is possible to 'see yourself see'. This seeing, this plumbing, imbues space with consciousness."[5]

The Visible

In a dialogue entitled "The Rainbow" Walter Benjamin dreams about a deeper form of seeing: "This is what it was like in dreams, I was nothing but seeing. All other senses had been forgotten, had disappeared. I myself did not exist, nor did my intellect which infers what things are like from the images presented by the senses. I was not somebody seeing but only seeing. And what I saw was not the objects, but only colors."[6] Benjamin talks about a kind of seeing which is so intense that the

person seeing is annihilated and vanishes into the act of seeing and making visible. This dream vision can serve as a starting-point for a discussion of the place of seeing and color in philosophy; and about the philosophical reflection on the work of art.

To a higher degree than any other philosopher Maurice Merleau-Ponty has made painting the point of departure for his thought. In "Eye and Mind" he prophesies about future thinking: "This philosophy still to be done is that which animates the painter – not when he expresses his opinion about the world, but in that instant when his vision becomes gesture, when, in Cézanne's words, he thinks 'in painting'."[7] In Merleau-Ponty's case, we are not dealing with a philosopher interested in painting who writes incisive analyses of the work of Cézanne and Klee, but with a kind of thinking whose very basis is inspired by painting and which makes the painter's at once passive and creative eye the model of philosophy: the painter receives and represents the visible world in a more primordial way than the reflective philosopher. Painting gives us access to a deeper kind of beholding which is obscured by philosophy as well as daily seeing, a kind of beholding which precedes the rigid distinction between the observing I and the observed world: "The visible in the profane sense forgets its premises; it rests on a total visibility which is to be recreated, and which liberates the phantoms captive in it. The moderns, as we know, have liberated many others; they have added many a blank note to the official gamut of our means of seeing."[8]

It would be easy to reject Merleau-Ponty's accounts of a "total visibility" – including both the seer and that which he sees – as a poetic incantation similar to the Benjamin vision referred to above. However, this would be misjudging the rigour and consistency of his attempt to transcend the conceptual terms of classical phenomenology in favour of a notion of "visibility" preceding the receptivity of the finite subject. What we must do is to think beyond the distinctions of a traditional philosophy in order to find a more primordial level where the poles (body and soul, opinions and terms, subject and object) of the dichotomies handed down to us have not yet fallen apart but are thought to be united in a "primordial ambivalence".

Where philosophy fails Merleau-Ponty turns to painting. In painting, being is received and is made visible for "The Painter, whatever he is, while he is painting practices a magical theory of vision".[9] Painting is a metaphysical activity; it is voracious seeing which goes beyond what is immediately available in order to demonstrate the hidden aspects of being by means of color and "dreaming lines". The truth of painting lies deeper than all mimetic demands. It is about primordial openness – about the occurrences which are the clearing of being itself.

No doubt these thoughts have been inspired by Martin Heidegger's views of primordial truth as a *Lichtung* – a play between what is open and what is closed, light and darkness. According to Heidegger, this game, which precedes all worldly objectivity, manifests itself in art: in Greek temples, in tragedy, in Hölderlin's poetry. Merleau-Ponty has transferred these thoughts to painting; on Cézanne's canvases the most primordial "visibility" appears.

What would Merleau-Ponty have had to say about James Turrell's objectless light installations – his *Wedgeworks* and *Dark Spaces*? Are not these subtle manipulations of light and space a way of addressing the most primary of "visibilities", of appearance itself? In Turrell's own words: "My works are about light in the sense that light is present and there; the work is made of light. It's not about light or a record of it, but it is light. Light is not so much something that reveals as it is itself revelation." Here no objects are presented. In this art nothing is revealed – it is revelation itself. Light and dark, dark and light: *Lichtung*.

Eye and Language

"The painter's vision is a continuous process" – the metaphysical position which Merleau-Ponty ascribes to painting imposes certain stipulations on the art which is to take up this heroic position. It

is obvious that his definition of the essence of painting is modelled on that of early modernism and that by emphasizing the immediacy and authentic presence of the painterly expression he excludes large sections of 20th century avant-garde art. It is Cézanne's view of color as "the point where our brain and the universe meet" and Klee's archaic color dots which are "older than everything else and find themselves at dawn" that has determined his view of art. Merleau-Ponty's mythology of the primordial has met with criticism, and his entire art-philosophical construction might be problematized if one adopts another view of the artwork and artistic creativity. How does Marcel Duchamp receive the gift of being? Where do we find primordial "visibility" in Dadaism? These are questions concerning the applicability of phenomenological philosophy to art which explicitly finish off the notion of the primordial and the demand for an authentic expression.

When, a decade after Cézanne's death, Duchamp rejects painting as *retinal* (too dependent on the retina), deciding instead to devote himself to linguistic experiments, he rebels against the notion of the privileged position of the eye. Similarly, demonstrating the dependence of visual terms on language games in his "Remarks on Color", Wittgenstein questions the priority of seeing in philosophy. Critique of the autonomy of the visual constitutes a powerful trend in our century. Before approaching Turrell's light installations from the vantage point of this problematics, let us briefly consider a position which may constitute the most powerful critique to date of the notion of the "primordial gaze": Wittgenstein's late philosophy.

"For looking does not teach us anything about the concept of color", runs one of Wittgenstein's most radical notes.[10] No? How, then, can we gain access to the meaning of the color terms? Wittgenstein answers: by studying their use. His "Remarks on Color", written as marginal notes on Goethe's "Theory of Color", seek to demonstrate that the experience of paint too is dependent on a deeper discursivity, a language game (or a set of related language games) which provides the framework within which visual concepts are accorded their meaning. His "Remarks on Color" are closely related to the critique of the priority of seeing which he develops in other texts dating from the same period, above all in "On Certainty". One of the central strategies here is to demonstrate the wrongness of the traditional (Cartesian) view of positive knowledge as a first evidence – as a kind of vision.

What is more obvious than the meaning of the word "red" – and that the word derives its meaning from the pure perception of the color in question? Wittgenstein's remarks on color aim chiefly at drawing attention to complications besetting the intuitive understanding of the meaning of color words. By means of a meticulous examination of the concrete situations in which color concepts are used Wittgenstein follows the Shakespearean formula he professes to adhere to: "I'll teach you difference" ("King Lear"). The matter he is concerned with here is not formulating a philosophical doctrine about color and sensuality but atomizing the general issues. Wittgenstein does not attempt to answer the question: what is color? On the contrary, he tries to determine the (linguistic) context which in a given case determines the use of color concepts. A word (a color word too) has its meaning only in relation to a complex structure of linguistic patterns. There is no such thing as the essence of color – color is many things.

The Spaces of Dreams

"If you only have five names for color, you see only five colors," Turrell declares.[11] What is the relations of his artistic projects to the positions sketched above? Few artists work as intensely with visuality and light. But rather than start from a fixed notion of human seeing he examines its limits. What is light, what is space, what is seeing? Turrell's installations radicalize the visual situation, stretching human perception to its utmost limits. If any artist deserves to be called a phenomenologist today, it is indeed Turrell.

In his emphasis on seeing Turrell is close to Merleau-Ponty, in whose philosophy he has taken an

explicit interest. However, the concrete examinations he has engaged in also reveals his affinity with Wittgenstein, who writes in "Remarks on Color": "There is no such thing as phenomenology but there are indeed phenomenological problems." If we really want to know what white light is we cannot fall back on a general principle but have to make a concrete analysis of how light behaves in specific cases; its transparency, its lustre, its ability to fill a room. Turrell's art does exactly that, while at the same time creating amazing spaces.

It is not always easy to fathom the philosophical relevance of Wittgenstein's sometimes very prosaic remarks on color. A typical note may sound like this: "Of two places in my surroundings which I see in one sense as being the same color, in another sense, the one can seem to me white and the other grey. To me in one context this color is white in a poor light, in another it is grey in good light. These are propositions about the concepts 'white' and 'grey'."[12]

Perhaps Turrell's installations should be seen as attempts at giving material form to this kind of dry observation, constituting as they do pure visual relations which create strange psychological effects through their radicality: light assumes tactile qualities. It takes "bodily" form and becomes visual in a curious way – making you wish to reach out and seize them. It is not, as Turrell himself has pointed out, a question of illusionism but of concrete presence. Extreme sobriety here creates a unique form of poetry.

The visual purity of Turrell's installations removes us from the familiar, shared world. Faced with these light phenomena, we are alone, just as alone as we are when faced with the expanses of the desert or the infinity of the sky. This is not the light of the quotidian, but that of dreams and fantasy. By means of scientific and rational tools, Turrell creates perceptions of something extraordinary and unknown. He explains his ambition: "I want to address the light that we see in dreams and the spaces that seem to come from those dreams and which are familiar to those who inhabit those places".

As an accomplished aviator, Turrell has experienced this light and these spaces at the altitude of several thousand feet and in extreme landscapes. However, all of us have at some point had intense sensations of the same kind: when confronted with open spaces, skyscapes and seascapes; in dreams and in imaginary landscapes. These are moments when light and void itself strike us as different and strange – producing a strong sense of presence.

In his works Turrell has incorporated nature's immense dimensions: celestial light and the infinite spaces of the sky. His most grandiose project, *Roden Crater* in Arizona, is being carried out in a place where these inhuman proportions are strikingly in evidence. An extinguished volcano becomes the site of unprecedented experiments with time an space.

What is peculiar about Turrell's work is, however, that he can create those intense sensations in artificial spaces anywhere. In Santa Monica, in Manhattan or in the free port of Stockholm – everywhere he manages to stage the same peculiar light and the same feeling of loneliness.

Step inside. Lose yourself.

Notes on the Sun

On my way back to Europe, in the plane, I again see the sun. It's incredibly bright, and a think about the famous words in the Bhagavadgita: "If the light of a million suns were to burst out into the sky, that would be like the appearance of the Mighty One". I try to develop a small, spontaneous theory of the sun. A theory for James Turrell and Olafur Eliasson, visionaries of light:

The Given: The sun spreads its energy without demanding anything in return. The rays of this self-consuming heavenly body reach the earth and are transformed into a vital force in plants, animals, and human formations. An increasing surplus of energy is accumulated: surfeit. Sooner or later the explosion is bound to come. The energy must be spent, in an act of transgression and excess. This

is Georges Bataille's cosmology in a nut shell: the sun is obscene and luxurious: "One might add that the sun has also been mythologically expressed by a man slashing his own throat, as well as by an anthropomorphic being deprived of a head. All this leads one to say that the summit of elevation is in practice

confused with a sudden fall of unheard-of violence". This anti-Platonic cosmology has turned all the hierarchies of light, truth and the Good up-side-down. The sun, originally the image of the Good, and the symbol of the idea of all ideas, has been denigrated and humiliated. From Plato to Bataille the distance is at once enormous and minute: the Platonic metaphors are still in use, but they have been reversed. The sun is no longer the eye, but the anus. The sun no longer shines in the heavenly infinity of truth, but at the bottom of a grave: "The sun, situated at the bottom of the sky like a cadaver at the bottom of a pit…"

This development and reversal has taken place through several steps

1. Platonism, Christianity: The sun is still shining in the sky.

2. Romanticism: The sun turns black. It's a nightly phenomenon (Novalis).

3. Nietzsche: The sun must be thought of in the plural. We are all "dancing stars" – the Superman is the sun to come.

4. Surrealism, Bataille: The sun is rotten, the eye is blinded.

5. The sun of the future…?

Eyes was published in 1994 in the catalogue *James Turrell* (Magasin 3, Stockholm). The *Preface* and *Notes on the Sun* were written for this MAK publication.

1 Barbara Gladstone Gallery, New York (31. October – 23. December, 1998).
2 *Jim Turrell: Light Projections and Light Spaces*, Stedelijk Museum, Amsterdam (09. 04. – 23. 05. 1976). *James Turrell: Light & Space*, Whitney Museum of American Art, New York (22. 10. 1980 – 01. 01. 1981).
3 See Julia Brown, interview with Turrell, *Occluded Front* (The Lapis Press, Los Angeles 1985): 13 ff.
4 Giuseppe Panza di Biumo, "Artist of the Sky", *Occluded Front:* 65
5 *Occluded Front:* 25
6 "Der Regenbogen. Gespräch über die Phantasie", *Gesammelte Schriften* (Suhrkamp, Frankfurt am Main 1989, vol. VII:I): 19 – 26
7 "Eye and Mind", *The Primacy of Perception* (Northwestern University Press, Evanston 1964): 178
8 Ibid.: 167
9 Ibid.: 187
10 *Remarks on Color* (Blackwell, Oxford 1977): 8 ff.
11 Quoted in Craig Adcock, *James Turrell: The Art of Light And Space* (University of California Press, Berkeley 1990): 73
12 *Remarks on Color*: 8.

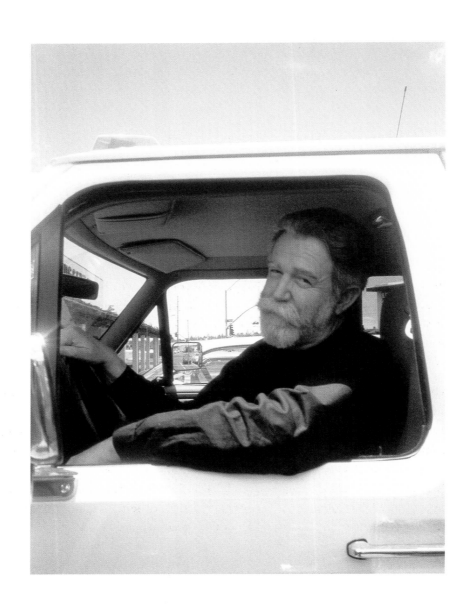

BIOGRAPHIE

1943 in Los Angeles geboren, studiert James Turrell von 1961 bis 1965 Psychologie, Mathematik und Kunstgeschichte am Pomona College, Claremont, Kalifornien. Anschließend bis 1965/66 Kunststudium an der University of California in Irvine und bis 1973 an der Claremont Graduate School. Der familiäre Hintergrund ermöglicht ihm eine erste Einführung in technologische Entwicklungen des Flugzeugbaus, Kenntnisse über Flugnavigation und Photogrammetrie.

Ab November 1966 mietet er als Atelier- und Ausstellungsort das ehemalige *Mendota Hotel* in Ocean Park, Kalifornien an. Die Atelierräume werden suksessive gegen Lärm und Licht von außen isoliert und er beginnt mit Lichtprojektionen im Innenraum. Es entstehen die ersten *Cross Corner Projections: Afrum-Proto, Catso, Shanta, Munson* und *Joecar*, die in unterschiedlicher Farbigkeit realisiert werden. Parallel dazu beginnt die Arbeit an den *Single Wall Projections* darunter *Decker, Pullen, Enzu, Prado* und *Tollyn*. Sämtliche der ersten *Projection Pieces* sind in der Serie von Zeichnungen *Out of Corners* von 1969 skizziert. Bis Mitte der 70er Jahre enstehen insgesamt 50 *Cross Corner* und *Single Wall Projections*, jede Arbeit mit eigener Farbigkeit und formalen Charakteristika.

1967 erste Einzelausstellung am Pasadena Art Museum.

1968 entwickelt er mit Sam Francis, mit dem er Ende der 50er Jahre als Pilot geflogen war, die Arbeit *Skywriting*, ein *Performance Piece* mit Flugzeugen, die ein farbig ephemeres Ornament an den Himmel malten. Sie war Teil des Ausstellungsprojektes *Easter Sunday in Brookside Park*, das gleichzeitig einige *Earthworks* umfaßte.

Ende des Jahres 1968 erhält er die Möglichkeit, zusammen mit dem Künstler Robert Irwin und dem Wahrnehmungspsychologen Edward Wortz innerhalb des *Art and Technology Program* des Los Angeles County Museum of Art, seine Arbeit im Grenzbereich von Wissenschaft und Ästhetik fortzusetzen. Im Verlauf dieses Projektes entwickelt Turrell einzelne Versuchsanordnungen von komplett abgedunkelten und schalldichten Räumen, um Veränderungen von optischen und akustischen Sinneswahrnehmungen unter extremen Bedingungen zu erforschen. Einige Konzeptionen integrieren die Erfahrung von *Ganzfeldern*, die später formal weitere Werkgruppen beeinflussen. Im gleichen Jahr erhält er ein Stipendium des National Endowment for the Arts.

Zwischen 1968 und 1969 beginnt die Arbeit an den *Shallow Space Constructions*, die auf Eingriffen in die vorhandene Raumstruktur basiert und die formalen Qualitäten der *Projection Pieces* dreidimensional aufgreift. Im *Mendota Studio* entstehen aus einem Prototyp insgesamt neun *Shallow Space Constructions*, darunter *Ronin*, *Raemar*, *Rondo* und *Nan Mun*.

1969 entstehen die *Mendota Stoppages*, Lichtarbeiten, die die Referenzialität zwischen Innen- und Außenraum thematisieren. Erste Aspekte der *Structural Cuts* und der *Skyspaces* sind in den *Mendota Stoppages* zugrunde gelegt und auf jahreszeitliche Bedingungen, beispielsweise dem Sonnenstand und Sternenkonstellationen, ausgerichtet. Für die *Mendota Stoppages* konzipiert er auch *Dark Spaces*, die er als Werkreihe erst in den 80er Jahren zu realisieren beginnt. Die zwischen 1970 und 1971 entstandenen Zeichnungen *Music for the Mendota* zeigen die insgesamt zehn voneinader abweichenden Nachtsituationen der *Mendota Stoppages*.

Zwischen 1970 und 1972 entstehen ebenfalls aus den *Mendota Stoppages* erste Prototypen für die Werkgruppe der *Wedgework Series*. Durch keilförmige Anordnung der Wände ergeben sich unterschiedliche Brechungen des Lichteinfalls und erzeugen plane, fein texturierte Flächen aus Licht. Die formalen Qualitäten der ersten *Wedgeworks* stehen in engem Bezug zu den *Projection Pieces*; beispielsweise greift *Lodi*, das erste *Wedgework*, die *Cross Corner Projection Joecar* auf.

1974 gibt Turrell seine Atelier- und Ausstellungsräume in Ocean Park auf. Im gleichen Jahr erhält er das Guggenheim Fellowship, das er einsetzt, um mit dem Flugzeug einen geeigneten Ort für die Fortsetzung seiner Atelierarbeit im Außenraum zu suchen. Nach sieben Monaten findet er den *Roden Crater* in Arizona und beginnt mit genauen Vermessungen und ersten Skizzenentwürfen. In dieser Zeit entwickelt er für den italienischen Sammler Giuseppe Panza di Biumo ortsspezifische Arbeiten in Varese, *Virga* (1974) und das *Skyspace I* (1975). Während folgenden Aufenthalten entstehen Pläne für *Structural Cuts* in gegebenen architektonischen Strukturen, wie *Inside Out* für das *Cascina Taverna Project* sowie Pläne für den zweigeschoßigen Neubau einer Kapelle, der *Chapel of Light*, die mehrere *Skyspaces* vorsehen.

1976 folgt die erste große Einzelausstellung im Stedelijk Museum, Amsterdam. Neben einem Überblick über bisher entstandene Werkgruppen sowie Zeichnungen zum *Roden Crater*, ist *City of Arhirit*, eine erstmalig ausgeführte, mehrteilige *Ganzfeld*-Installation, zu sehen. Im gleichen Jahr erfolgen der Umzug nach Sedona, Arizona und erste Entwürfe für die *Prado Series*, der ersten Werkgruppe der *Space Division Constructions*.

1977 erwirbt er mit Hilfe der *Dia Art Foundation* den *Roden Crater*.

1979 Umzug nach Flagstaff, Arizona.

1980 präsentiert er seine zweite große Einzelausstellung im Whitney Museum of American Art, New York und eine weitere Ausstellung in der Leo Castelli Gallery, New York, in der die erste Arbeit der *Phaedo Series*, *Phaedo*, zu sehen ist. Parallel entstehen die Baupläne zu *Meeting* für das P.S.1, New York.

1983 realisiert er für seine Ausstellung im ARC, Musée National d'Art Moderne, Paris, erstmals ein *Skylight* mit dem Titel *Hover*, das anders als die *Skyspaces*, die Kontrastwirkung zwischen Lichtverhältnissen im Innen- und Außenraum einsetzt. Für die permanente Sammlung in der Mattress Factory, Pittsburgh entwickelt er mit Rückgriff auf die *Mendota Stoppages* das erste *Dark Space* mit dem Titel *Pleiades*.

1984, im Rahmen des *Capp Street Project*, San Francisco, entsteht eine weitere Arbeit der *Dark Spaces*, *Selene*, sowie eine raumgreifende, ortsspezifische Lichtinstallation, *Wolf*, die die Arbeits-

weise der *Mendota Stoppages* völlig umkehrt und den urbanen Raum während der Nacht mit Lichtphänomenen bespielt.

Zwischen 1985 und 1989 ist die Auseinandersetzung mit der Wirkungsweise der *Dark Spaces* ein wichtiger Aspekt seiner Arbeit. 1985–86, im Rahmen seiner Ausstellung im Museum of Contemporary Art, Los Angeles, verwirklicht er eine Sequenz unterschiedlicher Raumsituationen, die auf die spezifischen Lichtmischungen der *Dark Spaces* ausgerichtet sind. Es entstehen in der Folge *Arkar's Visit* (1985), *Jadito's Night* (1985), *Meso* (1986), *Cloud of Dust* (1988), *Thought When Seen* (1988) und *Spread* (1989). Im gleichen Zeitraum nehmen die Ideen für die Lagerung der Kammern im Korpus des *Roden Crater* zunehmend Gestalt an. Dabei verknüpft er einzelne Lichtaspekte der bisher ausgearbeiteten Werkserien innerhalb komplexer Raumfluchten, die er in den Druckserien *Deep Sky* (1985) und *Mapping Spaces* (1987), sowie in Modellen und zahlreichen Plänen dokumentiert. Im Zusammenhang damit stehen auch die einzelnen Modellserien für die *Autonomous Structures*, die in den Jahren 1986 bis 1989 entstehen. Die *Cubes Series*, *Pyramids* und *Columns Series* sowie die Serien der *Vaultings*, *Basilicas*, *Spheres* und *Spaceships* reflektieren seine intensive Beschäftigung mit architektonischen Entwürfen, mit dem Ziel, den *Ganzfeldern*, *Dark Spaces* und *Skyspaces* eine feste eigenständige Struktur zu geben. Von den Entwürfen der *Cubes Series* werden *Second Meeting* (1986) und *Blue Blood* (1988) gebaut.

1989–90 arbeitet er intensiv an der Konzeption des *Irish Sky Garden* und begleitet das Projekt in der Ausarbeitung baureifer Pläne bis 1991. Der *Irish Sky Garden* ist in seinen Dimensionen vergleichbar mit dem *Roden Crater Project* und beinhaltet diverse Himmelsobservatorien, die aus den Landschaftsformen herausgearbeitet sind. Im Verlauf der ersten Planungsphase bezieht er einen zweiten Wohnsitz in Inishkame, Irland.

Ab 1991 beschäftigt sich Turrell verstärkt mit dem Phänomen der *Ganzfelder*. Die neue Werkserie der *Perceptual Cells*, besteht aus mobilen, erstmals nicht ortsspezifischen Einheiten, die auf die Forschungsergebnisse des *Art and Technology Program* zurückgreifen. Eine wichtige Serie dieser Wahrnehmungszellen sind die *Telephone Booths*, in die der Betrachter wie in eine Telephonzelle eintritt und einem genau kalkulierten, von ihm selbst beeinflußbaren, optischen und auditiven Erlebnis ausgesetzt ist. In den Ausstellungsräumen des Confort Moderne, Poitiers, realisiert er 1991 sein erstes *Water Piece*, das durch die Konstruktion einen neuartigen *Skyspace*-Aspekt durch Lichtspiegelungen im Wasser erzeugt.

1994 entsteht aus einer engen Kooperation mit dem französischen Komponisten Pascal Dusapin die Oper *To Be Sung*, ein weiteres *Performance Piece*, für das er ähnlich wie bei dem Tanzstück *Severe Clear* von 1985 eine *Space Division Construction* als bestimmendes Element der Szenographie entwirft.

1995 zeigt Turrell im Rahmen seiner ersten großen Einzelausstellung im Art Tower Mito, Japan, die Arbeit *Gasworks*, ein *Ganzfeld*, die das System der *Telephone Booths* aufgreift, jedoch eine klinische Situation suggeriert.

Seit Mitte der 90er Jahre führt die Kooperation mit internationalen Architekten zu Arbeiten, die sich auf unterschiedliche Weise mit der architektonischen Struktur auseinandersetzen. In Leipzig und in Bregenz realisiert er ortsspezifische Lichtinstallationen, darunter *Performing Lightworks* (1997), die die Gebäude in transluzide, skulpturale Körper verwandeln. Für das *Live Oak Friends Meeting* in Houston konzipiert er ein *Skyspace*, das die Spiritualität der Quäkergemeinschaft, für die das Gebäude geplant ist, versinnbildlicht. Ein weiteres Projekt mit Tadao Ando wurde 1998 für das Naoshima Contemporary Art Museum begonnen. Innerhalb eines japanischen Tempelbezirks entsteht ein Pavillon, der eine einzige Lichtarbeit enthalten wird.

1996 realisert er für das Hague's Center for Visual Arts einen künstlichen Kraterraum in den Geröllldünen der niederländischen Küstenlandschaft. *Celestial Vault in Kijkduin* ermöglicht in wesentlich kleineren Größenverhältnissen als der *Roden Crater*, die Veränderung der eigenen Wahrnehmung durch den gegebenen Landschaftsraum zu erfahren. Da der *Irish Sky Garden* nicht realisiert wurde, ist *Celestial Vault in Kijkduin* bisher das einzige Landschaftsprojekt das ausgeführt wurde und in konzeptioneller Verbindung mit dem *Roden Crater Project* steht.

1997–98 ist nach 15 Jahren, innerhalb einer Japan Ausstellungstournee, eine erste große Werk-übersicht zu sehen. Turrell realisiert dafür *Key Lime* π, ein *Spectral Wedgework*, das aus den früheren monochromen Arbeiten der *Wedgeworks I–IV*, sowie dualfarbigen Arbeiten dieser Serie, wie *Mikva* (1983) und *Zona Rosa* (1995) entwickelt wurde. Stationen der Tournee waren das Museum of Modern Art, Saitama, das Nagoya City Art Museum und das Setagaya Art Museum.

1998 sind die Baupläne am *Roden Crater* für die ersten einzelnen *Crater Spaces*, sowie die not-wendigen infrastrukurellen Ergänzungen abgeschlossen und behördlich genehmigt. Die erste Bauphase umfaßt den *Sun and Moon Space*, den zentralen Raum *Eye of the Crater*, die *South Lodge* sowie die unterirdische Verbindung des *East Alpha Tunnel*.

1998–99 im Rahmen der Einzelausstellung im MAK, Wien, konzipiert Turrell nach *City of Arhirit* (1976) eine weitere, großräumige, begehbare *Ganzfeld*-Installation, *Wide Out*, für die zentrale Ausstellungshalle, sowie den Entwurf für eine permanente Lichtfassade.

Im Jahr **2000** wird die erste Phase der baulichen Veränderungen am *Roden Crater* abgeschlossen.

James Turrell lebt heute in Flagstaff, Arizona, USA.

BIOGRAPHY

Born in Los Angeles in **1943**, James Turrell attended Pomona College at Claremont, California, from 1961 to 1965, where he majored in psychology, mathematics and art history. Completing his studies of fine arts he graduated from the University of California in 1965/66 and from Claremont Graduate School in 1973. His family background provided him with first insights into the technologies involved in aircraft construction, flight navigation and photogrammetry.

In November 1966, Turrell decided to rent the former *Mendota Hotel* at Ocean Park, California, turning it into a studio and exhibition space. All studio rooms were successively insulated to shut out sound and light from the outside, and he promptly began with his inside light projections, creating his first *Cross Corner Projections* entitled *Afrum-Proto, Catso, Shanta, Munson* and *Joecar,* all of which were realized in different colors. At the same time, he started working on his *Single Wall Projections,* among them *Decker, Pullen, Enzu, Prado* and *Tollyn.* A series of drawings, *Out of Corners,* dated 1969, features all of his first *Projection Pieces.* By the mid-seventies, Turrell has produced altogether 50 *Cross Corner* and *Single Wall Projections,* each with its own color scheme and formal characteristics.

In 1967, Turrell's first one-man show at the Pasadena Art Museum.

In 1968, he and Sam Francis, former fellow pilot in the late fifties, cooperated to create *Skywriting,* a *Performance Piece* involving airplanes painting colorful ephemeral ornaments into the sky. The piece was part of the exhibition project *Easter Sunday* in *Brookside Park,* which also included some *Earthworks.*

Towards the end of 1968, Turrell, the artist Robert Irwin, and Edward Wortz, a perceptional psychologist, were sponsored by the Los Angeles County Museum of Art to continue their research on the frontiers of aesthetics and science within the museum's *Art and Technology Program.* In the course of this project, Turrell set up a number of experimental sequences involving completely darkened and sound-proofed rooms in order to study the changes occurring in optical and acoustic perception under extreme conditions. Some of the experimental work involved *Ganzfelds* which would influence later works. In the same year, Turrell received a grant from the National Endowment for the Arts.

Between 1968 and 1969, Turrell began working on his *Shallow Space Constructions.* These pieces manipulate existing spatial structures, taking the formal qualities of his *Projection Pieces* into the third dimension. All in all, at the *Mendota Studio* nine *Shallow Space Constructions,* among them *Ronin, Raemar, Rondo* and *Nan Mun,* were created from a single prototype.

In 1969, Turrell moved on to create the *Mendota Stoppages,* lightworks that explored the interdependence of inner and outer space. In its alignment with seasonal phenomena such as the position of the sun and celestial constellations, the *Mendota Stoppages* presaged ideas that were to appear later in *Structural Cuts* and *Skyspaces.* The *Mendota Stoppages* also engendered the concept for the *Dark Spaces,* which, as an independent series, was of central relevance in the eighties. The drawings *Music for the Mendota,* dated 1970 to 1971, represent the altogether 10 different night stages involved in *Mendota Stoppages.*

Between 1970 and 1972 and based on *Mendota Stoppages,* Turrell develops the first prototypes for the *Wedgework Series. Wedge-like* wall arrangements caused different light refractions, resulting in finely textured surfaces of light. The formal qualities of these initial *Wedgeworks* had much in common with his *Projection Pieces. Lodi,* the first piece in the *Wedgework Series,* for instance, relies heavily on the *Cross Corner Projection Joecar.*

In 1974, Turrell decided to relinquish his Ocean Park studio and exhibition space. In the same year, he was awarded a Guggenheim Fellowship, which allowed him to take up his search by airplane for a suitable outside space to continue his studio work. After a period of seven months, he finally found the *Roden Crater* in Arizona and immediately started drawing up precise topographical maps of the site and sketching out his ideas. At the same time, he conceived site-specific works for the Italian collector Giuseppe Panza di Biumo in Varese, Italy. *Virga* (1974) and *Skyspace I* (1976) were realized at Panza's villa. Later stays resulted in proposals for *Structural Cuts* in given architectural spaces and *Inside Out* for the *Cascina Taverna Project,* as well as plans for a new, two-story *Chapel of Light,* which was to include several *Skyspaces.*

In 1976, Turrell presents in the first extensive one-man show at the Stedelijk Museum in Amsterdam not only an overview of his work to date and drawings for *Roden Crater,* but also *City of Arhirit,* a new *Ganzfeld* work consisting of several spaces. In the same year, Turrell moved to Sedona, Arizona, and began working on the *Prado Series,* the first group of works in the *Space Division Constructions* series.

In 1977, Turrell purchased the *Roden Crater* with the help of the Dia Art Foundation.

In 1979, Turrell moved to Flagstaff, Arizona.

In 1980, Turrell's second large solo exhibition took place at the Whitney Museum of American Art in New York, with another exhibition in progress at the Leo Castelli Gallery in New York, featuring *Phaedo,* his first work in the *Phaedo Series.* The construction plans for *Meeting* for the P.S.1 in New York date from the same time.

In 1983, his exhibition at the ARC, Musée d'Art Moderne in Paris, for the first time included the realization of a *Skylight.* Hover differs from his *Skyspaces* in that it uses the contrasting effects between the light present inside and outside a space. The first *Dark Space* entitled *Pleiades,* referring back to *Mendota Stoppages,* was created for the permanent collection of the Mattress Factory in Pittsburgh.

In 1984, his participation in the *Capp Street Project* led to the creation of another *Dark Space, Selene,* as well as an architectural, site-specific light installation, *Wolf,* which completely reversed his

approach of *Mendota Stoppages* in that light phenomena were projected onto the urban space at night.

Between 1985 and 1989, an important part of his work consisted of a deeper exploration of the characteristics of *Dark Spaces* especially in 1985–86, for his exhibition at the Museum of Contemporary Art in Los Angeles, where he realized a sequence of individual spaces tailored to the light mixtures in darkness. These included *Arkar's Visit* (1985), *Jadito's Night* (1985), *Meso* (1986), *Cloud of Dust* (1988), *Thought When Seen* (1988) and *Spread* (1989). At the same time, his ideas about the arrangement of chambers in the massive body of the *Roden Crater* were beginning to take shape. Certain light aspects from already existing work series were brought together in complex spatial sequences and documented in the print series *Deep Sky* (1985) and *Mapping Spaces* (1987) as well as in numerous models and plans. Individual series of models for *Autonomous Structures* from 1986–89 were also influenced by these ideas. His *Cubes Series, Pyramids,* and *Columns Series* as well as his *Vaultings, Basilicas, Spheres* and *Spaceships* series reflect his intensive exploration of architectural spaces and his intention to provide a solid, independent framework for his *Ganzfeld, Dark Spaces* and *Skyspaces* series. Of the numerous drafts for the *Cubes Series, Second Meeting* (1986) and *Blue Blood* (1988) were finally realized.

In 1989–90, Turrell concentrated on his idea of an *Irish Sky Garden*, progressing to a point where detailed building plans were worked out. The scale of the *Irish Sky Garden* was to be comparable to the *Roden Crater Project*, including several observatories built into the landscape. In the course of the first planning phase, Turrell even took up residence at Inishkame, Ireland.

Starting in 1991, Turrell explored the phenomenon of the *Ganzfeld* with renewed vigor. His new work series *Perceptual Cells* consists of mobile, and, for the first time, non-site-specific units based on findings from the Art and Technology Program, such as the important *Telephone Booths* series. Viewers enter the structure like they would a telephone booth and are then exposed to a minutely calculated optical and auditive experience they can control to a certain degree. Finally, at the Confort Moderne art space in Poitiers, Turrell realized his first *Water Piece,* a work constructed to create a new *Skyspace* experience by means of light reflections in the water.

In 1994, Turrell closely cooperated with the composer Pascal Dusapin to produce the opera *To Be Sung,* a *Performance Piece* for which he designed a *Space Division Construction* as a stage setting, not unlike for the dancing piece *Severe Clear* from 1985.

In 1995, at his first extensive one-man show at the Art Tower Mito in Japan, Turrell showed *Gasworks,* a *Ganzfeld* that refers back to *Telephone Booths* but evokes a clinical situation.

Since the middle of the nineties, joint projects with international architects have resulted in projects dealing with architectural space in various ways. At Leipzig and Bregenz, Turrell's site-specific light installations, among them *Performing Lightworks* (1997), have turned buildings into translucent, sculptural bodies. For the *Live Oak Friends Meeting* in Houston, Turrell has conceived a *Skyspace* that is to represent the spirituality of the Quaker community by which the plans were commissioned. Another joint project with Tadao Ando for the Naoshima Contemporary Art Museum began in 1998 and will feature a pavilion containing a single light installation for a Japanese temple district.

In 1996, Turrell also realized an artificial crater space for the Hague's Center of Visual Arts in the rubble dunes on the Dutch coast. On a much smaller scale than *Roden Crater, Celestial Vault in Kijkduin* allows the viewer to experience changes in his own perception in a given landscape. Since

Irish Sky Garden was not realized, *Celestial Vault in Kijkduin* is the only existing landscape project that is conceptually related to the *Roden Crater Project.*

In 1997–98, an exhibition tour in Japan provided the first opportunity in 15 years to see an extensive retrospective of Turrell's work. *Key Lime π*, a *Spectral Wedgework* referring back to his early monochrome works *Wedgeworks I – IV* and the diachromatic works in the series such as *Mikva* (1983) and *Zona Rosa* (1995), was created especially for this occasion. The exhibition was shown at the Museum of Modern Art in Saitama, the Nagoya City Art Museum and the Setagaya Art Museum.

In 1998, the building plans for the first *Crater Spaces* at *Roden Crater* and the necessary infrastructure have been completed and were approved by the building authorities. The first construction phase will include the *Sun and Moon Space,* the central space *Eye of the Crater*, the *South Lodge*, as well as the underground corridor *East Alpha Tunnel.*

For his one-man-show at the MAK in Vienna, Turrell has created an extensive, walk-in *Ganzfeld* installation for the main Exhibition Hall, *Wide Out,* after *City of Arhirit* (1976) and proposed a permanent light facade.

Plans for the year **2000** include the completion of phase 1 of the construction work on the *Roden Crater.*

James Turrell is currently living in Flagstaff, Arizona, USA.

MAK–Ausstellung / MAK Exhibition, 1998

Key Lime π 1998
Spectral Wedgework
Photo: Gerald Zugmann, 1998
S. / p. 26

Milk Run II 1997
Spectral Wedgework
Fluoreszenz-Licht / fluorescent light
Installation im / installation at Kunsthaus Bregenz, Austria, 1997
Photo: Gerald Zugmann
Sammlung / collection of Michael Hue-Williams Fine Art, London
S. / p. 27

Prana 1991
Space Division Constructions / Danae Series
Photo: Gerald Zugmann, 1998
S. / p. 24

St. Elmo's Breath 1992
Space Division Constructions / Danae Series
Curved Aperture
Photo: Gerald Zugmann, 1998
S. / p. 25

The other Horizon 1998
Skyspace
Photo: Gerald Zugmann, 1998
S. / p. 28–29

Wide Out 1998
Ganzfeld
Photo: Gerald Zugmann, 1998
S. / p. 22–23

Abbildungsverzeichnis in alphabetischer Ordnung
List of plates in alphabetical order

Acton 1976
Wolfram-Licht / tungsten light
Photo: Indianapolis Museum of Art, Gift of the Contemporary Art Society,
photograph © 1998 Indianapolis Museum of Art
Permanente Sammlung / permanent collection of Indianapolis Museum of
Art, Indiana
S. / p. 106

Afrum–Proto 1966
Quartzhalogen-Licht / quartz halogen light
Installation im / installation at Art Tower Mito, Ibaraki, Japan, 1995
Photo: Shigeo Anzai
Sammlung / collection of Mickey and Jeanne Klein
S. / p. 60

Air Mass 1993
Installation in der / installation at Hayward Gallery, London, 1993
Sammlung des Künstlers / collection of the artist
Permanente Sammlung / permanent collection of Kilfane Trust,
Thomastown, Co. Kilkenny, Ireland
S. / p. 100–101

Air Mass 1993
Auf- und Grundriß für / elevation and plan view for Kilfane Trust,
Thomastown, Co. Kilkenny, Ireland
Sammlung des Künstlers / collection of the artist
S. / p. 99

Amba 1968
Courtesy of ZEITGEIST-Gesellschaft e. V., Berlin
Photo: Werner Zellien
Sammlung des Künstlers / collection of the artist
S. / p. 67

Arcus 1989
Sammlung / collection of Michael Hue-Williams Fine Art, London
S. / p. 118

Blind Sight 1992
Installation in der / installation at the Fundación „la Caixa", Madrid, 1992
Sammlung des Künstlers / collection of the artist
S. / p. 129

Blind Sight 1992
Auf- und Grundriß für / elevation and plan view for Hayward Gallery,
London, 1993
Sammlung des Künstlers / collection of the artist
S. / p. 131

Call Waiting (Innenansicht / interior) 1997
Holz, Glasfaser, Neon-Licht, Stroboskop u. a. / wood, fiberglass, neon light,
strobe, etc.
239 x 126 x 126 cm (94 1/8 x 49 5/8 x 49 5/8″)
Photo: Sakae Fukuoka
Sammlung / collection of Setagaya Art Museum, Tokyo, Japan
S. / p. 149, 151

Catso Blue 1967
Xenon-Licht / xenon light
Photo: James Turrell
Sammlung / collection of Lannan Foundation, Santa Fe, New Mexico
S. / p. 62

Catso Red 1967
Xenon-Licht / xenon light
Courtesy of Mattress Factory, Pittsburgh
Permanente Sammlung / permanent collection of Mattress Factory,
Pittsburgh
S. / p. 63

Celestial Vault in Kijkduin 1996
Krater in Dünenlandschaft / crater in the dunes
Photo: Jannes Linders
Permanente Sammlung / permanent collection of Stroom, The Hague's
Center for Visual Arts, The Netherlands
S. / p. 181

Cardinal Spaces on Fumarole II Haupträume der Fumarole II
1993
Wachsenkaustik mit Glimmerstaub auf Tafel mit Stahlrahmen /
encaustic wax with mica powder on panel with steel frame
132 x 152,5 cm (52 x 60")
© James Turrell/Saff Tech Arts, Inc., 1993
S. / p. 165

Fumarole Space Fumarole-Raum 1996
Auf- und Grundriß / elevation and plan view
S. / p. 170–171

North Space Nördlicher Raum 1998
2-teiliges Modell / model in 2 parts
Modellbau / modelmaker: Eric H. Troffkin, Stephan Hillerbrand,
Janet Cross, Cross Architecture, New York
85,73 x 85,73 x 42,86 cm (33 3/3 x 33 3/4 x 16 7/8")
Maßstab / scale 1:48
Photo: Theodore Coulombe
S. / p. 168

North Space Nördlicher Raum 1997
Auf- und Grundriß / elevation and plan view
S. / p. 169

South Space Floor Plan Südlicher Raum, Grundriß 1998
Sammlung des Künstlers / collection of the artist
S. / p. 166

South Space 1998
2-teiliges Modell / model in 2 parts
Modellbau / modelmaker: Eric H. Troffkin, Stephan Hillerbrand, Janet
Cross, Cross Architecture, New York
85,73 x 85,73 x 42,86 cm (33 3/3 x 33 3/4 x 16 7/8")
Maßstab / scale 1:48
Photo: Theodore Coulombe
S. / p. 167

Sun and Moon Space Sonnen- und Mondraum 1997
Auf- und Grundriß / elevation and plan view
S. / p. 172

Side Look 1992
Permanente Sammlung / permanent collection of Städtische Galerie im
Lenbachhaus, Munich, Germany
S. / p. 119

Skyspace I 1975
Fluoreszenz- und Außen-Licht / fluorescent and natural light
Portal: 254 x 254 cm (100 x 100");
Raum / room: 599,4 x 360,7 x 360,7 cm (236 x 142 x 142")
Panza Collection, Gift, 1992
The Solomon R. Guggenheim Museum, New York
On permanent loan to FAI, Fondo per l'Ambiente Italiano
Permanente Installation in der / permanent installation at Villa Panza,
Varese, Italy
S. / p. 98

Skywriting 1968
In Zusammenarbeit mit / in collaboration with Sam Francis
s/w Photographie / black and white photograph
Pilot: James Turrell
Photo: Sam Francis
In: Avalanche, New York, 1, 1 (Herbst / Fall 1970): 2
S. / p. 152

Soft Cell 1992
Sperrholz, Schaumstoff, Glühlampe, Teppich / plywood, foam, incandescent
light, carpet
284,5 x 208,3 x 208,3 cm (112 x 82 x 82")
Courtesy of Art Tower Mito, Japan
S. / p. 144

Sounding 1997
Wolfram- und ultraviolettes Licht / tungsten and ultraviolet light
Installation im / installation at Kunsthaus Bregenz, Austria, 1997
Photo: Gerald Zugmann
Sammlung des Künstlers / collection of the artist
S. / p. 111

Space that Sees 1993
Permanente Sammlung / permanent collection of The Israel Museum,
Jerusalem
S. / p. 97

To Be Sung 1994
Erste Performance im / first performance at Théâtre des Amandiers,
Nanterre, France
Photo: Marthe Lemelle
S. / p. 153–155

Trace Elements 1993
Funds from NBT Foundation, In honor of Dianne Perry Vanderlip, Denver
Art Museum collection
Photo: James Milmoe
Permanente Sammlung / permanent collection of Denver Art Museum,
Denver, Colorado
S. / p. 112

Trace Elements 1993
Aufriß und Beleuchtungsanweisungen für / elevation view and lighting
directions for Hayward Gallery, London
S. / p. 105

Transformative Space: Milarepa's Helmet 1991
Gips / cast hydrocal plaster
46,3 x 88,3 x 88,3 cm (18 2/8 x 34 3/4 x 34 3/4")
Sammlung des Künstlers / collection of the artist
S. / p. 134

Transformative Space: Third Day 1991
Gips / cast hydrocal plaster
67,6 x 88,3 x 88,3 cm (26 5/8 x 34 3/4 x 34 3/4")
Sammlung des Künstlers / collection of the artist
S. / p. 135

Virga 1976
Tages- und Fluoreszenz-Licht / ambient skylight and fluorescent light
Raum / room: 373,4 x 447 x 937,3 cm (147 x 176 x 369")
Panza Collection, Gift, 1992
The Solomon R. Guggenheim Museum, New York
On permanent loan to FAI, Fondo per l'Ambiente Italiano
Permanente Installation in der / permanent installation at Villa Panza,
Varese, Italy
S. / p. 84–85

Wedgework III 1969
Fluoreszenz-Licht / fluorescent light
Installation im / installation at the Whitney Museum of American Art,
1980–81
Photo: John Cliett
Permanente Sammlung / permanent collection of De Pont Foundation for
Contemporary Art, Tilburg, The Netherlands
S. / p. 83

Wedgework IV 1974
Installation in der / installation at Hayward Gallery, London, 1993
Photo: John Riddy
Sammlung / collection of Lannan Foundation, Santa Fe, New Mexico
S. / p. 79

Wedgework IV 1974
Beleuchtungsanweisungen und Grundriß für / lighting directions and plan
view for Hayward Gallery, London, 1993
S. / p. 82

Wolf (Capp Street Project, San Francisco, USA) 1984
Courtesy of the artist
Photos: M. Lee Fatherree
S. / p. 205–207

Bibliographie – Auswahl / Selected Bibliography

Kataloge und Bücher / Catalogues and books

Adcock, Craig, *James Turrell: The Art of Light and Space*, University of California Press, Berkeley–Los Angeles–Oxford 1990

Air Mass, ed. by Mark Holborn, The South Bank Centre, London 1993

Avaar: A Light Installation, Herron Gallery, Herron School of Art, Indianapolis 1980

Bachelard, Gaston, *Poetics of Space*, Beacon, Boston 1969

Brecher, Kenneth, and Feirtag, Michael, eds., *Astronomy of the Ancients*, Massachusetts Institute of Technology Press, Cambridge 1980

Butterfield, Jan, *The Art of Light and Space*, Abbeville Press, New York 1993

Carterette, Edward C., and Friedman, Morton P., eds., *Handbook of Perception, Vol. I: Historical and Philosophical Roots of Perception*, Academic Press, New York 1974

Directions 1986, Hirshhorn Museum and Sculpture Garden, Washington, D.C. 1986

'Fritto, Misto' & 'Pleiades': Three Installations by James Turrell, Boulder Art Center, Boulder, CO 1990

Gombrich, E. H., *Art and Illusion*, Phaidon Press, London 1960

Held, Richard, ed., *Image, Object, and Illusion*, W. H. Freeman, San Francisco 1971

Individuals: A Selected History of Contemporary Art, 1945–1986, Museum of Contemporary Art, Los Angeles 1986

James Turrell, Kunsthaus Bregenz, Austria 1997

James Turrell, Contemporary Art Center, Art Tower Mito, Ibaraki, Japan 1995

James Turrell, Magasin 3 Stockholm Konsthall, 1994

James Turrell, Fundación „La Caixa“, Madrid 1992

James Turrell, Musée d'Art Contemporain, Lyon 1992

James Turrell, Stein Gladstone Galerie, New York 1990

James Turrell, Florida State University Gallery and Museum, Tallahassee 1989

James Turrell: A la levée du soir, Musée d'Art Contemporain, Nîmes, France 1989

James Turrell, Batten: An Installation, Massachusetts Institute of Technology, Cambridge, MA 1983

James Turrell: Celestial Vault in Kijkduin, Stroom, The Hague Centre for Visual Arts, The Hague 1996

James Turrell: Change of State, Friedman Guiness Gallery, Frankfort 1991

James Turrell: First Light, ed. by Josef Helfenstein and Christoph Schenker, Kunstmuseum Bern, Cantz, Ostfildern 1991

James Turrell: Four Light Installations, ed. by Laura J. Millin, Center on Contemporary Art and The Real Comet Press, Seattle 1982

James Turrell: Light and Space, ed. by Barbara Haskell, Whitney Museum of American Art, New York 1981

James Turrell: Light Spaces, Capp Street Project, San Francisco 1984

James Turrell: Long Green, Turske & Turske, Zurich 1991

James Turrell: Perceptual Cells, Kunstverein für die Rheinlande und Westfalen, Düsseldorf, Cantz, Ostfildern 1992

James Turrell: Sensing Space, Henry Art Gallery, University of Washington, Seattle 1992

James Turrell: Spirit and Light, Contemporary Arts Museum, Houston 1998

James Turrell: The Roden Crater Project, University of Arizona, Museum of Art, Tucson, AZ 1986

James Turrell: Two Spaces, Israel Museum, Jerusalem 1982

James Turrell: Un peu plus près du ciel, ed. by Pierre Restany, Galerie Froment & Putman, Paris 1989

James Turrell: Where Does the Light in Our Dreams Come From?, Setagaya Art Museum, Tokyo 1997

Jida: An Installation, ed. by Maurice E. Cope, University of Delaware, Art Gallery, Newark, NJ 1983

Jim Turrell, ed. by John Coplans, Pasadena Art Museum, Pasadena, CA 1967

Jim Turrell: Light Projections and Light Spaces, Stedelijk Museum, Amsterdam 1976

Kubler, George, *The Shape of Time: Remarks on the History of Things*, Yale University Press, New Haven, MA 1962

Mapping Spaces: A Topological Survey of the Work by James Turrell, Kunsthalle Basel, Peter Blum Edition, New York 1987

Merleau-Ponty, Maurice, *The Phenomenology of Perception*, trans. Colin Smith, The Humanities Press, New York 1962

Occluded Front: James Turrell, ed. by Julia Brown, Museum of Contemporary Art and The Lapis Press, Los Angeles 1985

Roden Crater, Museum of Northern Arizona, Flagstaff, AZ 1988

Silent & Violent, Selected Artists' Editions, ed. by Peter Noever, MAK, Vienna and Parkett, Zurich 1995

The 100 Days of Contemporary Art, Montreal 86, Lumières: Perception–Projection, Centre International d'Art Contemporain de Montréal, Montreal 1986

Three Installations by James Turrell, ed. by Suzanne Pagé, Musée d'Art Moderne de la Ville de Paris, Paris 1983

Tuchman, Maurice, *Art & Technology: A Report on the Art and Technology Program of the Los Angeles County Museum of Art, 1967–1971*, Los Angeles County Museum of Art, Viking Press, New York 1971

Un choix d'Art Minimal dans la Collection Panza, Musée d'Art Moderne de la Ville de Paris, Paris 1990

Wick, Oliver, *James Turrell: The Irish Sky Garden*, Turske Hue-Williams Ltd., London 1992

Artikel / Articles

Adcock, Craig, „Anticipating 19,084: James Turrell's Roden Crater Project“, *Arts Magazine* (New York), 58, May 1984: 76–85

Adcock, Craig, „Earthworks in the American Desert“, *Tema Celeste*, November–December 1990: 44–47

Adcock, Craig, „Light and Space at the Mendota Hotel: The Early Work of James Turrell“, *Arts Magazine* (New York), 61, 7, March 1987: 48–55

Adcock, Craig, „Perceptual Edges: The Psychology of James Turrell's Light and Space“, *Arts Magazine* (New York), 59, February 1985: 124–128

Adcock, Craig, „The Total Visual Field, James Turrell“, *Tema Celeste*, 25, April–June 1990: 44–46

Arnaudet, Didier, „James Turrell: Cet art de la lumière et du vide“, *New Art* (Paris), October 1989: 98–99

Baker, Kenneth, „Meg Webster and James Turrell at the Mattress Factory“, *Art in America* (New York), 73, 5, May 1985: 179

Bataillon, François, „James Turrell encadre le ciel“, *Beaux Arts Magazine* (Paris), 93, September 1991: 99

Beil, Ralf, „James Turrell in the Light of Aesthetics“, *Artefactum* (Arnurikalei, Belgium), 8, 40, September–October 1991: 23–27

Bizot, Jean-François, „En 1990, la galaxie chantera au-dessus du volcan“, *Actuel*, July 1986. 135–144

Blase, Christoph, „Durch Wasser zum Licht“, *Frankfurter Allgemeine Zeitung* (Frankfort), 158, July 11, 1991: 27

Bochner, Mel, „Primary Structures“, *Arts Magazine* (New York), 40, June 1966: 32–35

Boettger, Suzaan, „James Turrell, Capp Street Project“, *Artforum* (New York), 23, 1, September 1984: 118–119

Bonami, Francesco, „LeWitt, Nauman, Turrell“, *Flash Art* (Milano), June 1994: 106–107

Borden, Lizzie, „3D into 2D: Drawing for Sculpture", *Artforum* (New York), 11, 8, April 1973: 73–77

Bradley, Kim, „James Turrell: A Santa Fe Skyspace", *Artspace* (Albuquerque, NM), 13, 1, Winter 1988–89: 46–49

Bradley, Kim, „James Turrell, An Interview", *Artspace* (Albuquerque, NM), 13, 1, Winter 1988–89: 50–51

Bussell, David, „James Turrell, Meditations on Self-Illumination", *Flash Art* (Milano), 23, 154, October 1990: 147

Butterfield, Jan, „A Hole in Reality", *Images and Issues* (Santa Monica, CA), 1, Fall 1980: 53–57

Christianson, John, „The Celestial Palace of Tycho Brahe", *Scientific American*, February 1961: 119–128

Cohen, Walter, „Spatial and Textural Characteristics of the Ganzfeld", *American Journal of Psychology*, 70, 1957: 403–410

Cohen-Levina, Danielle, „Pascal Dusapin, le Minimal et le Musical", *Beaux Arts* (Paris), 128, November 1994: 94, 96–97

Colpitt, Frances, „Report From Los Angeles: Space Commander", *Art in America* (New York), January 1990: 66–71

Coplans, John, „James Turrell: Projected Light Images", *Artforum* (New York), 51, 2, October 1967: 48–49

Davis, Douglas, „James Turrell/Robert Irwin/Edward Wortz: The Invisible Project", *Art and the Future: A History/Prophecy of the Collaboration between Science, Technology and Art*, Praeger, New York 1973: 161–166

Didi-Huberman, Georges, „L'Homme qui marchait dans la Couleur", *Artstudio* (Paris), Spring 1990: 6–16

Failing, Patricia. „James Turrell's New Light on the Universe", *Artnews* (New York), 84, 4, April 1985: 70–78

Feliciano, Hector, „Taking the Plunge into a Batch of 'Heavy Water'", *Los Angeles Times* (Los Angeles), June 6, 1991: F4–F5

Gablik, Suzi, „Dream Space", *Art in America* (New York), 75, 3, March 1987: 132–133, 153

Garrels, Gary and Ammann, Jean-Christophe, et. al., „Fritsch Turrell, Collaborations", *Parkett* (Zurich), 25, 1990

Gendel, Milton, „If one hasn't visited Count Panza's Villa, one doesn't really know what collecting is all about", *Artnews* (New York), December 1979: 44–49

de Gramont, Laure, „James Turrell apporte ses lumières à l'opéra", *Le Journal des Arts*, March 1994

Hall, Charles, „Unkindly Light", *Art* (London), 45, December–January 1994: 32–35

Hammond, Pamela, „James Turrell, Light Itself", *Images & Issues* (Santa Monica, CA), 3, 1, Summer 1982: 52–56

Iden, Peter, „Wahrheit in der Wüste: Kunst in Amerika – James Turell's Krater in Arizona", *Frankfurter Rundschau* (Frankfort), October 3, 1987: 3

„James Turrell: Performing the music of the spheres of light", a conversation with Ziva Freiman, *Positions in Art*, ed. by Peter Noever, MAK, Vienna and Cantz, Ostfildern 1994: 10–32

„James Turrell, The Day When a Dead Volcano Changes into an Observatory for Meditation.", *BT*, November 1995: 12–17

Jonas-Edel, Andrea, „James Turrell: Die Körperlichkeit des Lichts offenbaren", *Das Kunst Bulletin*, January–February 1996: 10–17

Junker, Howard und Martin, Ann Ray, „The New Art", *Newsweek* (New York), 72, 5, July 29, 1968: 56–63

Knapp, Gottfried, „Das kubische Chamäleon", *Süddeutsche Zeitung* (Munich), August 2, 1997

Knight, Christopher, „Interview with Giuseppe Panza", interview, *Art of the Sixties and Seventies: The Panza Collection*, Rizzoli, New York 1988: 17–72

Larson, Kay, „Dividing the Light from the Darkness", *Artforum* (New York), 19, 5, January 1981: 30–33

Levin, Kim, „James Turrell", *Arts Magazine* (New York), 55, 4, December 1980: 5

Lewis, James, „James Turrell: Open Space for Perception", *Flash Art* (Milano), 24, 156, January–February 1991: 110–113

Liebmann, Lisa, „Cambridge: Dana Reitz, Severe Clear", *Artforum* (New York), 24, 2, October 1985: 127–128

Livingston, Jane, „Some Thoughts on 'Art and Technology'", *Studio International* (London), 181, 943, June 1971: 258–263

Marmer, Nancy, „James Turrell: The Art of Deception", *Art in America* (New York), 69, 5, May 1981: 90–99

Matta, Marianne, „Die Sammlung Panza di Biumo", *Du* (Zurich), August 1980: 6–9

Merleau-Ponty, Maurice, „Eye and Mind", *The Primacy of Perception*, Northwestern University Press, Evanston 1964

Metzger, Wolfgang, „Optische Untersuchungen am Ganzfeld, II. Zur Phänomenologie des homogenen Ganzfelds", *Psychologische Forschung*, 13, 1930: 6–29

Miedzinski, Charles, „A James Turrell Retrospective: Affirmations of Perception and Spirit", *Artweek* (Oakland, CA), 17, 3, January 25, 1986: 1

Miedzinski, Charles, „James Turrell: The Capp Street Project", *Artweek* (San Francisco), 15, 24, June 16, 1984: 1

Migayrou, Frédéric, „James Turrell", *Techniques & Architecture* (Paris), December–January 1992: 60–67

Monnier, Geneviève, „Brève histoire du bleu", *Artstudio* (Paris), 16, Spring 1990: 36–45

Nanjo, Tumo, „James Turrell", *Space Design* (Tokyo), October 1992: 40–41

Porter, William L., „Powerful Places, An Interview with Artist James Turrell", *Places*, MIT Press (Cambridge, MA), 1, 1, Fall 1983: 32–37

Ratcliff, Carter, „James Turrell's Deep Sky", *The Print Collector's Newsletter* (New York), 16, 2, May–June 1985: 45–47

Reeve, Margaret, „James Turrell and Dana Reitz: A Collaboration in Dance and Light", *Art New England*, 6, June 1985: 5

Robert, Jean Paul, „Turrell", *Architecture d'aujourd'hui* (Paris), 289, December 1992: 98–105

Rose, Barbara, „A Gallery without walls", *Art in America* (New York), 56, 2, March–April 1968: 60–71

Russell, John, „James Turrell: Light and Space", *The New York Times* (New York), 130, October 31, 1980: C22

Searle, Adriane, „Blue Heaven, James Turrell's Indoor Weather", *Artscribe* (London), January/February 1990: 48–49

Sharp, Wiloughby, „Rumbles", *Avalanche* (New York), 1, Fall 1970: 2–3

Tortosa, Guy, „James Turrell, L'Espace de la Perception", interview, *Art Press* (Paris), 157, April 1991: 16–23

Tuchman, Maurice, „An introduction to 'Art and Technology'", *Studio International* (London), 181, April 1971: 173–180

Tuchman, Maurice, „Art and Technology", *Art in America* (New York), 58, March–April 1970: 78–79

Walden, Gert, „Die Strahlkraft der Intervention", *Der Standard* (Wien), July 31, 1997

Weber, Nicholas Fox, „Building Gardens in the Sky", *Art & Auction*, November 1994: 142–145, 181–184

Weisang, Myriam, „Unnatural acts", *High Performance* (Los Angeles), 10, 4, 1987: 40–42

Welling, Helen G., „Space and Time revised in the American Landscape", *B Architectural Magazine*: 12–25

Weskot, Hanne, „Licht ist ein sehr kostbares Material", *tain – magazin für architektur, kunst und design* (Cologne), 6, November–December 1998: 52–57

Wisniewski, Jana, „Nichts ist mehr, wie es vorher war", *Salzburger Nachrichten* (Salzburg), August 1, 1997

Woodbridge, Sally, „The Mountain of Pegasus", *Progressive Architecture* (Cleveland, OH), 65, 12, December 1984: 20–21

Wortz, Melinda, „Exposure to Process", *Artnews* (Farmingdale, NY), 76, 1, January 1977: 88–89

Wortz, Melinda, „Water Gabrielson and James Turrell", *Artweek* (Oakland, CA), 7, 43, December 11, 1976: 1, 16

Zone, Ray, „Cyclopean Images", *Artweek* (Oakland, CA), 16, 12, March 23, 1985: 11